Philosophy and Conceptual Art

The fourteen prominent analytic philosophers writing here engage with the cluster of philosophical questions raised by conceptual art. They address four broad questions: What kind of art is conceptual art? What follows from the fact that conceptual art does not aim to have aesthetic value? What knowledge or understanding can we gain from conceptual art? How ought we to appreciate conceptual art?

Conceptual art, broadly understood by the contributors as beginning with Marcel Duchamp's ready-mades and as continuing beyond the 1970s to include some of today's contemporary art, is grounded in the notion that the artist's 'idea' is central to art, and, contrary to tradition, that the material work is by no means essential to the art as such. To use the words of the conceptual artist Sol Le Witt, 'In conceptual art the idea of the concept is the most important aspect of the work . . . and the execution is a perfunctory affair'. Given this so-called 'dematerialization' of the art object, the emphasis on cognitive value, and the frequent appeal to philosophy by many conceptual artists, there are many questions that are raised by conceptual art that should be of interest to analytic philosophers. Why, then, has so little work been done in this area? This volume is most probably the first collection of papers by analytic Anglo-American Philosophers tackling these concerns head-on.

Peter Goldie is the Samuel Hall Professor of Philosophy at the University of Manchester.

Elisabeth Schellekens is Senior Lecturer of Philosophy at the University of Durham.

Philosophy and Conceptual Art

Edited by Peter Goldie and Elisabeth Schellekens

CLARENDON PRESS · OXFORD

OXFORD
UNIVERSITY PRESS

Great Clarendon Street, Oxford OX2 6DP

Oxford University Press is a department of the University of Oxford.
It furthers the University's objective of excellence in research, scholarship,
and education by publishing worldwide in

Oxford New York

Auckland Cape Town Dar es Salaam Hong Kong Karachi
Kuala Lumpur Madrid Melbourne Mexico City Nairobi
New Delhi Shanghai Taipei Toronto
With offices in
Argentina Austria Brazil Chile Czech Republic France Greece
Guatemala Hungary Italy Japan South Korea Poland Portugal
Singapore Switzerland Thailand Turkey Ukraine Vietnam

ISBN 978-0-19-956825-3

Printed in the United Kingdom by
Lightning Source UK Ltd., Milton Keynes

CONTENTS

LIST OF ILLUSTRATIONS

1. Jenny Holzer, *Truisms*, 1978–87. Digital image © 2007, The Museum of Modern Art/Scala, Florence/© ARS, NY and DACS, Landon 2007.

2. Michael Craig-Martin, *An Oak Tree*, 1973. © Tate 2007.

3. Marcel Duchamp, *Fountain*, 1917. Photo by Alfred Stieglitz from the periodical "The Blind Man", Beatrice Wood. Philadelphia Museum of Art © Photo Scala, Florence, © Succession Marcel Duchamp/ADAGP, Paris and DACS, London 2007.

4. Bruce Nauman, *One Hundred Live and Die*, 1984. Neon tubing with clear glass tubing on metal monolith; $118 \times 132 \frac{1}{4} \times 21$ inches ($299.7 \times 335.9 \times 53.3$ cm). Collection Benesse Corporation, Naoshima Contemporary Art Museum, Kagawa Courtesy Sperone Westwater, New York. © ARS, NY and DACS, London 2007.

5. Joseph Kosuth, *One and Three Chairs*, 1965. © ARS, NY and DACS, London 2007. Digital Image © The Museum of Modern Art/SCALA, Florence.

6. Art—Language, *Index 01* (Art and Language, Index 001) (aka Kassel Index), 1972. By permission of the Lisson Gallery, London.

7. Robert Barry, *Inert Gas Series: Argon*, 1969. By permission of the artist. (From a measured volume to indefinite expansion on March 4, 1969 on a beach in Santa Monica, California, one litre of argon was returned to the atmosphere. Documentation: Catalogue page, diapositive, two colour photographs framed.) Collection Elisabeth & Gerhard Sohst in the Hamburger Kunsthalle, Hamburg, Germany. Photo Bridgeman Art Library.

8. Sol LeWitt, *Wall Drawing* No. 623, 1989. National Gallery of Canada, Ottawa. © ARS, NY and DACS, London 2007.

9. Adrian Piper, *Catalysis* IV, 1970–1. By permission of the artist.

Introduction

Peter Goldie and Elisabeth Schellekens

Philosophy and Conceptual Art

Art devoid of ideas is seldom good art. Ideas can wear many guises in an artistic context: they can be highly focused and convey one specific concern (such as the idea of the threat of domestic violence), or, alternatively, they can be quite indefinite (such as the idea of the wilderness of nature as evocative of the sublime). There are, in fact, many different kinds of ideas that can be conveyed by art, and so the claim that good art should involve ideas need not imply that only art which sets out to communicate specific thoughts is worthy of our attention.

However, there is one artistic movement which has claimed that art should invariably aim to engage its audience intellectually, and, moreover, that it need not do so aesthetically or emotionally. Art, on this view, should aim to be 'of the mind', not simply because it demands a primarily intellectual approach, but also because such artwork is best understood as an idea. The purpose of art, according to this movement, is analytic, and as such, art is in the business of creating and transmitting ideas. Artists are authors of meaning rather than skilled craftsmen, since it is the idea, and not the art object, that is at the heart of artistic experience.

With a plethora of bold claims such as these, the conceptual art movement placed itself firmly within a stream of controversy from its very outset.[1]

[1] Although the first publication to use the expression 'Conceptual Art' appears in Sol LeWitt's 'Paragraphs on Conceptual Art' (1967), Henry Flynt was already exploring the idea in his 'Essay:

And like other avant-garde movements before it, it not only welcomed but partly instigated the tumultuous debate that was to engulf much of the Western art world from the late 1960s onwards by posing questions such as 'What kind of thing can qualify as art?', 'Must art be beautiful?', and 'What is the role of artists?' Despite their considerable diversity, the multitude of manifestos, mission statements, projects, and discussions that emerged from this movement can all be said to share this one central tenet: in art, the 'idea is king'.[2] In conceptual art, that is, the concepts or ideas constitute the artworks' 'material'.[3]

In the process of redefining art-making and art appreciation in terms of a primarily intellectual process, many artists working in the conceptual tradition have drawn, and continue to draw, on philosophical theories and debates. Frequent appeals are made to philosophers from both the Anglo-Saxon and Continental perspectives: Wittgenstein, Carnap, Austin, Kuhn, Barthes, Althusser, Benjamin, Foucault, Lacan, Saussure, and many others.[4] Many conceptual artists even go further, claiming that conceptual art and philosophy are in much the same business, so that even if they approach their subject matter from different angles, there is considerable overlap in the questions explored by the two disciplines. One conceptual artist and writer, Joseph Kosuth, even heralds conceptual art as the eventual successor to philosophy.[5] Philosophy thus seems to have served not only as an inspiration, but, at times, even as a source of authority and justification for the work performed by conceptual artists.

As a matter of fact, comparatively few analytic philosophers have returned this interest and sense of amity. Even philosophers working on issues connected with artistic and aesthetic experience rarely appeal to conceptual artworks when it comes to illustrating their claims or supporting their views. Whilst critical discussions of the philosophical issues raised by conceptual art certainly

Concept Art', in La Monte Young and Jackson MacLow (eds.), *An Anthology of Chance Operations* (New York, 1963).

[2] Paul Wood, *Conceptual Art*, Movements in Modern Art (London: Tate Publishing, 2002), 33.

[3] Lucy Lippard and John Chandler, 'The Dematerialization of Art', *Art International*, 12/2 (February 1968), 31–6.

[4] See, for example, Art & Language's *Index 01* made for the 'Documenta' exhibition in 1972; Keith Arnatt's *Trouser-Word Piece* (1972) and Joseph Kosuth's 'Art After Philosophy' *Studio International*, 178 (October 1969), 134–7, all illustrated in this volume; and the work of Mel Bochner and Art & Language, especially Terry Atkinson and Michael Baldwin.

[5] See Kosuth, 'Art After Philosophy'.

have been given due attention by art critics and art theorists, such investigations are still to find their way into analytic philosophy in a similarly consistent and systematic fashion.

What is the explanation for this neglect? Is it justified, or is the neglect grounded in an unwillingness to pick up the gauntlet thrown down by conceptual art to the received wisdoms about the ontology, epistemology, perception, and appreciation of art? These are some of the questions that prompted this volume. Taking conceptual art on its own terms, the papers gathered here investigate, from a philosophical point of view, how the status of conceptual art as art challenges not only the more traditional concepts of art and the aesthetic, but also, the very way in which we philosophize about them. In so doing, they will hopefully persuade writers in philosophical aesthetics to entertain a less reserved, and perhaps even less sceptical, perspective both on conceptual art as a movement as well as on particular works of conceptual art.

What is Conceptual Art?

What criteria does an artwork have to meet for it to count as conceptual? Unsurprisingly, the question admits of no straightforward answer. Conceptual art does not employ one specific technique or art medium, nor can it be categorized according to one distinctive genre; as Lucy Lippard has famously argued, there seem to be as many definitions of conceptual art as there are conceptual artists.[6] However, if the only claim central to conceptual art were to be that the 'idea is king', then there may simply not be enough to go on in assessing whether a particular piece is conceptual or not. We need to do better than just say that conceptual art is not definable.

On closer scrutiny, there seems to be a choice to be made between two main ways of approaching the question: one more historical and the other more philosophical or conceptual. According to the more historical approach, the term 'conceptual art' refers exclusively to the artistic movement that took place roughly between 1966 and 1972. From this perspective, only pieces produced during that period, with the occasional exception of some works

[6] Lucy Lippard, *Six Years: The Dematerialization of the Art Object from 1966 to 1972*, 2nd. edn. (Berkeley: University of California Press, 1997).

steeped in that spirit, can rightly be called 'conceptual'. Examples of such works include Christine Koslov's *Information No Theory* (1970),[7] On Kawara's series *Date Paintings* (1966 onwards),[8] and Art & Language's *Hostage XXIV* (1989).[9]

The second approach is less historical and more philosophical or conceptual. From this perspective, artworks such as Damian Hirst's *The Physical Impossibility of Death in the Mind of Someone Living* (1991),[10] Marcel Duchamp's *Fountain* (1917, see Illustration 3), and Gavin Turk's *Cave* (1991),[11] qualify as 'conceptual' too, even though they were not part of the period of the conceptual art movement strictly speaking. We suggest that what holds these works together as, broadly speaking, works of conceptual art, is that they have certain important characteristics in common. Most of the papers in this volume adhere to this more inclusive understanding of conceptual art; from now on the capitalized 'Conceptual Art' will only be used to refer to the artistic movement that took place between 1966 and 1972. We would like to advance the following five characteristic features of conceptual art, with the caveat that, in doing so, we wish firmly to avoid advancing a conclusive definition as such.

1. Conceptual art aims to remove the traditional emphasis on sensory pleasure and beauty, replacing it with an emphasis on ideas and the view that the art object is to be 'dematerialized'.

2. Conceptual art sets out to challenge the limits of the identity and definition of artworks and questions the role of agency in art-making.

3. Conceptual art seeks, often as a response to modernism, to revise the role of art and its critics so that art-making becomes a kind of art criticism, at times also promoting anti-consumerist and anti-establishment views.

[7] Koslov's work consists of a tape recorder which, when activated, plays a statement made by the artist.

[8] This series comprises square canvases onto which the artist has, on a daily basis, printed the day's date (e.g. 'Jan. 15, 1966').

[9] In this piece Michael Baldwin, Charles Harrison and Mel Ramsden have superimposed a short text (black on white) onto a black and white photograph. The text reads as follows: 'There might be a picture of a place where a certain confusion is systematically suppressed; a place where a minor pragmatic violence is sustained by a trivial mechanism of fear. It is a place where Humpty Dumpty has the power of small adjustments in his métier. It is a place of contrivance and factitiousness, an unimportant enemy of public safety. For some reason it is an important place of celebration and display. It is also a place where inundation is ruled out by protocol.'

[10] Hirst's piece consists of a dead shark immersed in a transparent tank of formaldehyde.

[11] This work consists of a blue ceramic commemorative plaque carrying the inscription 'Borough of Kensington Gavin Turk Sculptor Worked Here 1989–1991'.

4. Conceptual art rejects traditional artistic media, particularly the so-called plastic arts, in favour of new media of production such as photography, film, events, bodies, mixed media, ready-mades, and more.

5. Conceptual art replaces illustrative representation by what some call 'semantic representation'—semantic not only (not necessarily) in the sense of words appearing on or in the work of art itself, but in the sense of depending on meaning being conveyed through a text or supporting discourse.

Conceptual Art as a Kind of Art

The chapters in this collection, and the remaining sections of this Introduction, are divided into four broad themes: conceptual art as a kind of art; conceptual art and aesthetic value; conceptual art, knowledge, and understanding; and appreciating conceptual art.

The first broad theme concerns what kind of art conceptual art is, and in what sense something can qualify as art when one of its self-avowed aims is precisely to throw into question the very idea of defining art. One question here, explored by Peter Lamarque, is what distinguishes a work of conceptual art from its visually accessible 'physical' base, perhaps in the form displayed in a gallery. He addresses this question within the wider context of the way in which art in general can be non-perceptual, and how that relates to the way in which art in general can be non-aesthetic. How can we locate the 'art-making' feature of a work of art in our perceptual experience if the artwork is self-avowedly non-perceptual? Lamarque's discussion first considers other non-visual art forms, such as literature and poetry, and the analogies that can be drawn with conceptual art. One of the things that such an examination of the literary arts establishes is that novels, for example, can be non-perceptual whilst being aesthetic. This indicates that the non-perceptual character of conceptual art need not originate from the denial that beauty and aesthetic value ought to be the goal of art-making. Lamarque suggests that a better way of isolating the identity conditions of conceptual artworks is to think in terms of experience rather than perception. He then presents us with his 'Empiricist Principle' which, in conjunction with the 'Distinctness Principle', has it that the difference between a work of conceptual art and its material base must be experiential (broadly conceived) rather than perceptual or visual. What such a

view can support, according to Lamarque, is an understanding of conceptual art that makes sense of the primacy of ideas over perception not by eliminating the perceptual entirely, but by rendering it subservient to the conceptual.

A second question concerning what kind of art conceptual art is centres around whether conceptual art, and its claim to 'dematerialize' the art object, is best understood as art either by conceiving of it as a reaction against the art that preceded it (and thus as an attempt to bring the story of art forward), or as an effort to halt the continuation of art (and perhaps thereby art history as we know it). For Derek Matravers, this question is pressing because, if conceptual art is to be appreciated only as a response to what has gone before, then we are misguided in setting out to appreciate and assess works of conceptual art solely in terms of the perceptual experiences they may yield. Focusing on the modernism of the 1950s, Matravers outlines why he thinks that conceptual art aims to overcome the difficulties presented by modernist art (in particular painting). Moreover, in the light of the institutional theory that he himself has defended, Matravers presents an argument for the view that external contextual factors *can* contribute to the process of determining whether an object is a work of art or not. What all this indicates, he suggests, is that if our aim is to defend conceptual art as a kind of art, we should look at the socio-historical context in which it emerged, and at the manner in which conceptual artists seek to readjust certain unbalances in art making and art appreciation, rather than in terms of any experiences it may lead us to enjoy.

Following on from the two questions discussed by Lamarque and Matravers, Gregory Currie explores the role played by appearances in conceptual artworks as contrasted with other kinds of art, and what any such contrasts may indicate about the ontology of conceptual works. Currie adopts an inclusive approach to conceptual art, and examines pieces such as Bruce Nauman's *One Hundred Live and Die* (see Illustration 4), a work which, whilst primarily concerned with the function of art and the artist, still somehow relies on its appearance. Currie argues against the claim that all of a work's art-relevant properties are available through sight alone, and that, accordingly, it is wrong to suppose that works with the same appearance have the same art-relevant qualities. But this, Currie explains, need not be incompatible with the idea that works of art are things primarily to be looked at, which is what most conceptualist artists reject. Accepting that artworks are first and foremost things to be looked at *whilst* rejecting the idea that artworks should be accessed by sight alone suggests that the process of engagement with artworks is what Currie

refers to as a 'visual engagement'. Included amongst the identity conditions for conceptual artworks are, Currie concludes, a work's visible features.

In his contribution, Robert Hopkins examines the question of how conceptual art distinguishes itself from other art in the context of the communicative means available to conceptual art. For Hopkins, what sets conceptual art apart from other art is not the way in which it typically does not rely on sense experience in order to be fully appreciated; after all, literary artworks are like this too. Instead of sense experience, it is more likely that the distinguishing factor lies in the manner in which execution in conceptual art is a rather 'perfunctory affair', as LeWitt puts it. In conceptual art, Hopkins argues, the work's artistic properties are fully determined by a less than fully specific conception of its base properties. That is to say, it allows for a particularly loose relation between base and artistic properties, in so far as a partial conception of the former suffices to determine the latter. Finally, and drawing on Grice's theory of conversational implicature, Hopkins discusses exactly how conceptual art communicates. The main distinguishing feature between conceptual art and other kinds of art is, Hopkins argues, to be found in the way in which the former sets up an expectation of sensory fulfilment that it knowingly goes on to frustrate.

Conceptual Art and Aesthetic Value

The second broad theme addressed in this volume is the relation between conceptual art and aesthetic value, and the way in which conceptual art challenges our understanding not only of the aesthetic as such, but also of whether art need always be aesthetic. Art in the conceptual tradition prompts us to consider questions such as 'Should the aesthetic be not so much a goal of art as an issue for it to address?', 'Can we disengage our view of good art from the notion of beauty?', and 'Is there any sense in which even purely conceptual artworks have aesthetic value?'.

Conceptual art's rejection of beauty as an artistic goal seems to be contingent on the primacy of ideas which it advocates; an artwork that aims to yield knowledge by conveying ideas should, it is generally assumed, set aesthetic aspirations aside. In her contribution, Elisabeth Schellekens asks whether this description accurately captures the relation between aesthetic and cognitive value in conceptual art. If we accept the stipulation that any aesthetic qualities

that a conceptual work's perceivable manifestation may have are irrelevant to its appropriate appreciation, the concern about whether the 'traditional model of value' still applies in the conceptual case becomes the question of whether the ideas at the heart of such works are capable of having some aesthetic value. Are ideas, the 'material' of conceptual art, capable of being beautiful? Exploring the distinction between propositional knowledge and experiential knowledge, Schellekens argues that ideas can indeed have a kind of aesthetic quality, and thus that conceptual art can have aesthetic value. Moreover, engaging with such aesthetic value might even play an important role in our appreciation of the cognitive value distinctive of much conceptual art.

The second question we turn to, in Diarmuid Costello's contribution, concerns the possibility of a theory of the aesthetic which is not only broad enough—but actually tailor-made—for conceptual art. The starting point of Costello's inquiry is the way in which our conception of the aesthetic has been shaped by a specific interpretation of Kant's theory. This reading, based on certain commitments to modernism and formalism, is, Costello argues, neither the only one available to us, nor is it particularly prone to fit the conceptual case. Instead, we should focus on Kant's view of how works of art express 'aesthetic ideas' by stimulating certain affective responses in perceivers and leading us to reflect upon our own cognitive abilities. Aesthetic feeling is operative not so much at the level of an aesthetic idea's execution or realization as at the level of the idea itself and its appreciation by perceivers. This focus, Costello suggests, is likely to circumvent some of the misleading assumptions of formalist aesthetics. If there can be a Kantian theory of the aesthetic suitable to conceptual art, he concludes, it is to be found here.

Conceptual Art, Knowledge, and Understanding

If, as some conceptual artists suggest, art should be about formulating and communicating ideas, we might ask how exactly this goal is to be achieved. This is the third broad theme tackled in this collection. It raises several important questions: the role of texts or supporting narrative discourse in conceptual artworks; the way in which these texts or discourses may be necessary to our experience of the ideas embodied in conceptual artworks; the kind of knowledge that conceptual artworks can yield; and what the role of imagination is in mediating any knowledge we might gain from conceptual art.

The first question concerns how ideas can be communicated by things which do not typically embody propositions. Carolyn Wilde investigates how conceptual artworks, in continuity with other artworks before these, can be meaningful in terms of the ideas embodied in the work. Tracing the history of this question from Plato to Joseph Kosuth via early Renaissance and modernist artists, Wilde describes how art gained intellectual prestige in terms of the ways in which it claimed to mediate between thought and the world. Open to the particular intellectual and cultural contexts in which it has been created, conceptual art, Wilde explains, goes so far as to bring these external conditions reflexively into the origin of the artwork. Using Kosuth's *One and Three Chairs* (see Illustration 5), Wilde discusses how the piece instantiates the process of its creation by drawing comparisons with Vincent Van Gogh's famous painting of his own chair, Jasper Johns's *Fool's House*, and a work by the contemporary conceptual artist, Jake and Dinos Chapman. Although critical of Kosuth's own propositional account of his work, she follows through his claim that *One and Three Chairs* is about the condition of art itself.

A second question concerns the way in which narratives appended to certain conceptual artworks or outlined in art books seem central to our appreciation, understanding, and perhaps even perception of them. Is a narrative constitutive of such an artwork? David Davies addresses this issue precisely, and guides us through a discussion of the question by examining three conceptualist pieces by Helen Chadwick, Robert Ryman, and Luc Tuymans. The function of narrative, Davies argues, is at least twofold. First, a narrative can be contextualizing; it can present an audience with a certain kind of frame in which to appreciate an artwork, and provide information about an artist's methods, means, and historical milieu. Second, a narrative can be identifying, that is to say, crucial to the process of singling out a thing or event as an artwork. What sets conceptual works apart from other pieces, for Davies, is not that they cannot 'speak for themselves' since all art is only really accessible through the mediation of a contextualizing narrative. Rather, conceptual pieces are special in so far as they require an identifying narrative. This, Davies concludes, constitutes the most important difference between conceptual pieces and more traditional artworks.

Another difference between conceptual art and traditional art might lie in its cognitive value. Some philosophers (and non-philosophers) have claimed that conceptual art lacks the kind of cognitive value that we find in the

great works of traditional art, such as, for example, the way in which we can learn about the loneliness of the human condition from Renoir's *La Loge*. Some even go on to claim that conceptual art has no significant cognitive value. Putting forward examples, Peter Goldie, in his contribution, argues against this latter claim, showing that we can gain significant knowledge from conceptual art, although not in the way that we gain knowledge from traditional art. From some conceptual artworks we can gain knowledge of what it is like to experience certain emotions in certain kinds of circumstances; but these emotions, such as frustration, horror, and disgust, are often not of the kind that are traditionally associated with aesthetic appreciation. Other works of conceptual art (and here Goldie discusses Kosuth's *One and Three Chairs*) can help us to think about difficult philosophical ideas, and thus they can facilitate knowledge and enhance our intellectual dispositions; moreover, they do this in an artistic way. If Goldie is right about this, then we have here another important difference between traditional art and conceptual art, but not a difference that is obviously to the detriment of the latter.

In addition to the question of whether conceptual art can yield significant knowledge, there is a question about whether it is possible to learn about things such as artworks by visualizing them or imagining them visually. If not, it might be held that any mental images we may have as a result of engaging with conceptual art are superfluous to understanding it. This, in turn, might present difficulties for any kind of art, including perhaps conceptual art, that does not rely simply on what is straightforwardly given in perceptual experience for its appropriate appreciation. Kathleen Stock frames this discussion in the light of Sartre's and Wittgenstein's rejections of the idea that visual imagining enables us to gain knowledge and understanding of the object visually imagined. Stock outlines several arguments for the view that Sartre and Wittgenstein seem incapable of establishing the validity of their claim on this matter. Our grasp and insight into conceptual art can, Stock holds, only benefit from mental imaging. Moreover, she shows how, if Sartre's and Wittgenstein's cases were to have been successfully made out, then this might damage the possibility of propositional imagining increasing our understanding of conceptual artworks.

Appreciating Conceptual Art

The final broad theme broached in this volume concerns the manner in which conceptual art should be appreciated *qua* art. If art in the conceptual tradition self-consciously sets itself apart in being the kind of art it is, in the way it relates to aesthetic value, and in the knowledge and understanding it may afford, then perhaps we ought to appreciate it in a different way. The proper appreciation of conceptual art as art (and the frequent frustration it often gives rise to) can only be understood once these prior issues have been clarified.

This thought is Matthew Kieran's starting point. Contemporary analytic aesthetics, he argues, has made some misleading moves in relation to conceptual art by overlooking the importance of aesthetic character and creativity. More specifically, Kieran describes three closely related aspects of the attitude apparent in philosophical aesthetics towards conceptual art: first, the way in which it tends to focus on the perceiver's reception of art; second, the assumption that the properties we tend to value in art are manifest to the perceiver; and thirdly, the rejection of the Romantic ideals of imagination and of the artist's personality. In so doing, philosophical aesthetics of the last twenty-five years has paid little heed to precisely what conceptual art encourages us to think about: art-making, artistic practices, and the creative character of the artist. Conceptual art, Kieran explains, does not hold up the art object as the locus of artistic creativity. It is, rather, the reflective process that leads an artist to the idea underlying a piece that should be the focus of attention. Thus, again, the 'idea is king'.

The notion of creativity, and the role it plays in conceptual art, is given a more distinctively psychological flavour by Margaret Boden. For Boden, there are several kinds of creativity, distinguished from one another by the kind of psychological processes involved in generating creative ideas. Boden proposes a threefold distinction, between combinatorial, exploratory, and transformational creativity. Which kind of creativity, Boden asks, is involved in the making of conceptual art? Perhaps the most intuitively obvious candidate for this task is transformational creativity, which is the kind of creativity that leads to the 'impossibilist' surprise involved when some defining aspect of an artistic style is altered in a way which enables the artist to generate ideas

that could not have been generated before. A second candidate is exploratory creativity, which is the kind of creativity at play when existing artistic styles and conventions are used to generate new ideas which may not have been realized before. But, Boden argues, neither of these adequately captures the creativity of conceptual art. Instead, it is combinatorial creativity, generating unfamiliar combinations of familiar ideas, which is the creativity that is appropriate to conceptual art.

Another approach to the problem of how conceptual art should be appreciated is adopted by Dominic McIver Lopes. Lopes considers and rejects two hypotheses: the 'New Art Hypothesis', that appreciative failure arises because the audience is committed to a traditional definition of art; and the 'Ontological Hypothesis', that appreciative failure arises because works of conceptual art have no place in our traditional 'folk' ontology of art. Lopes then goes on to argue for a third hypothesis, the 'Art Form Hypothesis', according to which appreciative failure arises because the audience wrongly assumes conceptual art to be 'plastic art'—paintings and sculpture. Finally, Lopes considers the possibility that conceptual art could be a new art form in its own right. For Lopes, developing the 'Art Form Hypothesis' represents the best chance we have to convert appreciative failure into appreciative success.

The final contribution to the collection comes from a group of artists who have been at the heart of the Conceptual Art project ever since its inception. The current members of Art & Language, a collective of British artists founded in the middle of the 1960s, should be well placed to offer an explanation of how Conceptual Art was influenced by philosophy. Michael Baldwin, Charles Harrison, and Mel Ramsden—by describing, from the inside, the intentions, aims, and results of the Conceptual Art movement in Britain from its beginning until today—uncover a different perspective on the matters investigated in this volume. So different, in fact, is their perspective that a summary of the aims and content of their contribution in this introduction would seem inappropriate; their chapter, uncompromising and singular, constitutes a challenge not just to some of the ideas presented in the rest of this volume, but also to the spirit and method in which they are examined. If conceptual art is the reflective exercise *par excellence* in art, it is really at its best when distinctively *self*-reflective.

Acknowledgements

The majority of the papers collected in this volume were presented at a conference organized by the editors at King's College London in June 2004 and funded by one-year 'Innovation Award', 'Perception, discourse, and conceptual art: a philosophical investigation', from the Arts and Humanities Research Council. The editors would like to express their sincere gratitude to the AHRC, and in addition thank Peter Momtchiloff, Rupert Cousens, and Jacqueline Baker from Oxford University Press for their support and encouragement during the planning and preparation of the collection. We also thank the philosophers, art theorists, and others who attended the conference at which earlier versions of these chapters were presented, and those graduate and undergraduate students who contributed to our seminars and lectures on conceptual art. The many stimulating and challenging comments and questions are now reflected in ways too complex for any more formal acknowledgement to be adequate.

References

FLYNT, HENRY, 'Essay: Concept Art', in La Monte Young and Jackson Maclow (eds.), *An Anthology of Chance Operations*. (New York, 1963).

KOSUTH, JOSEPH, 'Art After Philosophy', *Studio International*, 178 (October 1969): 134–7.

LEWITT, SOL, 'Paragraphs on Conceptual Art', *Artforum*, 5/10 (1967): 79–83.

LIPPARD, LUCY, *Six Years: The Dematerialization of the Art Object from 1966 to 1972*, 2nd edn. (Berkeley: University of California Press).

LIPPARD, LUCY and CHANDLER, JOHN, 'The Dematerialization of Art', *Art International*, 12/2 (February 1968): 31–6.

WOOD, PAUL, *Conceptual Art*, Movements in Modern Art (London: Tate Publishing, 2002).

Part I

Conceptual Art as a Kind of Art

1

On Perceiving Conceptual Art

Peter Lamarque

1.1 Introduction

In a recent graduation exhibition at a British art school a work was displayed which consists of a man bearing two full-length sandwich boards on which is printed, in large Times Roman type: 'This is not "Art" in itself but a means of creating it'. I have not seen the display, only a photograph of it on a flier sent to me by the art school.[1] But it has some paradigmatic features of the kind of conceptual art that I want to consider. It uses language as its central medium; it is a reflection on the status of art; it involves a mildly witty self-referential paradox; it is partially a performance work in that the man carrying the boards is standing outside at the edge of a park; and finally my description captures, I believe, enough to give you a pretty clear idea of the essence of the work itself. In fact the work is not especially original. There have been numerous efforts along similar lines, raising similar questions. There is, for example, a well-known work by Keith Arnatt from 1972, entitled *Trouser-Word Piece* (see Illustration 12), which consists of a photograph of the artist also holding a sandwich board on which is written 'I'm a Real Artist'; next to the photograph is a long quotation from the philosopher J. L. Austin stating that it is not the word 'real' itself

[1] This was a press release from the Nottingham Trent University's School of Art and Design, April 2004.

but the negative of 'real' that, in Austin's memorable phrase, 'wears the trousers'.[2]

What interests me about the art school piece is less what it tells us about art but rather what the word 'This' refers to in its legend 'This is not "Art" in itself but a means of creating it'. We might suppose that 'This' refers to the work itself. But what is the work? Is it the sentence? If so, is it the sentence token as it appears on the sandwich board, or the sentence type, as instantiated just now in my description? Or is it the sentence and the board and the man holding it? Again, if the work is the whole ensemble then is it the ensemble type or this one specific token? If I were to reproduce the sentence on a sandwich board of my own have I produced the *same* work? Or an *instance* of the work? Or a distinct but visually indiscernible work? These are familiar questions on the ontology and identity conditions of art and of course Arthur Danto has shown how such questions become especially pressing in the case of conceptual art.[3] Note that to pursue the question—as I want to—about what counts as a *work* in talking of conceptual art—and what counts as the same or distinct works—is not equivalent to asking what counts as *art*. I am not concerned here with the question whether conceptual art really is art or not, in any honorific sense, but I am concerned with the, to my mind more interesting, question of what the identity conditions are of objects or performances of this avowedly odd kind. I think that until we have some better idea of this we are not able to get much of a handle on what it means to appreciate the work so described *as a work*. Can I, for example, do full justice to this work and appreciate it as intended merely by thinking of it? Or by talking of it as I have just now? Or by reproducing a version of my own? Or by changing it in various ways (e.g. the layout of the words)? Or do I have to go to the art school to see it for myself?

1.2 The Issues in Question

My discussion will be focused on perception, with the broad question in mind whether or not the kind of conceptual art just exemplified is essentially *visual*

[2] See Tony Godfrey, *Conceptual Art* (London: Phaidon, 1998), 172.

[3] Arthur Danto, *The Transfiguration of the Commonplace* (Cambridge, MA: Harvard University Press, 1981).

art, whether the objects are necessarily objects of perception, and with more specific questions centring on exactly how perception, art, and the aesthetic are related. The starting point is whether it even makes sense to suppose that art could be both non-perceptual and non-aesthetic. It would be ill-advised to try to *define* conceptual art or over generalize, since conceptual art takes many different forms, yet it seems to be at least an aspiration of some such art, or a direction towards which it tends, to be both non-perceptual and non-aesthetic. The emphasis on ideas is a common feature and this is often associated with giving low priority to material form, to what is perceptible. Lucy Lippard writes: 'Conceptual art . . . means work in which the idea is paramount and the material form is secondary, lightweight, cheap, unpretentious and/or "dematerialized".'[4] Sol LeWitt goes further: 'What the work of art looks like is not too important. It has to look like something if it has physical form. No matter what form it may finally have it must begin with an idea. It is the process of conception and realisation with which the artist is concerned.'[5] Here too is Mel Bochner:

A doctrinaire Conceptualist viewpoint would say that the two relevant features of the 'ideal Conceptual work' would be that it have an exact linguistic correlative, that is, it could be described and experienced in its description, and that it be infinitely repeatable. It must have absolutely no 'aura', no uniqueness to it whatsoever.[6]

Three questions immediately present themselves: Can there be art that is non-perceptual? Can there be art that is non-aesthetic? Can something be aesthetic but not perceptual? It might be hoped that answers to these questions may cast light on what kinds of works are works of conceptual art.

1.3 Conceptual Art and Literary Art

The first question, 'Can there be art that is non-perceptual?', seems to yield an obvious Yes, citing the case of literature and poetry. This then encourages the

[4] Lucy Lippard, *Six Years: The Dematerialization of the Art Object from 1966 to 1972* (Berkeley: University of California Press, 1997), vii.

[5] Sol LeWitt, 'Paragraphs on Conceptual Art', *Artforum*, 5/10 (June, 1967): 79–83 Quoted in Lucy Lippard, *Six Years*, 29.

[6] Mel Bochner, 'Mel Bochner on Malevich: an Interview' (with John Coplans), *Artforum*, 12/10 (June 1974): 62. Quoted in Roberta Smith, 'Conceptual Art', in Nikos Stangos (ed.), *Concepts of Modern Art* (London: Thames & Hudson, 1994), 259.

thought that such conceptual art that de-emphasizes the perceptual and gives prominence to language and description might be assimilated to the literary arts. But this calls for more careful examination.

First of all, is it clear that literary works are non-perceptual? After all, our access to them must ultimately be through the senses; we read by scanning a text with our eyes or following it with our fingers in Braille, or hearing a spoken version with our ears. Does that make literature perceptual after all? No, because our senses give us perceptual access to a text and a text is not identical with a work. Texts are ordered strings of sentence types but any perceptual instantiation of the sentence types, in a particular font or size or in a particular pattern of sounds, is merely contingent to the identity of the work. And texts so defined are not identical with works because two identical strings might be different works. Or, put another way, any one string of sentence types might yield or make possible more than one literary work.[7] Different tokenings might be open to different interpretations or might be construed as works of different kinds. Our perceptual access to works through texts is not sufficient to determine what works the texts give us access to.

Of course one notable exception to this principle among literary works is the rather special case of concrete poetry where the configuration of the words on a page is essentially, not merely contingently, related to what the work is.[8] It might well be that some concrete poetry is quite close in kind to some conceptual art but this hardly helps establish that conceptual art is not essentially perceptual for the perceptual appearance of concrete poetry is essential to its identity.

More interesting is the role of ideas in literary art and conceptual art. It might seem that on this level the two come closest together. But, to anticipate, I don't think the analogy is very strong. How do ideas inform literary works? Obviously the question affords no simple answer. Wherever there are meanings there are ideas and wherever there is language there is meaning. I think the most promising analogies revolve round the notion of a *theme* in a literary work. One of the aims of literary interpretation is to elicit themes, that is ideas or conceptions, which can be seen to give coherence and interest to the

[7] See my 'Objects of Interpretation', *Metaphilosophy*, 31 (2000): 96–124.

[8] For examples see Emmett Williams (ed.), *An Anthology of Concrete Poetry* (New York: Something Else Press, 1967).

work's ostensible subject, be it poetic image or narrative event.[9] The theme of Shakespeare's Sonnet 65 is easy to discern: the inescapability of time and the sadness of mortality with a hint that love might attain a kind of immortality through the written word, perhaps in the form of the sonnets themselves. The beauty and power of the poem lie in the way that the apparent hopelessness of the ravages of time is expressed and developed, tempered at the end by a glimmer of hope. The images are mixed—from the military ('the wrackful siege of batt'ring days') to the mercenary ('Time's best Jewel from Time's chest lie hid')—but they cohere round the ever-present central theme. What is typical of a literary work is that an idea in the form of a theme—either individual concepts such as mortality or passing time, or a proposition such as 'poetry sustains love through the ravages of time'—is developed out of and gives coherence to specific detail at the subject level.

It is hard to see any exact parallel in the case of conceptual art. Certainly something like thematic ideas come to be associated with some works but the crucial features of the literary case are typically missing or blurred: the fine interplay between thematic description and subject description, the essentially linguistic development of the theme, the notion of detail cohering round a theme, even the requirement that themes in literary works centre on matters of universal interest. In conceptual art where there is an informing thematic idea—often, as in our earlier example, about the boundaries between art and non-art—it is only loosely, perhaps metaphorically, connected to the specific item displayed, be it a performance, a sequence of numbers, a disparate collection of objects, an empty frame, lights turned on and off, a beach hut, a pile of clothes, or, as above, a provocative sentence. These basic conceptions might prompt reflective thinking of a thematic kind but the close integration of subject and theme in the literary case—the way the subject matter both enhances and defines thematic content—is missing. Such complexity that is realized in conceptual art is, as we might say, external not internal to the work.

A closer parallel between ideas in conceptual art and literary ideas might be with the poetic conceit, familiar in metaphysical poetry, such as John Donne's famous comparison of absent lovers with the legs of a compass or his finding sexual connotations in a flea bite. In a conceit the poet works a seemingly

[9] See my 'Appreciation and Literary Interpretation' in Michael Krausz (ed.), *Is There a Single Right Interpretation?* (University Park, PA: Penn State Press, 2002), 285–306; also Peter Lamarque and Stein Haugom Olsen, *Truth, Fiction, and Literature: A Philosophical Perspective* (Oxford: Clarendon Press, 1994), Part 3.

mundane idea into a metaphor of ever-growing elaboration. Again, though, such elaboration occurs within the poem through image and description and its success rests on a sense of completeness and resolution: as Donne himself says, 'the whole frame of the Poem is a beating out of a piece of gold'.[10] Poetic language, like the language of fiction, allows for this 'beating out', for details to emerge through precision of expression. Although conceptual art might use snippets of language to set up something comparable to a poetic conceit it does not use linguistic resources to follow through. If it did it would become poetry. Any following through is left to the ingenuity of the spectator.

But this makes the claim that ideas are paramount a site of potentially serious weakness in conceptual art. For ideas are only of interest when they are articulated, worked out, when something is done with them. Literature and philosophy show two paradigmatic and radically different ways in which ideas can be worked out, either through the unification of a subject round a literary theme or through theory building, hypothesis testing, and intellectual analysis. Conceptual art sometimes aspires to both the literary and the philosophical but all too often, in having the resources only to suggest rather than develop ideas, it falls well short of both.

As to the thought that a *description* of the ideas in conceptual art might do just as well as the work itself—that the essence of the work could be captured in a description—this too distances it from literature, even if it brings it nearer to philosophy. For merely describing the themes of a novel or a poem could be no substitute for reading the work itself. To suppose that it might be not only raises the spectre of Cleanth Brooks's 'heresy of paraphrase'[11] but more crucially it eliminates what I can only describe as the 'experience', very broadly conceived, of reading and appreciating literature.

It is this appreciative experience, which in different forms characterizes responses to all art, that I want to take up. I think it is a mistake for conceptual art to associate itself too closely either with the literary or the philosophical. To stress the dominance of ideas is to encourage wrong—and mislead-ing—analogies. To understand what is unusual and of interest in conceptual art it is best to hang onto something like the notion of appreciative experience and to recover at least some role for the visual aspects of conceptual art, thus returning us inevitably to perception.

[10] Quoted in Helen Gardner (ed.), *The Metaphysical Poets* (Harmondsworth: Penguin, 1966), 22.

[11] Cleanth Brooks, 'The Heresy of Paraphrase', in id., *The Well Wrought Urn: Studies in the Structure of Poetry* (London: Methuen, 1968), 157–75.

Of course conceptual artists see themselves as breaking away from traditional forms of visual art—centred on the revered art object, the easy consolations of the aesthetically pleasing experience, the false reverence of the art gallery, and so on—but in producing objects that can be seen, however fleeting or insubstantial, they force us to confront facts of perception, in a way that is seldom relevant to literature or philosophy. Rather than trying to make conceptual art non-perceptual (setting aside the clear, but I think unusual, cases where that is literally true), it might be better to admit a perceptual level but somehow make it subservient to the conceptual. I hope to sketch out a way in which this might be possible, drawing on a range of separate but interrelated factors: the role of conceptualization in the perception of all art, the distinction between perceiving a work and perceiving a mere physical object, and the peculiar, perhaps unexpected, role of the aesthetic in all this.

1.4 Conceptual Art and the Aesthetic

Let me begin with the aesthetic. Much conceptual art sets itself resolutely against the aesthetic—it revels in being non-aesthetic or deliberately anti-aesthetic. It rebels against the idea that art must be pleasing, easy to look at, beautiful and ordered and unified. It seeks out the ugly, the repulsive, the ephemeral, the shocking, as well as cheap materials, kitsch, the banal, the boring, the ordinary, objects that are commonplace. For many critics and spectators it is precisely this self-conscious turning against the aesthetic that makes the art credentials of conceptual art so suspect. In turn conceptual artists themselves emphasize the dominance of ideas over the perceptual to reinforce their remoteness from the aesthetic. But both these reactions rest on false assumptions. The critics are assuming that art is necessarily aesthetic, the artists that the aesthetic is necessarily perceptual.

The artists' assumption is wrong given, once again, the existence of literature or poetry. Literature is a non-perceptual art open to aesthetic description. Nor need the aesthetics of literature be limited to what might be described as its sensuous aspects—fine writing, mellifluous prose, elegant phrases, vivid images, and so forth—or indeed to formal features, like structure, organization, and unity. All these count as aesthetic, of course, but they are also features that occur in all kinds of writing and do not capture what is distinctive about imaginative literature, more narrowly conceived. To do that

we need a conception of what it is to read and value a text from a literary point of view: a distinction again between text and work. Taking a literary interest in a text—as opposed to a philosophical or historical or sociological interest—is to attend to its aesthetic features in a deeper sense of asking how the sensuous and formal aspects are used to achieve some literary purpose. Mellifluous prose is not a literary virtue if one is trying to portray a dialogue between teenage street gangs. An aesthetic appraisal of literature must take into account the consonance of means to ends. And, coming full circle, literary ends typically centre on the development of themes, the shaping of a subject matter round some cohering vision, be it of moral, political, or broadly human concern. If the subject matter depicts destruction, fragmentation, or loss of identity in the service of a vision of a fractured and desolate world then beauty and harmony are unlikely to be the best means to achieve this.

It is no good, then, for conceptual artists to try to reject the aesthetic simply by stressing idea over perception. Literature is non-perceptual but amenable to aesthetic ends. But the lesson from literature, this time, is one that conceptual artists might do well to embrace. First, it shows that the aesthetic need not be confined to the beautiful, the sensuous, or the formally unified. The wider conception of seeking consonance of means to ends is compatible with the use of local detail that might be quite at odds with traditional but limited ideas of the aesthetic. There is a difference between the non-aesthetic and the anti-aesthetic. Non-aesthetic means an absence of aesthetic qualities, anti-aesthetic suggests the presence of negative aesthetic qualities. It is an aesthetic judgement to remark on the effective use of anti-aesthetic elements, such as ugliness, repulsiveness, kitsch, the shocking, etc. These means might be consonant with desired artistic ends.

Whether this implies the logical inescapability of the aesthetic in art I am not sure. It does not seem to be part of the *concept* of art that it demands aesthetic appraisal. I don't think P. F. Strawson is right to say that 'it would be self-contradictory to speak of judging something *as a work of art*, but not from the aesthetic point of view'.[12] But if the aesthetic includes, as I am suggesting, appraisal of the effectiveness of means to ends and if, as also seems to be the case, a work, in contrast to a text or mere object, is an essentially purposive

[12] P. F. Strawson, 'Aesthetic Appraisal and Works of Art', in Peter Lamarque and Stein Haugom Olsen (eds.), *Aesthetics and the Philosophy of Art: The Analytic Tradition: An Anthology* (Oxford: Blackwell, 2004), 239.

conception then it is hard to see in principle how any work could be genuinely non-aesthetic even if it employs anti-aesthetic means.

The second lesson to draw from the literary case highlights the distinctiveness of works over texts and concerns the idea of a distinctive kind of attention or interest directed at a text (or object more generally). The thought that written texts are open to different kinds of reading, and that there is something distinctive about a literary interest in a text, invites a parallel distinction in the case of conceptual art between what Danto calls the work and the 'mere real thing'. Conceptual art from the earliest days of the readymades has long established this distinction as pivotal and, aided by philosophical interpreters like Danto, this is perhaps one of the greatest contributions of conceptual art. On this occasion I am not going to argue for the distinction but largely take it for granted so I can move to the next stage and reflect on how it bears on perception. That Tracy Emin's bed or beach hut or Damien Hirst's medicine bottles or Duchamp's snow shovel become in some sense 'transfigured' by being put on show and invite a different kind of attention when removed from their original contexts is now a commonplace even if it remains problematic to say exactly what their new status is. Whether and how this affects how they are perceived is the matter at issue.

1.5 Experiencing Conceptual Art as Conceptual Art

I spoke earlier of a kind of appreciative experience associated with the reading of literature, an imaginative reflection on the ways that subject details are consonant with thematic ends. Perception in the case of the visual arts offers something analogous. The two can be brought together by the admittedly vague term 'experience'. There are important common features, I maintain, in the experience of all the arts, literature included, and one of the binding elements can be described as an experience of art *as art*. Experience in this sense is informed by knowledge about the kinds of objects being experienced. Few would deny that experience, perceptual or imaginative, is permeable to background knowledge. What I know affects what I experience.

The permeability of experience (and perception) to belief plays a crucial part in the perception of all visual art.[13] Kendall Walton has shown how perceptions of a work's aesthetic qualities can vary according to the category to which the work is thought to belong.[14] My concern is how perceptions are affected at a more fundamental level, the level at which a work is distinguished from a mere object. And I wish to propose a principle, which I shall call the Empiricist Principle, which bears on this in relation to experience.

Empiricist Principle
If there is a difference between a work and a 'mere real thing' or object (including a text) then that difference must yield, or be realizable in, a difference in experience.

There is a corollary principle, as follows:

Distinctness Principle
If a and b are distinct works then there is an experiential difference between them, when experienced correctly.

Note that 'experience' here includes but is not restricted to perceptual experience—it covers also the appreciative experience of reading literature as literature. This is not necessarily *aesthetic* experience in the way that is standardly understood. What is a difference in experience? It is a difference in either phenomenology (being pleasant, disturbing, vivid) or intentional content or both. Content here must be intentional not merely causal, internalist not externalist. What matters for the identity of an experience in this context is not what the experience is of in the sense of what causes it but what it is *thought* to be of. If the art school piece is a work and not just the tokening of a sentence—if the word 'This' refers to a work—then there must be an experience, broadly conceived, of the *work* distinct from the experience of (merely) reading the sentence. The sentence type itself, *qua* sentence type, is not yet a work. If there is no such experience then according to the Empiricist Principle there is no distinction between the work and the mere object and thus, I take it, no work of conceptual art. There must be something that counts as perceiving (or experiencing) conceptual art *as conceptual art*. I conjecture that

[13] Richard Wollheim describes the 'central phenomenological feature of seeing-in' as 'its permeability to thought'. See Richard Wollheim, 'On Pictorial Representation', in Lamarque and Olsen (eds.), *Aesthetics and the Philosophy of Art*, 403.

[14] Kendall Walton, 'Categories of Art', in Lamarque and Olsen (eds.), *Aesthetics and the Philosophy of Art*, 142–157.

something like this principle provides a rationale for printing the sentence on a sandwich board. Or take an even more difficult case: John Cage's 4′33″. If there is no experiential difference between attending a 'performance' of John Cage's work and simply listening to ambient sounds for a period of 4′33″ then there is no 'work'. Likewise, there is no 'work' if Cage's instruction collapses into a mere hypothesis or supposition, such as: suppose a performer sat in silence at a piano for 4′33″. That might be an idea that underpins the work but it is not yet a work.

But why accept the Empiricist Principle and its corollary the Distinctness Principle? After all they seem to fly in the face of well-known examples from Arthur Danto. Danto sought to show that two objects might be perceptually indiscernible but distinct as works or distinct because one is a work, the other a mere real thing. He famously said that 'to see something as art requires something the eye cannot descry'.[15] But I don't think either principle does contradict Danto's examples. His red square canvases might well be perceptually indiscernible in the sense that perception alone is not able to tell them apart. But that is compatible with their yielding different experiences—and perceptions—once the works have been identified as distinct, for example, by the use of titles. Seeing one red square as the Israelites crossing the Red Sea and another as Kierkegaard's dream are arguably different experiences. They have different intentional contents and quite possibly a different phenomenology.

But why stress perception at all in the case of conceptual art when the whole point, we are told, is that the idea is paramount and it is not important what the object looks like? Well, we have seen that an idea *per se* is not yet sufficient for a work, until something is done with it, and we have also seen that if conceptual art aligns itself too closely to non-perceptual art then it comes to seem impoverished next to literature and philosophy. In presenting objects or performances as vehicles for ideas conceptual art seems to offer something not available to these others forms of expression. The ideas can still be paramount but the ideas must inform the perception of the objects and performances.

So what is it to perceive a work of conceptual art as conceptual art and not as a mere object? I suggest it is, at least partially, a perception of saliencies and significance. The objects literally *seem* in appearance to be different from

[15] Arthur Danto, 'The Artworld', in Lamarque and Olsen (eds.), *Aesthetics and the Philosophy of Art*, 32.

what they are. The bottles, the branches, the bricks, the clothes, the on-and-off lights, if they are to succeed in becoming *works* distinct from the things themselves, must invite a kind of perception which makes salient particular aspects and suggests significance for them. If they fail to generate this kind of experience they have failed as art precisely because they have failed to distinguish themselves from the things that are their constitutive base. Being a work—certainly being a work of art—must make a difference and the difference, I suggest, must be realizable either in the phenomenology or the intentional content of an experience, broadly conceived.

Of course, experience of art does not take place in a cultural vacuum. A complex array of institutional and cultural conditions must be in place to make possible the apprehension of conceptual art as conceptual art. The frisson that always accompanies such art arises partly because the requisite conditions have not been widely assimilated, partly perhaps because they only have a tenuous hold in the first place. For those who can only perceive the objects in themselves, the works are literally invisible and thus non-existent. These works are a strange kind of cultural entity, dependent both for their creation and survival on a system of conventions, attitudes, and values. As such they have a precarious existence but I happen to believe that all works of art are similarly grounded in human practices and owe their survival to contingent facts about cultural and historical conditions.[16]

1.6 Normativity

An objection to this whole picture, though, as least for the case of conceptual art, might rest on the issue of normativity. To perceive conceptual art as conceptual art, just as to attend to a text as literature, must have a normative element. In effect it must allow for success or failure. Not just any experience is sufficient to differentiate work from object or art from non-art. But how many times are we told by conceptual artists that there are no norms of response to their work, that any response is fine by them? However, that attitude, when not disingenuous, itself becomes a norm: subjective responses are correct, the search for any single or true interpretation is incorrect. Pure permissiveness

[16] See my 'Work and Object', *Proceedings of the Aristotelian Society*, 102/2 (2002), 141–62.

of response, though, makes the notion that ideas are paramount difficult to sustain. For a response that takes an object at face value and finds in it no ideas would seem not to count as a response to conceptual art *as conceptual art*. Objects that cannot generate—or more seriously are not intended to generate—any reflection on ideas can hardly count as conceptual art. In this there is no escaping normativity.

I have tried to take seriously the thought that there is something *sui generis* about conceptual art, that reductive accounts that try to assimilate such art into pre-existing categories—the philosophical, the literary, the visual—are inadequate. Instead, I suggest, we should see conceptual art of the paradigmatic kind as offering a curious hybrid of experience having parallels with, but not reducible to, the cerebral reflection of ideas in philosophy, the apprehension of themes or conceits in literature, and the perception of sculpture and painting. To prioritize any one of these is in many cases to miss what is distinctive. Of course this balancing act puts great demands on conceptual art which are not always fulfilled or not fulfilled very rewardingly. But my point is that there must be something that counts as apprehending the works *as works* rather than merely as the objects or performances they seem to be and that this must be realizable in some broad sense experientially. Does it follow that one can only properly apprehend the works by being in their presence? Does the so-called acquaintance principle apply?[17] No. I think often the requisite experience can be had by attending to a photograph, say, or a copy. Ontologically I suspect most such works are types, allowing for multiple instantiations, rather than unique particulars. (As Bochner says, they are 'infinitely repeatable'.) As for identity conditions, the kinds of conceptual works I am thinking of are not mere ideas, mentalistically defined, accessible contingently through different media. There is an inescapable visual dimension, a physical medium which acts as a vehicle for the transmission of ideas. There is even an aesthetic dimension if we allow the consonance of means to ends under this heading. If our art school artist had his sandwich boards stolen I believe he could produce exactly the same work by drafting it all again. But I do not think I produced an instance of the work when earlier I used (or strictly mentioned) the sentence 'This is not "Art" in itself but a means of creating it'. The sentence type is not

[17] Malcolm Budd, 'The Acquaintance Principle', *British Journal of Aesthetics*, 43/4 (October 2003): 286–92; also Paisley Livingston, 'On an Apparent Truism in Aesthetics', *British Journal of Aesthetics*, 43/3 (July, 2003): 260–78.

enough—the work is more contextualized than that. Like so many works of conceptual art there is salience in the vehicle—the sandwich board, the typeface—and perceiving the ensemble, however deliberately unaesthetic, and perceiving it as a work, are integral to the apprehension it demands.

References

BOCHNER, MEL, 'Mel Bochner on Malevich: An Interview' (with John Coplans), *Artforum*, 12/10 (June, 1974): 59–63.

BROOKS, CLEANTH, 'The Heresy of Paraphrase', in id., *The Well-Wrought Urn: Studies in the Structure of Poetry* (London: Methuen, 1968), 157–75.

BUDD, MALCOLM, 'The Acquaintance Principle', *British Journal of Aesthetics* 43/4 (October, 2003): 286–92.

DANTO, ARTHUR, *The Transfiguration of the Commonplace* (Cambridge, MA: Harvard University Press, 1981).

—— 'The Artworld', in Peter Lamarque and Stein Haugom Olsen (eds.), *Aesthetics and the Philosophy of Art: The Analytic Tradition: An Anthology* (Oxford: Blackwell, 2003), 27–34.

GARDNER, HELEN (ed.), *The Metaphysical Poets* (Harmondsworth: Penguin, 1966).

GODFREY, TONY, *Conceptual Art* (London: Phaidon, 1998).

LAMARQUE, PETER, 'Objects of Interpretation', *Metaphilosophy*, 31 (2000): 96–124.

—— 'Work and Object', *Proceedings of the Aristotelian Society* 102/2 (2002): 141–62.

—— 'Appreciation and Literary Interpretation', in Michael Krausz (ed.), *Is There a Single Right Interpretation?* (University Park, PA: Penn State Press, 2003), 285–306.

—— and Olsen, Stein Haugom, *Truth, Fiction, and Literature: A Philosophical Perspective* (Oxford: Clarendon Press, 1994).

LEWITT, SOL, 'Paragraphs on Conceptual Art', *Artforum*, 5/10 (June, 1967): 79–83.

LIPPARD, LUCY, *Six Years: The Dematerialization of the Art Object from 1966 to 1972* (Berkeley: University of California Press, 1997).

LIVINGSTON, PAISLEY, 'On an Apparent Truism in Aesthetics', *British Journal of Aesthetics* 43/3 (July, 2003): 260–78.

SMITH, ROBERTA, 'Conceptual Art', in Nikos Stangos (ed.), *Concepts of Modern Art* (London: Thames and Hudson, 1994), 256–70.

STRAWSON, P. F., 'Aesthetic Appraisal and Works of Art', in Peter Lamarque and Stein Haugom Olsen (eds.), *Aesthetics and the Philosophy of Art: The Analytic Tradition: An Anthology* (Oxford: Blackwell, 2004), 237–42.

WALTON, KENDALL, 'Categories of Art', in Peter Lamarque and Stein Haugom Olsen (eds.), *Aesthetics and the Philosophy of Art: The Analytic Tradition: An Anthology* (Oxford: Blackwell, 2003), 142–57.

WILLIAMS, EMMETT (ed.), *An Anthology of Concrete Poetry* (New York: Something Else Press, 1967).

WOLLHEIM, RICHARD, 'On Pictorial Representation', in Peter Lamarque and Stein Haugom Olsen (eds.), *Aesthetics and the Philosophy of Art: The Analytic Tradition: An Anthology* (Oxford: Blackwell, 2003), 396–405.

2

The Dematerialization of the Object

Derek Matravers

> The point is . . . that unless the given contingent material is such as to
> be transformable by the artistic system, it is probably better treated in
> some other practical sphere; while if the supposed artistic system is such
> as to impose no limits upon the admission of the contingent or the
> political, it is probably not worth considering as art. And Conceptual Art
> is nothing if there is no power to its claim to be occupying the space
> of art.
>
> (Harrison, 1990: 554)

In general, interest in conceptual art among Anglo-American philosophers
springs from the challenge it poses to some claims that seem to lie at or near
the centre of the traditional concept of art. A rough characterization of such
claims might go as follows. Works of art are (1) objects, (2) which we appreciate
through direct experiential encounter and (3) such an experiential encounter
is non-instrumentally valuable. The challenge was, famously, articulated by
Lucy Lippard and John Chandler who, in 1968, wrote:

During the 1960s, the anti-intellectual, emotional/intuitive processes of art-making
characteristic of the last two decades have begun to give way to an ultra-conceptual
art that emphasizes the thinking process almost exclusively . . . Such a trend appears
to be provoking a profound dematerialization of art, especially of art as object, and
if it continues to prevail, it may result in the object's becoming wholly obsolete.
(1968: 36)

Whatever one thinks of the details of this (a debate raged within Conceptual Art as to whether art required an object or not), the dematerializing tendency was evident at least until the early to mid-1970s.

One response to this would be to find some way of rescuing the traditional conception, by showing how, despite the absence of the object, we could have some kind of experiential encounter which provided the right kind of non-instrumentally valuable experience. It would be interesting if such a response were successful: that is, if we did succeed in showing that Conceptual Art could provide satisfaction of the traditional kind. It would demonstrate that the circumstances in which such satisfactions (which it seems legitimate to call 'aesthetic satisfactions') can be had is wider than we might have expected. Indeed, it might be thought that unless some link could be found between Conceptual Art and satisfactions of the traditional kind, the former is not properly art. Thus we might think that were the response to fail, and we be unable to find such a link, then a terrible fraud was being perpetuated on the art-going public. In this paper I am going to propose an alternative: instead of defending (or not) Conceptual Art in terms of the satisfactions (or not) to which it gives rise, I am going to defend it in terms of its place in the history of art. Or rather, I am going to explore the form such a defence would need to take and express some scepticism as to whether it is successful. My starting point will be to look at the presuppositions behind the move to the dematerialization of the object. What was the perceived fault the move was attempting to correct? How was it aiming to correct it? Was there really a fault, and, if so, could it be corrected in this way? It should be noted that as this is a philosophical paper, rather than an art historical one, the art history will be sketched in largely without argument or support.

Charles Harrison, a noted historian of Conceptual Art, has claimed that 'no account of Conceptual Art can be adequate if it is not adequate in its understanding of modernism' (Harrison 1990: 540). Any characterization of modernism, even as it applies to a single discipline (in this case art history) is going to be tendentious. For my purposes I am going to focus on a version of modernism best captured through the work of Clement Greenberg. For Greenberg, there seemed to be two important theses. First, the history of the avant-garde was a developing process of self-criticism in which each of the arts attempted to articulate its own essence. This takes the form of a gradual elimination of properties from the practice of each of the arts, until one is left with objects with few relevant properties. These objects give us

the essence of the particular art form they are in. The story for painting begins with Manet, who attempted to draw attention to the nature of the properties of the support. There followed a development through cubism and abstraction, to Greenberg's favoured 'end of history', the paintings of the abstract expressionists. To some this is easy to reject on the grounds of its very doubtful Hegelianism. However, one does not have to view it like that. If there was a project of self-criticism with the aim of articulating an essence, then it will not be a surprise if the work that went into completing that project came in stages, each of which was a reasonable development from its predecessor. Indeed, it would be strange if this were not the case. Second, what was constant through this was a certain aesthetic. Greenberg himself subscribed to some kind of Kantian account of aesthetic merit, of which Arthur Danto gives us a particularly unsympathetic account:

Greenberg would stand with his back to a new painting until it was in place, and then wheel abruptly around to let his practised eye take it in without giving the mind a chance to interpose any prior theories, as if there were a race between the transmission of visual stimuli and the speed of thought. (Danto 1997: 89)

What we have here are the deliverances of the cultured eye. Dissenters could be easily dismissed: if they failed to see the merit in a favoured painting, this was evidence that they did not have a cultured eye.

A more sympathetic reading of Greenberg (which I shall mention only briefly) is to take him not as arguing for some kind of essentialist project, but rather as picking out some properties of works of art in virtue of which they can stand comparison with the art of the past. The 'modern masters' could not compare with the 'old masters' in providing 'illusions', however, they could in exploring the non-illusionistic properties of paintings: specifically, in exploring the nature of the support (the facticity of the paint and canvas). This account need not be developmental; at least, it leaves open the possibility that different properties might become important at different times. Each age will need to find its own properties to foreground, which will enable works of art to stand comparison with works in the past. This places less weight on the support from the history of art, although it would still need to be shown first, that this project was one the modern masters were engaged in, and second, that, if so, the endeavour was not completely misguided.

By common consent, at some time in the mid-1960s the avant-garde was in something of a crisis. Both minimalism (which had appeared in roughly 1963)

and pop art (which started to become prominent at around the same time) were controversial to the modernists. Let us focus on minimalism for the moment. Looked at one way, minimalism seems to fit easily into the modernist story. The process of reduction took us from figuration to abstraction, and then from abstraction to the bare object. Furthermore, minimalism was concerned with the modernist aesthetic: the works had 'presence', and were judged in terms of the aesthetic effects on their audiences. One quotation will have to stand for many.

A work needs only to be interesting . . . In the three-dimensional work the whole thing is made according to complex purposes, and these are not scattered but asserted by one form. It is not necessary for a work to have a lot of things to look at, to compare, to analyze one by one, to contemplate. The thing as a whole, its quality as a whole, is what is interesting. (Judd 1965: 813)

Looked at another way, however, minimalism was not a development but a retrograde step. The project was for art to articulate its own essence. It was Greenberg's view that this had been done in the work of the abstract expressionists, in their foregrounding the properties of the support. As the end had been reached, further developments were not possible. Second, minimalists were wrong to think that their works drew on something that was the same as, or continuous with, the aesthetic employed by those who had come before. Michael Fried, who, despite differences, was recognizably Greenbergian, thought the minimalist aesthetic was 'fundamentally theatrical' (Fried 1967: 130):

There is, in any case, a sharp contrast between the literalist espousal of object-hood—almost, it seems, as an art in its own right—and modernist painting's self-imposed imperative that it defeat or suspect its own objecthood through the medium of shape. In fact, from the perspective of recent modernist painting, the literalist position evinces a sensibility not simply alien but antithetical to its own: as though, from that perspective, the demands of art and the conditions of objecthood are in direct conflict. (Fried 1967: 125)

It was from this milieu that Conceptual Art emerged.

How does this serve to illuminate Conceptual Art? One way to read this is to see Conceptual Art as just another step in the unfolding modernist story. That is, the attempt at self-definition exhausts painting and (we can suppose) the other traditional art forms, so the project can only continue

by moving to non-traditional art forms. Thus Conceptual Art is seen as continuous with minimalism; more extreme but still vulnerable to Fried's accusations of theatricality. A defence of this position could possibly be mounted—modernism's 'last gasp' or perhaps 'last hoorah', depending on one's sympathies. The alternative was to see Conceptual Art not as continuous with, but as a reaction against, modernism (Art–Language 1969). Retrospectively, Charles Harrison has characterized the relation between Conceptual Art and modernism as follows:

By the mid-1960s modernism as theorized in dominant forms of criticism and as represented in dominant institutions was (a) morally and cognitively exhausted, and (b) materially entrenched; and, in consequence . . . there could be no critically adequate form of continuation of the practice of art which did not avail or imply (a) an account of the practical exhaustion of Modernist protocols for the production of authentic culture, and (b) an account of the mechanisms by which the effective power of these protocols was nevertheless sustained. According to this view of the determining condition of the time, the task in hand was twofold—albeit the respective requirements were not necessarily distinct in practice. The first requirement was to establish a critique of the aesthetics of modernism. This entailed the development of appropriate art-theoretical and art-historical tools. The second requirement was to establish a critique of the politics of modernism. This entailed the application of socio-economic forms of analysis. (Harrison 1990: 540)

Harrison then gives more detail about what this involved. In particular this form of conceptual art (that is, as practised by Art & Language) involved sceptical and elliptical re-examination of two assumptions central to the theoretical and ideological character of modernism. The first assumption is that the authentic experience of art—the experience by which the very function of art is defined—is a disinterested response to the work of art in its phenomenological and morphological aspects, which is to say that the experience is cast in the self-image of the sensitive, empiricistic, and responsible (bourgeois) beholder. The second assumption is that modern art develops along a fixed trajectory marked by a gradual reduction of its means (Harrison 1990: 541).

There are a number of issues here. The one on which I would like to focus is that modernism was 'morally and culturally exhausted'; that it was incapable of producing 'authentic culture'. What is it for a form of art (if I can put it that way for the moment) to be 'exhausted'? The specific claim that Harrison makes is that the *aesthetics* of modernism was exhausted. That charge

can be interpreted in several different ways: that a certain aesthetics has played itself out (and this is the aesthetics of modernism); that a certain aesthetics is inappropriate for the time (and this is the aesthetics of modernism); or that within the theoretical framework of modernism, a certain aesthetics is exhausted. Each of these claims could be the subject of an extensive discussion, so I shall have to narrow my focus to those claims that seem most illuminating about Conceptual Art. The danger, I think, would be if the claim that the aesthetics of modernism is exhausted only made sense from within the theoretical perspective of modernism. I say danger, because if one rejects that theoretical perspective one has no reason to believe the exhaustion claim. If one has no reason to believe the exhaustion claim, then one is on the road to thinking that Conceptual Art is a solution to a non-existent problem. The exhaustion claim seems premised on something like the following. Taking painting as our exemplar (for interesting reasons the selection of painting for this role is not arbitrary), it is evident that certain aspects of the tradition have a history. The content changes in that popular subjects change over the course of time. The style changes—Renaissance art succeeded Gothic art, and was itself succeeded by the Baroque. However, something is constant: using Malcolm Budd's terminology, a painting has a pictorial field (the visible nature of the picture's surface), a subject (the Annunciation, for example), and a depicted scene (the depicted arrangement of the objects seen from the point of view from which they have been depicted) (Budd 1995: 61–6). The value of painting emerges from these three and the relations between them. For as long as these are present, then, given the infinite varieties of pictorial fields, subjects, and depicted scenes and of relations between them, it is difficult to see how painting as such (rather than a particular content or style) could become exhausted. Harrison's contention, however, is that the elements of painting as such—rather than simply the content or the style—had a developmental history. If this claim is accepted then it is easy to see how painting might have become exhausted. One would then have to generalize this exhaustion to aesthetics (traditionally conceived) and one would be on the way to Conceptual Art.

Should the claim that painting as such had a developmental history be accepted? Greenberg's argument for thinking so, that underpinned his views that I described above, ran as follows:

The essence of Modernism lies, as I see it, in the use of the characteristic methods of a discipline to criticize the discipline itself, not in order to subvert it but in order to entrench it more firmly in its area of competence. Kant used logic to establish the limits of logic . . . Each art, it turned out, had to perform this demonstration on its own account. What had to be exhibited was not only that which was unique and irreducible to art in general, but also that which was unique and irreducible in each particular art. (Greenberg 1961: 308–9)

Two things might strike one as particularly odd in the light of the current discussion. The first is the link Greenberg draws between the project of defining painting and finding some property, or some small set of properties, that are 'unique and irreducible' to painting. One might rather have thought that the definition of painting would be some complicated package, which might contain no elements that were unique and irreducible to that package. That in itself is enough to show that the project of finding a definition by gradual stripping to essentials is misconceived. Second, while there is some reason for using logic to find the limits of logic (given that finding limits is one of the things that logic does, and there is no reason why it should not do this to itself), there is no reason at all to think that painting is going to be the activity suited to finding the limits of painting. This suggests that even if the project of finding a limit made sense, it would not make much sense for this to be done by the activity of painting. To those two worries we can add what seems to me the most cogent criticism of Greenberg: that made by Richard Wollheim in 'The Work of Art as Object' (Wollheim 1970/1973). The 'unique and irreducible property' it was the proper task of painting to foreground, Greenberg argued, was the property of the support—in particular, the surface. In reply, Wollheim argued that the task could only be to draw attention to the surface *as the surface of a painting*. If this is the case, the project is not particularly distinctive as creating the object is subject to all the traditional constraints of creating a painting.

What would be the appropriate reaction to this? One reaction would be to agree that the claim that the activity of painting itself had a developmental history was misguided. One could then return to where the wrong turning was taken and not take it. In other words, one could return painting to its traditional role, even with a contemporary content and in a contemporary style. There is nothing here that would seem to justify the move to the dematerialization of the object.

For some, however, the return to the traditional role of painting would have been a mistake. The demonstration that Greenberg was wrong did not put the traditional way of doing art in the clear. It was not any single thing that had gone awry, but rather a whole package of which both modernism and the traditional conception of art were a part. One could sum this up by saying that modernism and traditional conceptions of art had become complicit with, and inextricably linked to, bad ways of doing things. It was only by eliminating certain things—in particular, the object—that one could carry on producing art without being complicit in this bad way of doing things oneself. What were those bad ways of doing things? How had modernism (and, by extension, traditional art) become complicit, and how would the dematerialization of the object help?

The relatively simple issue can be summed up in the term 'commodification'. The more complicated issue is the Vietnam War, and the more complicated issue still is the perceived link between politics and the aesthetic experience. I shall not dwell much on the first of these. The traditional conception of art relies, as we have seen, on there being an object that provides a non-instrumentally valuable experience through direct perceptual encounter. Because of its capacity to do this, the object is itself valuable. There is a market for valuable objects which often means (a) that the objects are available only to those that can afford them and (b) through buying and selling profits can be made. It is possible for an artist to avoid the market by not producing objects (indeed, given that artists have little control over what happens to their work when they are dead this is the only safe way). Hence, there is a link between the desire to avoid commodification and the dematerialization of the object. The philosophical issue here is why this is not simply giving up art, as opposed to giving up making objects and not giving up art. I shall consider this at the end of the paper.

The second issue is the link with the Vietnam War. Part of this issue (the part on which I will focus) lies in a misconception that runs through Greenberg's essay discussed earlier: namely, that figurative painting is illusionistic. This enables Greenberg to accuse the 'Old Masters' of 'dissembling the medium' of 'using art to conceal art' (Greenberg 1961: 309). What he meant, of course, is that the power of a three-dimensional image draws our attention away from the properties he found important: the nature of the support. This sets up a division. On the one side is illusion, aesthetic value, civilization, genius. On the other are the properties of the support, the bare object. The

generation of avant-garde artists prior to the conceptualists had already set up this opposition, and declared their allegiance to the 'object' side of the divide. Tony Godfrey reports Frank Stella as saying:

I always get into arguments with people who want to retain the old values in painting—the humanistic values that they always find on the canvas. If you pin them down, they always end up by asserting that there is something there besides the paint on the canvas. My painting is based on the fact that only what can be seen there is there. It really is an object . . . What you see is what you see.' (Godfrey 1998: 112)

What is the connection between this and the Vietnam War? To quote Tony Godfrey again, 'the Vietnam War was the key political and cultural event of this period, underpinning everything' (Godfrey 1998: 124). Modernism, and by extension traditional art forms, are on the side of illusion, lies, and obfuscation that stood opposed to clarity, objectivity, and truth. The politically aware felt that the Vietnam War, or rather the way the Vietnam War was presented, lay with the former. With modernism and traditional art 'what you saw was not what you saw, but a whole lot more: the ideology of the culture then parading itself in Vietnam' (Godfrey 1998: 112).

This makes some sense as an explanation of events. If one is sufficiently disgusted with something one may well get the urge to smash things up. It could only underpin a justification, however, if it is right in dividing modernism, illusion, and lies from conceptual art, objectivity, and truth. However, this seems a stark example of the mistake identified by Wollheim of confusing the surface of a painting with the surface of a mere physical thing. The characterization of modernism (and by extension traditional art) is an egregious error. Figurative painting is not illusionistic, nor are figurative painters trying to dissemble. What you see is indeed what you see, but what you see is a great deal more than a two-dimensional painted surface. What you see, indeed, is a three-dimensional image.

The third of the issues that might justify the change from modernism to conceptualism was that the notion of the aesthetic experience is (or had become) politically tainted. The claim is not that modernism (or, more particularly Greenbergian formalism) was at least apolitical, possibly reactionary, but that the whole notion of aesthetic engagement is politically suspect regardless of its object. It needs to be 'regardless of its object', otherwise the problem could be solved simply by changing the object rather than dematerializing it. There are many routes to this conclusion (most, as far

as I am aware, worked out well after the heyday of Conceptual Art). A philosophical defence of the view that painting is reactionary that pre-dates conceptual Art is given in Walter Benjamin's essay, 'The Work of Art in the Age of Mechanical Reproduction' (Benjamin 1968). Tony Godfrey reports this as being 'widely known' in the 1960s, although Charles Harrison has claimed (in conversation) that it was not widely read until later (Godfrey 1998: 152). Whoever is right about this (and evidence favours Harrison), Benjamin's arguments, if cogent, would provide a defence of the view that painting is reactionary even if it was not the defence the practitioners actually relied upon.

One needs to be careful to distinguish two points here. The first is the claim that painting is reactionary, the second is the claim that this is best dealt with by dematerializing the object. In as much as they are successful at all, Benjamin's arguments address the first point rather than the second. That is, he argues that painting belonged to a period in which the importance of art was connected to it having an 'aura', which was of necessity exclusive. This cannot engage people en masse; it cannot engage people in their own particular situation. Works of the latter sort (paradigmatically film) are able to play a broader cultural role that spills over into politics.

Rather than engage directly with Benjamin's essay, let us accept the broad thrust of the argument and try to relate it to the dematerialization of the object. The crucial claim in Benjamin's essay seems to be this: the technique of reproduction detaches the reproduced object from the domain of tradition. By making many reproductions it substitutes a plurality of copies for unique existence. In permitting the reproduction to meet the beholder or listener in his own particular situation, it reactivates the object reproduced. These two processes lead to a tremendous shattering of tradition which is the obverse of the contemporary crisis and renewal of mankind (Benjamin 1968: 168).

The claim is that it is a necessary condition of being a progressive art form that the medium be reproducible and able to 'meet the beholder . . . in his own particular situation'. Film, as Benjamin makes clear, is the paradigm example of this. If (as with conceptual art) the work of art is identified with an idea, rather than an object, this too seems reproducible in places outside the hallowed spaces of art. Thus far, one might take the dematerialization of the object to be one way to follow the progressive path Benjamin has laid down. However, Benjamin's necessary conditions are there to allow people to engage with works of art. There would be no rationale for his conditions unless the works were such that people were motivated to engage with them. In short, art must

not only be available to the masses, it must appeal to the masses. This raises the obvious problem with respect to Benjamin's chosen medium, as clearly films that have mass appeal tend not to be in the revolutionary vanguard and vice versa. Benjamin himself was aware of this (even if any solution he might have had disappears behind some opaque Marxist theorizing).

The same problem is raised for conceptual art. If the dematerialization of the object is to be an adequate response to the problem we suppose was raised by Benjamin, it would need to have mass appeal. Some of the theoretical work produced by conceptual artists aims to oppose the perceived elitism of traditional work, but much of what is produced is of the same intimidating surface complexity as academic philosophy. Although it is an issue for sociologists to answer rather than for philosophers, it would be a brave person who argued that a distinctive property of conceptual art was its appeal to the masses.

There were, I am sure, more ways in which the move away from aesthetics to dematerialization was held to be justified. For example, it might be thought that the concepts characteristically used in aesthetic appreciation—'quality', 'genius', 'civilization'—had become corrupted by their being used by those in power, and thus we needed an art form that avoided those concepts. It is difficult to know what to do with this claim. The fact that those in power make use of a certain set of concepts is, without elaboration, no more of an argument for giving them up than the fact that Nazis enjoyed sausages is an argument for vegetarianism. The argument would have to be that their use by those in power changed their meaning in a way that made it impossible to say what we wanted to say with them. One would need to argue about individual cases, but it is surely unlikely that the meaning of words such as 'quality', 'genius', or 'civilization' is so malleable.

Another, unrelated, view (expressed famously by Tony Smith but also present in the work of Gregory Battcock) was that, by the 1960s, the world had become so glitzy that 'mere real things' could provide an experience that rendered the experience of paintings obsolete (Smith 1966; Battcock 1969). For that to be true, the 'mere real things' would provide an experience of the same type as paintings had previously provided, only better. This assumption, however, simply denies in a question-begging way the central claim of the traditional conception of art (however broadly or narrowly construed): namely, that the experiences provided by art are not replaceable by the experiences of mere real things.

Let me summarize the paper so far. I have accepted the claim that Conceptual Art was a reaction against, rather than a development of, modernism. That is, Conceptual Art emerged out of the perception that modernism—and by extension, the traditional way of doing art—was exhausted. This in turn relies on the claim that not only does the content of painting have a history (in as much as few people these days settle down to paint *The Judgement of Paris*), and the style of painting have a history (in that it is probably conceptually impossible now to paint a Mannerist painting), but that painting itself is part of history. That is, for some, it is a way of producing art whose time has come and gone. Furthermore, dematerializing the art object is in some way an appropriate response to this: a way of continuing to make art that is not open to the same problems. I have been looking at these latter two claims: trying to put some meat on the bones of the charge that modernism is exhausted, and then, in turn, trying to find a justification for the abandonment of the object. In this, so far, I have been unsuccessful. Of course, this would only prove that the move to conceptual art was not justified if I could show that the reasons I have considered exhaust all those there could be, and there is no way in which I could show that. I have, however, considered those reasons that seem to me obvious or potentially compelling.

Perhaps this is too pessimistic. The conclusion might rest upon an overly demanding conception of the necessity involved in the history of art. There is a less demanding conception, consonant with recent work within Anglo-American philosophy on the definition of art, which might provide more of a defence of dematerialization. It would not do, as Harrison says in the quotation that heads this paper, for there to be *no* limits on the contingent and political reasons through which something could become art. This raises the question of what the limits are through which something becomes art. At the beginning of this paper I alluded to the challenge made to the traditional concept of art by conceptual art, and the project of defending conceptual art through showing that it could provide aesthetic satisfaction. It is part of that project to argue that the limits through which something could become art are linked to the aesthetic: it is through showing that conceptual art provides some aesthetic satisfaction that we show that it is properly art. There is, however, an alternative view, which, for ease of reference, I shall call 'institutionalism'. This argues that, at any stage in the history of the social practice of the production and appreciation of works of art ('the art world'), there will be *some* set of reasons such that an object becomes a work of art for one of those reasons.

Many of these reasons will be constant across the ages: for example, 'being a painting'. Others might once have been, but are no longer: for example, 'being a prospect in a landscaped garden'. Many are now, but were not previously: for example, 'being declared a work of art by a recognized artist'. The twentieth century saw an expansion of the set of reasons, and thus an increase in the variety of objects that could become works of art.

It might be thought that institutionalism is not truly an alternative to the aestheticist view, as it still needs to face the question of why the reasons under consideration are reasons for something to be art, as opposed to anything else. The obvious answer to this is that what makes all these reasons art-conferring reasons is some link to the aesthetic. However, the institutionalist has a more radical alternative. That is, for each of these reasons, there will be some story of how it came to be a reason. The crucial point is that, although the story might be aesthetic, it might be economic or it might be political. Furthermore, such stories might not be obvious, even to those who are championing the reasons. In short, there is no systematic justification about why the reasons operative at any particular time in the art world are those reasons and not some others (Levinson 1979/1990: Dickie 1984; Matravers 2000). This, however, would seem to make the radical view unhelpful as, throughout this paper, I have been arguing that there *are* reasons why the art world came to be operating with the reasons with which it was operating in the 1960s: namely, those provided by the historical story about the development of art that is modernism. I then argued that, as we have no reason to accept that historical story, we had no reason to accept that the reasons operative in the art world were good reasons. However, that need not be the case, for one can simply see the reasons as forming layers, none of which are grounded in anything substantial. In short, these reasons are only reasons because they are grounded in modernism. However, modernism itself is only another layer of reasons (reasons why certain things are reasons) that are a contingent feature of the history of art; it is simply the way that the history of art developed in the late twentieth century, for reasons it might take a political historian (or perhaps an economist) to work out.

Let me put that point in other, perhaps more familiar, terms. Duchamp had introduced into the arts the notion of 'provoking a meta-narrative' being a reason why an object could be a work of art. This did not tell us anything in particular about the essence of art, it was just something that happened. At some later time, again for reasons not to do with the essence of art, some other

people used this precedent, producing objects they intended to be regarded in this way. Finding the limits of the object constraining in fulfilling this intention, they dematerialized it (Art–Language 1969: 102–3). Reasons given for doing this made sense against a background theory that linked Duchamp and the later work. However, these reasons were themselves simply part of the story that art told itself in the twentieth century, and have no more claim to the truth than any other reason that picks out the 'way art has previously been regarded' (Levinson 1979).

I have argued that Conceptual Art was a reaction against, and repudiation of, modernism. Hence, the attempt to show that it is art should not be the attempt to connect it to traditional notions (or even expanded traditional notions) of aesthetics. (Having said that, if such an attempt succeeded it would show that Conceptual Art was mistaken about what it was up to—and it would not be the first art movement to be convicted on that score.) Instead, the defence of Conceptual Art should take the form of showing that it was the right step to take following the internal exhaustion of modernism (and by extension, traditional art). This would involve showing that ways of producing art (for example, painting) themselves have a history. This defence is available within the perspective of modernism; however, I have found no grounds for thinking that we have to take that perspective. Finally, I have offered a weak line of defence. This involves accepting the claim that there are no deep reasons why, at any time, the art world operates with the reasons it does for enfranchising certain objects as art. During the late 1960s and early 1970s, amongst those reasons, for some, were those used by the Conceptual artists that allowed the dematerialization of the object. These reasons were grounded in a deeper layer of reasons, to do with the repudiation of modernism, but those reasons are themselves just contingent historical artefacts. Whether or not this is acceptable depends on the extent to which one thinks it matters that art has roots outside of itself.

References

ALBERRO, A. and STIMSON, B. (eds.) (2000), *Conceptual Art: A Critical Anthology* (Cambridge, MA: MIT Press).

ART AND LANGUAGE (1969), 'Introduction to *Art-Language: The Journal of Conceptual Art*, 1:1', in Alberro and Stimson (2000: 98–105).

BATTCOCK, G. (1969), 'Painting is Obsolete', in Alberro and Stimson (2000: 88–9).

——— (ed.) (1995), *Minimal Art* (Berkeley, CA: University of California Press).

BENJAMIN, W. (1968), 'The Work of Art in the Age of Mechanical Reproduction', in Kearney and Rasmussen (2001: 166–81).

BUDD, M. (1995), *Values of Art: Pictures, Poetry, Music* (Harmondsworth: Penguin).

DANTO, A. (1997), *After the End of Art: Contemporary Art and the Pale of History* (Princeton, NJ: Princeton University Press).

DICKIE, G. (1984), *The Art Circle: A Theory of Art* (New York: Haven).

FRASCINA, F. and HARRIS, J. (eds.) (1992), *Art in Modern Culture: An Anthology of Critical Texts* (London: Phaidon).

FRIED, M. (1967), 'Art and Objecthood', in Battock (1995: 116–47).

GODFREY, T. (1998), *Conceptual Art* (London: Phaidon Press).

GREENBERG, C. (1961), 'Modernist Painting', in Frascina and Harris (1992: 308–14).

HARRISON, C. (1990), 'Conceptual Art and Critical Judgement', in Alberro and Stimson (2000: 538–45).

——— and WOOD, P. (eds.) (1992), *Art in Theory: 1900 to 1990* (Oxford: Blackwell).

JUDD, D. (1965), 'Specific Objects', in Harrison and Wood (1992: 809–13).

KEARNEY, R and RASMUSSEN, D. (eds.) (2001), *Continental Aesthetics: A Reader* (Oxford: Blackwell).

LEVINSON, J. (1979/1990), 'Defining Art Historically', in id. *Music, Art and Metaphysics: Essays in Philosophical Aesthetics* (Ithaca and London: Cornell University Press), 3–25.

LIPPARD, L. and CHANDLER, J. (1968), 'The Dematerialization of Art', in Alberro and Stimson (2000: 46–51).

MATRAVERS, D. (2000), 'The Institutional Theory: A Protean Creature', *British Journal of Aesthetics*, 40/2: 242–50.

SMITH, T. (1966). 'Talking with Tony Smith', in Harrison and Wood (1992: 742–3).

WOLLHEIM, R. (1970/1973). 'The Work of Art as Object', in id., *On Art and the Mind* (London: Allen Lane), 112–29.

3

Visual Conceptual Art[1]

Gregory Currie

We are sometimes urged to see artworks, movements, and styles as connected by narrative. A strong formulation of this view has it that these narratives play a role in determining what is to count as art; something is art partly in virtue of the narratives that link it to already established members of the kind (see e.g. Carroll 1993). But we need not accept the strong view in order to think that art historical narratives are important for our understanding of the particular works they connect. For such narratives provide answers to questions about how the works in question came to be made, and understanding a work of art is not separable from understanding its making (Currie 1989).

Rejecting the strong view, we might still think of artworks as paradigmatic narrative entities: things apt to be described or thought of in narrative terms, and highly resistant to capture in other ways. We turn to narrative when we want to focus on the particularity of things, their relations to the intentions and other mental states of agents, and in situations where recourse to causal laws is beyond our reach or unlikely to be helpful. Artworks are particular in the extreme, and we constantly celebrate their individuality; they are the products

[1] The paper read at the Conceptual Art Conference, King's College London, in 2004 went through a process of radical change amounting, in effect, to its abandonment. The good work of the audience in commenting on the text presented, and especially of Jerry Levinson who provided a brief formal commentary on all the papers, is therefore reflected here only by the absence of that paper. Thanks to Elisabeth Schellekens and an anonymous referee for the Press for comments on an earlier version of the paper printed here.

of intentional agency in ways that subtly affect our appreciation of them; their most salient properties, such as beauty or shockingness or wholeness, are not explicable by reference to causal laws or even to generalizations of any informative kind—at least, no one has yet succeeded in giving us the generalizations. So telling an artwork's story looks like the only way to do justice to its nature.[2] But narrative on its own is not always sufficient; we sometimes need the aid of theory. Both modernism and conceptualism are somewhat unusual as artistic movements in the close connections they exemplify between practice and theory; indeed, conceptualism is sometimes represented as a movement which abolishes this distinction altogether.[3] And some narratives have to be written with an eye to getting theory right. Take narratives of theory change. We don't have to think of the theories themselves as changing; theories may be treated as timeless propositional structures and the story written as an account of changes in the understanding of and credence given to those theories. But such narratives have to tell us how it is that the contents of the theories help to explain changing commitment and changing interpretation.

So, a narrative of the reciprocally changing fortunes of modernism and conceptualism will be highly dependent on the characterization of theories. The subject matter we are interested in—the emergence of an art-historical movement—is partly theoretical; we aim to tell a story about the under-standing, and the rhetorical use, of propositions. And choosing the relevant propositions is something we can do only by looking at the history. We are stuck in something like a hermeneutical circle, hoping to distill the theory from a history we can't properly write until we know what theories we are dealing with. The solution is, as always, to muddle along, hoping that success-ive refinements of a crude first attempt will give us, in the end, a plausible and coherent picture that makes good sense of the historical data. What I aim to provide here is certainly very provisional. But it does suggest something about the origins of conceptualism in art—something rather different from that often told by the friends of conceptualism. This will lead me to a suggestion about the nature of works of conceptual art; not surprisingly, they turn out

[2] On the relations between narrative and agency see Currie and Jureidini 2003 and Currie forthcoming.

[3] Following the convention for this volume, 'conceptualism' (uncapitalized) is used to refer to a very vaguely defined art movement which properly includes the analytical conceptualism ('Conceptualism') which flourished roughly between 1966 and 1972.

to be different in kind from works in a more traditional mold. But they are not so different that we can't see why all these things should be called 'art'. In fact they are just about as different as we would expect when one results from a self-conscious inversion of the aesthetic ambitions of the other.[4] So I shall argue.

3.1 Conceptualism and the Visual

Advocates of conceptual art have sometimes said that its practice consists in the uttering of propositions, and that it is these 'analytical propositions about art' which constitute their art.[5] Art—if that's what it is—of this kind would exist in no medium and would have no significant relations to any medium except in so far as one would need a medium of some kind (it should not matter which) wherein to register the utterance. But conceptualism is often characterized more liberally so as to include art-making which is medium-specific, though it may discourage or frustrate responses we traditionally associate with those media. Here I am concerned particularly with works in visual media. It is not always easy to say, of a particular work, whether it is genuinely a conceptual work, or whether it is right to think of it as medium-specific. But it is difficult to see how a work like Bruce Nauman's *One Hundred Live and Die* (see Illustration 4) could really be said to consist merely of 'words'—abstract or conceptual entities—when the words Nauman gives us are colourfully instanced in a complex structure of neon and glass tubing.[6] It could, I suppose, be said that part of the meaning of the work is to get us to see that the work's rather elaborately crafted appearance is irrelevant to understanding that meaning—assuming it has one. But this move is threatened by paradox: an artist who signals, by means of an act of elaborate crafting, the irrelevance of that crafting to the meaning of the work cannot expect to get that point across unless we see how elaborately crafted it is; there must be something in the particular manner of that crafting which makes this point. So the work needs, after all, to be seen. There is no paradox in the

[4] There are, of course, works of other kinds entitled to be called modernist; it is painting, or at least the broadly visual arts, that interests me here.

[5] This was typical of Conceptualism: 'Works of art are analytical propositions' (Kosuth 1969). On the value of Kosuth's philosophizing, see Sclafani 1975.

[6] Godfrey (1998: 10) says this is a work made of words.

idea that the viewer is expected to notice the appearance of the work and then self-consciously to put it aside, though this may in fact be a difficult thing to do. But doing it involves seeing the work.[7] Anyhow, this work seems to me to be an example—one of many that are conceptual in a broad sense—of which we can say: 'The work is meant to be looked at'.[8] And as things have turned out, separating works of conceptual art from their media-specific embodiments has proved surprisingly difficult, as we can see from the difficulty there has been in discouraging curators and connoisseurs of conceptualism.[9]

What does this mean for the theory of conceptual art? Acknowledging that

(1) Works of art, including conceptual ones, are meant to be looked at

is not, I shall argue, the collapse of the conceptualist project. But it does raise the question of how we should see the relations between conceptualism and modernism. Charles Harrison, long-time advocate of the Art & Language group's version of conceptualism, makes clear how much their energy derived from an enthusiastic rejection of Clement Greenberg's version of modernism, with its insistence that, as Harrison puts it, 'the authentic experience of art is a disinterested response to the work of art in its phenomenological and morphological aspects'—a 'purely optical' response, that is, to the work's appearance (Harrison 2001: 41).[10] In the light of such statements, my claim that works of conceptual art are properly objects of visual attention may

[7] Suppose that artist had crafted the work as it actually is but then had hidden it, providing only a description and an assurance that one does not need to see the work to engage with it. This would avoid the paradox above because the irrelevance of appearance would be signalled in some way other than via the nature of that appearance. But that is not how it is with the work we actually have.

[8] Even Kosuth's early works, such as *One and Three Chairs* (1965, Museum of Modern Art) seem to me of this kind. Discussing Kosuth's project, Peter Osborne concludes that '... as the documentation of performance pieces and temporary works shows, it is an irreducible dimension of the logic of the artistic field to present visual form, however attenuated or seemingly irrelevant' (1999).

[9] On the transition to collectibility in conceptual art see Wood 1999.

[10] Joseph Kosuth's influential essay (1969) makes much of the rejection of Greenberg's formalism; Adrian Piper speaks of the 'repressive McCarthyite ideology of Greenbergian formalism' (1993); see also work of Harrison discussed later on. Duchamp, an inspiration for conceptualism, similarly rejected the view he attributes to Courbet: 'that painting is addressed to the retina' (Cabanne 1971: 43, quoted in Harrison 1991: 264). Arthur Danto comments on how Greenberg embodied this philosophy in his practice: 'Greenberg would stand with his back to a new painting until it was in place and then wheel abruptly around to let his practised eye take it in without giving the mind a chance to interpose any prior theories, as if there was a race between the transmission of visual stimuli and the speed of thought' (Danto 1996: 109).

seem questionable. In sorting out the difficulty, it will help if we start with Greenberg's theory.

3.2 Greenberg

Greenberg's theory of visual art is complex and not wholly systematic. Yet two principles have undoubted prominence in his thinking and are reflected in much of his critical writing. These are two conditions of purity: purity of the medium and purity of looking. I take these in turn. Artists generally gained Greenberg's approval by giving visibility to the medium, as with Morris Louis, who soaked diluted paint into untreated canvas 'so that it became one with the fabric' (Greenberg 1995: 152). (I'll come back to this example later.) Greenberg was especially interested in 'the ineluctable flatness of the support' in painting, as being proprietary to the medium and hence the means by which painting makes its possession of the medium 'more secure'. While advocating abstraction in painting, he was not so much against the representations of objects as against the representation of space—the 'illusionistic' space inhabitable by three-dimensional objects and within which one can imagine moving. Greenberg (1960) admitted that marking the surface is bound to create an illusion of depth, but this must be a 'purely optical' depth.[11]

These appeals to the purity of the medium look very insecure. Call the capacity to represent an illusionistic space habitable by objects using only the resources of two dimensions, 'R'. Greenberg does not tell us why painterly exploitation of R cannot be defended as similarly distinctive of the medium. Interested, as he was, in contrasting the painterly with the sculptural, Greenberg might then have *advocated* this kind of illusionism in painting as part of what makes it distinctive. Also, as Leo Steinberg has argued, Greenberg distorts the history of painting by failing to acknowledge that the works he calls illusionistic often intentionally subvert or frustrate the tendency to imagine one's self within the space, or to make sense of the placement of objects therein.[12] And what are we to make of this purely optical category of

[11] Michael Fried develops the idea of a 'space accessible to eyesight alone' (1966: 794). Richard Wollheim says that Morris Louis 'seeks a form of representation where the representation of space or of anything spatial is at a minimum' (1973).

[12] See Steinberg (1968). Thanks to Jerry Levinson for calling my attention to this excellent piece.

depth anyway? Optical depth is a category to be defined in terms of a picture's capacity to generate certain responses; there can't literally be a depth which is somehow, in itself and without reference to perceiving subjects, optical rather than tactile or kinaesthetic. What entitles Greenberg to the assumption that there is a purely visual response to pictures? Claims based on introspection should carry little weight in this area, when recent work in cognitive science has done much to link our visual perception of the world with our capacity to act in it (Hurley 1997; Nöe 2004). And we know that visual displays easily trigger motoric forms of imagining; seeing a represented object generates simulations of movement appropriate to interacting with that object.

Suppose, contrary to all this, that the idea of a 'purely optical' illusion of depth in painting finds a place in the best account we can give of human perceptual capacities. What would make such an illusion benign by Greenberg's lights? The best answer available to Greenberg, it seems to me, is to be found in his second kind of purity: purity of looking. Illusion can be tolerated—perhaps even welcomed—when it arises in the course of a purely visual exploration. But illusions of depth that recruit tactile or kinaesthetic forms of imagination violate the notion that works of visual art are to be engaged with in a purely optical way. So Greenberg's system is driven by its insistence on purity, with opposition to illusion a purely dependent factor. Illusion is benign when it meets the condition of purity, and malign only when it doesn't.

Whatever the role of illusion in his thinking, Greenberg's view involves a recommendation:

(2) The work should be accessed by sight alone;

and a psychological or philosophical principle:

(3) Sight gives us a purely optical access to the work: an access untainted by thoughts, impressions or imaginings in other modalities.

3.3 The Primacy of Looking

For reasons already given, (3) is implausible. But the significance of (3) depends on how we evaluate (2); if (2) is to be rejected, (3) loses its interest, at least so far as the exploration of Greenberg's system is concerned. As I shall show in the next section, we have very good reasons to reject (2). Conceptualists reject (2), but so, these days, does more or less everyone else. And conceptualists, in

taking against the idea of the visual, have tended to reject a great deal more than (2). Charles Harrison, who charts in some detail the dissatisfactions of conceptualists with the modernist's valorization of 'the gaze', identifies the assumption that 'works of art are things made primarily to be looked at' as part of the rejected modernist package (Harrison 1991; 33). He describes conceptualism as an art in which 'objects are presented to view . . . only as contingent illustrations or demonstrations of some "idea".' (*Ibid.* 47).[13] These works achieve 'their intended form of distribution . . . not through being beheld . . . but through being elaborated, extended or otherwise worked on' (*ibid.* 51).

On this account, conceptualism is distinctive in rejecting the principle:

(4) Works of art are things primarily to be looked at

(4) is, I think, a plausible principle; in fact I take it to be constitutive of a great deal of art up to and including high modernism and minimalism. Principle (4) is, therefore, worth some attention.

(4) is a principle prescribing the canonical mode of access to the work *qua* work of art. It is not meant to rule out non-visual modes of access to the work when one is, for example, trying to find out something about the chemical constitution of the paint on its surface or the glue holding its frame together. Indeed I take it that (4) functions as a partial characterization of what it is to be a work of visual art: it is, at least in part, to be an object to which (4) applies. Further, acceptance of (4) does not mean acceptance of the view that engagement with a work of art, *qua* work of art, must always involve an act of looking at it. People certainly do think, speak, and write about works of art, *qua* works of art, which they are not currently looking at. (4) claims only that these activities, in so far as they are directed at the work *qua* art, be intended to make some contribution to a suitably informed act of looking at the work.

Principle (4) is also consistent with (though it does not entail) the idea that the act of informed looking at the work itself may have cognitive and behavioural consequences well beyond the domain of the work itself: that the experience of the work might, indeed, enrich one's life and those of others in various ways. It is also consistent with (though it does not entail) the idea that a principled motivation both for the production and for the consumption of

[13] Harrison cites Sol LeWitt: 'Ideas alone can be works of art' (LeWitt 1969).

art is to bring about these consequences. The crucial point is that these further acts of attention, analysis, and engagement are not focused on the work itself.

Note, however, that we cannot transform (4) into a criterion for the relevance to the work of non-optical knowledge: we cannot say that a piece of knowledge K is relevant just in case knowing K will affect one's experience of looking at it. Many things might affect one's experience of looking at a painting which ought not to count as relevant to an engagement with the work *qua* work of art: imagine knowing that the work had been owned by Hitler, or had been used to finance criminal activity for example. (4) provides at best a necessary and not a sufficient condition of relevance.

But what has the rejection of (4) to do with the rejection of Greenbergian modernism, with its emphasis on (2)? (4) is much weaker than (2), and much more widely accepted.[14] (2) claims an exclusive role for looking, while (4) claims merely a *primary* role for it. In rejecting (4) one is, of course, rejecting (2), but this observation does not establish any close engagement between conceptualists and modernists. The modernist-conceptualist dispute is starting to look artificial—like the dispute between A, who says that the object is round and B, who denies it has any shape at all; B is likely to find herself in opposition to many people beside A and it would be confusing for B to represent herself as saving the rest of us from A's error.

This is an example of how narrative, uninformed by theory, can mislead us. Narratives of conceptualism often tell us how strongly conceptualism was a response to—perhaps even a revolution against—modernism. Given what I have said about the propositional contents of these two movements, this can be true only in a psychological sense. Perhaps conceptualism seemed attractive to people exposed to what they saw as the excesses of modernism. What is not true is that conceptualism was a *logically focused response* to modernism: its leading principle contradicts not merely modernism but the whole tradition of painting.

3.4 Not by Sight Alone

I said that

(2) The work should be accessed by sight alone

[14] (2) entails but is not entailed by (4).

is widely rejected. Why is that? I said that (2) is a recommendation concerning how we should engage most appropriately and fully with a work of art *qua* work of art. Such a recommendation would be persuasive only if it were true that

(5) All the art-relevant properties of the work are available through sight alone

where the art-relevant properties are those you must access fully to engage with the work *qua* work of art. This principle does not require that one can literally see all the art-relevant properties of the work; at least some of these properties may be such that one cannot see them in the full and literal sense in which one can see, say, the colours on its surface. What it requires is that one has access to these properties (whatever kind of access this is) merely *by* seeing the object and not at all by virtue of what you know about the object in other ways.

Let us now say that the *appearance* of an object is what two objects must have in common when no one can tell them apart merely by looking at them. For (5) to be true the following supervenience thesis must also be true

(S) Works with the same appearance have the same art-relevant qualities.

For suppose that (S) was false, and two objects, O_1 and O_2, that could not be distinguished by sight had distinct art-relevant qualities; suppose that O_1 has Q and O_2 does not. In that case one would not be able to tell by looking at them which one possessed Q. But if you cannot tell by looking at both of them which one possesses Q, you cannot tell by looking at either one of them that it possesses Q or that it does not. So Q would be an art-relevant property not accessible by sight alone. So showing that (S) is false is sufficient to show that (5) is false.

Is (S) false? The promptings of some thought experiments suggest that it is. The relevant thought experiments generally involve us in imagining two objects identical in appearance but so different in other ways that they have different art-relevant properties. A number of such imagined cases have been constructed, but one is particularly apposite, given my earlier discussion of Greenberg. Imagine we have a work by Morris Louis, where diluted paint has been soaked into untreated canvas, together with a work with the same appearance but made in a quite different way. In the case of the second work the structure is not a canvas at all but a smooth surface of some kind, on which the paint has been laid, perhaps mechanically, in such a way as to achieve a

surface appearance just like that of paint soaked into canvas. It would be hard even for Greenberg to argue that these two works are artistically equivalent, given that he would not be able to say admiringly of the second that 'the paint had become one with the fabric'.

In summary the argument is this: (S) is false, and so (5) is false, and so (2) is a recommendation we have no reason to conform to. But none of this touches

(4) Works of art are things primarily to be looked at,

yet it is (4), as we have seen, which is rejected by the conceptualists. The question, then, is this: what sort of philosophy of visual art are we left with if we reject (2) but retain (4)? Having answered that question, we can then say what, if anything, is left of the idea of visual art if we then abandon (4) itself.

3.5 The Direction of Engagement with the Work

It is possible to combine acceptance of (4) with a rejection of (2) in different ways; acceptance of these two principles does not amount, in itself, to a coherent theory of the role of vision in art. Here is one way to combine them which seems to me plausible and attractive. The idea is that the process of engagement with the work, while it essentially involves knowledge not made available by vision alone, is a *directed* process: directed, that is, towards a visual engagement with the work. Works are intended to be looked at, but they should be looked at in the right way, with a proper understanding of the work's circumstances. It is not, on this account, the agglomeration of the looking and the knowing that constitutes a proper engagement with the work: there is also a relation of priority that holds between them. The knowing is the necessary means to achieve the properly informed looking. This explains what is meant by 'primarily' in (4): things primarily to be looked at are things which may need to be engaged with in various non-visual ways, but where the justification of the non-visual form of engagement (whatever that is) is that they make available the right kind of looking. It is the primacy, in this sense, of looking which explains a sometimes remarked asymmetry in the relations between visual engagement with a picture and other modes of knowing about it. Contrast the situations of the following two people: A, who knows nothing about seventeenth-century portraiture or indeed about the tradition of Western depiction, is currently looking at Van Dyke's portrait

of Charles I with some attention; and B, who knows as much as you care to specify about the picture and its history, but who has never seen it. Intuitively, A's position differs only qualitatively from that of an expert who is visually acquainted with the picture, whereas B's position seems radically defective. We think of A as on a path to understanding, and that increased knowledge can accelerate her progress along it, while B is not yet on the path.[15]

It is this account, I take it, that it is characteristic of conceptualism to deny, even while it admits that works are to be looked at. The conceptualist project is best understood as challenging the claim I have just outlined concerning priority, which was proposed in (4). The conceptualist allows that the work needs to be looked at, but that the looking is directed towards a further, non-visual engagement with the work. When Harrison says that conceptual works achieve 'their intended form of distribution . . . not through being beheld . . . but through being elaborated, extended or otherwise worked on' he should not be understood as denying that they need to be beheld; he is saying that this beholding, necessary though it may be, does not in itself constitute the proper mode of engagement with the work: it is not the work's 'intended form of distribution'. Now Harrison holds that, for at least some conceptual works, the finished product is not the primary object of our attention; the act of inquiring into it is (Harrison 1991: 49). This adds to the complexity of the task of giving an ontology of conceptual art: the object now is a constitutive part of the work—because the inquiry is, essentially, an inquiry into that object—rather than identical to it. Still, the point about priority seems to hold; Harrison's primary reason for wanting to emphasise the importance of 'inquiry' is this: inquiry plays the role in the conceptualist's account of engagement that looking played in the Greenbergian account, and possibly in earlier accounts also. This, I think, is best accommdated as a claim about the priority of looking.

One objection to this account of the role of appearances in conceptual art claims that I have represented the conceptualist as conceding too much; namely that while looking is instrumental in achieving, and does not itself constitute, proper engagement with the work, conceptual works are all, nonetheless, 'meant to be looked at'. Some conceptualists may insist that

[15] Christopher Janaway puts the point well: 'The untutored judge and the expert critic are on a continuum. The elaborations of critical discourse enable one to see and judge beauty more finely and in more challenging material, but should not be mistaken for an acquisition of the capacity to apprehend beauty' (Janaway 1997: 461).

this does not fully acknowledge the radical nature of their departure from traditional thinking. What they deny, they might say, is not (4), but the weaker

(6) Works of art are things to be looked at.[16]

And by having the conceptualist deny, not the weak (6) but the strong (4), I am weakening their position, for the stronger the proposition you are denying, the weaker the proposition you thereby affirm.

There may be a position, fairly called conceptualist, which denies (6), and such a position is certainly very radical; I am not sure what to say about that position. But it seems to me that there is value in charting the boundaries of another position which is still radical in that it denies something intrinsic to traditional conceptions of visual art, and yet retains a link to that tradition via its retention of some conception of *visual* art. I think we should agree on this: that works which deserve to be called *visual* works are such that proper engagement with them requires them to be seen. Now there are conceptual works which are visual in this sense, or so I claim, and there may well be conceptual works which are not. If there are conceptual works which are not visual in this sense, then they are not contrastable with traditional visual works from the point of view of the priority of looking over knowing (which is unsurprising). Conceptual works like Robert Barry's *Something which is very near in place and time, but not yet known to me* (1969), which is simply a printed sentence displayed within borders, might not count as visual conceptual works, and proper engagement with them might not require them to be seen—a description might do just as well. I am interested in how we should understand the conceptualist's project for those cases where looking does seem to be important, as with Bruce Nauman's colourful and intricate *One Hundred Live and Die.*

What justifies me in insisting that the Nauman is, and the Barry is not, a visual conceptual work? While these judgements seem to me plausible, I am not insisting on them. Nothing I have said depends on how they should be categorized, or even on whether there is some privileged way of categorizing them. My point is purely hypothetical: if you characterize either as a visual conceptual work, then you ought to acknowledge that the role of looking in engagement with that work is best understood as differing from the role of looking for a traditional visual work in this way: that the looking is

[16] (4) entails but is not entailed by (6).

directed towards a further, non-visual engagement with the work. If you and someone else have an irresolvable disagreement about whether either of these works is a visual work, then I am telling you what it is you are having an irresolvable disagreement about: it is disagreement about the priority of looking. If you think that either of these works is indeterminate with respect to membership in the category visual conceptual art, then I am telling you what this indeterminacy amounts to: it is indeterminacy with respect to the priority of looking. If you think that all this is just a matter of subjective preference, and you prefer to treat one or other of these works as a work of visual conceptual art, then I am telling you that you are preferring to look at the work in order to further some other, not essentially visual engagement with it.

3.6 The Work of Conceptual Art

I have outlined a theory about the canonical mode of engagement with works of traditional art, and have suggested how conceptualism can be seen as challenging that mode of engagement without denying that certain conceptual works are to count as visual works—works meant to be looked at. Does this also tell us anything about the nature of the works themselves? It is not obvious that it does, since questions about how works are to be engaged with and questions about what works are seem to be different questions.

I agree that they are different questions. However, it is surely sensible to have our views about what artworks are informed by our views about proper modes of artistic appreciation. The reason for this is that the primary question we want a theory of the nature of artworks to answer is a question about work identity: under what circumstances is work A identical with work B? And an intuitively compelling negative test for whether A and B are identical is whether there are features of the one that are relevant to its proper appreciation which are not features of the other. Certain theories about the nature of works have spectacularly failed this test. For example, it has been held that musical works are sound-structure types. But it is at least imaginable that two musical works, produced in quite different musical traditions and having quite different intended performance means, should have the same sound-structure type, their scores being note-for-note identical. Such works will be appreciable in radically different ways, in which case we ought to count

them distinct works.[17] So it seems to me reasonable to link work identity to our best account of work appreciation.

One thing that is often said about works of conceptual art is that the work itself is the activity or, in a familiar but unsatisfactory formulation, the artist's 'conception', rather than the finished product. Can we connect this idea, in some more acceptable formulation, with the idea that the looking that one engages in when one confronts a conceptual work is done in the service of some other activity? My suggestion is that these two ideas are connected by giving an answer to the question: In the service of *what* is the activity of looking undertaken? For the natural answer is 'In the service of understanding the activity of the artist who has made the thing we are looking at'.

This may seem to support the following idea. For traditional works of visual art, we have

(4) Works of art are things primarily to be looked at.

And given that looking has this sort of primacy for such works, we should regard the work itself as the thing to be looked at: the marked surface. And in the case of works of visual conceptual art, where the understanding of the artist's activity is primary, we should regard that activity as the work itself.

However, this is not satisfactory. To say that in the one case the work is the marked surface and in the other the work is the activity of making gives us no clue as to how the marked surface and the activity are linked. And they are linked, both for traditional visual art and for visual conceptual art (or so I have suggested). I have been arguing that in *both* the case of traditional visual art and visual conceptual art, an acquaintance with the marked surface and an understanding of the artist's activity is essential to a proper engagement with the work. The difference between them is, precisely, the appropriate direction which engagement should take. Our theory of the natures of these works should reflect this fact, and not pretend that traditional visual art focuses exclusively on the marked surface, and conceptual art exclusively on the activity.

This is not the occasion to elaborate a detailed theory of the nature of the artwork. Such a theory would have disputable features not relevant to our

[17] See Levinson 1980; Currie 1989; and Davies 2003. Such arguments as this need to be sensitive to the distinction between cases where we have two distinct works appreciable in different ways and cases where we have one, multiply interpretable work. Levinson's exposition is sensitive to this distinction.

present concern. Let us look instead to a broad class of proposals about the nature of visual works which I shall call *two-factor proposals*. A proposal of this kind says that one constitutive element in the work (in the case of visual art) is its appearance, while another is some thing or group of things which specifies something about the action that resulted in the production of an object with this appearance. These things will include biographical and historical information that would help us to understand the nature of the artist's action, and in particular the character of his or her artistic achievement, by enabling us to place the work in an appropriate stylistic, technical, and social context. I'll call such proposals as these *Action-Result proposals*: any such proposal says that two things are essential to the identity of a given work: an act of artistic production, and the object with a specific visible appearance that this act gives rise to.[18]

However, to say only this much about the identity conditions for works is not yet to make a connection with the debate, referred to earlier, about the proper form of engagement with works. What is lacking so far is any specification of the *directions of priority* that obtain between these distinct elements.

What I have said so far is consistent both with the traditional view that the marked surface has priority over the act of making it, and with a conceptualist-inspired story about the priorities that hold between the work's elements such as this: 'What is important about the appearance of the work is that it enables us to engage in the right way with the action performed by the artist; for if we do not fully understand the appearance of the object which resulted from the action, we cannot understand that action'.

We ought, therefore, to acknowledge at least two sub-classes within the class of Action-Result proposals: we can designate them this way, indicating that *direction* matters: <action, result> and < result, action>.[19] These correspond to our two proposals about the relations of priority that hold between the work's appearances and the action that brought it about. A proposal which belongs to the class <result, action> says that the appearance of the work has priority, and that the action is important because understanding it provides

[18] The Action-Result distinction corresponds closely to Walton's distinction between the products and processes of art; I am indebted to the discussion in Walton 1979.

[19] But note that I am using the notation in an unusual way: <action, result> is not for me an ordered pair, but a class of proposals about the nature of artworks that (i) recognizes two constituent components in the work and (ii) a certain relation of priority of the first over the second.

the kind of informed looking that constitutes a proper engagement with the work. On the other hand, a proposal which belongs to the class <action, result> claims that the action has priority, and the work's appearance is important because it enables one to grasp something important about that act. Any proposal which belongs to <action, result> automatically belongs to the class of Action-Result proposals, but not vice versa, because the constitutive conditions for <action, result> proposals are strictly stronger than those for Action-Result proposals, since they add a requirement of priority; similarly for <result, action> proposals.

My suggestion is, then, that a satisfactory ontology for traditional visual art is likely to be of the kind <result, action>, while a claim about the nature of a work of conceptual art is more likely to belong to <action, result> variety. However, this difference with respect to direction of priority suggests another sort of difference between conceptual and traditional artworks; this difference has implications also for how works of these different kinds should be engaged with. I have in mind that *the different directions of priority are likely to go with different ways of conceptualizing the action of the artist.* Where the direction is, as with the traditional approach, from act to appearance, the act is likely to be conceptualized as one involving a response to certain problems, including technical problems to do with the manipulation of materials, but also to do with, say, handling of perspective, colour relations, and the inclusion in the work of certain formal relations.[20] Where the direction is, as with a conceptualist work, from appearances to act, the act is likely to be conceptualized as one which communicates, or expresses, or is in some more general sense revelatory of certain thoughts about art in general or about a certain kind of artistic project. So we can say that the narrative one aims to elaborate in describing a work of traditional visual art will differ from the narrative for a work of visual conceptual art in several ways. One difference is that these narratives will emphasize different relations of priority between the artist's activity and the marked surface to which that activity gives rise. But they will also differ, perhaps radically, in the ways they describe the activity.

Works of conceptual art are, on my proposal, rather different kinds of things from the sorts of things more traditional works of visual art are. But they are not utterly different. There are categories we can put them into

[20] This is the approach which Harrison (mis)characterizes as the view that 'the value of the work is . . . the possibility of its revealing the physical trace of a specific authorial hand' (1991: 92).

which distinguish them (<action, result> and <result, action>), and there is a single category (Action-Result proposals) of which these are merely two special cases. This, I suggest, is the sort of ontology we would hope for in thinking about a form of art which radically and self-consciously rejects the priority of visual experience in art, without abandoning the idea that visual experience is important to a proper engagement with art.

References

CABANNE, P. (1971), *Dialogues with Marcel Duchamp* (London: Thames & Hudson).

CARROLL, N. (1993), 'Historical Narratives and the Philosophy of Art', *Journal of Aesthetics and Art Criticism*, 51: 313–26.

CURRIE, G. (1989), *An Ontology of Art* (London: Macmillan).

_____ (2006), 'Narrative Representation of Causes', *Journal of Aesthetics and Art Criticism.*, *64, 309–16.*

_____ and Jureidini, J. (2004), 'Narrative and Coherence', *Mind and Language* 19/4: 409–27.

DANTO, A. (1996), From Aesthetics to Art Criticism and Back', *Journal of Aesthetics and Art Criticism*, 54: 105–15.

FRIED, M. (1966), 'Shape as Form: Frank Stella's New Paintings', *Art Forum*, 5: 2.

GODFREY, A. (1998), *Conceptual Art* (London: Phaidon).

GREENBERG, C. (1960). 'Modernist Painting', reprinted in *Art and Literature*, 4 (1965): 193–201.

_____ (1995), *The Collected Essays and Criticism, Volume 4: Modernism with a Vengeance, 1957–1969*, ed. John O'Brian (Chicago: University of Chicago Press).

HARRISON, C. (1991), *Essays on Art and Language* (Cambridge, MA: MIT Press).

_____ (2003), *Conceptual Art and Painting: Further Essays on Art & Language* (Cambridge, MA: MIT Press).

DAVIES, D. (2003), *Art as Performance* (Oxford: Blackwell).

HURLEY, S. (1997), *Consciousness in Action* (Cambridge, MA: Harvard University Press).

JANAWAY, C. (1997), 'Kant's Aesthetic and the "Empty Cognitive Stock"', *Philosophical Quarterly*, 47: 459–76.

KOSUTH, J. (1969), 'Art after Philosophy', *Studio International*, 178: 134–7, 160–1, 212–3.

LEVINSON, J. (1980), 'What a Musical Work Is', *Journal of Philosophy*, 77: 5–28.

LEWITT, S. (1969), 'Sentences on Conceptual Art', *Art-Language*, 1: 11–12.

LIPPARD, L. and CHANDLER, J. (1968), 'The Dematerialization of Art', *Art International* 12/2 (February): 31–6.

NOË, A. (2004), *Action in Perception* (Cambridge, MA: MIT Press).

OSBORNE, P. (1999), 'Conceptual Art and/as Philosophy', in M. Newman and J. Bird (eds.), *Rewriting Conceptual Art* (London: Reaktion Books, 1999), 47–65.

PIPER, A. (1993), 'The logic of modernism', *Flash Art*, 26: 56–8, 118, 136.

SCLAFANI, R. (1975), 'What kind of nonsense is this?' *Journal of Aesthetics and Art Criticism*, 33: 455–8.

STEINBERG, L. (1968), 'Other Criteria', in id., *Other Criteria: Confrontations with Twentieth Century Art* (Oxford: Oxford University Press), 55–92.

WALTON, K. L. (1979), 'Style and the Products and Processes of Art', in *The Concept of Style*, ed. Berel Lang (Philadelphia, PA: University of Pennsylvania Press, 1979), 72–103. (Second edition: Cornell University Press, 1987.)

WOLLHEIM, R. (1973), 'The Work of Art as Object', in id., *On Art and the Mind* (London: Allen Lane), 112–29.

WOOD, A. (1999), ' "Still You Ask for More": Demand, Display and "The New Art" ', in M. Newman and J. Bird (eds.), *Rewriting Conceptual Art* (London: Reaktion Books, 1999), 66–87.

4

Speaking Through Silence: Conceptual Art and Conversational Implicature

Robert Hopkins

4.1 The Problem of Conceptual Art

Does conceptual art raise a distinctive problem for philosophical aesthetics? Many have thought so. There is thought to be a tension, if not down-right contradiction, between the notion of art that seemed viable before the turn to the conceptual, and the works to which that development gave birth. My first task is to attempt to focus this tension. I will not be directly concerned with the question of what defines conceptual art. No doubt the question of what is distinctively problematic about that art cannot be separated entirely from the question of its nature. However, to the extent that the two can be kept apart, it is the former that will concern me.

A useful starting point is the idea that conceptual art is distinctive in not speaking to the senses. Let us, broadly following James Shelley,[1] begin to capture this idea with the following principle:

[1] James Shelley, 'The Problem of Non-Perceptual Art', *British Journal of Aesthetics* 43/4 (2003): 363–78.

(ECA) There exists conceptual art, that is art that can be fully appreciated (as art) without being the object of sense experience.

(We need not intend, for the purposes of what follows, that this define conceptual art; it suffices that it accurately describes one of its features.)

If (ECA) is to generate a problem, it needs to be incompatible with some apparently plausible general principle, or principles, governing art. Here is a principle that I, at least, find tempting:

(P) Aesthetic features must figure in sense experience.[2]

If this is to conflict with the preceding, we need to bridge an obvious divide between the two: whereas (ECA) concerns appreciation, (P) places a condition on a property's being aesthetic. The bridge lies in a plausible corollary of the second principle:

(PC) Necessarily, an aesthetic feature can be appreciated in sense experience.

All that then remains is to explain the relation between the notions of art and the aesthetic, again in the context of a claim about appreciation:

(R) To appreciate something as art is to appreciate the aesthetic properties of that thing.[3]

These three principles seem plausible, and to capture important ideas about art and the aesthetic. Suppose they also form an inconsistent set. They would then invite one of three responses. We can reject the idea that conceptual art really is art; reject the idea that aesthetic properties are appreciable in sense experience; or reject the idea that the properties we engage with in appreciating art—call them *artistic properties*—are necessarily aesthetic.[4] (The third option could be pushed farther. Given the 'fully' in (ECA), the existence of conceptual art suggests not only that some artistic properties are not aesthetic, but that it is not necessary, for something to count as art, that it possess *any* aesthetic properties.)

[2] Prima facie, (P) is incompatible with the intuition that some features are aesthetic even though sense experience does not allow us to discriminate their presence. I attempt to reconcile the apparent conflict in 'Aesthetics, Experience and Discrimination', *Journal of Aesthetics and Art Criticism*, 63/2 (2005), 119–33.

[3] Again, I follow Shelley closely. The main difference between our formulations of the problem is that he ignores the bridge closed above. For this reason, his three principles, (X), (R), and (S) (*op.cit.*, 364) do not form even a prima facie inconsistent set, contrary to advertisement; let alone the genuinely inconsistent set his argument requires.

[4] Again I borrow from Shelley. He opts for the second option.

However, we have not yet successfully identified the problem posed by conceptual art. The three principles above are *not* inconsistent. On the face of it, the corollary of (P) merely requires that any aesthetic property *can* be appreciated in sense experience. This does not exclude such a property also being appreciated in other ways. If it is nothing more than that possibility that conceptual art exploits, then (ECA) is quite consistent with (PC) and (R) combined.

There are three obvious ways in which we might generate the inconsistency needed:

1. We might strengthen (PC), so that it claims that an aesthetic feature can *only* be appreciated in sense experience.

But why think that (P) has that consequence, or that such a claim is independently plausible?

2. We might strengthen (ECA):
 (ECA$^{\text{Strong}}$) There exists art the appreciation of which (as art) cannot be through sense experience.

There are works of conceptual art for which this stronger claim is correct. Consider, for instance, Walter De Maria's *Vertical Earth Kilometer* (Illustration 11).[5] This consists of a one-kilometre-deep hole in Germany, drilled with the aid of an oil rig, into which a one-kilometre-long brass rod has been inserted. The whole is capped with a metal plate. This work is not, it seems, available to sense experience. Its parts—the rod, the (top of) the hole—can be seen or felt. But they can be only by dismantling the piece. When assembled, only a tiny part of it, the plate, can be experienced. True, the fact that the work cannot be experienced does not *entail* that those properties that are the source of its artistic interest cannot be. For perhaps another work could exhibit the very same artistic properties, only in a form open to sense experience. But although logic does not close down this possibility, serious reflection does. Artistic properties may not be as context-sensitive as aesthetic properties have traditionally been taken to be, but they are surely not sufficiently insensitive to context to survive this transition. To suppose otherwise is to suppose that it

[5] See Robert Hughes, *The Shock of the New* (London: British Broadcasting Corporation, 1980), 390.

is an unimportant, or at least detachable, fact about *Vertical Earth Kilometer* that it cannot be felt or seen.[6]

Vertical Earth Kilometer may not be alone in providing an instance of (ECA) in its strengthened form. Nonetheless, at least many works of conceptual art do not exhibit the feature it describes. Duchamp's readymades, for instance, hardly elude sense experience; and nor, for that matter, does Cage's 4′33″. Its auditory properties are all (in some sense) negative, but auditory perception is not limited to sound—we can also hear silence. Thus, while this second move may indeed provide us with a serious philosophical difficulty, and while conceptual art is the source of that problem, it seems it cannot provide us with what is distinctively problematic about conceptual art. Too much of what has been taken to fall under that banner is simply not problematic in the way described.

Anyone sympathetic to this line of criticism will want to find a problem that is thrown up as readily by such works as Marcel Duchamp's *Fountain* (Illustration 3) as by De Maria's buried rod. The thought will be that the latter eludes sense experience completely only because it takes to the limit a way of rendering experience irrelevant that the former already embodies. For both, sense experience is dispensable as it never was for traditional art. In pursuit of this thought:

3. We might try to distinguish between sense experience as *means of access* to the work, and sense experience as *medium of appreciation*. It is the latter that *Fountain* already jettisons, for all that it remains burdened with the former.

How might we make out the distinction between medium and means? One attempt would be to appeal to the idea that, when sense experience is the means of access to the work, one's experience could have been different without affecting one's appreciation. Any work, if it is to be appreciated by those other than its maker, has to be grasped somehow. Given our dependence on sense experience for our knowledge of contingent aspects of the world, this grasp will have to be mediated by experience. But if this is the only role sense experience plays, one might find out about the work using one of several sensory modes. One might, for instance, touch *Fountain*, rather than seeing it. And one might find out about it without experiencing the work itself at all,

[6] I ignore any complication introduced by the documenting, in photographs and the like, of the work. A very similar work might not have been documented. That hypothetical piece can serve as our example.

as when one reads a description of it, or is told about it by someone else. No doubt this second sort of case will involve one's occupying a place in a chain, at one end of which lies sense experience of the work. But in neither this sort of case nor the first, do the details of one's sensory experiences—not even such central features as the modality they are in, or the objects they present—matter to one's appreciation. These features can change without one's appreciation changing, provided only one retains one's grasp on the nature of the work. In contrast, where sense experience is the medium of appreciation, almost any difference in experience might in principle affect the appreciation one has; and in any given case a far wider range of aspects of experience will bear on one's appreciation of the piece.

This proposal would need refining in various ways to be satisfactory. But I think it faces a serious objection that renders any such refinement pointless. Suppose there to be an art form meeting two conditions. First, it exploits symbols that do not admit of ready translation into language. Perhaps these symbols form a syntactically and semantically dense set, so that there can be no guarantee that, for every such symbol, there is a linguistic one conveying the same meaning.[7] Second, these symbols can only be taken in via a single sense modality, M. In such a case, our only means of access to works of art of that form would be via M-experience of the works themselves. The second condition precludes experiencing them in another sense modality; the first precludes grasping their content, and hence their nature, via descriptions. Thus this art form meets the conditions above for being one in which sense experience plays the role of medium of appreciation. Yet nothing in the situation as so far described secures that that is intuitively the case. It is true that the only art form that we know to meet these two conditions, painting, is one in which sense experience does play the role of medium. But it is quite unclear that this is so only because painting meets the two conditions above. It seems that appreciation can depend closely on sense experience without experience playing the role of medium of appreciation. The proposal fails to do the work required.

A better way to make out the distinction will, I think, begin with a positive characterization of the notion of medium. Where sense experience is the medium of our appreciation, that experience is altered by our awareness of

[7] For semantic and syntactic density, see Nelson Goodman, *Languages of Art* (Oxford: Oxford University Press, 1968).

the feature we appreciate. When, for example, I appreciate the muscularity of Caravaggio's style, my awareness of that feature is part of what constitutes my experience of his work: had I not been aware of it, my experience would have had a different phenomenology. In contrast, when sense experience merely provides a means of access to the work's nature, that nature, via my awareness of it, does not permeate the experience itself.

These ideas are a little elusive.[8] Nonetheless, they do offer a way to draw the distinction between medium and means that bears on the issue in hand. Some works of conceptual art, such as *Vertical Earth Kilometer*, cannot be experienced by the senses at all. But even with those, such as *Fountain*, that can be, that experience is merely a means of access to their nature. It is not the medium of appreciation because the artistic features appreciated do not enter experience in the way the notion of medium requires. For, while I might appreciate, say the audacity of *Fountain* on seeing it, my experience is not altered by my awareness of that feature. The urinal looks the same, whether I am engaging with its audacity or not. And in this the Duchamp contrasts with the Caravaggio. To see the muscularity of its style is to experience it differently, for one's sense experience to be altered by awareness of that feature.

This distinction provides one way to capture what is problematic, from the point of view of philosophical aesthetics, about conceptual art. The idea is that for other art, sense experience plays the role of medium of appreciation; whereas for conceptual art, it provides nothing more than means of access to the work. Other art is appreciated in experience; conceptual art is experienced only as a means to its appreciation. Thus conceptual art does indeed fail to speak to the senses in a way in which other art does. We seem to have found a way to make good our original idea, and a way which should apply to more than a limited range of conceptual art. For—although this would need arguing—the points just made look, prima facie, as if they should hold of most, perhaps of all, the works that have been considered conceptual.

However, there is a serious difficulty with the proposal. The feature described might be exhibited by much conceptual art, and by no painting, sculpture, or music in the traditional mode. But it can hardly constitute a distinctive challenge posed by conceptual art to our conception of art. For this is just as

[8] For more, see my 'Aesthetics, Experience and Discrimination', where I interpret principle P in light of the idea here deployed to give an account of medium: aesthetically significant features must enter experience in the sense that awareness of them partially constitutes its phenomenology.

much a feature of at least one of the traditional arts—literature. There too, sense experience is no more than means of access to the work. The printed page, or the heard poem, does not look or sound different when one engages with whatever features render it of artistic interest. One's sense experience is unchanged by appreciating those properties of the work. True, there may be a sense of 'experience' in which one experiences, say, *Daniel Deronda* differently, when one grasps F. R. Leavis's thought that it is in effect two novels welded awkwardly together.[9] But since it is clearly not sense experience that is in question, that observation is of little help. To appreciate the daring quality of *Fountain* is just as much to experience it anew, in *some* sense. What reason is there to think that literature engages with experience in any sense in which conceptual art fails to?

One response might be to see conceptual art's distinctiveness as lying in its mixed nature. Like visual and musical art, its works are the kind of thing that *could be* experienced by the senses. Even *Vertical Earth Kilometer* and the like fit this characterization. Although it cannot be experienced without being taken apart, it belongs to the kind of object for which sense experience is always in principle a possibility. After all, it's a composite of several perceptible parts. It's only the way they're combined that leaves some hiding others, so placing the whole beyond experience. In this, *Vertical Earth Kilometer*, like every piece of conceptual art, is unlike literature, since a novel or poem, whatever its precise nature, is not a material object, available to the senses. Yet, as with literature, sense experience does not form the medium through which it is appreciated. Now, this feature of conceptual art, that its objects belong to the realm of that which can be experienced, is important, and we shall return to it. But the current suggestion about the use to make of this feature faces a serious difficulty. The distinctiveness it wins conceptual art is not particularly interesting. How does the fact that conceptual art is the sort of stuff that can be seen, heard, or felt, make any difference to the philosophical conclusions we should draw? We are already committed, given the existence of the literary arts, to abandoning any thought that art is tied to sense experience as medium. Given this, the fact that there can be art objects for which experience is not the medium, but which nonetheless can be experienced, looks unsurprising. There can be art for which sense experience is not the medium of appreciation,

[9] F. R. Leavis, *The Great Tradition* (London: Chatto & Windus, 1948).

and there can be objects perceivable by the senses. What is surprising or interesting about the claim that these two features can be combined?

A better response requires a more radical rethink. Perhaps conceptual art's specialness does not lie in its relation to the senses after all. One respect in which literary art is quite typical of art as traditionally conceived is in the importance of execution. It is not enough, to appreciate a work of literary art, that one grasp its central idea. That idea must be executed, and the details of execution will be crucial to the success or otherwise of the finished work. For a novel, for instance, knowing the mere outline of the plot, however original or intriguing, is hardly a sufficient basis for appreciating the work. With conceptual art, or so at least the suggestion goes, this is not so. The conception is the key, its execution largely irrelevant. If we wanted to work in slogans, we could say that what makes conceptual art distinctive is not that it fails to speak to the senses, but that its value lies entirely in the idea. Can we turn this slogan into a developed view?

A crude first attempt would be to suggest that with conceptual art it does not even matter that the work has been made. Conception is so central that execution is not even necessary. This, though, is too crude. Perhaps some conceptual art fits this bill. Douglas Huebler's proposal (1971) for his *Variable Piece # 70 (In Process) Global* was 'throughout the remainder of the artist's lifetime [to] photographically document, to the extent of his capacity, the existence of everyone alive in order to produce the most authentic and inclusive representation of the human species Editions of this work will be periodically issued in a variety of topical modes: "100,000 people", "1,000,000 people", "10,000,000 people", etc.' This work could not, in practice, be completed; perhaps it is unimportant that it even be started. But even if this is the right thing to say about the Huebler, it is certainly not true of all conceptual art. *Vertical Earth Kilometer*'s interest lies partly in the fact that a gesture on this scale was really carried out; and *Fountain* would surely be far less interesting if Duchamp had merely contemplated infiltrating so ordinary an object into the world of the gallery. The point, then, needs making in more sophisticated form.

What is lacking, in the case of *Vertical Earth Kilometer* or *Fountain*, if all we have is the conception of the work? The answer, surely, is the audaciousness of the latter, or the imposing pointlessness of the former. Ideas can be audacious, but thinking of something audacious is not itself necessarily to think audaciously. And this is true even if one has conceived of every aspect

of the thing on which its audacity turns. The boldness of the gesture in *Fountain* required that Duchamp really put an ordinary urinal into a space devoted to art; merely thinking of doing so was, in contrast, timid. These points are even more plausible for the imposingness of gesture of *Vertical Earth Kilometer*. In this respect audaciousness and imposingness contrast, perhaps, with ingenuity. Thinking of an ingenious solution to a problem is itself to have an ingenious thought—provided, that is, that everything that renders the solution ingenious is present in one's conception of the solution. (To think of a proposed solution *as* ingenious, or as a solution, hardly suffices for it to count as either.) Perhaps the difference between conceptual art that does need to be executed and conceptual art, if any, that does not, is a matter of whether its interest lies in properties that function as audaciousness does, or properties that function as ingenuity does.

However, whichever sort of artistic property is involved, the distinctive thing about conceptual art, I suggest, is that that property is already determined in conception. In conceiving *Fountain*, Duchamp had come up with a work that *would be* audacious, were it executed. For he had conceived it as having features sufficient, on instantiation, to render it audacious. Execution mattered, in that in merely producing the idea of *Fountain*, Duchamp had not yet produced anything with the relevant property. But execution did not matter in any further respect. In particular, it did not matter how the work was executed—provided the execution was true to the conception, the resulting work would be dazzlingly bold. And this not for the trivial reason that it was *conceived as* audacious. Rather, Duchamp conceived it as having certain other properties, and these properties were such that anything having them would be audacious. And similarly, in broad outline, with Huebler. In conceiving *Variable Piece # 70*, Huebler had not only conceived of something that would be mind-boggling; perhaps the conception already was so. But whether that is so or not, the mind-boggling nature of *Variable Piece # 70* was fully determined by the properties Huebler conceived it as having. No matter how it was executed, provided it had those properties, it would be mind-boggling.

In this respect, conceptual art contrasts with other art, including literature. The conception of a novel or poem is insufficient to determine its artistic properties. It is not simply that, as with *Fountain*, those properties are absent until something has been built to fit that conception; rather, the way in which the thing is executed determines whether or not it will have those properties after all. Provided we set aside the trivializing case, in which the work is

conceived as having a certain artistic property, and stick to conceptions which specify only the properties on which artistic properties are to depend, then the gap between conception and execution will always leave room for the fatal slip. Must this be so? Can't the work be conceived in sufficient detail that there is no question that any execution true to it will have the properties aimed at? In the context of the plastic arts, we might doubt that a sufficiently detailed conception is in principle within our grasp. In the literary arts, there is no similar worry. It is only a contingency that prevents us being able to plan every word of a novel; and nothing prevents us being able to plan a poem in sufficient detail to fix its artistic properties. The point rather is that by the time conception is sufficiently determinate to secure this result, there is nothing left for execution to do. If one has conceived every word of the poem or novel, the thing is written. If one has done less than that, then execution still has its chance to affect the artistic properties of the thing. In neither case does literary art match conceptual. And if literary art does not, what does?

Let me try to put the claim more formally. A work's *artistic properties* are those we appreciate in appreciating it as art, and its *base properties* are the properties on which its artistic properties depend. Then we might try claiming that the following is distinctive of conceptual art:

(1) The work's base properties can be conceived in sufficient detail to determine its artistic properties, without conception amounting to execution of the work.

However, this will not quite do. The problem lies in the last clause. That is intended to exclude literature. It does so, but in the wrong way. For it leaves (1) capturing a difference between literature and conceptual art that turns on the ontology of the two art forms, and that is not the difference we are after. Works of conceptual art are material objects, works of literature are not. To execute a work is to create it. If the work in question is a material object, no act of conceiving, however specific, can constitute the work's creation. If the work is not material, there is no such obstacle to conception equalling execution. The difference between the art forms that (1) captures is just this, that in the case of conceptual art, but not literature, the material status of the work prevents conception amounting to execution. But this difference is precisely the one I discussed earlier under the proposal that conceptual art has a mixed nature, and which I there described as uninteresting. That is, it leaves the two art forms, in terms of their relation to central ideas in the philosophy of art, on

a par: it's just that conceptual art represents the intrusion into the realm of the material of the sort of structures of evaluation (no role for sense experience as the medium of appreciation, or conception's ability fully to determine artistic properties) that literature already embodies in the non-material realm.

To avoid this difficulty, we need to rejig (1). To see how to do so, let's introduce the notion of a *fully specific conception* of a work of art. This specifies every detail of how the work is to be: the precise nature of every base property is fixed by the conception. Of course, in the case of a work of conceptual art, such a specification determines the thing's artistic properties. The point, though, is that such a work's artistic properties are also fully determined by a conception that falls far short of this ideal. In literature, in contrast, only a fully specified conception determines artistic properties. Perhaps conceiving its properties in that detail also suffices for one to have created the work. But whether this is so or not is a further matter, one precisely introducing the ontological considerations that we are now setting aside. Thus, what is true of conceptual art, but not of literature or any other traditional art form is this:

(1*) The work's artistic properties are fully determined by a less than fully specific conception of its base properties.[10]

[10] One might wonder whether we could not replace this with something that did not speak of conception at all. Why not instead characterize the distinctiveness of conceptual art by the relations holding between the base and artistic properties of the work? The idea would be that in conceptual art dependence is much looser than in other art, so that the base properties on which the work's artistic properties depend are far less determinate than those in the case of traditional art. However, I am doubtful that we can drop talk of conception in this way. First, what does it mean for artistic properties to depend on *less determinate* base properties? Aren't all actual property instantiations fully determinate? If so, talk of less determinate properties threatens to be mere shorthand for talk of such properties *conceived* in such a way as to overlook some of their determinacy. Second, even if we can make sense of the determinable-determinate distinction within properties, rather than within conceptions of them, it is unclear to me that the distinction will capture every aspect of the intuitive difference between conceptual and other art here. At least some of the variation that leaves the artistic properties of conceptual art unaffected is not, apparently, variation within determinates of a given determinable. Thus, just as it seems unimportant to *Fountain* that it be one shade of white rather than another, it also seems unimportant that it be a rounded urinal, rather than a squared-off one. But, while being one shade of white is determinate relative to the determinable *white*, it is far from clear that being a rounded urinal is determinate relative to the determinable *being a urinal*. If not, the new proposal needs phrasing in terms loose enough to capture this sort of independence too. And what would do, short of saying simply that some of the work's properties affect its artistic properties, and others do not? Since that is as true of traditional art as it is of conceptual art, what distinction

4.2 Conceptual Art and Conversational Implicature

So far, we have reached two main conclusions about conceptual art. First, like literature, but unlike other traditional arts, it does not have sense experience as its medium of appreciation. Second, unlike all traditional art, it allows for a particularly loose relation between base and artistic properties, so that a partial conception of the former suffices to determine the latter. These claims, and particularly the second, constitute the challenge conceptual art poses to traditional theorizing about the arts. In the rest of this essay I want to take some first steps towards meeting this challenge. I will do so by investigating the mechanism by which the audience comes to grasp the interesting features of a conceptual artwork.

This is the time to deploy an observation we have occasion to make more than once above, but on those occasions have had to set aside. Conceptual artworks belong to kinds that are essentially available to sense experience. Even if a particular work, such as *Vertical Earth Kilometer*, is not so available, it belongs to a kind of thing that standardly can be experienced. This feature of conceptual art establishes an expectation on the part of someone confronted with such art. The expectation is that it, like other art that can be experienced, will be satisfying in sense experience. In other words, the expectation is that sense experience will be the medium for appreciating what is interesting about the work. But the first of our two conclusions above was precisely that that expectation will be frustrated. The viewer can find no artistically rewarding properties of the work that can enter her experience of it in the way required. Given that, she is driven to wonder what the point of the work can be. It sets up an expectation, in virtue of the sort of thing it is, and the context in which it is found (e.g. a gallery), which it then fails to meet. Why does it do this? It is in answering this question that the viewer engages with the point, or perhaps many points, of the work. She engages with its artistic interest by seeking to understand the point of its frustrating her legitimate expectations.

Thus far I do not take myself to have said anything particularly controversial. But we can make these homely observations do a surprising amount of work. To do so, we should begin by drawing an analogy between the situation just described and one that holds in the context of conversation. Suppose I ask

remains? Claiming that conceptual art's artistic properties depend on *a smaller portion* of its base properties is not obviously true, and no other claim is clearly available.

you a question. You don't answer me. I am left wondering why not. Perhaps you simply don't know the answer, and are embarrassed to admit as much; or perhaps you just didn't hear me. But something more subtle might be going on. Perhaps you are trying, by refusing to answer, to tell me something. You might be seeking to let me know that my question is inappropriate. If I ask a distinguished philosopher whether the rumours about her moving university are true, she might change the topic, as a way of indicating that I should not be inquiring on such matters. A refusal might convey other things too. If I ask the philosopher at a departmental party what she found most interesting about the paper we have just heard, she might stay silent, as a way of communicating that she found nothing worthwhile in it. Equally, she might reply 'its delivery', as a way of making much the same point. In all these cases, in various ways, my interlocutor refuses to answer what, given the context, was clearly my question. She thus explicitly frustrates an expectation we both knew me to have. Her doing so prompts me to ask why she should do this. In answering that question, I can come to grasp some point she wishes to convey.

The phenomenon thus indicated is, of course, what Paul Grice called 'conversational implicature'.[11] Grice offered a relatively precise definition of the phenomenon, and a relatively detailed explanation of how it operates. He appealed to various principles governing conversational exchanges. He explained communication in these cases via a detailed account of the nature and relative priority of those principles, and the thoughts one might reasonably work through when one's interlocutor bucks one's expectations by not following those principles in the most obvious ways. Moreover, Grice described the phenomenon so as to cover a far wider range of conversational exchanges than are suggested by my examples above. However, we can afford here to ignore many of the details of Grice's account. I want to draw only on the central analogy it offers for our understanding of conceptual art. In our confrontations with the latter, and in conversations where our questions go unanswered, communication is effected in a somewhat roundabout way. Rather than meeting our expectations, and getting a point across that way, the speaker/artist frustrates them, and gets her point across by prompting us to wonder why she has done so. It is not what she says that is the mechanism of communication, but what she fails to say, and the reasoning that prompts.

[11] Paul Grice, *Studies in the Ways of Words* (London: Harvard University Press, 1989).

We can use this analogy to illuminate three aspects of conceptual art. To get to the first, we must begin with one disanalogy between that art and standard conversation. Normal conversation is one-to-one, and takes place in the presence of both parties. It involves a two-way interaction between them, with each being highly responsive to the moves made by the other. Our relation to conceptual art is quite different. We encounter it in a certain institutional context, and in the absence of its maker. The work is already finished. It is addressed, not to us personally, but to us *qua* spectator or audience. In consequence, it can only be responsive to expectations that we might reasonably be expected to have as occupants of those roles. Everything particular and unpredictable in our reactions will be irrelevant to the way the work is intended to strike us. Indeed, all this is reflected in the generality of the expectation I identified above as the one conceptual art begins by frustrating: the expectation that what is before us will prove satisfying to the senses *in some way*.

A consequence of this disanalogy between standard conversation and conceptual art is a tendency in the latter towards generality in the points it indirectly conveys. It is as if my interlocutor failed to say anything, though not in response to a specific question of mine, and the consequent expectation that she answer it; but in response to an expectation that she say *something*. Such silence might still indirectly convey some message, but the message it conveys will not be one specific to concerns of mine, or of any other particular interlocutor. Given this generality, there are few topics on which relevant points could be indirectly conveyed. Indeed, especially if we further depersonalize the situation, one might think that the range of possible topics contracts towards one. For the topic that will be the last to go is surely that of conversation itself. The points that could be conveyed in the most indeterminate such situations are ones about the very act of conversing. Analogously, given the impersonal nature of our relation to conceptual art, and the fact that it makes its points by frustrating, not meeting, our expectations with respect to sense experience; it should be no surprise that much conceptual art takes as its topic art itself. Its interest lies in the reflections it prompts on the nature of art, art institutions, and the practices of art-making, distributing and consuming. I think this tendency to reflexivity is characteristic of conceptual art. What I am suggesting is that it is a natural

consequence of that art exploiting the communicative mechanisms I have described.[12]

There is a second aspect of conceptual art which the analogy with conversation illuminates. This is the feature touted above as distinctively problematic about that art, viz. that it allows for a particularly flexible relation between base properties and artistic ones. The central mechanism by which conceptual art communicates is, I am suggesting, the frustration of expectation. One expects, but does not find, features that can be appreciated in the medium of sense experience. But it is a general truth about expectations that there are more ways to frustrate them than to meet them. Thus, in the case of conversation, if you ask me a question and I answer it, quite what I say will affect quite what you take my answer to be. In contrast, there are many ways in which I might fail to answer. I might change the subject; I might stay silent; I might say something on the matter too elusive to prove helpful; I might say that I refuse to answer; and so on. In so far as these are all ways of frustrating your expectation, and thus ways to trigger the chains of thought that conversational implicature exploits, they are, or at least often can be, on a par. Analogously, I suggest, there are many ways in which a given conceptual artwork can frustrate the expectation to satisfy the senses, and it matters little quite what the details of its nature are, provided that it does indeed so frustrate.

I am not claiming, of course, that everything about the nature of a conceptual artwork is irrelevant. It matters very much whether it is a deep hole filled with a brass rod, a piece of music with no notes to play, an impossibly large collection of photographs, or a collection of boxes filled with the artist's excrement. But the precise nature of the works fitting these descriptions is irrelevant, at least beyond a certain point. And it is so because any way of filling out those descriptions will be a way that frustrates the fundamental expectation identified. In so far as the nature of the works does matter, that is because interpreting conceptual art involves more than simply noting that the expectation of sensory satisfaction is not met. But whatever else does feed

[12] Of course, historically it might be that art took a reflexive turn before it took a turn to the conceptual. My claim is that conceptual art, in exploiting the communicative mechanism identified, naturally takes a reflexive subject matter. This tendency renders conceptual art suited to times in which art focuses on self-reflection. It is another matter whether such self-reflection leads to, or is itself instigated by, the discovery of conceptual art.

into that process, that frustration is its starting point. The need to frustrate expectation in this way imposes very slender requirements on the nature of conceptual art. And that is what liberates its artistic properties from the particularly close tie to other properties that holds for other kinds of artwork.

Third, and finally, the analogy allows us to confront the problem that conceptual art poses. The structure of that problem was revealed in our early discussion (section 4.1). If conceptual art lacks some feature that all other art has, or has some feature that all other art lacks, and if that feature was one we took to be definitive of art, then we seem forced either to deny that conceptual art is art; or to deny that the feature is definitive of art; or to reconstrue that feature so that conceptual and other art are after all alike in that respect. I argued that there is indeed a feature in which conceptual differs from all other art, and that it is a matter of the relation between artistic and other properties. Conceptual art is unique in that its artistic interest does not turn on the precise nature of its base properties. So the ingredients are in place for a problem with the structure described.[13] Which of the three solutions should I choose?

Rather than answer this question, I here intend to do no more than make it seem less pressing. In the light of the communicative mechanism I have described as underpinning our interpretation of conceptual art, we can place that art in relation to other, more traditional, work. Conceptual art is different from traditional art in terms of the relation of artistic to other properties. But I just explained that difference by appeal to another. Conceptual art is unique in setting up an expectation of sensory fulfilment that it goes on to frustrate. For literature sets up no such expectation, and everywhere else the expectation is met. This second difference between conceptual and traditional art is both striking and significant. But it reveals a certain kinship between the two. Conceptual art works by frustrating an expectation that traditional art either satisfies or does not raise. It is thus in an important sense parasitic on

[13] The problem might be formulated in the following inconsistent triad:

(A) There exist works of conceptual art, that is works the artistic properties of which are fully determined by a less than fully specific conception of their base properties.

(Again, this need not be taken as *defining* conceptual art.)

(B) Aesthetic properties are such that they can't be fully determined by a less than fully specific conception of the relevant base properties.

(C) Artistic properties, i.e. those which one appreciates in appreciating something as art, are necessarily aesthetic properties.

that art. Without art to raise that expectation, there could be no conceptual art to frustrate it. And just as traditional non-literary art communicates through meeting that expectation, conceptual art communicates through refusing to meet it. Thus, although conceptual works break with tradition in some radical ways, they do so precisely by exploiting features in other works that define them as traditional. To this extent, conceptual art represents a reconfiguring of the traditional art project—rather than a complete break with it. Does this prevent it from being art, or show that close dependence of artistic on base properties is not essential to art? Well, what turns on this question? Consider the analogy one last time. Communication through conversation, one might have thought, involves the use of a public language. Then one realizes that, against the background of such linguistic practices, communication can equally be effected through silence. Does this force us to redefine communication? It is not as if the feature we appealed to, public language, plays no role, not even in the cases that prove testing for the traditional view. Perhaps all we need do here is trace the relations, between speech, silence, and communication, and treat the definitional question as stipulative. And perhaps that is also the line to take with the problem of conceptual art.

References

GOODMAN, NELSON, *Languages of Art* (Oxford: Oxford University Press, 1968).

GRICE, PAUL, *Studies in the Ways of Words* (London: Harvard University Press, 1989).

HUGHES, ROBERT, *The Shock of the New* (London: British Broadcasting Corporation, 1980).

HOPKINS, ROBERT, 'Aesthetics, Experience and Discrimination', *Journal of Aesthetics and Art Criticism* 63/2 (2005): 119–33.

LEAVIS, F. R., *The Great Tradition* (London: Chatto & Windus, 1948).

SHELLEY, JAMES, 'The Problem of Non-Perceptual Art', *British Journal of Aesthetics* 43/4 (2003): 363–78.

Part II

Conceptual Art and Aesthetic Value

5

The Aesthetic Value of Ideas

Elisabeth Schellekens

In conceptual art the idea of the concept is the most important aspect of the work. When an artist uses a conceptual form of art, it means that all of the planning and decisions are made beforehand and the execution is a perfunctory affair . . . This kind of art is not theoretical or illustrative of theories; it is intuitive, it is involved with all types of mental processes . . . It is the objective of the artist who is concerned with conceptual art to make his work mentally interesting to the spectator, and therefore usually he would want it to become emotionally dry. There is no reason to suppose, however, that the conceptual artist is out to bore the viewer. It is only the expectation of an emotional kick, to which one conditioned to expressionist art is accustomed, that would deter the viewer from perceiving this art.

Sol LeWitt (1967)

5.1 Conceptual Art as Non-Aesthetic Art

One of the least controversial aspects of the highly provocative project that was early conceptual art was its wholesale rejection of the modernist paradigm.[1]

[1] For interesting discussions of how this contrast is best understood, see the contributions of Derek Matravers and Diarmuid Costello to this volume.

For artists adhering to the conceptual approach, modernism's loyalty to the notions of beauty, aesthetic sensation, and pleasing form, represented a commitment to obsolete artistic axioms.[2] Art, it was argued, should be purged of expressivist or emotivist aims; it was to '[free] itself of aesthetic parameters' and embrace an altogether different ontological platform. On this line, a conceptual artwork was taken to be 'a piece: and a piece need not be an aesthetic object, or even an object at all' (Binkley 1977: 265). In contrast to modernism, then, conceptual art set itself, from its very beginning, a distinctively analytic agenda by proposing to revise the kind of thing an artwork can be in order to qualify as such, and pronouncing aesthetics 'conceptually irrelevant to art' (Kosuth 1969). It is in view of this that conceptual art, to use the words of some of its most prominent exponents, can be understood as 'Modernism's nervous breakdown' (Art–Language 1997).

A philosophical examination of the challenge posed by conceptual art with regards to the notion of the aesthetic can be divided into two main instances. First, we may reflect upon what it is for art to be completely lacking in aesthetic ambitions. We might, for example, worry about the means by which art can be distinguished from non-art if an appeal to the aesthetic is no longer at our disposal. More specifically, one might ask whether the anti-aesthetic conceptual project actually succeeds, and whether it is philosophically sound. After all, are conceptual artworks really always non-aesthetic, and if not, how are we to account for those artworks?

These questions are given a context and focus by that aspect of conceptual art which leads it to alienate the aesthetic in the first place. The second instance of our inquiry thus introduces the element heralded as art's new objective, namely the representation of ideas and the bearing of cognitive value. For, in seeking to replace matters of the senses with those of the intellect, conceptual art is primarily an art of the mind. In conceptual artworks, the 'idea is King' (Wood 2002: 33)—the existence of an 'idea is necessary and sufficient for [the existence of] art' (Piper 1969)—and these ideas can be seen to fall into three main categories.

First and foremost, and underlying the other two kinds of idea, conceptual art can be a critique of the purpose of art and the role of the artist. Conceptual

[2] See Wood 2002: 26–7: 'For modernists . . . the aesthetic was the be-all and end-all of art, its unique and proper area of competence . . . [for conceptual art] the question of the aesthetic was strategically put in brackets: not so much a goal for critical art as an issue for it to address.'

art is self-reflexive; its main aim is to question what can count as art, what the function of an artist amounts to, and what role art must play in society. A conceptual work of art is thus 'a kind of *proposition* presented within the context of art as a comment on art' (Kosuth 1969). Second, conceptual art can offer a commentary on socio-political events or states of affairs. Third, conceptual art can set out to represent ideas traditionally tackled by philosophy.

5.2 Aesthetic Value and Cognitive Value

Whilst the attempt to determine the distinction between the aesthetic and the cognitive is far from a recent endeavour in strictly philosophical circles, few artistic movements have sought to distinguish these two notions as explicitly as conceptual art. However, its rejection of aesthetic value as a legitimate artistic goal, effected in order to elevate the role of the cognitive, rests on the assumption that a genuine emphasis on the latter somehow requires a rejection of the former. That is to say, the conceptual project takes it as a given that aesthetic value, if not mutually exclusive in principle with cognitive value, then at least seriously undermines or disrupts it. At the very best, it is presumed to be merely extraneous to cognitive value.

But must art be anti- or non-aesthetic if it is to have cognitive value? Clearly not; the history of art is full of cases where artworks have both aesthetic *and* cognitive value. A painting such as Edouard Manet's *The Execution of Emperor Maximilian* (1867) has cognitive value in virtue of yielding not only knowledge of an historical event but also understanding of the humiliation of such an execution for a head of state, *and* aesthetic value in virtue of the harmony of the composition and the intensity with which the scene is depicted. Again, a musical work such as Mozart's *Marriage of Figaro* (1778) has cognitive value because it yields insight into the instability of eighteenth-century social structures, and, in addition, it has considerable aesthetic value owing to the beauty of the arias and the balance of the piece as a whole. On the traditional model, then, an artwork can very well have both kinds of value. What is more, a work's aesthetic value may well strengthen and intensify its cognitive value, and vice versa. For example, the intensity with which the scene is rendered onto the canvas might enable us to add depth and reach to our grasp of Maximilian's disgrace; the intricacy of Susannah's position might facilitate our perception of the beauty of the arias sung. According to what I will hereafter

refer to as the 'traditional model of value', then, cognitive and aesthetic value can not only co-exist quite happily, but can also benefit from one another.[3]

Nevertheless, the question that we are primarily concerned with cannot be settled by such cases alone, since our aim is to establish whether the rejection of the aesthetic is indeed necessary to bolster the cognitive value of *conceptual* art, since such art sets out to denounce traditional artistic models. For this reason, our examination of the question as applied to the distinctively conceptual case will comprise two phases. First, we have to ask whether conceptual art actually succeeds in isolating itself from the aesthetic. Second, we ought to address whether it really needs to do so in order to pursue its aims. My conclusion will be negative on both counts. Although I do not hereby wish to suggest that an effective separation between the aesthetic and the cognitive could not be drawn in art, I shall hold that such a principled division is not realized in conceptual art. I shall argue that most conceptual art is not as non-aesthetic as it may seem to be, and, moreover, that the cognitive value of conceptual art does not actually stand to profit from its renunciation of aesthetic value.

5.3 Ideas and Aesthetic Value

The other aspect of conceptual art which, in conjunction with the weight placed on cognitive value, accounts for its anti-aesthetic character is its commitment to the view that art is prior to its materialization (Lippard and Chandler 1968). Not only is the representation of ideas taken to be central to art-making, but it is also held that these ideas are themselves the proper 'material' of conceptual pieces. To use Sol LeWitt's words, it is 'the process of conception and realization with which the artist is concerned' (1967), since '[i]deas alone can be works of art' (1969).

Puzzling though this claim may seem at a first glance, the point is relatively straightforward: the artistic status—the 'arthood', so to speak—of the piece lies in the ideas it sets out to represent rather than in any object or event that might be involved in that representation.[4] Interestingly, then, the thought is

[3] For another discussion of the kind of cognitive value that can be had by conceptual art, see Peter Goldie's contribution to this collection.

[4] For an interesting development of this idea, see David Davies's contribution to this volume.

not merely that traditional artistic media such as painting and sculpture, say, are to be superseded by alternative (and often more technological) ones such as film, photography, or 'happenings'. Rather, the claim is that the artwork actually is the idea; 'the "art idea" and art are the same' (Kosuth 1969).

Once grasped, the view that the idea is the material of art, and thereby the artwork itself, may be considered both liberating and unsettling. For with the recommended transfer of our artistic awareness from an art *object* to an art *idea* comes the loss of any crucial aspect of art appreciation that is tangible or immediately perceivable; and if there is no such focal point for our artistic experience, then there seems to be no potential bearer of aesthetic value either. That is to say, if there is no 'focus of appreciation'[5] in the form of a thing or event that can properly be referred to as the artwork as such, then there seems to be no thing or event to which any possible aesthetic value can be ascribed.

Whilst this does not *per se* exclude the possibility that some thing or event that may come about as a result of the (now purely intellectual) art-making process can yield some aesthetic value, it does follow that that value will necessarily be trivial: since the artwork is not, strictly speaking, the thing or event we may be able to perceive, touch, and position ourselves in relation to in space, any aesthetic value that such a thing or event may have is of no significance to the art as such. And this explains how some conceptual artworks, despite their stated anti-aesthetic goal, nonetheless can seem to afford some aesthetic satisfaction. However, whatever aesthetic pleasure they may yield, it will only pertain to the perceivable thing or event that is contingent to the artwork itself, and thus, will not really be ascribable to the art as such.

This feature of conceptual art complicates our task considerably. For if we are to show that conceptual art does not manage to exclude the aesthetic completely, and if conceptual artworks can have some kind of significant aesthetic value, there is only one element that can be the bearer of such value, and that is the idea at the heart of the artwork. So, the question we have to turn to in order to establish the extent to which conceptual art really is anti-aesthetic, if indeed at all, is this: can the ideas constitutive of conceptual artworks have aesthetic value?

[5] For a very helpful discussion of this question and of the notion of a 'focus of appreciation' in artistic experience, see Davies 2004. In brief, Davies holds that the focus of appreciation is all too often assumed to be the 'end result' of the performative and creative artistic act rather than that act itself.

In the remainder of this paper I shall develop an affirmative answer to that question. My aim is to show that there is room within the conceptual framework for aesthetic value in a way that does not annul such art's twofold commitment to (1) art's cognitive value and (2) art's dematerialization. In a nutshell, I shall argue not only that conceptual art need not be anti-aesthetic, but also that it may have aesthetic value that is crucial to the appreciation of its cognitive value. Moreover, I will try to show that the media by which ideas are represented in conceptual art are considerably more important to its artistic value than tends to be conceded. In order to distinguish the traditionally conceived art object (for example, sculpture or painting) from the manifested representation of ideas that conceptual art offers, I will hereafter use the terminology coined by David Davies and refer to the latter as the artwork's 'vehicular medium'.[6] The advantage of this expression is that it allows for less conventional (and perhaps narrowly conceived) artistic representative means. Let us then take a closer look at the three kinds of ideas that conceptual art concerns itself with and the means chosen to represent them in order to get a better grasp of the suggestion that ideas can have aesthetic value.

5.4 Three Kinds of Ideas in Conceptual Art

As mentioned above, the three main kinds of ideas conceptual art seeks to represent include (*a*) art-reflexive ideas, (*b*) socio-political ideas, and (*c*) philosophical ideas.[7] Whilst the very fact that art is considered capable of conveying a socio-political or philosophical message relies on conceptual art's revisionary approach to art and its critical role, I will discuss cases that primarily represent (*b*) and (*c*) in some isolation from (*a*). In addition, and at the risk of imposing an at least at times relatively artificial division, I will consider conceptual artworks that can be described as purely self-reflexive, that is to

[6] Davies 2004: 59: 'We may adopt the term "vehicular medium" as a generalization of a physical medium that accommodates for such [conceptual] works. The product of an artist's manipulation of a vehicular medium will then be the *vehicle* whereby a particular artistic statement is articulated . . . The vehicle may, as in the case of Picasso's *Guernica*, be a physical object, or, as in the case of Coleridge's *Kubla Kahn*, a linguistic structure-type, or, as arguably in the case of Duchamp's *Fountain*, an action of a particular kind.'

[7] Or ideas with philosophical content.

say, as solely concerned with questioning the nature of art, art-making, and art appreciation. I will begin by describing particular artworks, examples of the cases I have in mind, and then proceed to a discussion of whether aesthetic value can in some significant sense properly be ascribed to them.

(a) Art-Reflexive Ideas: Two Pieces

Amongst the earliest conceptual artworks is Mel Bochner's *Working Drawings and other Visible Things on Paper not Necessarily Meant to be Viewed as Art* (1966). This piece was created as a result of Bochner being asked to organize an exhibition of drawings at the New York School of Visual Arts gallery. Bochner duly proceeded to ask some of his friends (including Dan Flavin and Sol LeWitt) to lend him some of their drawings, as he intended to frame these drawings and exhibit them as 'art'. However, on being presented with this collection of drawings, the Director of the School's gallery refused Bochner the funding necessary to frame them. When Bochner subsequently asked permission to photograph the drawings and exhibit those photographs instead, authorization was not granted either. Bochner therefore decided to photocopy the one hundred drawings four times, insert them into four identical notebooks, and display them on four identical sculpture plinths (Godfrey 1998: 115–16).[8] In a rather Duchampian spirit, Bochner thus sought to represent the thought that art need not be something unique, something that can only be reproduced at the price of losing its status as art. Rather, art's manifestation allows for multiplication.

Robert Barry's *Inert Gas Series* (1969) may be seen to push the conceptual challenge even further by stepping outside an artistic context altogether. Instead of working in the enclosed space of a gallery or museum, Barry simply set about releasing small amounts of gases into the atmosphere. One such piece, *Inert Gas: Helium,* involves two cubic feet of helium being released in a Californian desert. An added narrative explains: '[s]ometime during the morning of March 4, 1969, 2 cubic feet of helium was returned to the atmosphere' (Wood 2002: 36). (For documentation of a very similar piece, see Illustration 7.) According to Barry himself, '[i]nert gas is a material that is imperceptible—it does not combine with any other element . . . It continues to expand forever in the atmosphere, constantly changing, and it does all of this without anybody being able to see it' (Osborne 2002: 82; Meyer 1972: 38–9).

[8] This exhibition is sometimes cited as the first exhibition of conceptual art.

What Barry produced, then, was an artwork that exists but cannot be seen. Art, in other words, does not require a perceivable object or event—art as process can be present yet thoroughly imperceptible.

(b) Socio-Political Ideas: Two Pieces

In 1970, the Art Workers Coalition exhibited *Q. And babies? A. And babies*. This piece involved a photograph of about twenty bodies piled up on a road in Vietnam with the title written over the photograph in red. Its origins lay in an interview with a discharged soldier broadcast by CBS in November 1969. The soldier was asked how one brings oneself to shoot babies. He replied 'I don't know . . . It's just one of those things.' The event referred to had occurred the previous year in My Lai, a small village in Southern Vietnam, when, despite not being attacked or fired at by the inhabitants, American soldiers had been sent in to 'neutralize' the village. Hundreds of people were executed and the village pillaged and burned. A few days before the interview was broadcast on CBS some photographs of the massacre had appeared in a newspaper, and it was one of these photographs, depicting several dead women and babies that the Art Workers Coalition enlarged and onto which they superimposed the text 'Q. And babies? A. And babies'. Clearly, the intention was for the piece to carry a very specific political message, namely that the United States's Vietnam policy was indefensible and that gross injustices were being carried out in the name of democracy.

In a somewhat similar vein, the Brazilian artist Clido Meireles's *Insertions into Ideological Circuits* (1969) set out to denounce the expanding consumerism of the United States. Singling out Coca-Cola as a symbol of what the artist saw as a form of economic imperialism, Meireles silk-screened provocative messages onto the empty bottles in the same style as the content and brand information usually printed on them. He then returned the bottles to the factory, where they were filled with the dark-brown drink again, thus making the text legible. Now, inflammatory texts such as 'Yankees Go Home' stood out for everyone to see. By removing everyday objects from their distributive chains, and adding seditious messages before returning them, Meireles obviously sought to convey a specific anti-capitalist message with the help of a new kind of readymade.

(c) Philosophical Ideas: Two Pieces

Michael Craig-Martin's piece *An Oak Tree* (1973) exhibits a glass shelf attached onto a white wall with a transparent glass of still water placed on it. (See

Illustration 2.) In addition to a label with the work's title positioned in proximity to the shelf, there is also a sheet of paper with questions and answers. It reads:

Q: To begin with, could you describe this work?
A: Yes, of course. What I've done is change a glass of water into a full-grown oak tree without altering the accidents of the glass of water.
Q: The accidents?
A: Yes. The colour, feel, weight, size.
Q: Haven't you simply called this glass of water an oak tree?
A: Absolutely not. It is not a glass of water anymore. I have changed its actual substance. It would no longer be accurate to call it a glass of water. One could call it anything one wished but that would not alter the fact that it is an oak tree.
Q: Do you consider that changing the glass of water into an oak tree constitutes an artwork?
A: Yes. (Godfrey 1998: 248)

This act of calling something by a completely different name (one, moreover, which bears no apparent relation to that thing) is intended as a theological reference. More specifically, the idea central to Craig-Martin's piece is the philosophico-theological notion of transubstantiation, that is to say, the changing of one substance such as bread or wine into another, namely Christ's body and blood.

Finally, one of the most famous works of conceptual art is Joseph Kosuth's *One and Three Chairs* (1965–7). Visible is a wooden chair placed against a gallery wall, a photograph of that chair (to scale), and a framed and enlarged dictionary definition of the term 'chair'. (See Illustration 5.) What we are presented with, then, are three manifestations of a chair: the concept of a chair, an actual 'instantiated' chair, and a depiction of the instantiated chair. Kosuth explicitly alludes to Plato's theory of forms. The idea at the heart of the piece is thus the following metaphysical question: 'Which is the "real" chair?'—'What is mere appearance and what is reality?'

5.5 The Cognitive Value of Conceptual Art

Artistic Value as Cognitive Value

Cognitive value of the kind conveyed by self-critical, socio-political, and philosophical ideas is the *raison d'être* of most conceptual art. In fact, of all

the kinds of value that art in general seems capable of affording (including historical, financial, and sentimental value), cognitive value is the only one that conceptual art directly aspires to possess. That is to say, for most conceptual artists, artistic value is only to be gained from the knowledge, insight, or understanding that artworks may generate. And, as previously explained, equating artistic value with cognitive value in this fashion is taken to vindicate not only conceptual art's disregard for aesthetic value, but also its claim that ideas are the true 'material' of art. For if art is to be dematerialized in the manner prescribed by conceptual artists, there is nothing concrete that may yield non-trivial aesthetic value.

However, if a conceptual artwork's artistic value is exhausted by its cognitive value in this way, what, if anything, is there to secure a significant distinction between art on the one hand, and the ordinary proposition or statement expressing that same idea in a non-artistic context on the other hand? Is it not the case, in other words, that my explanation of Bochner's, Meireles's, or Kosuth's idea covers everything that the artwork itself may convey about it? If the question is to be answered affirmatively, we gain an explanation of why the appreciation of conceptual artworks does not seem to call for first-hand experience in the manner of the appreciation of more traditional artworks. After all, many people wary of conceptual art cite precisely this reason in defence of their position, namely that nothing is to be gained from standing face to face with a conceptual artwork over and above what I can read about it in a newspaper article or a guide book. The reason why the appropriate artistic appreciation of a work such as *The Execution of Emperor Maximilian* requires a first-hand experience which *Inert Gas: Helium* does not seem to demand is that the former involves the perception and experience of an artwork's distinctively *aesthetic* features, qualities that are by nature perceptual (broadly conceived). After all, in the *aesthetic* case, we cannot merely base our judgements on someone else's perception or assessment—we need to see or hear aesthetic qualities for ourselves. Yet once these aesthetic qualities are circumvented, so too it seems is this experiential requirement in the appreciation of artworks.[9]

[9] For a version of what is now for many the standard line on the importance of first-hand experience in aesthetic appreciation, see Sibley 1965: 135–59 (repr. in Benson, Redfern and Cox 2001: 33–51). As Sibley writes, '[p]eople have to *see* the grace or unity of a work, *hear* the plaintiveness or frenzy in the music, *notice* the gaudiness of colour scheme, *feel* the power of a novel, its mood, or its uncertainty of tone. They may be struck by these qualities at once, or they may come to perceive them only after repeated viewings, hearings, or readings, and with the help of critics. But

So, perhaps this is where the conceptual project breaks down—by pinpointing cognitive value as the only source of artistic value, conceptual art seems to have rendered itself redundant, thereby strengthening the very view it set out to disprove, namely that art without aesthetic value cannot properly qualify as such.

Conceptual Art and Propositional Knowledge

As its title suggests, *Working Drawings and other Visible Things on Paper not Necessarily Meant to be Viewed as Art* is based on the idea that art need not be some unique and irreplaceable object. The knowledge conveyed by Bochner's piece is thus, in a nutshell, that an artist's creative intention can be imposed on an item (or set thereof) that is not merely mass-produced, but, further still, a duplicate of something mass-produced. This in order to show that the intellectual process, rather than the perceivable object, is the (conceptual) artwork strictly speaking.

Now, for the claim that art cannot convey anything more than the independent proposition 'Art need not be some inimitable and irreplaceable thing' to be true, what needs to be the case is that the piece cannot yield any other kind of understanding or insight than that which this proposition can communicate single-handedly. However, if we pause to think about this suggestion, it seems a rather inadequate account of the cognitive scope of pieces such as *Working Drawings and other Visible Things on Paper not Necessarily Meant to be Viewed as Art* or indeed *Inert Gas: Helium*. The cognitive value of such pieces does not seem limited to the kind of knowledge that can be translated into orderly propositions. What is so astute about Bochner's and Barry's pieces is that by choosing to represent the ideas in such a way as not only to make their point but also to instantiate it, so to speak, they manage to turn what in the form of a proposition seems to be a rather prosaic comment into something more experiential—not experiencing the act of releasing gas but experiencing the idea. This generates a different kind of understanding of the idea, one that might be portrayed as inviting increased sensitivity towards or engendering a more profound comprehension of the idea and its ramifications.

This difference is perhaps particularly evident in relation to pieces such as *Q. And babies? A. And babies* and *Insertions into Ideological Circuits*. For the

unless they do perceive them for themselves, aesthetic enjoyment, appreciation, and judgement are beyond them' (2001:34).

contextualized photograph of human corpses strewn over a small road in South-East Asia brings the idea of injustice to us in a way that a mere statement of the event cannot. The power of the artwork, its artistic value, cannot be reduced to the proposition 'Innocent people have suffered tremendously as victims of US foreign policy'. The image of the massacred women and children, together with the burning question and shocking answer painted over it enables us to appreciate the situation's true callousness and horror. And likewise with the slogans silk-screened onto the Coca-Cola bottles. The combination of short but concise messages about imperialism in its new guise has a force that is somehow dependent upon the fact that it is to be seen where we least expect it, namely on the very symbols of that imperialism. The boldness of metaphorically infiltrating the enemy camp, so to speak, puts across the socio-political idea in a particularly compelling and memorable way.

Lastly, a similar story can be told with regards to pieces representing philosophical ideas: what *An Oak Tree* and *One and Three Chairs* encourage us to do is not simply to rehearse the relevant metaphysical thoughts as we might find them in philosophical textbooks, namely '*that* there is such a thing as the metaphysical relation between appearance and reality', and '*that* it is unclear whether we can always distinguish between them'. Rather, in the context of conceptual art, the philosophical idea is brought home to us by means of the relative simplicity of the play between three manifestations of 'chairhood', or of a transparent glass of water on a completely see-through shelf. By turning art theory into art practice, conceptual artists dealing with philosophical notions and distinctions also turn the abstract into something concrete. They do so not in virtue of the perceivable thing or event that illustrates the idea, but by transforming the idea itself into something with a firm grounding in our ordinary lives (such as a glass of water on a bathroom shelf or a foldable chair). This, in turn, gives us an insight and understanding that may well help to unlock a thorough knowledge of the idea of transubstantiation and the metaphysical distinction between appearance and reality.

It seems unlikely, then, that the cognitive value of conceptual art is exhausted by propositional knowledge—conceptual art's commitment to semantic representation and the view that art is 'a kind of *proposition* presented within the context of art' (Kosuth 1969) carries no such implications.

Conceptual Art and Experiential Knowledge

Clearly, the claim that conceptual art's cognitive value cannot be exhausted by the statement of a work's principal idea does not, in and of itself, provide us with an argument for the view that conceptual art can have some aesthetic value. All it rules out is the claim that conceptual art is capable of yielding only propositional knowledge. However, the observations sketched above suggest that such art may be able to yield another kind of knowledge—one that is not propositional—by urging us to engage with self-critical, socio-political, or philosophical ideas in a different manner. How, then, are we to address the ideas raised by conceptual artworks in this seemingly more involved fashion?

It seems to me that what conceptual art encourages us to do is to enter into a very thought-provoking relationship with the piece; to engage in an emphatic and imaginative manner with the idea it sets out to convey. That is to say, we need to relate to that idea in a way that goes beyond entertaining it in the form of a proposition. Now, if the appreciation of conceptual artworks involves a significant degree of contemplation of the horror of political injustice, the problematics of discerning what is real and what is not, or the subtleness of art, this suggests that conceptual art's cognitive value is rather more *experiential* than propositional. In other words, conceptual art can convey understanding and awareness of being, say, the victim of neo-imperialist or belligerent forces or in the grip of metaphysical doubt in a particularly experiential way. The cognitive value of conceptual art—as with most other art, it must be said—lies in breathing life into the idea it seeks to represent by making us grasp the idea phenomenologically. It is this ability to yield experiential knowledge that saves conceptual art from being superfluous.[10]

Although a conceptual artwork cannot be reduced to the manifested representation of the idea in question—that is to say, that artwork's vehicular medium—it is this medium's task to *trigger* the imaginative exercise that can eventually lead to the experiential knowledge described above. In other words, it is the transparent gas and its release into the atmosphere or the three instantiations of a chair that is to *prompt* this more personally involved engagement with the idea.

[10] I have chosen the term 'experiential' here rather than the expression 'what it is like' in order to avoid committing myself to a view whereby the kind of knowledge I have in mind here is merely one of 'what it is like' from *one* specific perspective (say, that of the photographer in My Lai or of the visitor to the New York School of Art gallery in 1966).

However, and at the risk of casting a shadow of doubt on the conceptual project, once we grant that the vehicular medium can play this role in the artistic appreciation of conceptual artworks, it may become problematic to adhere to the view that the vehicular medium is of no importance whatsoever to the conceptual artwork *qua* art because even though the traditional structure of a medium representing an idea is not exactly reproduced here—it is, after all, still the idea that is the artwork and not the medium as such—the medium still needs to be well chosen if it is successfully to articulate the idea it seeks to represent. That is to say, it is in virtue of 'fitting' the idea in question and of being able to render it adequately, that an artwork may be deemed successful or not (at least in the sense of conveying ideas). So, it is precisely because helium is entirely invisible and the Californian desert is so vast and uninhabited that *Inert Gas: Helium* works as a piece centred on the idea of the invisibility and process-like nature of art. Similarly, it is precisely because we are presented with Coca-Cola bottles—the most paradigmatic example of American capitalism—that the message is brought home to us so effectively.

Interestingly, then, we have been led to ask whether the notion of a focus of appreciation in conceptual art really is as immaterial as all that: if the vehicular medium is important to the kind of engagement that can yield the cognitive value capable of rescuing conceptual art from reduction to mere propositions, then it seems that we may need to operate with a more inclusive interpretation of that notion. Perhaps, then, the focus of appreciation in conceptual art *does* need to be able to incorporate the vehicular medium after all. If so, conceptual artists need to provide us with an alternative explanation of the sense in which the conceptual artwork really is 'dematerialized', if indeed at all.

5.6 The Anti-Aesthetic Character of Conceptual Art Revisited

The cognitive value that the kind of imaginative engagement described above may yield sits very comfortably with the suggestion that ideas can have aesthetic qualities. For aesthetic qualities, as mentioned above, are properties that need to be experienced too, and as such, they can be part of the overall experience of the artwork that yields the form of knowledge and understanding that

we have been discussing. Experiencing an aesthetic quality might, moreover, be instrumental to the successful communication of cognitive value as such: perceiving the harmony or impenetrability, say, of an intellectual process can be the psychological key to seeing its suitability for the set purposes or its lack of explanatory power.

Looking to non-artistic contexts, the suggestion that an idea or intellectual process may have aesthetic qualities seems relatively uncontroversial. We speak of the elegance of a mathematical demonstration, the beauty of a chess move, and the ungainliness of a failed experiment. Similarly, we hear of the beautiful simplicity of a good explanation or solution, and the dynamism of a team effort. Again, we talk of the gracefulness of an argument and the balance or insipidness of a personality trait. There seems, then, to be no difficulty *per se* in the suggestion that ideas and intellectual processes can allow for aesthetic qualities.[11]

On the account I am proposing for conceptual art, a work may allow for some aesthetic value simply in virtue of the idea central to it. One may well, for example, be inclined to ascribe sublimity to the notion of transubstantiation in and of itself, so to speak. Yet a work may also be seen to have aesthetic value if its vehicular medium is well chosen in relation to the idea in question and therefore manages to represent that idea successfully. In such cases, it is at least partly in virtue of its successful articulation and communication that the idea or intellectual process can be seen to have aesthetic qualities. To be clear: if the idea is well represented through its vehicular medium, it is the artwork conceived as idea—not the medium—that can be said to have certain aesthetic qualities.[12] So, just as the medium can *trigger* the imaginative exercise that may yield experiential knowledge, it can also prompt us to perceive the work's aesthetic value. It is in this sense, then, that I think we should be wary of the conceptualist's claim that the focus of appreciation in conceptual art does exclude the vehicular medium completely and art has been entirely dematerialized.

If we allow for the possibility that the ideas central to conceptual art can be the bearers of aesthetic qualities, and that the appreciation of those qualities

[11] Clearly, when we speak of the beauty of a chess move or the harmony of a solution we do not have the actual physical move of the pawn or the practical application of the solution in mind.

[12] Similarly, if the vehicular medium is badly chosen in relation to the idea, the conceptual artwork may be described as, say, kitsch or ungainly.

may be conducive to the cognitive value distinctive of conceptual art, several aspects of the philosophical question we have been examining seem to fall into place. First, there is the issue of first-hand experience in the appreciation of conceptual art. For whilst the appropriate appreciation of a conceptual piece need not require first-hand experience of the vehicular medium's aesthetic qualities, some relatively intimate relation with the idea in question seems to be required if conceptual art is to convey experiential knowledge. Reformulating the initial experiential requirement so as to adapt it to this new context, then, we may get something like this: in the appreciation of conceptual art we need to have a 'personal first-hand experience' of the idea central to a piece. That is to say, we ought to 'undergo' the idea rather than merely think of it (as we tend to do when it is expressed by a mere proposition). To engage with an idea in this way will involve all the idea's experiential qualities, amongst which aesthetic ones are included. The experience of aesthetic qualities (be they positive such as 'elegant' or negative such as 'ungainly') will thus be part of the direct experience that can convey conceptual art's cognitive value. In this sense, then, a version of the experiential requirement still holds, albeit one that urges us to engage fully with the idea at the heart of the work of art.

The second advantage of allowing the ideas central to conceptual art to have aesthetic qualities is that it enables us to make sense of the non-trivial aesthetic experience some conceptual artworks actually do give rise to. If, for example, I find aesthetic pleasure in engaging with a conceptual piece, and my appreciation is not focused on the vehicular medium alone, I can explain the occurrence of that pleasurable experience by appealing to the aesthetic qualities of the idea. Such an aesthetic pleasure might not always be qualitatively similar to what I might experience upon admiring one of Turner's sunsets, for example. Instead, and by relying on, say, simplicity, wit, and balance, it might be rather more reminiscent of the pleasure we gain from hearing a good joke, or looking at a satirical cartoon.[13]

Finally, if we grant that the ideas represented in conceptual art can have aesthetic qualities, the dematerialization of art need no longer imply any incommensurable philosophical divide between conceptual art and other forms of art.

[13] Piero Manzoni's act of simply signing the arms of various people and then referring to it (i.e. the act) as art may be seen as an example of such conceptual works.

On my suggestion, then, the traditional model of value can extend to conceptual art even if we adhere to those tenets that seem to force it into anti-aestheticism. In other words, we can retain the emphasis on cognitive value and the dematerialization of the art object whilst allowing for the presence of aesthetic qualities and their role in the appropriate appreciation of conceptual art. The traditional model of value, that is, can apply to works by Kosuth, Barry and the Art Workers Coalition just as well as to Manet and Mozart: conceptual artworks can have both cognitive value and aesthetic value. Moreover, and as explained above, conceptual artworks are not so dissimilar to more traditional ones in that the success of the artwork *qua* art does, at least to some extent, depend upon whether the artist has chosen the appropriate medium with which to represent the idea in question.

5.7 Possible objections

If it is granted that conceptual art can have aesthetic value in the manner described above, two general difficulties may be seen to arise. First, one may ask what, if indeed anything, is to distinguish ideas in art from ideas in non-art? In other words, how are we to draw a line between the conceptual case and, to use an example already mentioned, the elegance of a mathematical demonstration? Second, one may wonder whether the qualities I have described as pertaining to ideas in conceptual art really are aesthetic in character. After all, could it not be held that these qualities are not actually distinctively aesthetic but, rather, merely some kind of sensory properties part and parcel of the cognitive experience conceptual art can afford? Let us deal with these two concerns in turn.

Ideas in Art and Ideas in Non-Art

Generally, there seem to be two main ways of approaching the relation between ideas in art and ideas in non-art. On the one hand, one can simply hold that there is no genuine need to spell out a principled distinction between the two; that there is no significant divide between ideas in art and ideas in non-art, and, moreover, that this is not a source of concern. This lack of clear demarcation between ideas in art and ideas in non-art actually matches the spirit of conceptual art perfectly: since every kind of thing or event can become (part of) a work of art and its process, there should be no dichotomy between

(potential) art and non-art. Rather than highlighting what may be seen as a weakness, this approach to the relation thus helps us to make sense of one of conceptual art's most fundamental tenets.

Having said that, one might want to approach the concern on its own terms, and uphold some form of dissimilarity between ideas in art and ideas in non-art. One could, then, concede that part of the driving force of conceptual art is indeed to blur the traditional distinction between art and non-art, whilst denying that the aesthetic qualities of ideas in conceptual art play exactly the same *role* as the elegance of a philosophical argument or the harmony of an explanation. On this line, then, the elegance of the idea at the heart of *An Oak Tree* and that of a good explanation differ in respect of what it is elegance can do in art and what it cannot do in science. In the former, our aesthetic experience of an idea's simple elegance is part of the distinctively artistic experience yielded by the conceptual artwork: 'getting' the idea behind the artwork goes hand in hand with perceiving its elegance. As we have already seen, one could say that the perception and appreciation of the aesthetic quality can itself be part of the cognitive experience conceptual art can yield. In the scientific case, however, the perception and appreciation of the aesthetic quality tends to operate rather more like an afterthought—the explanation's simple elegance is not that which helps us 'see' what the solution or explanation we are seeking consists of any more than it is the beauty of a winning chess move that enables us to perceive what the best move is, or the gracefulness of a valid philosophical argument that leads us to develop that argument in the first place. In non-artistic contexts, then, aesthetic qualities do not, at least on the whole, seem to participate in our understanding and appreciation of the idea in question in the same way as in conceptual art.[14]

The worry about differentiating ideas in an artistic context from ideas in a non-artistic context may, then, be answered in the following way: whereas there seem to be no good reasons to distinguish between kinds of ideas as such (i.e. artistic and non-artistic), it may be agreed that ideas can play different roles according to their context. So, unless one is inclined to defend the unlikely view that aesthetic qualities can only be ascribed to art—in which case, it should be noted, the account advocated here still stands—the concern seems settled by the more inclusive approach whereby there is a distinction to be

[14] This is not to say, of course, that simplicity or elegance, say, cannot be an ambition scientists bear in mind in their investigative pursuits.

upheld between ideas in art and ideas in non-art, albeit one concerned with the function rather than nature of those ideas.

Is this Really a Case of *Aesthetic* Qualities?

The second main concern one might have about the suggestion that ideas in conceptual art can have aesthetic qualities has to do with whether these qualities really can be called *aesthetic*. Perhaps, then, what has been discussed here is merely some sensory or phenomenal aspect of experiencing conceptual art rather than a distinctively aesthetic kind of quality? Clearly, the charge here is not that qualities such as elegance, simplicity, ungainliness, balance, beauty and gracefulness somehow lose their aesthetic character once they are ascribed to ideas in conceptual art. Rather, the claim must be that when we think we are perceiving the aesthetic qualities of ideas in such art, what we are experiencing is in actual fact something else.

One way of defending this view is to argue that aesthetic qualities simply cannot be ascribed to ideas, and so, that the theory is a non-starter. As I understand it, this claim can be interpreted in two main ways. First, one may simply hold that aesthetic qualities cannot be ascribed to ideas, be it in artistic contexts or not. However, and as should be clear from the above, I take this suggestion to be highly improbable since there doesn't seem to be any principled reason why aesthetic predicates should be excluded from any kind of area either in practice or as a matter of definition. Second, and related to the previous point, one may claim that aesthetic qualities cannot be predicated of ideas because such qualities can only be ascribed to artworks, where artworks are conceived of as art objects in the traditional sense. Yet if this were so, we would have to deny that landscapes, sunsets, items of clothing, or stained-glass windows could ever rightly be described as, say, graceful, ugly, stylish, or sublime, and this seems at best implausible and at worst simply misguided.[15]

Rather than attacking the theory that ideas in conceptual art can have aesthetic qualities merely by stating that aesthetic qualities cannot be ascribed to ideas, one might want to argue that the theory is guilty of confusing the experiential knowledge conveyed by ideas in conceptual art with the experience of aesthetic qualities. But again, this seems unlikely. After all, even in experience, the phenomenological aspect of grasping, for example, that art (rather like a transparent gas) can be imperceptible yet present, is quite

[15] The cases of music and dance might also present difficulties for such a view.

unlike perceiving and appreciating that idea's subtle elegance. Whilst the latter might well form a part of the former broadly conceived, the perception and appreciation of an aesthetic quality does not, by itself, constitute the kind of cognitive value that we have been examining in relation to conceptual art. Any discerning perceiver would soon grasp the difference between the two.

5.8 Conclusion

This paper has argued that conceptual art's twofold commitment to (1) the cognitive value of art and (2) art's dematerialization does not in actual fact call for the rejection of aesthetic value. Aesthetic value, it has been held, can be allowed for in conceptual art as long as the aesthetic qualities in question are ascribed to the *idea* at the heart of the conceptual artwork rather than the vehicular medium through which that idea is represented. Perhaps surprisingly, then, the traditional model of value still applies: conceptual artworks can have both cognitive and aesthetic value. Rather than somehow undermining or having a detrimental effect on the other, these two kinds of value can actually interact and benefit from one another in our appreciation of conceptual art. Moreover, and in the process of developing this argument about the traditional model of value, it has become clear that the vehicular medium used by conceptual artists in order to represent their ideas, their art, may play a more important role than tends to be conceded. That is to say, whilst conceptual art can still be defined as 'dematerialized', it may have to grant that the vehicular medium influences our appreciation and understanding of the conceptual artwork in a way that affects the value that work may have.

References

ART & LANGUAGE (MICHAEL BALDWIN, CHARLES HARRISON, MEL RAMSDEN) (1997), 'Memories of the Medicine Show', *Art-Language* New Series, 2 (June): 32.

BINKLEY, TIMOTHY (1997), 'Piece: Contra Aesthetics', *Journal of Aesthetics and Art Criticism*, 35: 265–77.

CORRIS, MICHAEL (ed.) (2004), *Conceptual Art: Theory, Myth, and Practice* (Cambridge: Cambridge University Press).

DAVIES, DAVID (2004), *Art as Performance* (Oxford: Blackwells).

GODFREY, TONY (1998), *Conceptual Art* (London: Phaidon Press).

KOSUTH, JOSEPH (1969), 'Art After Philosophy', *Studio International*, 178 (November–December): 915–17. Reprinted in id., *Art After Philosophy and After: Collected Writings, 1966–1990* (Cambridge, MA: MIT Press, 1991). Also reprinted in Alexander Alberro and Blake Stimson (eds.). *Conceptual Art: A Critical Anthology* (Cambridge, MA: MIT Press, 2000), 164–77.

LEWITT, SOL, (1967), 'Paragraphs on Conceptual Art', *Artforum*, 5/10: 79–83.

—— (1969), 'Sentences on Conceptual Art', *Art-Language : The Journal of Conceptual Art*, 1/1 (May): 11–13.

LIPPARD, LUCY and CHANDLER, JOHN (1968), 'The Dematerialization of Art', *Art International*, 12/2 (February): 31–6. Reprinted in Lucy R. Lippard, *Changing Essays in Art Criticism* (New York: Dutton Press, 1971), 255–76.

MEYER, URSULA (1972), *Conceptual Art* (New York: Dutton Press).

OSBORNE, PETER (ed.) (2002), *Conceptual Art: Themes and Movements* (London & New York: Phaidon Press).

PIPER, ADRIAN (1969), 'Idea, Form, Context', in id., *Out of Order, Out of Sight*, vol. 2 (Cambridge, MA: MIT Press), 5–12.

SCHELLEKENS, ELISABETH (2005), ' "Seeing is Believing" and "Believing is Seeing" ', *Acta Analytica*, 20/4 (October): 10–23.

SIBLEY, FRANK (1965), 'Aesthetic and Non-Aesthetic', *Philosophical Review* 74: 135–59. Repr. in John Benson, Betty Redfern, and Jeremy Roxbee Cox (eds.), *Frank Sibley: Approach to Aesthetics—Collected Papers* (Oxford: Clarendon Press, 2001), 33–51.

YOUNG, JAMES (2001), *Art and Knowledge* (London: Routledge).

WOOD, PAUL (2002), *Conceptual Art*, Movements in Modern Art (London: Tate Publishing).

6

Kant After LeWitt: Towards an Aesthetics of Conceptual Art*

Diarmuid Costello

6.1 Introduction

Conceptual Art is generally portrayed as a rejection of aesthetic theory as an adequate basis for understanding artistic value or significance. In what follows I want to see whether one can understand Conceptual Art, contrary to this orthodox art-historical and philosophical narrative, in aesthetic terms—but without fundamentally distorting the nature of the work.[1] Perhaps even more outlandishly, I want to examine whether Conceptual Art's aesthetic dimension can be understood by extrapolating from Kant's enigmatic account of what works of art do in the third *Critique*—namely, 'express aesthetic ideas'. Now, given that the third *Critique* is generally taken to underwrite the kind of theorizing about art that conceptual artists repudiated, largely in reaction to Clement Greenberg's use of it to prop up his practice as a formalist critic and theorist of modernism, this will entail departing from art-historical and

* I would like to acknowledge the support of a Leverhulme Trust Research Fellowship while working on this paper.
 [1] Hence I have no intention of adopting the kind of approach that takes ostensibly anti-aesthetic objects, such as readymades, and admires them for their previously overlooked formal qualities. To my mind, that is to misconstrue the nature of aesthetic value in art as surely (and for essentially the same reasons) as those who understand Conceptual Art in unreservedly anti-aesthetic terms.

philosophical orthodoxy, both about Conceptual Art, and about what the third *Critique* may have to offer art theory, even today.

As a consequence, this might be regarded (especially by artists, theorists, and historians) as a piece of flagrant historical revisionism. Against this, I will try to show that it can also be seen as a corrective to what is underplayed in both the standard accounts of Conceptual Art's anti-aestheticism, and of the third *Critique* as little more than a discredited basis for formalism in art theory. But to see this first requires retrieving the third *Critique* from Greenberg: this is because it was Greenberg's recourse to Kant that set the parameters against which Conceptual Art is routinely held up as a paradigm of the inadequacy of aesthetic theory to art after modernism, and in the light of which Kant has come to serve as the whipping boy for formalist aesthetics in the theory of art. Hence, I put the stress on the word 'towards' in my title: what I try to do here is no more than clear the ground for an aesthetic theory of Conceptual Art, by removing certain prima facie obstacles to bringing Kantian aesthetics to bear on Conceptual Art, rather than seeking to provide a fully articulated aesthetic theory of Conceptual Art per se. Though I will conclude by indicating how I think such a theory should proceed.

One final disclaimer: I do not try to define Conceptual Art in this paper. All I want to say on this front is that, in terms of the various attempts at definition articulated by key first-generation Conceptual artists, I take a broad view of it, both as a historical and as a descriptive term.[2] As will become apparent, my use of the term is closest to what Peter Osborne recently called Sol LeWitt's 'weak' or 'inclusive' Conceptualism.[3] By 'Conceptual Art,' then, I mean a kind of art that came to prominence in the latter half of the 1960s and in doing so initiated a tradition that, broadly speaking, foregrounds art's intellectual content, and the thought processes associated with that content, over its form. What I do not mean by the term is work that focuses narrowly on a putatively philosophical analysis of the *concept of art* (as typified by Joseph

[2] For an idea of the competing positions of early Conceptual artists see the statements, documents and polemics collected in Alberro and Stimson 2000. Alberro's introductory essay, 'Reconsidering Conceptual Art, 1966–1977', provides an elegant overview. See Alberro 2000.

[3] Osborne 1999 distinguishes between the 'expansive, empirically diverse and historically inclusive' taxonomy of Conceptual Art advocated by Sol LeWitt in his 'Paragraphs' and 'Sentences' (discussed in detail below) which he calls 'weak' or 'inclusive' Conceptualism, and the 'restricted, analytically focused, and explicitly philosophical definition' advocated, in competing ways, by Joseph Kosuth and the Art & Language group, which he calls 'strong' or 'exclusive' Conceptualism, for obvious reasons. See Osborne 1999: 48–9 and 52–6.

Kosuth's recourse to A. J. Ayer to underwrite an incoherent theory of art as analytic proposition).[4] I have a more generous idea of Conceptual Art as a classificatory term in mind, one that picks out a broad cultural shift away from its historical art world's prior formalist commitments. Of course, to those internal to the often fiercely partisan fine-grained debates about the nature of Conceptual Art, and its legacy, that will no doubt seem woefully unspecific, but my wager is that there is something to be gained from adopting this more aerial perspective.[5]

6.2 Greenberg's Kant

I therefore begin with the theoretical context against which many Conceptual artists polemicized in writings and interviews, and to which their work may be seen as a series of practical counter-demonstrations: Clement Greenberg's co-option of aesthetics, particularly Kant's theory of 'taste', for modernist theory. Greenberg's interpretation of Kant came to the fore during the same period as Conceptual Art became prominent. As such, Greenberg's explicit recourse to Kant in the late Sixties and early Seventies may be viewed, symptomatically, as an attempt to fortify modernist aesthetics in the face of Conceptual Art's challenge to taste as an adequate basis for understanding or appreciating art. In the teeth of this rejection of taste and aesthetic quality in art, Greenberg claimed:

when no aesthetic value judgement, no verdict of taste, is there, then art is not there either, then aesthetic experience of any kind is not there . . . it's as simple as that. [. . .] I don't mean that art shouldn't ever be discussed in terms other than those of value or quality. [. . .] What I plead for is a more abiding awareness of the substance of art as value and nothing but value, amid all the excavating of it for meanings that have nothing to do with art as art.[6]

[4] On this point see Osborne 1999: 56–62 and Sclafani 1975: 455–8. The latter is invoked by Thierry de Duve in his critique of Kosuth (de Duve 1996a: chs. IV and V, 244–50, 269–71, and 305–7 in particular). See Kosuth 1991 for the best collection of Kosuth's own writings.

[5] A flavour of such internecine debates can be gleaned from Corris 2000.

[6] Greenberg, Seminar VII, first delivered as one of nine such 'seminars' at Bennington College, Vermont, in April 1971. It was subsequently published in *Arts Magazine*, 52 10, June 1979. Both have since been collected in the posthumously published Greenberg 1999, a book that Greenberg had projected since the late 1970s, but failed to bring to fruition at the time of his death in 1994. See 'The Experience of Value', 62–3.

Unsurprisingly, in view of this identification of art with aesthetic experience, Greenberg characterized modernism in art as a heightened tendency towards aesthetic value, and the foregrounding of such value, in art:

Modernism defines itself in the long run not as a 'movement,' much less a programme, but rather as a kind of bias or tropism: towards aesthetic value, aesthetic value as such and as ultimate. The specificity of Modernism lies in its being so heightened a tropism in this regard.[7]

The Conceptual cornerstone of modernism, as Greenberg theorized it, was 'medium-specificity': the self-reflexive investigation of the constraints of a specific medium through the ongoing practice of the discipline in question. In this spirit, Greenberg conceived modernist painting as an investigation into the essence of painting that proceeded by testing what had hitherto been accepted as its 'essential norms and conventions' as to their 'indispensability' or otherwise, thereby gradually foregrounding what was genuinely 'unique and irreducible' to its medium (Greenberg 1960 [1993]: 86 and 89). Hence, when Greenberg identified *modernism* with the pursuit of aesthetic value in art, he was thereby identifying *medium-specificity* with the pursuit of such value, for the simple reason that cleaving to the specificity of their respective media is what made the modernist arts modernist.

Now, in so far as art theory has generally failed to interrogate the *legitimacy* of Greenberg's claim to a Kantian provenance for his aesthetic theory and practice as a critic, particularly his use of Kant to underwrite this equation of medium-specificity with value in art, it has been complicit in Greenberg's distortion of Kant's aesthetic. As a result, the widespread contemporary indifference to the idea of aesthetic quality as a significant artistic concern, for which Conceptual Art provided a strong initial impetus, still tends to be framed in opposition to the allegedly Kantian aesthetic Greenberg bequeathed to the art world. Here I concur with Charles Harrison's central claim in 'Conceptual Art and Critical Judgement,' namely, that one cannot understand Conceptual Art without first understanding its relation to modernism, more specifically, its relation to modernist *aesthetics* (Harrison 2000). Nonetheless, I shall contest the widespread art-world belief that Greenberg's aesthetic is a faithful reflection of its alleged philosophical sources. The point of this approach is to clear the ground for an aesthetics adequate to the challenge of Conceptual Art. To extrapolate such

[7] This remark also dates from 1971. See Greenberg 1971: 191–4 (this remark, 191).

an aesthetic from the third *Critique* is no doubt deeply counter-intuitive. Yet, for this very reason, if the third *Critique* can be shown to meet this challenge, it will have gone a long way to demonstrating its contemporary worth.

Greenberg appealed to Kant on several fronts, the most famous being his invocation of Kant as the 'first real modernist' in 'Modernist Painting' (Greenberg 1960: 85), because he used reason immanently to criticize reason, and thereby entrench it more firmly, if more narrowly, in its area of competence. But Greenberg's appeals to Kant are both more varied, and more fundamental, than this well-known remark suggests; I shall argue that *mis*readings of Kant underwrite both Greenberg's modernism, his recounting of the history of the best modern art as a gradual 'reduction' to the essence of each art, and his formalism, the understanding of aesthetic theory that underpinned his activity as a critic.[8]

Greenberg's formalism, his theoretical self-understanding of his activity as a critic in a Kantian mould, is beset by several difficulties. At the most general level, it suffers from his failure to distinguish between free and dependent beauty in the third *Critique*. Greenberg attempts to apply Kant's account of *pure* aesthetic judgement, a judgement about the aesthetic feeling aroused by 'free' (or conceptually unconstrained) beauty, to works of art—thereby ignoring, in a way that has since become the norm, Kant's more apposite remarks on fine art, genius, and aesthetic ideas, in favour of an account that takes natural beauty (and decorative motifs) as its paradigm.[9] It is above all Greenberg's recourse to Kant's *formalism* to underwrite a theory of *artistic* value that is responsible for the general rejection of Kantian aesthetics in subsequent art theory.[10] As a result, Greenberg misses two distinct kinds of

[8] I take this way of parsing Greenbergian theory—in terms of its 'modernism' and its 'formalism'—from Thierry de Duve's exemplary work on Greenberg. See de Duve 1996a: ch. IV 'The Monochrome and the Blank Canvas' and de Duve 1996b.

[9] The influence of this identification is such that it extends to both those opposed to the Kantian legacy in art theory and criticism *and* those who seek to retrieve it. For the former, see Danto 1997: chs. IV and V; for the latter see de Duve 1996a: ch. V. De Duve defends this identification in a forthcoming publication (de Duve 2007). It is also the subject of a debate between de Duve and Paul Crowther, forthcoming Crowther's *Progress and the Visual Arts: Why Art History Matters to Aesthetics*, in preparation. For a critique of this identification in both Danto and de Duve see Costello 2007 (forthcoming).

[10] This identification of judgements of artistic value with pure aesthetic judgement pervades Greenberg's work throughout the late Sixties and Seventies, from 'Complaints of an Art Critic' (1967) onward. It reaches fruition in the essays and seminars, originally dating from 1971, collected in *Homemade Esthetics*.

conceptual complexity that attach to works of art, even for Kant, that present difficulties for the rejection of Kant as an arch-formalist in art theory. That is, the constraint that the *concept* a work of art is meant to fulfil imposes on artistic beauty, and the complexity that conceiving works of art as expressions of aesthetic *ideas*, and hence as having an irreducible cognitive function, adds to Kant's conception of fine art (Kant 1790 [1987]: § 16 and § 49). Indeed, the fact that neither is considered in the rush to reject Kant's aesthetics shows the extent to which *Greenberg's* Kant continues to mediate the reception of the third *Critique* in art theory, even today.

Moreover, Greenberg tends to empiricize and psychologize Kant's theory of aesthetic judgement. Greenberg's erroneous belief that he could demonstrate the 'objectivity' of taste by appealing to the empirical record of past taste—when induction could not possibly provide the necessity he required to support his argument—is evidence of his empiricization of Kant, in this case, the judgement of taste's *claim* (but only claim) to validity over all judging subjects.[11] The fact, if it is a fact, that judgements about artistic worth have tended to converge over time, provides no guarantee that they will continue to do so in future. Should they not, the conceptual fallacy involved in appealing to the arguable fact that they have done so to date would be apparent. In effect, Greenberg mistook the 'fact' of a past consensus for a past consensus of fact.[12] Relatedly, Greenberg's psychologization of Kant is evidenced by his tendency to conflate the Kantian criterion of 'disinterest' as a necessary precondition on aesthetic judgement with his own, psychologistic, conception of 'aesthetic distance'.[13] As a result, Greenberg conflates a transcendental theory with a

[11] 'The solution to the question of the objectivity of taste stares you in the face, it's there in the record [. . .] In effect the objectivity of taste is probatively demonstrated in and through the presence of consensus *over time*. That consensus makes itself evident in judgements of aesthetic value that stand up under the ever-renewed test of experience.' See 'Can Taste be Objective?' (Greenberg 1973a: 23). This is the published version of 'Seminar III'. Both versions are collected in *Homemade Esthetics* (Greenberg 1999: 23–30 and 103–15).

[12] For a reading of this Seminar see de Duve 1996b: 107–10 ('Wavering Reflections').

[13] This conflation of 'disinterestedness', for Kant a necessary condition for judgement to count as aesthetic, with aesthetic distance, a mental act or state of mind, is often explicit: 'Kant pointed [. . .] to aesthetic *distance* when he said that the "judgement of taste [. . .] is indifferent as regards the being of an object"; also when he said "Taste is the faculty of judging of an object, or a method of representing it, by an entirely *disinterested* satisfaction or dissatisfaction".' See 'Observations on Esthetic Distance', in Greenberg 1999: 74 (my italics). Greenberg attributes his own psychologistic conception of aesthetic distance to Edward Bullough's account in 'Psychical Distance' (1912), reprinted in Neill and Ridley 1995: 297–311.

psychological description of a particular state of mind. This deprives his own theory of what is in many ways most persuasive about it, its attention to the specificity of its artistic object. For if aesthetic experience really were as voluntaristic as this implies, a matter of merely *adopting* a distancing frame of mind towards an object, the nature of that object itself would fall away as a significant determinant on aesthetic judgement. Or, at the very least, its role in determining such judgement would be significantly underplayed; for one can adopt such an attitude towards anything—at least in principle.[14]

Greenberg's modernism is similarly compromised, in this case by dogmatic epistemological and ontological assumptions about the individual senses and their relation to individual arts. As early as 'Towards a Newer Laocoon' (1940), his second major paper on modernism, Greenberg seeks to align specific arts, under the influence of music, with specific senses in a way that continues to underpin his theorization of modernism throughout his career.[15] But in order to do so he is forced to conceive the intuition of works of art in terms of *discrete* sensory tracks. Like his psychologizing of Kant, this is essentially a product of Greenberg's deep-seated empiricism as a critic. As a result, he conflates judgements of taste, properly so-called, with what Kant would have concurred were aesthetic judgements, albeit of sense rather than reflection.[16] That is, judgements grounded, like judgements of taste, in feeling, albeit, unlike judgements of taste, in feeling occasioned

[14] To his credit, Greenberg meets this consequence head-on: 'the notion of art, put to the test of experience, proves to depend in the showdown [. . .] on an act of distancing. Art, coinciding with aesthetic experience in general, means simply a twist of attitude towards your own awareness and its object.' See 'Seminar One' (Greenberg 1973b: 44). De Duve attributes this conclusion to Greenberg's tussle with Duchamp's readymades in 'Wavering Reflections', (de Duve 1996b: 89−119).

[15] 'The advantage of music lay chiefly in the fact that it was an "abstract" art, an art of "pure" form. It was such because it was incapable, objectively, of communicating anything else than a sensation, and because this sensation could not be conceived in any other terms than those of the sense through which it entered consciousness. [. . .] Only by accepting the example of music and defining each of the other arts solely in terms of the sense or faculty which perceived its effect and by excluding from each art whatever is intelligible in the terms of any other sense or faculty would the non-musical arts attain the "purity" and self-sufficiency which they desire.' Greenberg 1940: 31−2.

[16] 'Agreeable is what the senses like in sensation'; 'A liking for the beautiful must depend on the reflection, regarding an object [. . .] This dependence on reflection also distinguishes the liking for the beautiful from [that for] the agreeable, which rests entirely on sensation'; 'Insofar as we present an object as agreeable, we present it solely in relation to sense' (Kant, *Critique of Judgement*, 1790 [1987]: § 3, p. 47, Ak. 206; § 4, p. 49, Ak. 207; § 4, p. 49, Ak. 208 respectively). Hereafter *CJ*.

by objects impacting causally on the sense organs (what one might call 'sensation'), rather than in reflection on an object or perceptual configuration's 'subjective purposiveness' for cognition in general (that is, its suitability for engaging our cognitive faculties in an optimally enlivening way).[17] As such, Greenberg's key idea of medium-specificity is based on an attempt to align an essentially empiricist notion of cognitively uninflected 'sensation', that owes more to Hume than to Kant, with specific artistic mediums, as if the sensory impression made by a work of art were a simple correlate of the intrinsic properties of its medium, from which it could therefore be directly read off.[18]

If Greenberg's desire to align specific arts with specific senses explains *why* he sought to differentiate the arts in terms of media, the question it provokes is analogous to that provoked by his view of the senses. Namely: *can* the arts be so easily parsed in this way? The fact that they could, as it so happens, be separated at the height of Greenberg's authority as a critic, clearly does not entail that this is a *necessary* feature of art's, or even good art's, identity. This was demonstrated by minimalism, an art form Greenberg's theory could not accommodate simply because it refused to accept that the arts were discrete (see de Duve 1996a: ch. IV, de Duve 1983: 249). Had Greenberg not hitched his idea of aesthetic quality so irredeemably to the separateness of the arts in the first place he could have avoided this impasse. Moreover, had Greenberg's supposed Kantianism stretched as far as the 'Transcendental Aesthetic' of the first *Critique* he would not have sought to parse the arts in terms of either

[17] '[P]leasure in aesthetic judgement [. . .] is merely contemplative [. . .] The very consciousness of a merely formal purposiveness in the play of the subject's cognitive powers, accompanying a presentation by which an object is given, is that pleasure. For this consciousness in an aesthetic judgement contains a basis for determining the subject's activity regarding the quickening of his cognitive powers, and hence an inner causality (which is purposive) concerning cognition in general, which however is not restricted to a determinate cognition. Hence it contains a mere form of the subjective purposiveness of a presentation' Kant, *CJ*, § 12, p. 68, Ak. 222.

[18] Thus Hume comments on the famous anecdote about the key sunk in the barrel of wine: 'The great resemblance between mental and bodily taste will easily teach us to apply this story [. . .] Where the organs are so fine, as to allow nothing to escape them; and at the same time so exact as to perceive every ingredient in the composition: This we call delicacy of taste, whether we employ these terms in the literal or metaphorical sense' (Hume, 'Of the Standard of Taste', [1757], reprinted in Neill and Ridley 1995: 260). As a result, Hume recognizes no distinction between what Kant will subsequently distinguish as aesthetic judgements of taste and of the agreeable (not because he confuses intersubjective validity with mere personal preference, but because he grants no distinction, akin to Kant's, between reflection and sensation). See *n.* 16 above.

medium or sense. For on Kant's account of space and time as *a priori* 'forms of intuition', our perception of works of art, like perception in general, would have to be grounded in an underlying *unity* of sensibility.[19] While it may make sense to talk about the contribution made by an individual sense to our intuition of works of art in the anomalous event that a given sense is defective, it is both alien to Kant's epistemology, and phenomenologically unpersuasive, to construe normal instances of intuition as mere *aggregates* of the senses—the more so when it comes to such culturally and historically complex entities as works of art.

The point of these objections to Greenberg is to show that rejecting Kantian aesthetics on the basis of Greenberg's appeal to it is an ill-founded rejection.[20] And herein lies the irony of art-world hostility to Greenberg since late 1960s: despite that antipathy, the majority of artists and art theorists continue to operate with an essentially *Greenbergian* conception of aesthetic theory. What Greenberg once valued is now roundly devalued, but what has *not* changed is the understanding of aesthetics underpinning his critics' position. As a result art theory has rejected Kant's aesthetics as a viable discourse about art after modernism on the basis of a distortion. So far this result is entirely negative: if the argument is sound it shows only that art theory goes astray to the extent that it takes Kant at Greenberg's word; it does not preclude the possibility that the art world may have been right to reject Kant nonetheless, if for the wrong reasons. That is, it does not show that Kant's aesthetics *can* accommodate ostensibly anti-aesthetic art. To show that it can (and that what passes for anti-aesthetic is such only when viewed through the optic of a formalist aesthetics) I now want to consider what Kant himself had to say about works of art as expressions of 'aesthetic ideas,' and whether this can be applied to Conceptual Art.

[19] For Kant, space is the form of all outer sensibility, hence a condition of perceiving anything at all in the external world, while time, as the form of inner sensibility is a condition of perceiving anything whatsoever. 'Time is the formal *a priori* condition of all appearances whatsoever. Space, as the pure form of all *outer* intuition, is so far limited; it serves as the *a priori* condition only of outer appearances. But since all representations, whether they have for their objects outer things or not, belong, in themselves, as determinations of the mind, to our inner state; and since this inner state stands under the formal condition of inner intuition, and so belongs to time, time is an *a priori* condition of all appearance whatsoever.' See Kant, *Critique of Pure Reason*, 1781 [1929]: A34/B50.

[20] I deal much more fully with all these issues and problems in Greenberg, and the way in which they overdetermine subsequent attitudes towards aesthetics in art theory, which I have only summarized here, in Parts I-II of my forthcoming monograph, *Aesthetics after Modernism*.

6.3 Kant on Works of Art as the 'Expression of Aesthetic Ideas'

For Kant, works of art are expressions of 'aesthetic ideas.' Kant introduces such ideas with the explanation: 'by an aesthetic idea I mean a presentation of the imagination which prompts much thought, but to which no determinate thought whatsoever, i.e., no [determinate] concept, can be adequate, so that no language can express it completely and allow us to grasp it.'[21] As such, aesthetic ideas have both a technical and an architectonic significance for Kant. As I intend to abstract largely from their significance for Kant's critical project in what follows, I shall begin by outlining his own conception, in order to make clear where I am departing from it.

To put it in the most straightforward terms, an aesthetic idea is Kant's take on what is distinctive about both the content of works of art, and the way in which works of art present that content. What is distinctive about the *content* of works of art is either that they present concepts that may be encountered in experience, but with a completeness that experience itself never affords or, more radically, that they communicate ideas that cannot, in principle, be 'exhibited'—that is, presented by imagination to intuition—in experience.[22] Think, for example, of the difference between the *idea* of freedom, the object of which cannot be presented in intuition, and everyday *concepts*, the objects of which can. What is distinctive about the way in which works of art *present* such content is that they 'expand' the ideas presented, by virtue of the indirect means through which they embody them in sensible form.

This is because, rather than seeking to present the idea itself (which would be impossible, ideas being by definition what cannot be exhibited in experience for Kant), an aesthetic idea presents the 'aesthetic attributes' of its object, thereby expressing an idea's 'implications' and 'kinship with other concepts'.[23] In effect, aesthetic ideas present indirectly what cannot be presented directly.

[21] *CJ*, §49, p. 182, Ak. 314.

[22] Kant claims, for example, that the poet 'ventures to give these [ideas such as death, envy, love and fame that *are* exemplified in experience] sensible expression in a way that goes beyond the limits of experience, namely, with a completeness for which no example can be found in nature' and, more radically, that aesthetic ideas are properly so-called because 'they do at least strive toward something that lies beyond the bounds of experience, and hence try to approach an exhibition of rational concepts . . .'. See *CJ*, § 49, pp. 182–3, Ak. 314.

[23] *CJ*, § 49, p. 183, Ak 315.

To take Kant's own example, 'Jupiter's eagle with the lightning in its claws' expands the idea of God's majesty by presenting it aesthetically.[24] What Kant calls the 'logical' attributes of an object, in this case God, would be those in virtue of which it fulfils a concept, in this case majesty. Jupiter's eagle with the lightning in its claws, by contrast, is a *metaphorical* expression of those same attributes, through which we are encouraged to envisage God's majesty in the light of the thoughts provoked by Jupiter's eagle, thereby opening up a rich seam of further associations. In this way, works of art present ideas in sensible form that would otherwise remain unavailable to intuition, by using their 'aesthetic' attributes in ways that provoke 'more thought' than a direct conceptual elaboration of the idea itself would facilitate, thereby 'expanding' the idea in the process.[25]

In one respect, then, aesthetic ideas might be said to achieve the impossible: they allow works of art to present rational ideas which exceed the bounds of sense in determinate sensuous form. Consider Delacroix's *Liberty Leading the People to Victory* (1830) as a sensuous embodiment of the idea of freedom. The aesthetic attributes through which freedom is personified in the guise of 'Liberty', and shown leading her people to victory (fearlessness, spontaneity, resoluteness, leadership, all attributes of an active self-determining will) while holding a flag, symbol of freedom from oppression, aloft in one hand and clutching a musket in the other, serve to 'aesthetically expand' the idea of freedom itself. By presenting freedom metaphorically in the guise of 'Liberty' in this way, freedom is depicted concretely as something worth fighting for, indeed, as something requiring courage and fortitude to attain. Through the expression of ideas in this way, Kant claims, works of art 'quicken the mind' in a way that is purposive for cognition itself. This quickening inheres largely in the freedom of the imagination from mechanically schematizing concepts of the understanding. Rather than being constrained to present one or more concepts of the understanding in sensible form, aesthetic ideas stimulate the imagination to range freely and widely over an 'immense realm of kindred presentations'. As such, works of art stimulate the mind, albeit in a less

[24] *CJ* § 49, p. 183, Ak. 315.

[25] '[A]esthetic attributes [. . .] prompt the imagination to spread over a multitude of kindred presentations that arouse more thought than can be expressed in a concept determined by words. These aesthetic attributes yield an *aesthetic idea* [. . .] its proper function is to quicken [*beleben*] the mind by opening up for it a view into an immense realm of kindred presentations.' *CJ*, § 49, pp. 183–4, Ak. 315.

structured way than determinate thought, by encouraging us to think about such ideas in a new light.[26]

This gives rise to what Kant calls a 'feeling of life' in the work's recipient, a feeling of the enhancement, or furtherance, of the subject's cognitive powers. Works of art do this, not by giving rise to determinate thought, but to a *feeling* of mental vitality that mirrors the cognitive state to which Kant attributes the production of aesthetic ideas.[27] Hence the common claim that Kant's theory of art is a form of expressionism. Accordingly, 'genius' (the productive faculty responsible for fine art) is defined as the ability to 'discover [aesthetic] ideas for a given concept' and 'hit upon a way of expressing these ideas that enables us to communicate to others [. . .] the mental attunement [. . .] those ideas produce.'[28] Genius, in other words, is the ability to 'communicate' the free play of the faculties (the cognitive state responsible for the production of aesthetic ideas in the first place) and thereby occasion a similarly enlivening cognitive play in the work's recipient. The little Kant says concretely about what this free play of imagination and understanding occasioned by aesthetic ideas might amount to empirically, suggests a kind of free-wheeling, associative play in which the imagination moves freely and swiftly from one partial presentation of a concept to another. Thus Kant claims that aesthetic ideas encourage the imagination to 'spread over a multitude of kindred presentations that arouse more thought than can be expressed in a concept' and thereby 'quicken the mind by opening up for it a view into an immense realm of kindred presentations.'[29]

What I want to emphasize, and retain, from Kant's account of works of art as expressions of aesthetic ideas is his stress on the *imaginative engagement with ideas* that works of art induce in the spectator, far removed from the

[26] Hence, Kant claims that the aesthetic attributes that yield the aesthetic idea 'give the imagination a momentum which makes it think more in response to these objects, though in an undeveloped way, than can be comprehended within one concept and hence in one determinate linguistic expression'. *CJ*, § 49, p. 184, Ak. 315.

[27] In *CJ*, § 1 Kant distinguishes aesthetic from cognitive judgements by characterizing the former as those in which a given presentation is attended to exclusively for the feeling of pleasure or displeasure it occasions in the subject: 'the presentation is referred only to the subject, namely, to his feeling of life, under the name feeling of pleasure or displeasure, and this forms the basis of a very special power of discriminating and judging. This power does not contribute anything to cognition, but merely compares the given presentation in the subject with the entire presentational power, of which the mind becomes conscious when it feels its own state' (*CJ*, § 1, p.44, Ak. 204).

[28] *CJ*, § 49, pp. 185–6, Ak. 317. [29] *CJ*, § 49, pp. 183–4, Ak. 315.

astringent formalism generally attributed to the third *Critique* as a reception aesthetic. Given that this is all I want to take from Kant's account, it might reasonably be asked why I bother going through Kant, and the reception of his aesthetics in art theory, to arrive at something so minimal. By doing so, I have sought to clear enough ground to demonstrate that there is no *prima facie* obstacle to the application of Kant's theory of art to the kind of art generally perceived as anti-aesthetic on the formalist interpretation of his aesthetics that holds sway in the art world. To show that the way in which much Conceptual Art engages the mind—*despite* its strategy of deliberate formal self-impoverishment—may still credibly be called 'aesthetic' in Kant's terms, I now want to analyse Sol LeWitt's 'weak' or 'inclusive' account of Conceptual Art in some detail.

6.4 The Aesthetics of Conceptual Art: LeWitt after Kant

Though it would be misleading to categorize LeWitt narrowly as a 'pure' (as opposed to 'proto-') Conceptual artist himself, LeWitt is nonetheless widely regarded as having been hugely influential for both the production and the reception of Conceptual Art through the publication of his 'Paragraphs' and 'Sentences' on Conceptual Art in Summer 1967 and January 1969. Though these texts are generally remembered today for programmatic claims such as the 'idea is the machine that makes the art' or 'ideas alone can be works of art', they are also striking when reviewed in the light of the foregoing account of Kant's theory of art as the expression of aesthetic ideas. Consider the following empirical generalizations LeWitt makes about the new art in 1967:

- This kind of art is not theoretical or illustrative of theories; it is intuitive, it is involved with all types of mental processes and it is purposeless.
- Conceptual Art is not necessarily logical [. . .] Ideas are discovered by intuition.
- Conceptual Art does not really have much to do with mathematics, philosophy, or any other mental discipline.
- Conceptual Art is made to engage the mind of the viewer rather than his eye or emotions.
- Conceptual Art is only good when the idea is good.[30]

[30] I have taken these remarks out of the order in which they appear in the text.

What I want to draw attention to in such early formulations is the rejection of the analogy with philosophy or logic and of the narrow definitional project (so pronounced, in Osborne's terminology, in the work of 'strong' or 'exclusive' Conceptual artists such as Kosuth and Art & Language), and the related stress on 'intuition' in the creation of art. Intuition, as LeWitt employs the term here, can only mean something like 'grounded in feeling'. An idea reached 'by intuition', then, is one reached, neither through ratiocination, nor through following a logic, but by an artist 'feeling' or 'sensing'—that is, *intuiting*—his or her way. A 'good idea', in this context, is presumably one that just *feels right* as art, for which no rule may be given in advance, but for which ideas that have worked well in past art may serve as exemplars. On this account, a 'good work of Conceptual Art' would be one in which a good idea is reached in an intuitive (and to that extent 'irrational') way, through feeling. This set of concerns is even more pronounced in the 'Sentences on Conceptual Art,' from a year and a half later:

- Conceptual artists are mystics rather than rationalists. They leap to conclusions that logic cannot reach.
- Rational judgements repeat rational judgements. Illogical judgements lead to new experience.
- Ideas do not necessarily proceed in logical order.
- Once the idea of the piece is established in the artist's mind and the final form is decided, the process is carried out blindly.
- The process is mechanical and should not be tampered with. It should run its course.
- The artist's will is secondary to the process he initiates from idea to completion. His willfulness may only be ego.[31]

At least two important considerations emerge from these and similar remarks. First, that what distinguishes art from philosophy is precisely that it does *not* proceed rationally or according to logic. As 'mystics rather than rationalists', for LeWitt, the source of an artist's ideas is opaque and cannot be rationally reconstructed. Moreover, for LeWitt, the true Conceptual artist endeavours to efface him or herself as much as possible in the service of their ideas. Hence ideas should be allowed to 'run their course' once the idea for a work has been conceived, the work being merely executed in accordance with it. Tampering

[31] Again, the remarks do not appear here in LeWitt's own order.

with an idea by amending it, for example in the light of the way its execution looks, always compromises the integrity of the work and may be merely an expression of the artist's wilfulness or 'egotism'.[32] By interfering with their idea, the artist only 'gets in the way', so to speak, of their own work. As a result, the work risks coming off as laboured or wilful. To put the same point in Kant's idiosyncratic terminology in the third *Critique*, it ceases to 'look like' nature; that is, not so much to *resemble* nature, as to appear *similarly free* of any hint of laboriousness that might impede its free appreciation.[33]

Hence, one suggestive way of reading these remarks is as a critique, *avant la lettre*, of the belief, bordering on solipsism, that a self-reflexive stress on the artist's declarative intentions (typical of 'strong' Conceptual practices such as Kosuth's or Art & Language's) could suffice to determine what is actually achieved in a work of art (what might be called, after Robert Rauschenberg's infamous telegram, the 'This is a portrait of Iris Clert if I say so' syndrome).[34] That bit of art-world enthusiasm is no more true (and no less ridiculous)—*if* taken as a statement of fact—than my claiming that this paper is an elephant;

[32] That this is a hard trap to avoid is attested to by the following anecdote about LeWitt himself conveyed to me by several people who were present. In 1971 LeWitt was invited to participate in the forward-looking lithography workshop at NSCAD (Nova Scotia College of Art & Design). He sent through the instructions for a suite of ten lithographs in advance, as was his practice, and students were employed to execute the work accordingly. When he arrived to view the results he balked at signing two, because the students responsible had found clever ways to interpret the instructions that totally undercut LeWitt's expectations about how the finished works would look. One in particular had been done in such a way that rather than the random series of lines LeWitt expected, the results looked like an early work by Frank Stella. To his credit, however, LeWitt accepted that the results did represent a legitimate interpretation of the instructions and signed them accordingly. See Kennedy 1994: 24–5.

[33] 'Nature, we say, is beautiful [*schön*] if it also looks like art; and art can be called fine [*schön*] art only if we are conscious that it is art while yet it looks to us like nature.' Contrary to the assumption that Kant is here committing himself to the claim that art must literally *resemble* nature, his real meaning, that art must appear as free or unwilled as nature is clear: 'In [dealing with] a product of fine art we must become conscious that it is art rather than nature, and yet the purposiveness in its form must seem as free from all constraint of chosen rules as if it were a product of mere nature.' And further: 'Even though the purposiveness in a product of fine art is intentional, it must still not seem intentional: i.e., fine art must have the *look* of nature even though we are conscious of it as art [. . .] the academic form must not show; there must be no hint that the rule was hovering before the artist's eyes and putting fetters on his mental powers.' *CJ*, 45, pp. 173–4, Ak. 306–7.

[34] This was the text of the infamous 'nominalist' *Portrait of Iris Clert* that Rauschenberg sent to the French dealer in 1961, consisting of a postcard bearing these words.

the conditions for x being correctly described as a portrait or an elephant (or, for that matter, an oak tree) not being open to wilful dictat—*even* if one is an artist. Here I am essentially in agreement with Alexander Alberro, that what most differentiates LeWitt's position from Kosuth's is the former's stress on eliminating the subjectivity of the artist (Alberro 2000: xx). As LeWitt puts it: 'To work with a plan that is pre-set is one way of avoiding subjectivity [...] This eliminates the arbitrary, capricious, and the subjective as much as possible. This is the reason for using this method (1967 [Alberro and Stimson 2000: 13]).' But this hardly commits LeWitt, as Alberro would have it, to a 'mode of production [...] that does not require intuition, creativity or rational thought (Alberro 2000: xx).' LeWitt's own stress on intuition, amply documented in the 'Paragraphs' and 'Sentences' cited above, flatly contradicts this, and it is at the level of intuition, in LeWitt's sense of the term (namely, that of *conceiving* the idea for the work) that the aesthetic and what, I take it, Alberro must mean by the 'creative' dimension of the work resides. Indeed, even the claim that LeWitt's work lacks rational thought is potentially misleading; it is 'irrational' only in conception, though anything but in execution.

Moreover, this suggests a way of overcoming what would otherwise be an embarrassing difficulty for the analogy with Kant's theory of art that I am proposing. Namely, how can *mechanically* executing a work in accordance with a pre-set plan not constrain the freedom of the artist's and the viewer's imagination so essential to Kant's aesthetics in both its productive and its receptive dimensions? My suggestion is that aesthetic feeling, as it is being theorized here, operates at the level of the *intuition* (or conception) of the idea on the part of the artist, and of its subsequent *appreciation* on the part of the viewer, and *not* at the level of its execution or realization. Like Kant's theory of art, LeWitt's is essentially a species of expressionism, indeed, in LeWitt's case, a fairly bald form of expressionism: 'A work of art may be understood as a conductor from the artist's mind to the viewers (1969 [Alberro and Stimson 2000: 107]).' On LeWitt's expressionism—which I am not endorsing—the aesthetic dimension of art is pushed back to the conception and reception of the idea alone. 'In terms of idea,' LeWitt writes, 'the artist is free to even surprise himself. Ideas are discovered by intuition (1967 [Alberro and Stimson 2000: 13]).' As I interpret him, this makes 'intuition' LeWitt's term for what Kant means by 'Spirit' in his account of genius, namely: 'the ability to apprehend the imagination's rapidly passing play and unite it in a

concept |the aesthetic idea| that can be communicated without the constraint of rules'.[35]

If this is correct, it provides a solution to a second potential problem for my analogy between LeWitt's theory of art and Kant's. The idea of 'genius', so out of favour today, is widely understood as signifying something that marks the genius out from other mortals, that is, as a mark of subjective distinction that is out of the ordinary. An argument can be made, however, that in at least one respect this is antithetical to Kant's own use of the term. Seemingly in line with standard usage, Kant characterizes genius as an 'innate productive ability', 'talent', or 'natural endowment' responsible for the creation of works of art.[36] The problem is this: how is one to *reconcile* Kant's stress on an innate, and therefore presumably subjective, talent responsible for fine art, with LeWitt's broadside against the subjectivity or wilfulness of the artist getting in the way of their own work? Kant defines genius, in a typically transparent manner, as follows:

Genius is the talent (natural endowment) that gives the rule to art. Since talent is an innate productive ability of the artist and as such belongs itself to nature, we could also put it this way: *Genius* is the innate mental predisposition (*ingenium*) *through which* nature gives the rule to art.[37]

What is this 'innate mental predisposition *through which* nature gives the rule to art'? Kant argues that, like any other intentional activity, the production of fine art must, of necessity, proceed according to some conception (or 'rule') of what the artist is trying to achieve. That is, the artist must have some end in mind that guides his or her actions. But this creates a problem since, in order to please *freely* in aesthetic judgement, the resulting work's 'beauty' (that is, its propensity to engage the mind in an aesthetically enlivening way) cannot be based on any rule against which its success or failure could be measured. For if it could, this would render aesthetic judgement 'determinative' rather than 'reflective', that is, a case of *subsuming* a particular (in this case a work of art) under a rule (the artist's conception of what they were trying to achieve) in order to determine how well the former instantiated the latter, and thereby gauging the success of the resulting work. As should be clear, this could no longer be an aesthetic judgement in Kant's sense, because it would have a concept as its determining ground. Indeed, it would be a largely mechanical

[35] *CJ*, § 49 p.186, Ak. 317. [36] *CJ*, § 46 p.174, Ak. 307. [37] *CJ*, § 46 p. 174, Ak. 307.

process of holding an instance up to a concept to gauge the extent to which the former instantiated the latter. Kant is aware of the problem and even proposes a solution: 'Since [. . .] a product can never be called art unless it is preceded by a rule, it must be *nature in the subject* (and through the attunement of his powers) that gives the rule to art.'[38]

In other words, genius names an artist's ability to grasp what makes aesthetic feeling universal (on Kant's account, the free play of those cognitive faculties with which we are universally endowed *qua* human), and make it manifest by embodying it in a determinate sensible form. For LeWitt this ability resides in the process of 'intuition' through which ideas for works of art are conceived; for Kant it resides in the ability to 'apprehend the imagination's rapidly passing play' and embody it in an aesthetic idea. If this is correct, LeWitt's stress on preventing the subjectivity or wilfulness of the artist from coming between their idea and its realization in the work, and hence between the work and its receiver, is compatible with Kant's theory of genius as the productive ability responsible for fine art. For it must be by deferring to something like 'nature in the subject', that is, the free play of the subject's cognitive powers, to which LeWitt as much as Kant attributes a work's inception in 'intuition'. Moreover, like Kant's account of artistic production through genius, LeWitt's account is intended to preserve the *freedom* of the viewer's imaginative engagement with the work from any strictures that might be laid down in advance by its author. Once again, this distinguishes LeWitt's Conceptualism from Kosuth's.[39]

6.5 Conclusion: Towards an Aesthetics of Conceptual Art

Though what I have said thus far should serve to dispel some of the initial implausibility of viewing Conceptual Art through the optic of Kant's theory of art, there are clearly limits to this project—not least the divergent roles of, and significance attached to, the notion of *form* in Conceptual Art and Kant's

[38] *CJ*, § 46 p. 175, Ak. 307; my italics.

[39] Thus Kosuth's famous programmatic declaration: 'A work of art is a tautology in that it is a presentation of the artist's intention, that is, he is saying that a particular work of art is art, which means, is a *definition* of art. Thus, that it is art is true *a priori*. . .' (Kosuth 1969).

theory.[40] The problem becomes acute when one recalls that, for Kant at least, it was largely the way in which a work indirectly presents an idea, by bringing together its aesthetic attributes in a unified form, that is the focus of aesthetic judgements of art. But while Kant's stress on the sensible form of the work *is* a limit on the analogy I have drawn between Kant's and LeWitt's theories of art, this should neither disguise, nor detract from, the broader point: namely, the extent to which writing on Conceptual Art routinely understates the way in which such art *expands ideas in imaginatively complex ways*, ways that may be understood according to the spirit, if not the letter, of Kant's text.

Thus I want to conclude by briefly indicating some examples that might be used to make good this claim. One might point to LeWitt's own work, which plays with the notion of systematicity, often reducing it to absurdity by taking it to extremes.[41] Or one might point to works such as Dan Graham's *Homes for America* which consists of a monotonous piece of prose about suburban tract housing accompanied by deadpan images presented, unannounced as art, in an art magazine.[42] Or one might consider Art & Language's *Index 01*

[40] The debates concerning Kant's formalism are far too complex to go into here. But it is worth remarking, in the light of the received wisdom about Kant's formalism in art theory, that the notion of form in Kant is far more complex than Greenberg's claims to a Kantian provenance for his *empirical* formalism as an art critic might lead one to expect. There are Kantian aestheticians, such as Paul Crowther, who rely on Kant's theory of perception in the first *Critique,* along with the remarks about form and design in §§ 13–14 of the third *Critique*, to argue that Kant is committed to a substantive, and hence restrictive, formalism—such that when we reflect aesthetically we engage contemplatively with spatio-temporal complexity in a perceptual manifold. Nonetheless, the extent to which Kant may be used to underwrite formalism in art theory remains far from clear. Kant's own conception of fine art clearly cuts against Greenberg's supposedly Kantian claim that aesthetic judgement is predicated solely on form. Moreover, it seems increasingly that the consensus among Kant scholars is shifting away from this view. Thus it is notable that Guyer and Allison concur that Kant slides from invoking the formal notion of a 'form of purposiveness' to invoking the substantive notion of a 'purposiveness of form' in the third Moment in a manner that is neither supported by, nor necessary to, the internal argument of the third *Critique* itself. See Guyer 1997: ch. VII, especially 199–210 and Allison 2001: ch. VI, especially 131–43. For Crowther's view of the relation between aesthetic judgement and perception see, for example, Crowther 1996. It remains unclear how Crowther intends to reconcile this account with his own interest in developing Kant's theory of aesthetic ideas, without turning pure and dependent aesthetic judgement into two entirely distinct forms of judgement, thereby overplaying the distinction.

[41] For an exemplary account of this aspect of LeWitt's reduction of seriality to absurdity see Krauss 1986.

[42] *Arts Magazine*, December 1966. See Dan Graham's 'My Works for Magazine Pages: A History of Conceptual Art' (reprinted in Alberro and Stimson 2000: 418–22).

(see Illustration 6), 1972 (a.k.a. *Documenta Index*), a vast and complexly cross-referenced index of the group's writings on art and the relations between them. Or Lawrence Weiner's *A 36″ × 36″ Removal to the Lathing or Support Wall or Plaster or Wall-Board from a Wall*, the nature of which is self-explanatory. Or Adrian Piper's early *Catalysis* series (see Illustration 9), in which Piper documents herself doing something, such as travelling on a bus smelling foul, or with a towel stuffed in her mouth, that instantly makes her an outcast within a public space.

In each instance, these works' physical embodiment is crucial to their effect. Without their use of a *particular* sensible form, the experience of these works would trigger no more thoughts or imaginative associations than their bare descriptions, as Kant's account suggests. Contrary to the critical orthodoxy that ideas stand or fall in Conceptual Art without reference to their execution, our response to these works is significantly shaped by *how* they embody their meaning. The 'same' idea in a *different* form might have an altogether different meaning, and give rise to an altogether different experience as a result. Hence, one should be wary of taking the rhetoric of Conceptual Art at face value; in this respect it is not so different from art in general.[43]

Assuming one grants that the particular forms, or means of presentation, of these works are crucial, a question would remain as to whether they constitute indirect presentations of ideas that cannot be directly presented, as Kant's account would seem to require, and, if so, of what ideas. LeWitt's work plays with the ideas of seriality or systematicity, Graham's with standardization and homogeneity in mass production, Art & Language's with the Borgesian idea (which can only ever exist as an idea) of the exhaustive catalogue, Weiner's with making visible the background conditions and support structures of art, and Piper's with the ideas of social exclusion and marginalization. None of these ideas is *directly* or *exhaustively* instantiated in experience in the way that the objects of everyday concepts are, and the success of these works turns on the range of associations and thoughts triggered by their material embodiment. Clearly, there are limits to this argument. These works cannot be conceived, straightforwardly, as metaphors; nor is it clear whether they may be said to 'symbolize morality' in Kant's sense. Nonetheless, they may still be called

[43] The widespread belief that Conceptual Art *does* mark some kind of categorically shift from prior art, or art in general, is to a large extent a result of the art world's unfortunate tendency to take works of art at their producers' word, when artists are about as interested, and hence potentially as *unreliable*, guides to their own artistic achievements as one could hope to find.

aesthetic, in Kant's terms, by virtue of triggering a wealth of imaginative associations through the indirect presentation of an idea in sensible form.

But what about the many works, for which Conceptual Art is perhaps best known, that have no such form, unless one is going to stretch the meaning of form to include the minimal visible properties of a line of text? Here, the analogy with Kant does begin to unravel, though it is worth noting one feature of such works to which their absence of form contributes. While clearly not aesthetic ideas in Kant's sense, their lack of form enables them to fulfil, in a pronounced way, Kant's claim that aesthetic ideas 'emulate the example of reason in striving for a maximum', that is, for a completeness that experience does not afford. Consider the infinite regress opened up by Robert Barry's *All the things I know but of which I am not at the moment thinking — 1.36 P.M.; 15 June 1969, New York* or Lawrence Weiner's equally illusive *The Arctic Circle Shattered*. In concert with seemingly more banal works, such as Weiner's *One Quart Exterior Green Industrial Enamel thrown on a Brick Wall*, such works have the advantage, by virtue of their linguistic form, of *not* restricting the viewer's imagination through a single determinate empirical realization. Nonetheless, one might also say that this is where Conceptual Art reaches its vanishing point (both literally and metaphorically). Or, perhaps, that the exhaustive projects that constitute a substantial genre of Conceptual Art, and which *are* sensibly realized, do this more successfully. Think, for example, of the Bechers' lifelong project of documenting 'Typologies' of disappearing industrial forms, On Kawara's lifelong project of painting the date or his more 'occasional' pieces such as *One Million Years*, or Douglas Huebler's project photographically to document everyone alive, *Variable Piece 70*. In each case such works (or projects) seem to strain, quite literally, against the finitude of human experience.

I will conclude here. While I hope to have shown that the broad outlines of Kant's theory of art are not prima facie inapplicable to Conceptual Art, given the constraints imposed on Kant's theory of art in virtue of his wider critical project, it may be more productive to move from his own schematic account of artistic expression to a more substantial, and psychologically informative expression theory of art, if one wants to do justice to Conceptual Art. Though the emphasis on idea *at the expense of* form in both LeWitt's writings and in the criticism of Conceptual Art more generally, might suggest some version of the 'ideal' or 'mental entity' variant of expressionism as the most obvious way to go, I would resist this move, above and beyond the well-known objections to such theories, for the simple reason that even the most pared-down and

banal work of Conceptual Art makes a *liminal* aesthetic use of its form. The fixation on lists, diagrams, and maps, and the cheap 'xerox aesthetic' to which many early commentators on Conceptual Art drew attention is just that, *an aesthetic*—if not an especially gratifying one, sensuously.[44] Moreover, many of the artists most associated with such an aesthetic in their early work, moved on to carefully crafted, elaborately staged, text installations when this became financially viable.

That Conceptual Art is nonetheless widely assumed to be anti-aesthetic shows how ingrained two assumptions remain in the theory and philosophy of art: how traditional a conception of form many commentators approach such art with, as if Conceptual Art were to be measured in terms of the very art forms it set out to contest (and thereby found wanting), despite having transformed our expectations concerning what *counts as* artistic form; and, more importantly, how quickly the aesthetic dimension of visual art is equated with an affective response to its visual properties *in isolation from* the ideas such properties or qualities convey. What Conceptual Art demonstrates, against such assumptions, on my account, is neither the limit of aesthetic theory *per se*, nor the limit of Kantian aesthetics, but the limit of *formalist* aesthetics, as mediated by Greenberg, in coming to terms with the cognitive dimension of works of art.

References

ALBERRO, ALEXANDER (2000), 'Reconsidering Conceptual Art, 1966–1977', in Alexander Alberro and Blake Stimson (eds.), *Conceptual Art: A Critical Anthology* (Cambridge, MA: MIT Press), xvi–xxxvii.

ALBERRO, ALEXANDER and STIMSON, BLAKE (eds.) (2000), *Conceptual Art: A Critical Anthology* (Cambridge, MA: MIT Press).

ALLISON, HENRY (2001), *Kant's Theory of Taste* (Cambridge: Cambridge University Press).

BUCHLOH, BENJAMIN H. D. (1989/1990), 'From the Aesthetic of Administration to Institutional Critique', *L'Art conceptuel, une perspective*, exhibition catalogue (Paris: Musée d'Art Moderne de la Ville de Paris). Repr. 1990 in *October* 55: 105–43.

[44] For a striking retrospective account of this aspect of Conceptual Art as capitulating to an administered world by aping its repressive effects through an aesthetics of administration, see Buchloh 1989/1990.

BULLOUGH, EDWARD (1912), 'Psychical Distance', in Alex Neill and Aaron Ridley (eds.) (1995), *The Philosophy of Art: Readings Ancient and Modern* (New York: McGraw Hill), 297–311.

CORRIS, MICHAEL (2000), 'Inside a New York Art Gang: Selected Documents of Art & Language, New York', in Alexander Alberro and Blake Stimson (eds.), *Conceptual Art: A Critical Anthology* (Cambridge, MA: MIT Press), 470–85.

COSTELLO, DIARMUID (2007), 'Retrieving Kant's Aesthetics for Art Theory After Greenberg: Some Remarks on Arthur C. Danto and Thierry de Duve', in Francis Halsall, Julia Jansen, and Tony O'Connor (eds.), *Rediscovering Aesthetics* (New York: Columbia University Press), forthcoming.

CROWTHER, PAUL (1996), 'The Significance of Kant's Pure Aesthetic Judgement', *British Journal of Aesthetics* 36/2 (April): 109–20.

DANTO, ARTHUR C. (1997), *After the End of Art: Contemporary Art and the Pale of History* (New Jersey: Princeton University Press).

DUVE, THIERRY DE (1996a), *Kant after Duchamp* (Cambridge, MA: MIT Press).

—— (1996b), *Clement Greenberg Between the Lines* (Paris: Dis Voir).

—— (1983), 'Performance Here and Now: Minimal Art, A Plea for a New Genre of Theatre', *Open Letter* 5–6 (Summer-Fall): 249.

—— (2007), 'Do Artists Speak on Behalf of All of Us?', in Diarmuid Costello and Dominic Willsdon (eds.), *After Beauty: The Ethical Life of Images* (London: Tate Publishing), forthcoming.

GRAHAM, DAN (2000), 'My Works for Magazine Pages: A History of Conceptual Art', in Alexander Alberro and Blake Stimson (eds.), *Conceptual Art: A Critical Anthology* (Cambridge, MA: MIT Press), 418–22.

GREENBERG, CLEMENT (1940), 'Towards a Newer Laocoon', in id., (1986), *The Collected Essays and Criticism, vol. I, Perceptions and Judgments (1939–1944)*, ed. John O'Brian (Chicago: University of Chicago Press), 23–38.

—— (1960), 'Modernist Painting', in id. (1993), *Clement Greenberg: The Collected Essays and Criticism*, vol. IV, ed. John O'Brian (Chicago: University of Chicago Press).

—— (1967), 'Complaints of an Art Critic', in id., (1993), *The Collected Essays and Criticism, vol. IV, Modernism with a Vengeance (1957–1969)*, ed. John O'Brian (Chicago: University of Chicago Press), 265–72.

—— (1971), 'The Necessity of Formalism', *New Literary History* 3/1 (Autumn): 191–4.

—— (1973a), 'Can Taste be Objective?' *Art News* 72/2 (February): 22–3 and 92. Repr. with its unpublished version 'Seminar Three' in Greenberg (1999), 23–30 and 103–15.

—— (1973b), 'Seminar One', *Arts Magazine* 42/2 (November): 44–6. Repr. in Greenberg (1999), 3–9.

—— (1999), *Homemade Esthetics: Observations on Art and Taste* (Oxford: Oxford University Press).

GUYER, PAUL (1997), *Kant and the Claim of Taste*, 2nd edn. (Cambridge: Cambridge University Press).

HARRISON, CHARLES (2000), 'Conceptual Art and Critical Judgement', in Alexander Alberro and Blake Stimson (eds.), *Conceptual Art: A Critical Anthology* (Cambridge, MA: MIT Press), 538–45.

HUME, DAVID (1757), 'Of the Standard of Taste', in Alex Neill and Aaron Ridley (eds.) (1995), *The Philosophy of Art: Readings Ancient and Modern* (New York: McGraw Hill), 254–68.

KANT, IMMANUEL (1781), *Critique of Pure Reason*, trans. Norman Kemp-Smith (1929) (London: Macmillan).

—— (1790), *Critique of Judgement* (*CJ*), trans. Werner S. Pluhar (1987) (Indianapolis: Hackett Publishing Company).

KENNEDY, GARRY NEILL (1994), 'NSCAD and the Sixties', in *Conceptual Art: The NSCAD Connection: 1967–1973*, exhibition catalogue, November (Halifax: Anna Leonowens Gallery, NSCAD).

KOSUTH, JOSEPH (1969), 'Art after Philosophy', Part I, *Studio International* 178 (October): 915. Repr. in Alexander Alberro and Blake Stimson (eds.) (2000), *Conceptual Art: A Critical Anthology* (Cambridge, MA: MIT Press), 165.

—— (1991), *Art after Philosophy and After: Collected Writings 1966–1990*, ed. Gabriele Guercio (Cambridge, MA: MIT Press).

KRAUSS, ROSALIND (1986), 'LeWitt in Progress', in id., *The Originality of the Avante-Garde and Other Modernist Myths* (Cambridge, MA: MIT Press), 244–58.

LEWITT, SOL (1967), 'Paragraphs on Conceptual Art', *Artforum* 5/10 (Summer): 79–84. Repr. in Alexander Alberro and Blake Stimson (eds.) (2000), *Conceptual Art: A Critical Anthology* (Cambridge, MA: MIT Press), 12–16.

—— (1969), 'Sentences on Conceptual Art', 0–95 (January): 3–5. Repr. in Alexander Alberro and Blake Stimson (eds.) (2000), *Conceptual Art: A Critical Anthology* (Cambridge, MA: MIT Press), 106–8.

OSBORNE, PETER (1999), 'Conceptual Art and/as Philosophy', in Michael Newman and Jon Bird (eds.), *Rewriting Conceptual Art* (London: Reaktion Books), 47–65.

SCLAFANI, RICHARD (1975), 'What Kind of Nonsense Is This?', *Journal of Aesthetics and Art Criticism* 33: 455–8.

Part III

Conceptual Art, Knowledge and Understanding

7

Matter and Meaning in the Work of Art: Joseph Kosuth's *One and Three Chairs*

Carolyn Wilde

The very stuff of art is indeed greatly related to 'creating' propositions.

(Joseph Kosuth, 'Art After Philosophy')[1]

My interest in Joseph Kosuth's assemblage, *One and Three Chairs* of 1965 (see Illustration 5), is in the way in which it requires us to consider how meaning is embodied within the work of art. In his discussion of Conceptual Art the art historian Hans Belting said that this work, "proposed a thesis that could have been voiced at any time, even a century earlier. But the proposition could not have been exhibited as *art* until the mid-1960s."[2] This statement is interesting but problematic. The idea that any work of art 'proposes a thesis' or 'presents a proposition' is problematic. For it seems to imply that we can expect some determinate meaning from a work of art. Yet a common assumption is that although works of art are subject to interpretation, whatever is communicated, at least in its presentation as a work of art, is not equivalent to any determinate

[1] Joseph Kosuth, 'Art After Philosophy, I and II', *Studio International* (October 1969); repr. in G. Battcock (ed.), *Idea Art* (New York: Dutton, 1973), 81.

[2] Hans Belting, *Art History after Modernism* (Chicago: University of Chicago Press, 2003), 20.

statement. In this way works of art can be contrasted with such things as diagrams used to 'propose a thesis' about the workings of some system, or maps intended to contain particular information. But the wider claim here, that whatever it is that this work does, it could not have been done as a work of art before its own times, is an interesting claim. For one thing that can distinguish a more serious or original work of art from other, more derivative ones, is the fact that it is evidently made in acute response to its own times.

I want to bring these two issues, the particular one about the 'propositional content' of Kosuth's work, and the general one about the temporal acuity of art, together, and to place them both in the context of what is perhaps the most general and long-standing question about the nature of art. How are ideas, or how is thought more generally, embodied in a work of visual art, that is, in something that does not typically contain language and is, ultimately, just matter, or brute stuff? Conceptual Art does not merely inherit this enduring interest in the relationship between mind and matter in the work of art, it makes it a central concern of the work. Conceptual Art wants to elevate the motivating idea or intellectual content of the work over any other value which its material presence may offer.

7.1 Plato and the Unreality of the Work of Art

Although Kosuth uses quotations and ideas from Analytical Philosophy in order to give foundation to his work, there is a sense in which, by rejecting any value in the representational functions of art and by denying any more direct sensuous or material value, he reinvokes Plato's dismissal of the work of art as mere appearance.[3] Plato tells us that the work of the painter or sculptor, being a copy of mere appearances, puts us at three removes from reality. Those who think that neither the wider metaphysical framework of Plato's argument, nor his particularly narrow claims about art as *mimesis*, need delay us, may

[3] Kosuth puts his own point about the reality of the materials of art in this way: ". . . a few years ago I became increasingly aware of the fact that the separation between one's ideas and one's use of material, if not wide at the inception of the work, becomes almost incommunicatively wide when confronted by a viewer. I wanted to eliminate that gap. I also began to realize that there is nothing abstract about a specific material. There is always something hopelessly real about materials, be they ordered or unordered." From an interview published in *Arts Magazine* 43 (February 1969), repr. in G. Battcock, (ed.), *Idea Art* (New York: Dutton, 1973), 144–5.

find it easy to dismiss this and move on. Yet the residual issue remains. If all a painting or work of sculpture can do is fabricate the appearances of things, how does it contain any significant meaning about those things? In particular, when the things depicted or assembled in the work of art are themselves just material artefacts, such as chairs or beds—how can art, when it has removed all such things from all practical purpose, provide them with any meaning? Yet still life, the very genre of art which seems to present this issue most obviously, by depicting merely the fruits and bodies of the world as they are subject to indifferent cycles of generation and decay, itself offers some immediate reply. By representing such things in a form that holds them suspended in time, outside the cycle of change, history, and decay, the very contingency and ephemerality of things is itself, as *vanitas,* brought to thought. Thus one way to consider *One and Three Chairs* could be as a contemporary still life. Yet this work has nothing to do with such existential or metaphysical issues.

How the perennial question about the relationship between matter and meaning in the work of art has been addressed has, of course, depended on the wider cultural and intellectual context in which it is framed. Thus I want first to recall some moments from the beginnings of the tradition of Fine Art in order to show how Conceptual Art can be seen as one particular stance within that tradition, a stance, as all others, peculiarly related to its own times. Very broadly, Conceptual Art can be seen as a twentieth-century formulation of the continuing issue of the *paragone*, of the comparative virtues of the word, or the textual, over the image, the merely sensible or textural. The issue focused by Conceptual Art is not new, but inevitably, the way in which it deals with it, is.

At the turning point of the late medieval tradition Cennino Cennini was already claiming that painting had the capacity of poetry to reveals things not seen, and as the work of the artist gradually grew in prestige through alignment with the concerns of the Liberal Arts, this idea acquired its own theoretical support. In the 1430s Leon Battista Alberti began the first theoretical treatise on the art of painting by emphasizing the fact that in introducing the method of artificial perspective to the artist, he was not just teaching mathematics or optics, but was bringing *la piu grassa Minerva*—a more sensate or 'fatty' wisdom—to his teaching. For, as he said, the principles of perspective are to be applied to the realization of bodies in paint.[4] Directed by this intellectual

[4] Leon Battista Alberti, *On Painting*, trans. John R. Spencer (New Haven: Yale University Press, 1966), 43 and *n*.

understanding of the visual order of things the artist is able visibly to realize the solidity and spatial alignment of the bodies and buildings of the world. But this is only the setting, for the larger aim of the artist in Alberti's teaching is to realize the *invention* or idea of the work, that is, to make significant moments of Biblical or Classical narrative present to our imagination in the *istoria*. Within such a grand work, the deeper meaning and significance of things represented within it can be understood by anyone sufficiently educated in the Liberal Arts. A work of grand narrative in the visual arts can do more than illustrate some moment from the story, for through its very particularity of composition and other artistic devices it can focus reflection on such concepts as fate, courage, or ambition. When, at a similar time, the Neoplatonic transformation of Plato's thought was introduced into these theoretical debates, the different idea that divine beauty casts its light onto the perceptible things of this world also serviced the emerging Fine Arts with the cultural prestige that they have held onto ever since. Conceptual Art is a direct heir to these intellectually grounded ways in which thought and understanding can be made to inform the sensible and material stuff of art. More particularly, it is a twentieth-century attempt to preserve the intellectual status of Fine Art in response to the fact that the tradition of grand narrative had degenerated and been superseded by radical abstraction.

Most explicitly for the purpose of talking about Conceptual Art however, at the point at which those formative institutions of Fine Art, the Academies, were being founded, Federico Zuccari based his theoretical teachings about the artistic process, or *disegno*, on a distinction between the *concept* or idea of the work and its realization. He first distinguished between *disegno interno*, "the concept formed in our mind', and *disegno esterno*, or the external design, which is the concept or idea as it is visibly organized through the formal outline or composition of thing. A drawing of a circle, for example, can make visible the concept of a sphere. Neither the internal concept, nor the external design, however, is yet material substance, for 'the external design is nothing but that which is circumscribed by form without corporeal substance".[5] That is, through the initial drawing or cartoon, the artist makes his idea or *conception* of the work visible by pure line, but what is presented in these lines, like any

[5] Quotations from D. Heikamp (ed.), *Scritti d'arte de Federico Zuccari* (Florence: L. S. Olschki, 1961) taken from Moshe Barasch, *Theories of Art. 1 From Plato to Winckelmann* (New York: Routledge, 2000), 295–303.

geometric diagram, itself lacks substance. A diagram of a modulated sphere, for instance, could serve as the external design for the way a head is tilted, but it is not yet itself a substantial representation of a human head or any other solid thing. However, once this design is realized—made real—through daubing coloured plaster onto a wall or pigment on canvas, the substance is revealed as a corporeal thing with a distinctive capacity to make material things of the world, such as the heads, bodies, and even actions of men, vividly present to sense and imagination. I suggest that this originating thought of the Academic tradition is still relevant in twentieth-century art.

In the early part of the twentieth century, the abstraction of Mondrian's early paintings or of Brancusi's sculpture, required their contemporaries, our more immediate cultural forebears, to face the question of the relation of matter and thought in the work of art anew. The work of these artists however, was still in some direct continuity with methods of painterly or sculptural construction, such as Cubism, which abstracted from the familiar conventions of representation, of *designo esterno*. Thus they still held a residue of something figured or contained in the work. But during the last phase of Modernism, when such movements as Abstract Expressionism and Minimalism completely excluded all sign of representational content, the problem of mind and matter in the work of art was brought to the point of impasse. How could such works, consisting merely of the material organization of sensible form, without any representational content at all, contain any thought or idea? Yet, it could be said, it was at this very point that art was instantiating Zuccari's teachings in its purest form, although in a very different way than he intended. Anthony Caro's early 1960s works, for example, are often described as 'drawings in metal'. But they are not drawings of anything. The term 'drawing' as it is used in this context is actually closer to the original sense of *disegno* as it was used by Zuccari. For Caro's works at that time used the material of industrialized metal to engage directly in a pure play of *disegno esterno*, that is, to make visible a particular tension between line, mass, and balance in themselves.

Kosuth however dismissed the work of Caro and other contemporary abstract artists as formalist art, art which he described as "the vanguard of decoration". "Formalist art", he said, "is only art by virtue of its resemblance to earlier works of art. It is a mindless art."[6] *One and Three Chairs* is made in polemical

[6] Kosuth, 'Art After Philosophy', in Battcock, *ibid.*, 77 and 79. In addition to Anthony Caro, Kosuth also includes the work of Kenneth Noland, Jules Olitski, Morris Louis, John Hoyland and others within this criticism.

opposition to these works of pure abstraction. Yet Kosuth aims to authorize his claim that the significance of a work of art lies in its 'propositional' content in a way which also connects directly with my emphasis on the role of *disegno esterno* in art. He quotes a passage from A. J. Ayer: "A geometry is not in itself about physical space; in itself it cannot be said to be 'about' anything. But we can use a geometry to reason about physical space. That is to say, once we have given the axioms a physical interpretation, we can proceed to apply the theorems to the objects which satisfy the axioms."[7] Kosuth uses this and other extracts from Ayer's writings in order to make his own point, which is to claim that art, at that point in the second half of the twentieth century, shared with logic and geometry the function of stating propositions which are not about anything beyond themselves, but which are, as Kosuth puts it in his appropriation of Ayer's philosophical terminology, "purely analytic propositions".

I am going to approach this curious claim indirectly by contrasting Kosuth's work with that of other artists in order to indicate some general conditions for attributing meaning to works of art, some of which Kosuth repudiates.

7.2 Three Chairs Compared

One and Three Chairs consists of three discrete objects placed together. Against the wall is a simple wooden chair, facing outwards in a position that would, in a local dance hall or other practical setting, invite sitting. On the wall at standing height to the left of the chair is placed a photograph of that same chair large enough to present the image at a similar scale to the actual one when perceived from the same distance. On the wall to the right of the chair is hung a photographic enlargement of a dictionary definition of a chair. The rectangle of the photograph is in portrait, or presentational format, whereas, in contrast, the rectangle containing the text is in landscape proportions. Thus there is evident decision and purpose in this selection and placing of these manufactured objects, that is, there is evident *design* or composition.

There is another, very well-known work of art which has a chair as its most evident content: Van Gogh's painting of his own chair, done in 1888, now

[7] *Ibid.*, 90; quotation taken from A. J. Ayer, *Language, Truth and Logic* (London: Penguin, 1971), 90–1.

hung in the National Gallery in London. Although this work has not made the radical move of replacing a depicted object with either an actual one or a mere verbal definition of it, in its own times this was also a challenging piece. For it presents the same trivial thing, a chair, this time a plain wooden straw seated chair standing on a tiled floor. On the chair there is a pipe and some tobacco. Like Kosuth's work, the content of this picture could seem curiously banal and uninteresting. Even the artistry of the work, in its own time, would have brought its own problems. For the perspective of the floor is up-tilted and looks 'wrong'; the colours are not those of the finely toned and rich still life, but vivid and 'garish'; and the paint is thickly applied, with evident heavy brushstrokes, which could be thought 'clumsy'. Kosuth's work, in contrast, was equally challenging to its times, but because of its Duchampian precedents, sophisticated taste, this time, was more receptive.

Does Van Gogh's work exhibit any proposition or propose any thesis? Well, various sorts of information can be derived from this work, such as how rooms were furnished in Arles at that time or which pigments were available to the artist, and an accurate description of the content of the work could be given to someone who had not seen it. But none of this captures whatever meaning this presentation has as a work of art. We are often told that this painting is a symbolic self-portrait. Thus there is a fact external to the work, namely that this was Van Gogh's own chair, which significantly informs our understanding of the work. How this knowledge informs what we see can be shown by comparing this work with Van Gogh's painting of someone else's chair, namely Gauguin's. There is a difference in status, for example, shown in Van Gogh's plain domestic chair, in contrast to Gauguin's more elegant and curvaceous one. But it is the artistry of these two paintings that makes the most pointed contrast. This is not just the differences in the choice of colours—the earth and open-field colours of the painting of Van Gogh's own chair contrasted with deep, luxurious red and interior colours used in painting Gauguin's chair—it is also about the choice of objects, the little still life within each picture, placed on each chair. Van Gogh is incorporating an understanding of the symbolic practices of art when he places a lighted candle and two books on Gauguin's chair, signifying inspiration and cultivation, but only modest items of personal pleasure on his own. In this way the subject matter or theme of each of these paintings is not a chair, but a person, an absent person. Whether or not any viewer of Van Gogh's chair paintings will know anything about the symbolic use of the empty chair in the nineteenth-century

literary tradition—Van Gogh had been impressed by a print entitled *The Empty Chair*, showing the study of Charles Dickens, recently deceased—or whether they are merely engaged by the pointed absence of any person in either of the paintings, the pathos of these works can be evident. Van Gogh's paintings of chairs are about such things as absence, intimate location, personal identity, the vicissitudes of friendship. But since these are works of art and not illustrations or diagrams intended to impart determinate information, the work presents no thesis or proposition about any of these things. Yet, through the way in which these paintings embody the artist's particular process of attention to such mundane things as chairs, this process, in its unique subjectivity, is made apparent to others. Even when the artist is long dead, the result of their activity of looking, gauging and discerning remains evident *in* the work and makes the mere material thing, the marked surface, intelligible to others and open to their own imaginative interest. Van Gogh's paintings of the two chairs are particularly vivid examples of how the process of attention to things can be embodied in a work of art in ways which give it a unique and particular meaning.[8] This intersubjective feature of art, foregrounded within Romanticism and Expressionism, is of course one source of its interest and value. In Van Gogh's painting it is such particularities of composition and handling, particularly the activity evident in the brushwork, which give particular significance to the content of the work. By the time of Van Gogh, the way in which the meanings of a work of art are embodied within that work as a result of its particular *artistry* or unique process of production was itself becoming a distinguishing value of the art, a value central to later moments of Modernism. It is however, one of the main things which Kosuth's work aims to relinquish when he proposes his thesis about the conditions of art. For, as is evident in *One and Three Chairs*, Kosuth's work adamantly rejects all the expressive and symbolic practices which give Van Gogh's work its particular meaning *and* value.

Most artists at any particular time work within the constraints set by whatever medium they are using. But, significantly, it is a distinctive feature of many outstanding works of art that they extend or push against the limitations of the medium and the conventions of genre or style. Thus

[8] Although the process of production of the work of art is deliberative and intentional, discerning meaning in the work, or providing an interpretation of it, cannot be reduced to, or be simply derived from, statements about the artist's intentions. In some cases what can be known about the artist's intentions may be relevant to understanding what is to be seen, but in others, such statements, by the artist or others, may be at odds with what is there to be seen.

A LITTLE KNOWLEDGE CAN GO A LONG WAY
A LOT OF PROFESSIONALS ARE CRACKPOTS
A MAN CAN'T KNOW WHAT IT'S LIKE TO BE A MOTHER
A NAME MEANS A LOT JUST BY ITSELF
A POSITIVE ATTITUDE MAKES ALL THE DIFFERENCE IN THE WORLD
A RELAXED MAN IS NOT NECESSARILY A BETTER MAN
A SENSE OF TIMING IS THE MARK OF GENIUS
A SINCERE EFFORT IS ALL YOU CAN ASK
A SINGLE EVENT CAN HAVE INFINITELY MANY INTERPRETATIONS
A SOLID HOME BASE BUILDS A SENSE OF SELF
A STRONG SENSE OF DUTY IMPRISONS YOU
ABSOLUTE SUBMISSION CAN BE A FORM OF FREEDOM
ABSTRACTION IS A TYPE OF DECADENCE
ABUSE OF POWER SHOULD COME AS NO SURPRISE
ACTION CAUSES MORE TROUBLE THAN THOUGHT
ALIENATION PRODUCES ECCENTRICS OR REVOLUTIONARIES
ALL THINGS ARE DELICATELY INTERCONNECTED
AMBITION IS JUST AS DANGEROUS AS COMPLACENCY
AMBIVALENCE CAN RUIN YOUR LIFE
AN ELITE IS INEVITABLE
ANGER OR HATE CAN BE A USEFUL MOTIVATING FORCE
ANIMALISM IS PERFECTLY HEALTHY
ANY SURPLUS IS IMMORAL
ANYTHING IS A LEGITIMATE AREA OF INVESTIGATION
ARTIFICIAL DESIRES ARE DESPOILING THE EARTH
AT TIMES INACTIVITY IS PREFERABLE TO MINDLESS FUNCTIONING
AT TIMES YOUR UNCONSCIOUS IS TRUER THAN YOUR CONSCIOUS MIND
AUTOMATION IS DEADLY
AWFUL PUNISHMENT AWAITS REALLY BAD PEOPLE
BAD INTENTIONS CAN YIELD GOOD RESULTS
BEING ALONE WITH YOURSELF IS INCREASINGLY UNPOPULAR
BEING HAPPY IS MORE IMPORTANT THAN ANYTHING ELSE
BEING HONEST IS NOT ALWAYS THE KINDEST WAY
BEING JUDGMENTAL IS A SIGN OF LIFE
BEING SURE OF YOURSELF MEANS YOU'RE A FOOL
BELIEVING IN REBIRTH IS THE SAME AS ADMITTING DEFEAT
BOREDOM MAKES YOU DO CRAZY THINGS
CALM IS MORE CONDUCIVE TO CREATIVITY THAN IS ANXIETY
CATEGORIZING FEAR IS CALMING
CHANGE IS VALUABLE BECAUSE IT LETS THE OPPRESSED BE TYRANTS
CHASING THE NEW IS DANGEROUS TO SOCIETY
CHILDREN ARE THE CRUELEST OF ALL
CHILDREN ARE THE HOPE OF THE FUTURE
CLASS ACTION IS A NICE IDEA WITH NO SUBSTANCE
CLASS STRUCTURE IS AS ARTIFICIAL AS PLASTIC
CONFUSING YOURSELF IS A WAY TO STAY HONEST
CRIME AGAINST PROPERTY IS RELATIVELY UNIMPORTANT
DECADENCE CAN BE AN END IN ITSELF
DECENCY IS A RELATIVE THING
DEPENDENCE CAN BE A MEAL TICKET
DESCRIPTION IS MORE VALUABLE THAN METAPHOR
DEVIANTS ARE SACRIFICED TO INCREASE GROUP SOLIDARITY
DISGUST IS THE APPROPRIATE RESPONSE TO MOST SITUATIONS
DISORGANIZATION IS A KIND OF ANESTHESIA
DON'T PLACE TOO MUCH TRUST IN EXPERTS
DON'T RUN PEOPLE'S LIVES FOR THEM
DRAMA OFTEN OBSCURES THE REAL ISSUES
DREAMING WHILE AWAKE IS A FRIGHTENING CONTRADICTION
DYING AND COMING BACK GIVES YOU CONSIDERABLE PERSPECTIVE
DYING SHOULD BE AS EASY AS FALLING OFF A LOG
EATING TOO MUCH IS CRIMINAL
ELABORATION IS A FORM OF POLLUTION
EMOTIONAL RESPONSES ARE AS VALUABLE AS INTELLECTUAL RESPONSES
ENJOY YOURSELF BECAUSE YOU CAN'T CHANGE ANYTHING ANYWAY
EVEN YOUR FAMILY CAN BETRAY YOU
EVERY ACHIEVEMENT REQUIRES A SACRIFICE
EVERYONE'S WORK IS EQUALLY IMPORTANT
EVERYTHING THAT'S INTERESTING IS NEW
EXCEPTIONAL PEOPLE DESERVE SPECIAL CONCESSIONS
EXPIRING FOR LOVE IS BEAUTIFUL BUT STUPID
EXPRESSING ANGER IS NECESSARY
EXTREME BEHAVIOR HAS ITS BASIS IN PATHOLOGICAL PSYCHOLOGY
EXTREME SELF-CONSCIOUSNESS LEADS TO PERVERSION
FAITHFULNESS IS A SOCIAL NOT A BIOLOGICAL LAW
FAKE OR REAL INDIFFERENCE IS A POWERFUL PERSONAL WEAPON
FATHERS OFTEN USE TOO MUCH FORCE
FEAR IS THE GREATEST INCAPACITATOR
FREEDOM IS A LUXURY NOT A NECESSITY
GIVING FREE REIN TO YOUR EMOTIONS IS AN HONEST WAY TO LIVE
GOING WITH THE FLOW IS SOOTHING BUT RISKY
GOOD DEEDS EVENTUALLY ARE REWARDED
GOVERNMENT IS A BURDEN ON THE PEOPLE
GRASS ROOTS AGITATION IS THE ONLY HOPE
GUILT AND SELF-LACERATION ARE INDULGENCES
HABITUAL CONTEMPT DOESN'T REFLECT A FINER SENSIBILITY
HIDING YOUR MOTIVES IS DESPICABLE

1. Jenny Holzer, *Truisms*, 1978–87

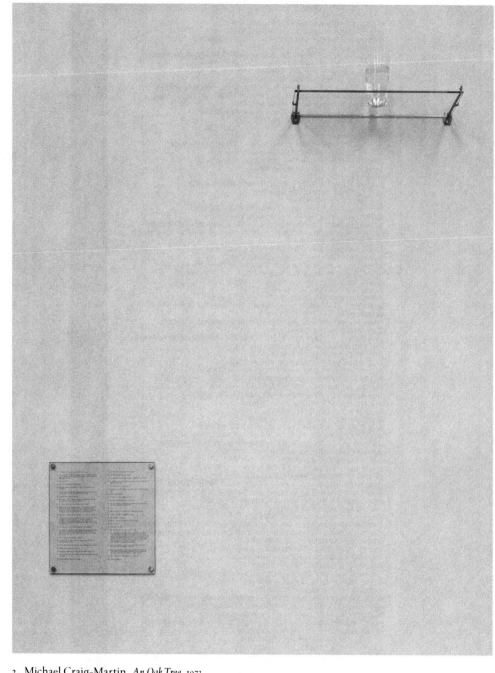

2. Michael Craig-Martin, *An Oak Tree*, 1973

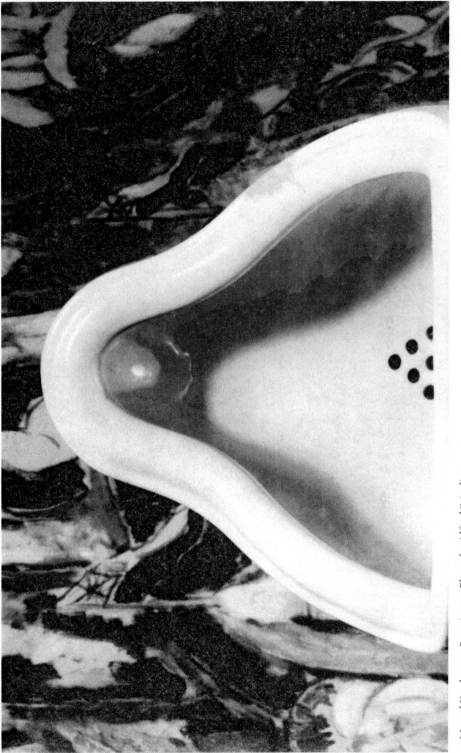

3. Marcel Duchamp, *Fountain*, 1917. Photo by Alfred Stieglitz

4. Bruce Nauman, *One Hundred Live and Die*, 1984

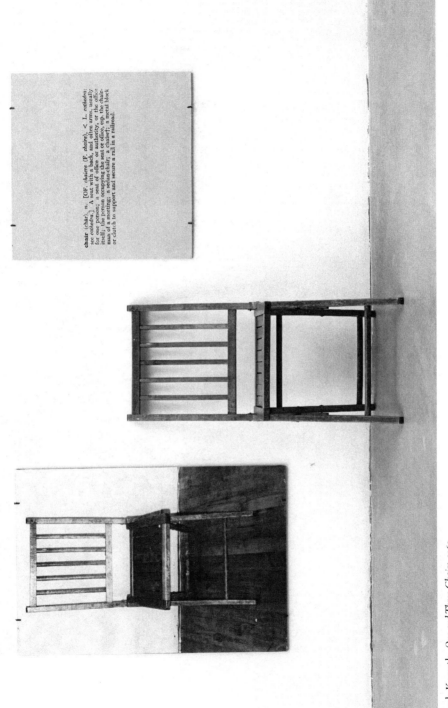

5. Joseph Kosuth, *One and Three Chairs*, 1965

6. Art & Language, *Index 01*, 1972

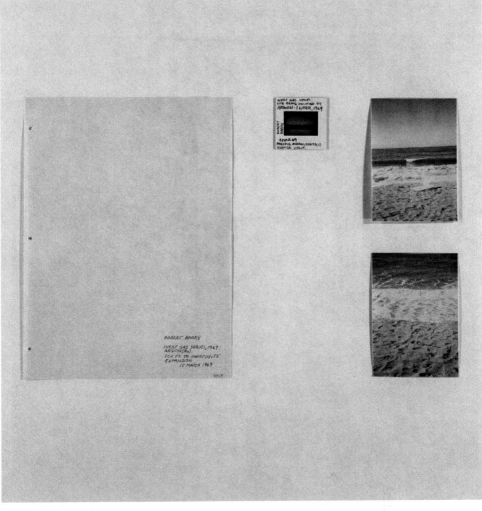

7. Robert Barry, *Inert Gas Series: Argon*, 1969

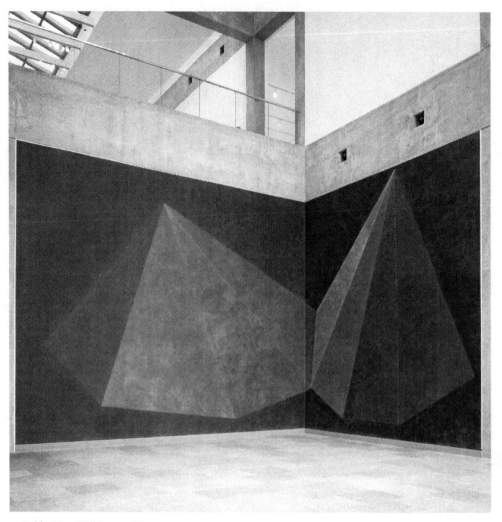

8. Sol le Witt, *Wall Drawing* No. 623, 1989

9. Adrian Piper: *Catalysis IV*, 1970–1

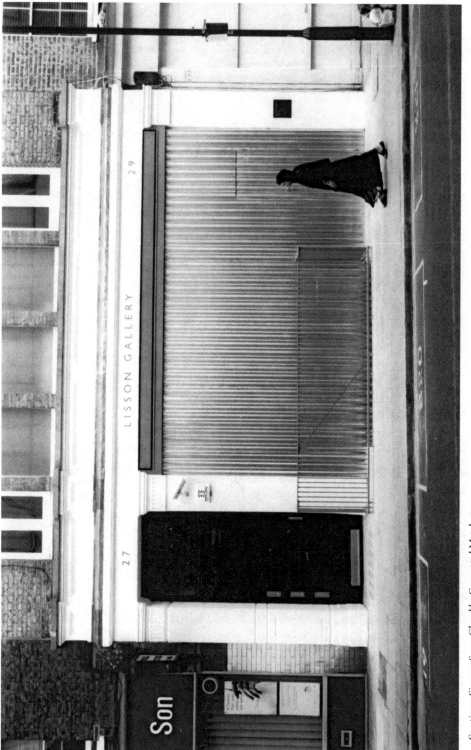

10. Santiago Sierra, *Space Closed by Corrugated Metal*, 2002

11. Walter de Maria: *Vertical Earth Kilometer*, 1977

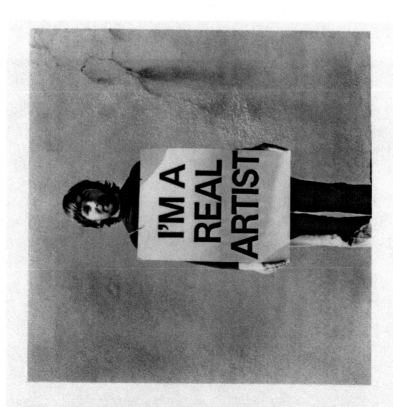

Keith Arnatt
TROUSER – WORD PIECE

'It is usually thought, and I dare say usually rightly thought, that what one might call the affirmative use of a term is basic - that, to understand 'x', we need to know what it is to be x, or to be an x, and that knowing this apprises us of what it is **not** to be an x. But with 'real' ... it is the **negative** use that wears the trousers. That is, a definite sense attaches to the assertion that something is real, a real such-and-such, only in the light of a specific way in which it might be, or might have been, **not** real. 'A real duck' differs from the simple 'a duck' only in that it is used to exclude various ways of being not a real duck - but a dummy, a toy, a picture, a decoy, &c.; and moreover I don't know **just** what. on that particular occasion, the speaker had it in mind to exclude . . . (The) function of 'real' is not to contribute positively to the characterisation of anything, but to exclude possible ways of being **not** real - and these ways are both numerous for particular kinds of things, and liable to be quite different for things of different kinds. It is this identity of general function combined with immense diversity in specific applications which gives to the word 'real' the, at first sight, baffling feature of having neither one single 'meaning.' nor yet ambiguity, a number of different meanings.'

John Austin. 'Sense and Sensibilia.'

12. Keith Arnatt, *Trouser-Word Piece*, 1972–89

Abstract Expressionism, that leading form of painting immediately preceding the emergence of Conceptual Art, makes the creative process itself, as an embodiment of the subjectivity of the artist, the very subject matter, or content, of the work. In this particular sense Abstract Expressionism was one end point of the tradition in which this valued idea of the creative process had held such a central place.

Bridging Abstract Expressionism and Conceptual Art however is the work of Jasper Johns. Johns's work *Fool's House* of 1962 offers another significant point of contrast with that of Kosuth. *Fool's House* is a sort of painting, because it consists of oil paint daubed or swiped around on canvas, in a mode reminiscent of abstract expressionist work, but with real objects attached to it, in a manner prefiguring Kosuth. These are various objects from the artist's studio—a long-handled sweeping brush hangs centrally down the work, a small towel and similar-sized picture stretcher are aligned with the bottom edge, and a cup is suspended from a hook on the lower frame of the work. There are also words within the work: the name of each item is handwritten beside the appropriate object, with an arrow pointing to that object, and a reassembled form of the title of the work is stencilled across the top. The words 'Fool's House' begin in the middle, but the letter 'f' is obscured by the brush handle, as though the word could be 'tools', and the right-hand edge of the work breaks off the last three letters of the second word. These last three letters then occur as though having been brought around to re-enter the work on the left-hand side, and now present the word 'use'.

This work then is poised between the earlier Abstract Expressionist works and later Conceptual ones. The gestural way in which the paint is applied, in the manner of abstract expressionist art, is in continuity with the expressivity valued in Van Gogh's work, but the fact that it is overlaid with actual objects and contains words in diverse forms undermines such expressive innocence. Similarly, although the assemblage of mundane objects from the artist's studio might seem to have affinity with Van Gogh's painting of his own chair, the fact that they are real objects and are positioned or hung in ways which displace all notions of traditional artistry radically severs any such connections. Like Kosuth, Jasper Johns was also interested in philosophy and was at this time reading Wittgenstein's later writings. Put against this background this work makes play with Wittgenstein's remarks about the relationships between the meaning of a word and its use within different activities, not only by placing words in a simple referring relationship to each object and by signalling the

word 'use' in the top left of the work, but by his choice of objects—various tools. Johns's work thus has evident affinities with Wittgenstein's thought in the *Philosophical Investigations*, specifically about meaning and the practical application or use of words in section 43, and his analogy of the tool box in section 11.[9] But does the work state any proposition about any of these things? No. It merely puts them in play together. Johns's work is, after all, a work of art and not something aiming to present a philosophical thesis.

One thing all three of these works, Van Gogh's *Chair*, Johns's *Fools House*, and Kosuth's *One and Three Chairs,* have in common however, is use of text *within* the work as part of the work. For in Van Gogh's painting the word 'Vincent' is placed on the side of a box of onions placed on the upper left of the work as though written on the side of that represented thing. In this sense the word is *in* the work and signifies something like presence or ownership. Yet in so far as the word is also a signature, it is not *in* the work at all, it is merely *on* it, signifying the identity of the artist. But in both ways the status and the significance of the writing in this work is very different from that of the text within Kosuth's *One and Three Chairs*. Whereas Van Gogh's work ambiguates the function of the text in a way which both emblematizes the subjectivity of the work and authorizes it, Kosuth's work makes the anonymity and neutral objectivity of the text part of the subject of the work. The words in Johns's work, however, mediate between both. For although, like Van Gogh, the words are handwritten, explicitly displaying the subjectivity of the process, their function is, as in Kosuth's work, to make the activity of naming or meaning itself part of the subject of the work.

Thus, although all three works invite interpretative interest in the composition or design of the work, that is, in the significance of the relationships between its parts, Kosuth's work, in marked contrast to that of Van Gogh, does so by evacuating all sign of subjectivity and relies entirely on the selection and ordering of its pre-made parts. Thus a dominant aspect of Kosuth's work is the impersonality of each part, presented in impartial regimentation. Furthermore Van Gogh's work is enclosed within clear boundaries—the frame of the work both clearly marks the limiting edge of attention and separates it, as an imagined space, from the space in which the viewer is standing. In Johns's piece the suspended cup disturbs both the physical boundaries of the work

[9] Ludwig Wittgenstein, *Philosophical Investigations*, trans. G. E. M. Anscombe (Oxford: Basil Blackwell, 1963), 20 and 6.

and its limits as a work of art. But much more radically, Kosuth's work breaks with these boundary conventions altogether. In his work there are three very different categories of objects, and the only thing that contains them is their proximity and juxtaposition. And, as a final contrast, in Kosuth's work there is no facture, no process in which one material, paint, has been transformed into another, not even as the residue of the creative process, as in Johns's work. Rather, there is merely the assemblage of manufactured objects, an enlarged dictionary definition, a photograph, and a chair. These objects, or even other objects of the same kind and relationship, could in fact be assembled by gallery assistants, as indeed this and many of Kosuth's works are. *One and Three Chairs* does not need the hand of the artist for its realization. His role is merely to initiate the *designo interno*. It is, in that sense, a realization of something, as Sol LeWitt insists, preconceptualized.

7.3 Art in the Context of its Times

In order to understand the obvious differences between all these works of art, differences which completely override any superficial similarity of content, we have, of course, to see each of them within the context of their own times. A work painted now with the expressive innocence of Van Gogh could be charming and engaging in many different ways, but it would not be a substantial or significant piece—it would be merely derivative. Anthony Caro's more recent works, such as *Chair IV (After Van Gogh)* of 1997, exemplify his understanding of this fact. More radically however, if we reverse the point, and try to imagine Kosuth's work being done in Van Gogh's times, we are trying to imagine something impossible. Each work is significantly of its own times. This, then, is a further element contributing to the meaning of a work of art—its place within and relationship to its own times.

We are now all fully aware that the meaning and significance of a work of art, at the most general level, is framed within some larger context of production, part of which is its place within the tradition of art itself. This broad truth is, of course, at the base of Institutional and Historical accounts of art. How different artists position themselves within that tradition, more or less reflectively or explicitly, is one basic condition which not only identifies what they are doing as making art, but also frames whatever sense or meaning their work has, both for the artist and for any viewer of it. Although a

viewer ignorant of the historical or cultural conditions framing a particular work may still find some arbitrary interest or associative pleasure in it, their understanding of it will be significantly limited. Yet recognizing the wider formative conditions of the artist's activity is not in itself a simple matter. For in many cases, particularly with more significant works of art, the work does not merely instantiate or reflect themes or aspects of the culture and society in which it is made; it can, more or less explicitly, be critically responsive to them. Thus works of art which are particularly acute to their own times do not merely reflect or mediate the dominant themes or interests of a time and culture: they can themselves be constitutive of the character of that time.

In his illuminating book on fifteenth-century painting, the art historian Michael Baxandall provides a vivid example. He situates the particular sort of realism being developed in fifteenth-century painting, in which the bodies of people are depicted with a full substance and volume, within the development of the mercantile culture of the times.[10] The need for the buying and selling of wine in a wider commercial field, for example, gave rise to the use of barrels to store and transport the wine. And in turn this required devising instructional diagrams for making barrels and mathematical techniques for measuring and gauging volume. So, in addition to Alberti's more intellectual and philosophical reasons for applying mathematical skill to the construction of pictures at that time, which themselves connect with new interests in cosmology and the structures of the natural world, there were more immediate and quotidian practices informing an interest and growing expertise in the artistic skills of making things look solid. For example, compared to the work of earlier and most other contemporary artists, the figures to be seen in frescoes by Masaccio or Piero della Francesca are more tangible, their expressions are less schematic. Thereby their conscious presence is both more spatially and imaginatively continuous with the presence of the viewer. The realism of their work, however, is not merely reflective of its times, it is *constitutive* of a new sense of material reality.[11]

[10] Michael Baxandall, *Painting and Experience in Fifteenth-Century Italy* (Oxford: Oxford University Press, 1972), 86–7.

[11] I have discussed this issue with different purpose in 'The Intrinsic Value of the Work of Art: Masaccio and the Chapmans', in M. Hutter and D. Thursby (eds.), *Beyond Price: In Search of Cultural Values* (Cambridge: Cambridge University Press, 2007).

At the other end of this tradition, we are now familiar with the work of artists in our own times that challenges, or more commonly *subverts* the norms of a culture. The brothers Jake and Dinos Chapman, for example, who describe their work as conceptual art, said in a recent television interview that "Conceptual art challenges the idea that it's the job of a work of art to create objects of transcendent beauty."[12] What seems to be a strong motivation within their work is contempt for more popular works of fine art, seen in high-street galleries, or summer exhibitions, such as nostalgic landscapes or tasteful abstractions, reminiscent of past genres. In contrast, the Chapmans are conspicuously alert to the culturally distinguishing aspects of our own times, in particular the dominant and all-pervasive culture of advertising and media-generated fantasy. In their work they arrange such things as disfigured toy soldiers in scenes of carnage and violence, or graft plastic genitalia onto shop-window mannequins. But again, their work is not merely reflecting their culture. Through their easy familiarity with the manipulation of meaning and desire within the public environment, their work cynically exploits the disturbation within the pervasive marketed fantasies of a sexually charged public culture. In this way their work, at this much later stage of the mercantile context identified by Baxandall, is also culturally reflexive. But although the Chapmans describe their work as conceptual art, and although their assemblages are directed by such concepts as are listed, often without syntax, in the titles of their works, it is not Conceptual Art in the sense originally intended by Kosuth, for although their work exploits the condition of art and its traffic with entertainment, their work is not *about* art.

One and Three Chairs was produced at a time and place when any leading or serious artist could be expected to have had some sophisticated knowledge and reflective understanding of the tradition in which he or she was working. If we look at this fact in terms of the institutions of art then we should acknowledge the changing nature of art education in the middle of the last century, particularly the fact that the theoretical study of art was beginning to replace training in skills and methods of using materials. If, in addition, we look to wider cultural formations of this work, we could put the increasingly exclusive work of the fine artist alongside the dominance and proliferation of

[12] 'How Sick is Your Art?' *The Art Show*, presented by Jake Chapman, produced and directed by Bernadette O'Brian, Channel 4, December 2003.

other more populist ways of engaging public visual imagination and thought at that time, in such things as photographs, films, and commercial illustration.[13] Once the work of the fine artist is taken away from all context of commission or wider public interest, so that its subject, content, and interest is merely that generated by the concerns of individual artists, then the practice becomes vulnerable to cultural marginalization and introverted theorizations. Merely to place Kosuth's work against the background of these conditions, however, would only be to speak of the work as a *symptom* of its times. Although I do think that Conceptual Art in general is highly symptomatic of the state of fine art in the middle of the last century, in contrast, we are looking to see how a particular work makes some more active response to, or critical intervention within those times.

If there had been no text in *One and Three Chairs* the work might seem merely to be dealing with appearances, i.e. with the play between Plato's second order of reality, material objects as they appear in the world, and objects as they appear in their third remove, in representation. But the text adds a different dimension to these two levels of appearance. For it pushes through or past these more ontological interests to the more particular issues of meaning and reference as they were debated by the linguistic philosophers in mid-twentieth-century Analytic Philosophy.

Yet, this is not a work of art whose subject is the meaning of the word 'chair', nor even the meaning of concepts more generally. Had it been so, perusing this material realization of the play of meaning might have held its own aesthetic interest. But it is not the meaning of the word 'chair' which is at stake, it is the meaning of the concept of art itself. By the mid-1960s the relation between theory and practice in the fine arts meant that the serious artist was now expected to have reflective understanding of the conditions of his work, and, if that work was to have any substantial import, that understanding had now, directly or indirectly, to be manifest within it. Yet how *One and Three Chairs* addresses this more general issue about the conditions of art is not evident merely from looking at the work. And this is where I have my problem. For the fact that this work is done with such radical purpose is only evident if we read Kosuth's writings about Conceptual Art.

[13] Kosuth himself makes his own point about this when he says that art cannot be expected to compete experientially with the fact that now the whole world is there to be seen in cinema, television, and modern urban spectacle (Battcock, *ibid.*, 88).

7.4 The Meaning of *One and Three Chairs*

In describing some of the conditions contributing to the meaning to be found in the work of other artists I implied that some interpretations or meanings were more appropriate or correct than others. Some people of course dispute this, claiming that a work of art means whatever you take it to mean. But such licence exaggerates the fact that meaning in the work of art is not determinate. Much of course depends on what we take 'the work of art' to be. A devotional sculpture may have more circumscribed meaning than one made for more intrinsic interest. But within the narrower field of fine art, the extent to which any particular work is open to radically different interpretations, in some cases depends on the fact that we have inadequate information about it, in others, on the fact that the work is ill conceived or poorly executed, and in yet others, is a function of the work itself, which may make play with figural ambiguity or formal relationships. *One and Three Chairs* is not in any of these categories. We have very explicit information about its meaning, it is very exactly executed, and the information we have explicitly rules out any 'aesthetic' interest we may have in the relationship of objects or forms. Yet although Kosuth's writings do give us a context in which we can place the curious idea that *One and Three Chairs* 'proposes a thesis' or presents a 'proposition', they do not transform how we see the piece; rather, they merely explain his intention.

To understand a work of art which is explicitly informed by some text, such as the Bible or some Classical source, for example, it is necessary to know something of that story. But such knowledge is not, in itself, a sufficient condition, for we also need to understand what the artist has done with it. And this we can see only by looking at the work. Although understanding any work of art depends on external information to some extent, the work of art is not merely informed by such external details. In particular, the relationships between any external text, whether that is a Classical literary source or, as in Kosuth's case, the texts of Analytic Philosophy, are not like the relationships between a text and a diagram or simple illustration. Although knowledge of the text can both inform and transform how we see a particular work of art, with significant works of art the relationship between text and work is reciprocal. The work of art gives some significant focus or particular under-standing of the text—sometimes even a misunderstanding, which does not necessarily negate the work. Kosuth's writings haphazardly draw on the writings of different Analytic philosophers. "What", asks Kosuth, "is the function

of art, or the nature of art?" His answer is this: "If we continue our analogy of the forms art takes as being art's language one can realize then that a work of art is a kind of proposition presented within the context of art as a comment on art. We can then go further and analyze the types of propositions."[14] In speaking like this Kosuth is drawing from his reading of A. J. Ayer's *Language, Truth and Logic*, in particular from Ayer's way of describing the nature and role of a proposition within a theory of meaning and his deployment of the distinction between synthetic and analytic propositions. Kosuth wants to draw an analogy between this way of speaking about linguistic meaning and the 'forms' or 'conditions' of art. If I understand Kosuth's point here rightly, he is saying that at one stage, the stage of 'realistic' or representational art, the condition of art was of the form 'This is how things are'. (He speaks of 'realistic' art as tempting one to 'verify' its proposition empirically.)[15] But in rejecting this form he writes, "The unreality of 'realistic' art is due to its framing as an art proposition in synthetic terms . . . (thus) one is flung out of art's 'orbit' into the 'infinite space' of the human condition." Non-representational art however, he says, such as Abstract Expressionism, does not have the form of a proposition at all. Following Ayer's description of non-propositional forms of language, he says that such works are mere ejaculations: "Expressionist works are usually such 'ejaculations' presented in the morphological language of traditional art."[16] However, he says, "The validity of artistic propositions is not dependent on any empirical, much less any aesthetic presuppositions about the nature of things . . . what art has in common with logic and mathematics is that it is a tautology; i.e., the 'art idea' (or 'work') and art are the same and can be appreciated as art without going outside the context of art for verification."[17] On these grounds he thus makes his central claim that works of art are analytic propositions. A work of art, he claims, is a statement about what art is. If, at this point, we bring Belting's remark, quoted at the beginning of this paper, back into the discussion, we are, then, being asked to accept the claim that *One and Three Chairs* is 'proposing the thesis' that this work is, analytically, a work of art. This self-reflexivity of the artwork could, to continue the point using Belting's words, "have been voiced at any time. But the proposition could not have been, exhibited as *art* until the mid-1960s". Although talk of 'propositions' or 'theses' is not strictly appropriate when speaking of something which lacks

[14] 'Art After Philosophy', Battcock, *ibid.*, 82–3. [15] *Ibid.*, 85, quotation marks in original.
[16] *Ibid.*, 85–6. [17] *Ibid.*, 84–5.

syntactical structure, we can see the general point here. Namely, that it was not until art had reached the point of crisis in relation to its interests in referring beyond itself that the nature of art itself explicitly becomes its own introverted concern.

However, although there is clearly some parallel or analogy between the ways in which Analytic Philosophy in the twentieth century moved from the study of thought and reality to the analysis of language as the medium of thought, and the way the practice of art focused increasingly on the intrinsic interest of the process itself, Kosuth's use of linguistic philosophy is problematic. For in so far as Kosuth's analogy between language and the condition of art depends on A. J. Ayer's assumption that language is essentially propositional, it ignores Wittgenstein's own insistence that language does not function only in one way. At the end of section 304 of the *Philosophical Investigations*, for example, Wittgenstein writes, "The paradox (about the reference of the word 'pain') disappears only if we make a radical break with the idea that language always functions in one way, always serves the same purpose: to convey thoughts—which may be about houses, pains, good and evil, or anything else you please".[18] This applies equally to chairs, of course. When we apply this point to art then we can also see that in speaking of the work of art as a kind of proposition, Kosuth is employing the very same limited conception of meaning in art that Wittgenstein was rejecting in language. For even if we confine ourselves to the example of 'realistic' art—that is to depictions of things which actually exist, such as chairs belonging to particular people—even in these cases there is no *one* way in which the figurative content of a work of art must depict such things. The conventions of representation are various, depending on many factors, including particular resources of medium and genre. Kosuth's description of *One and Three Chairs* as an analytic proposition is dependent on his rejection of what he calls 'realistic' art as a form of synthetic proposition. But if we do not have this singular notion of representation, we do not need this philosophically artificial manoeuvre. Yet of course we have to recognize that *One and Three Chairs* is not a philosophical intervention but is, just that, an *artificial* man-oeuvre.

But if we give up trying to fit talk of propositions with this work in any direct sense, knowledge of Kosuth's theoretical ambitions at least enables to

[18] Wittgenstein, *Philosophical Investigations*, 102.

see that in looking at it we can be invited to draw an analogy between the way in which the elements of the work are inter-referential and the way in which this work refers to 'its own condition as art', as he puts it. Doing so however, makes this work, and others which Kosuth had assembled using not chairs, but, in one case, a stool, with photograph and definition, and in another a table presented in the same three ways, artistically identical. Yet this is consistent with Kosuth's claim that the value of a work of art, "is its idea in the realm of art, and not the physical or visual qualities seen in a specific work."[19] If this applies to this work so be it. But his generalization of this claim beyond his own version of Conceptual Art is not so easy to accept. For he says that once the way in which *any* particular work presents its idea about the condition of art has been absorbed, then that work is little more than a historical curiosity. "As far as *art* is concerned", he says, "Van Gogh's paintings aren't worth any more than his palette is."[20] Kosuth's generalization of his point in this way shows us how limited an application it actually has. But if we do allow his writings to direct and restrict attention to *One and Three Chairs* in the way he insists, then it follows that its interest is merely the historical one of how it instantiated a crisis in the tradition of Fine Art in the middle of the last century. Kosuth may well be right when he says that questioning the nature of art is a very important concept in understanding the function of art. But not only is the nature of art more complex than his analogy with a propositional account of meaning in language will allow, but also, the analogy itself does not do the job intended. For the mode of linguistic philosophy which inspired Kosuth was not interested in the conditions of meaning merely in order to understand how language works. It focused on language, whether described narrowly in terms of truth conditions, or more adequately through its rule-governed use within the spectrum of human activities and concerns, as the medium through which the events and things of the world beyond it are made intelligible. Similarly, an interest in the conditions of art is an interest not just in the forms which art can take for its own sake. It is an interest in the ways in which a work of art can articulate the many different interests and meanings which we find in the world beyond the work itself.[21]

[19] Wittgenstein, *Philosophical Investigations*, 81. [20] *Ibid.*, 82, italics in original.

[21] I thank the staff and postgraduate students of the Department of the History of Art at the University of Bristol for their helpful comments in response to this paper given in the Spring term, 2006.

References

ALBERTI, LEON BATTISTA, *On Painting*, trans. John R. Spencer (New Haven: Yale University Press, 1966).

AMES-LEWIS, FRANCIS, *The Intellectual Life of Early Renaissance Art* (New Haven: Yale University Press, 2000).

AYER, A. J., *Language, Truth and Logic* (London: Penguin, 1971).

BARASCH, MOSHE, *Theories of Art: 1 From Plato to Winckelmann* (New York: Routledge, 2000).

BAXANDALL, MICHAEL, *Painting and Experience in Fifteenth-Century Italy* (Oxford: Oxford University Press, 1972).

BELTING, HANS, *Art History after Modernism* (Chicago: University of Chicago Press, 2003).

HEIKAMP, D. (ed.), *Scritti d'arte de Federico Zuccari* (Florence: L. S. Olschki, 1961).

'How Sick is Your Art?', *The Art Show*, presented by Jake Chapman, produced and directed by Bernadette O'Brian, Channel 4, December 2003.

KOSUTH, JOSEPH, 'Art After Philosophy, I and II', *Studio International*, (October 1969); repr. in G. Battcock (ed.), *Idea Art* (New York: Dutton, 1973), 70–101.

_____ Interview in *Arts Magazine* 43 (February 1969); repr. in G. Battcock (ed.), *Idea Art* (New York: Dutton, 1973), 144–5.

WILDE, CAROLYN, 'The Intrinsic Value of the Work of Art: Masaccio and the Chapmans', in M. Hutter and D. Thursby (eds.), *Beyond Price: In Search of Cultural Values* (Cambridge: Cambridge University Press, 2007).

WITTGENSTEIN, LUDWIG, *Philosophical Investigations*, trans. G. E. M. Anscombe (Oxford: Basil Blackwell, 1963).

8

Telling Pictures: The Place of Narrative in Late Modern 'Visual Art'

David Davies

8.1

Helen Chadwick's *Viral Landscapes* (1988–9) consists of five photographs, each three metres wide, in enamelled frames. The photographs are of the Pembrokeshire coastline, with a monochromatic rectangle to the left of each image and with smearings of paint and of what looks to be cellular matter superimposed over the entire manifold. This much one can tell by looking at the objects hanging on the gallery wall and the appended labels. However, if one reads Mark Sladen's commentary (2004) on Chadwick's work in the catalogue for the recent retrospective at the Barbican Gallery, one learns that the cells are samples taken from the artist's own body, that the images of smeared paint were produced by pouring paint onto the sea and dragging a canvas through the waves, and that the various elements were merged using computer-imaging technology. One also learns that, in her own commentary on the work, Chadwick 'elaborates a theory of self which celebrates the invasion and dissolution of the self by the other . . . "The living integrates with other in an infinite continuity of matter and welcomes difference not as damage but as potential." This interpenetration is figured in the *Viral Landscapes*

as the exchange between shore and sea, landscape and body, nature and culture' (Sladen 2004: 20−2).

In the Stedelijk Museum in Amsterdam, one can sometimes see Robert Ryman's *Untitled* (1972), which is, to all appearances, a square canvas covered in white paint, belonging to a tradition of such canvases that includes such painters as Malevich and Yves Klein. If one reads a text adjacent to the canvas provided by the museum curator, however, one learns the following:

The essence of all painting is what is done with paint. With this idea since 1957 Ryman has worked exclusively with white paint and square formats. The various vehicles, brushstrokes, and materials appear to guarantee an infinite variation within these limitations. Ryman systematically investigates all elements of painting before intuitively incorporating them in his paintings. Even the manner of hanging the paintings—sometimes with clearly visible hooks—is a component of the artwork.

The Belgian artist Luc Tuymans produces enigmatic and minimal representational images that sometimes resemble the simple illustrations one finds in children's dictionaries. In one such work, *Recherches* (1989), we are presented with a triptych of images, which appear to represent a lampshade standing on a table, a window looking into an office or laboratory, and an indeterminate grey oval with a smaller black contiguous mass. The guide for the recent retrospective of Tuymans's work at Tate Modern informs us that the indeterminate object is a tooth, that the three images are details of objects in the museums at Auschwitz and Buchenwald, that the work thereby refers to the Holocaust and to science and eugenics, and that this illustrates one of Tuymans central themes, namely, 'the ultimate failure of painting to offer any true representation of past events' (Tate Modern 2004: 5).

8.2

I begin with these examples because they might seem to confirm the suspicions expressed some thirty years ago by Tom Wolfe in *The Painted Word*. Wolfe provocatively claimed that our appreciation of late modern art is mediated by language in a way that our appreciation of traditional art is not:

All these years I, like so many others, had stood in front of a thousand, two-thousand, God-knows-how-many-thousand Pollocks, de Koonings, Newmans, [etc.] . . . now squinting, now popping the eye sockets open, now drawing back, now moving

closer—waiting, waiting, forever waiting for . . . it . . . for *it* to come into focus, namely, the visual reward (for so much effort) which must be there, which everyone (*tout le monde*) knew to be there . . . All these years, in short, I had assumed that in art, if nowhere else, seeing is believing. Well, how very shortsighted! Now at last . . . I could see. I had gotten it backward all along. Not 'seeing is believing' . . . but 'believing is seeing', for *Modern Art has become completely literary: the paintings and other works exist only to illustrate the text.* (Wolfe 1976: 6; stress in the original.)

Wolfe's central contention is that the emergence of abstract expressionism instituted a radical discontinuity in the visual arts concerning the role that art *theory* plays in both the generation and the appreciation of works. The activities of late modern painters, Wolfe maintains, are driven by the proclamations of art theorists such as Clement Greenberg, and their products serve as 'illustrations' of those theories. Thus one cannot make sense of the paintings unless one knows the relevant theories.

We may also note a second purported discontinuity between traditional and late modern art. residing in what Lucy Lippard (1973) termed 'the dematerialization of the art object'. In the case of blatantly conceptual pieces like Robert Barry's *All the things I know but of which I am not at the moment thinking: 1:36 p.m., 15 June 1969, New York*, there seems to be no material 'art object' whose manifest qualities could be a focus of our appreciative attention to a work. Even where there is such an object, as in the case of Duchamp's 'readymades' (see, for example, Illustration 3) or Robert Morris's exhibited piles of felt, it does not seem to function as an 'art object' might be thought to function in traditional visual art—that is, through what is given in experience of the art object in its materiality.

To see such radical discontinuities, one must, like Wolfe, operate with a particular view of the being and being appreciated of traditional works of visual art—a view that might be represented in terms of the following claims:

1. Instances of works are the kinds of things we encounter in galleries, concert halls, libraries, theatres, and cinemas. The works themselves are the kinds of things that hang on the walls of galleries, are performed in concert halls or theatres, can be read in books, or are projected on screens.

2. Properly appreciating a work is a matter of having a direct experiential encounter with one of its instances. For there are appreciable properties bearing on the distinctive value of a work that are graspable only in

such an experience, and any properties of a work not accessible in an experiential encounter with one of its instances have no bearing on the work's artistic value, and no bearing on its artistic appreciation.

3. The consummation of such a direct experiential encounter with an instance of a work—say a painting—is the 'reward' of which Wolfe speaks, an intrinsically valuable experience elicited by the work.

It is assumed, then, that traditional works of visual art are 'art objects' in this sense, material entities the appreciation of which is a matter of responding to their manifest qualities, thereby eliciting what is standardly characterized as an aesthetic experience. Such a view finds late modern visual art inaccessible, and discontinuous with traditional art, because (a) late modern works often seem to lack an appropriate material 'art object', and (b) late modern works do not seem to be given for appreciation through an unmediated experiential engagement with such an art object, and thus are unable to 'speak for themselves'—they require an explanatory narrative in which the requisite body of theory is set out, as illustrated by the three examples with which I began.

I think that these two supposed discontinuities are closely related, and are only properly understood as inflections of underlying continuities in both the visual and the non-visual arts. Artworks, I shall argue, never 'speak for themselves', but are always accessible only through the mediation of a narrative. Such narratives play certain quite distinctive and necessary roles in artistic practice and appreciation, but their mode and function are newly inflected in late modern art as a result, in part, of the manner in which what Lippard terms 'the art object' has changed. It is for this reason that narratives—or, more broadly, mediating texts—have come to seem distinctive of our engagement with late modern art, in a manner generative of the sorts of discontinuities noted above. To understand why *no* artwork can 'speak for itself' in the way Wolfe suggests, and why late modern artworks appear singularly mute, we need to look more closely at the roles that narratives play in the apprehension and appreciation of artworks in general, and the ways in which those roles have been modified in late modernism.

8.3

There is *one* sense in which no work can 'speak for itself' that resonates in much of the recent literature in analytic aesthetics, and, it might be thought, provides

us with an easy answer to Wolfe. Consider, for example, the origins of Jackson Pollock's distinctive style of painting, and his relationship to the art critic Clement Greenberg. In Wolfe's externalist account,[1] it is Peggy Guggenheim's personal tastes in painting that account for Pollock's artistic direction, the members of her social circle who account for his becoming established as a painter of importance, and Clement Greenberg who provides a theory in terms of which that importance can be communicated—a theory that the hapless Pollock is then committed to illustrating through his paintings (Wolfe 1976: 63 ff.) Access to Pollock's work is impossible without the mediation of Greenberg's theory of 'Flatness': the paintings cannot 'speak for themselves'.

Compare this with the account of Pollock's development in a representative internalist history of art, Edward Lucie-Smith's *Late Modern* (1976: 32–6). Lucie-Smith begins with Pollock's training as a painter under Thomas Benton, and then talks of his falling under the influence of Diego Rivera, which 'may have helped to develop Pollock's sense of scale'. He refers briefly to Pollock's flirtation with surrealism and his being under contract to Peggy Guggenheim, before stating that 'by 1947, Pollock had broken through to the style for which he is now best known: free, informal abstraction, based on a technique of dripping and smearing paint on the canvas'. After citing at some length Pollock's own description of his method of painting, where he claims to be indebted to some of the methods used by Navajo painters, Lucie-Smith quotes, in comparison, Andre Breton's instructions on the production of a surrealist text, remarking how the passivity prescribed by Breton is a large component in the sort of 'gestural' or 'action' painting practised by Pollock. He then proceeds to discuss Pollock's distinctive treatment of pictorial space, something that links Pollock to Cezanne rather than to surrealism. Finally, he notes that Pollock's impact, first in America and then in Europe, depended upon his participation in an artistic community whose founding figure was the painter Hans Hofmann. In

[1] I draw here on the literature concerning internalist and externalist histories of *science*—see, for example, Laudan 1977. Externalist histories explain developments in science in terms of the institutional structure of science and the extra-scientific concerns of scientists, while internalist histories present such developments as the result of rational deliberation on the part of agents pursuing the 'proper' goals of science—truth or empirical adequacy, for example. Wolfe's account of late modernist art is externalist in that it appeals to the same sorts of sociological variables as do externalist histories of science. Internalist histories of visual art, on the other hand, present developments in art as the result of the pursuit by artists of whatever are taken to be the proper goals of the practice of painting—for example, the manipulation of media in novel ways in the interest of producing visually interesting objects.

the internalist story told by Lucie-Smith, what drives the development of late modern art is not 'theory' but rather problems that arise within a tradition of painting concerning the ways in which established and novel media can be worked so as to realize certain plastic values. Artists explore the aesthetic potentialities of different media and, in so doing, draw upon resources available to them in both their own and other artistic traditions. The variables to which we appeal in telling this story about late modern art are continuous with the ones to which we would appeal in furnishing an account of the development of traditional painting.

More significantly for our present purposes, while access to Pollock's painting is possible only through the kind of *contextualizing narrative* provided by Lucie-Smith, this does not represent a discontinuity with traditional works of visual art. Like any painting as comprehended through such an internalist theory, the piece can speak to us *as the work it is*, rather than as a visually interesting surface, only when the art object is contextualized through such a narrative. The narrative serves to contexualize the art-object in two ways: first, it locates it in a particular art-historical context, and, second, it characterizes it as the product of a particular generative act performed in that context. Well-rehearsed arguments against empiricist epistemologies of art bring out the importance of such contextualising narratives and thereby demonstrate the fallacy in the idea that any artwork can 'speak for itself'.[2]

8.4

But the appreciation of late modern art seems to involve more than simply contextualizing narratives of the sort just identified. A second kind of narrative that one frequently encounters in galleries presenting late modern works is what might be termed a *reception narrative*. The aim of such narratives appears to be to locate a puzzling art object in the context of an act of reception in which value is found in the object's cultural resonances for the receiver. Such narratives may find their rationale in the idea that appreciation of an artwork is a matter, not of contextualizing an art object in the manner characterized above, but of finding interesting things to do with the products

[2] See, for example, Levinson 1980; Wollheim 1980: 185–204; Danto 1981; Currie 1989; and Davies 2004: chs. 2–3.

of artistic activity by *recontextualizing* them in ways that speak to the receiver's concerns.[3]

But such narratives in the case of late modern art are more problematic than one might think. Consider, for example, the following text by Patricia Ellis which accompanied Damien Hirst's notorious dead shark suspended in a tank of formaldehyde when that object was exhibited at the Saatchi Gallery in 2003:

A 17' Australian tiger shark is suspended in a glass tank filled with formaldehyde, its predatory viciousness just inches from grasp. Fantastically animate, its frigid stillness is shockingly incomprehensible. Sleek, potent, powerful, corporate: it's a trophy of masculine vitality. Hirst presents a Hemingwayesque bravado, the untamed quest of Santiago captured and put on spectacle in a tank.

Ellis bravely ignores the title of the piece—*The Physical Impossibility of Death in the Mind of Someone Living*—in her boldly emblematic reading. More crucially, and perhaps relatedly, she also ignores the optical properties of the material of which the enclosure containing the shark is constructed. The importance of the optical properties of the physical medium is noted by art critic and historian Richard Cork: 'The optical illusion of movement, generated by its abrupt shifts of movement behind the glass as awed visitors walked round the tank, suggested that the shark was still, somehow, alive' (Cork 2003: 5). One may disagree with Cork's interpretation of the significance of the illusion of movement generated by the optical properties of the physical medium.[4] But the relevance of these properties to the appreciation of the work—as contrasted with their irrelevance to our scientific appreciation of an exhibited shark in a natural history museum—seems clear.

To express what is wrong with the sort of reception narrative offered by Ellis, it will be helpful to introduce a couple of bits of terminology. Artworks, we may say, come into existence because something is done in a context where this doing counts as doing something else. For example, an individual applies oil paint to a canvas, and this counts as the production of a painting to which

[3] This idea is often traced to the post-modernist views of authors such as Barthes and Foucault, but it also finds expression in the analytic literature in the claim that interpretation seeks to maximize the artistic value of the interpreted work (Goldman 1990), or is an exercise in imagination rather than in discovery (Feagin 1982), or that the pleasure in interpretation derives from finding interesting readings that can be 'put upon' a work (S. Davies 1995).

[4] See, for example, the alternative reading of this in my 2004: 251–3.

various representational, expressive, and formal properties can be ascribed by receivers. An artist, then, creates a work by generating something that receivers will interpret as having certain meaningful properties that bear on its appreciation. We can call the thing that the artist produces which is open to such interpretation the *artistic vehicle*—e.g. the painted canvas by Pollock titled *Lavender Mist* which hangs on the wall of MOMA in New York. We can then term the meaningful properties that viewers ascribe to that vehicle in their attempts to appreciate the work the *artistic content* or *artistic statement* they take to be articulated through that vehicle—e.g. what we take the canvas to represent or express or what formal or material properties we take it to make manifest. The activity whereby an artistic vehicle is generated counts as the articulation of an artistic statement because the context in which the former doing takes place, or in which the product of the former doing is received, provides shared understandings that license so taking it. We may call these shared understandings an *artistic medium*.[5]

The shared understandings that make up an artistic medium are what allow receivers to take a doing characterizable in terms of manipulation of the vehicular medium—usually some kind of material—to be an artistic act whereby a particular artistic statement is articulated, and to take the resulting vehicle to be the articulation of such a statement. This involves two interrelated modes whereby the vehicle is 'transcended'. First, the manifest features of the vehicle are apprehended as permeated with the intentionality of the process whereby the vehicle was formed through the manipulation of the vehicular medium. We see the painting as an array of brushstrokes, not as mere marks on a surface; we see design, not pattern; we see the movings and posings of the dancer, rather than her body in motion. Second, the vehicle so apprehended is understood as articulating certain 'meanings' broadly construed—as representing or expressing or exemplifying certain qualities.

The issue between traditional and postmodernist views of appreciation may then be seen as in large measure a disagreement over whether, in appreciating a given work, the ascription of artistic content to its artistic vehicle requires locating that vehicle in its actual historical context, via a contextualizing narrative, or whether what matters is what we can do with the vehicle by

[5] On the notion of an artistic medium, see Margolis 1980, and the elaboration of this notion in my 2004: 56 ff.

recontextualizing it. The problem with Ellis's reception narrative, however, is that she fails to take account of crucial elements of the artistic vehicle—the optical properties of the container and the title. She wrongly takes the vehicle to be just the shark. Thus, even if one's theory of interpretation favours recontextualizing over contextualizing narratives, Ellis's reception narrative fails as an interpretation of Hirst's *work*.

8.5

This is significant because it alerts us to a more general problem that attends the understanding and appreciation of much late modern art. In introducing the notion of a contextualizing narrative, it was assumed that what was given unproblematically was an 'art object' present to the receiver in the gallery, and that the issue was simply whether this object/vehicle, whether traditional or contemporary, can, as an artwork, 'speak for itself'. But a central issue in late modern art is to identify just what it is that plays this role of 'art object' or artistic vehicle. The 'art object' 'dematerializes', but doesn't *disappear*, according to Lippard. But, in dematerializing, it becomes more elusive.

The following example may help to clarify this point. In a room in the National Gallery of Canada in Ottawa is a large mural, taking up most of two walls that meet at right-angles, that features two overlapping pyramid-like figures in a very pleasing arrangement of visually rich colours, all of this against an equally rich but monotone ground. The mural impresses itself on the viewer as an object of considerable visual interest, pleasing in virtue of both its structure and use of colour. A text on the adjacent wall indexes the piece presented for appreciation in this room as Sol LeWitt's *Wall Drawing No. 623 Double asymmetrical pyramids with colour ink washes superimposed* (see Illustration 8). But appended to this is a further description of the work in the form of a set of constraints laid down by LeWitt and realized in the mural: 'colour ink wash: the background is grey, blue, grey, blue; left pyramid: the apex is left—four sides: 1—red, blue, blue, red, blue; 2—yellow, blue, grey, blue; 3—grey, grey, blue, red, red; 4—red, grey, red; right pyramid: the apex is centre—four sides: 1—grey, grey; 2—grey, red, yellow; 3—yellow, grey, blue, blue; 4—grey, blue, red, red'. *Wall Drawing No. 623* is one of over a thousand such pieces created by LeWitt. The mural itself, however, like others generated in compliance with the specifications for the wall drawings, was not painted by LeWitt, but by two

other artists who 'executed' his 'plan'. Furthermore, it is clear from the verbal characterization of the piece that most of the visually attractive features of the exhibited mural are *contingent* features, relative to LeWitt's specifications: the constraints in no way mandate the formal and design features that give the mural its initial visual appeal. Given that visual structures differing sharply in their perceptible properties, and thus in the experiences they engender in receivers, can serve as realizations of LeWitt's constraints, it is unclear how the experiences elicited by a particular instantiation bear upon the appreciation of the piece.

The *Wall Drawings* are puzzling pieces in a number of respects, something well brought out by Kirk Pillow (2003) in a recent paper on this subject. For example, in his comments on the pieces, LeWitt sometimes talks of the 'same work' as being multiply 'performable', much as musical works can be multiply performed (LeWitt 1984: 21). At other times, however, he maintains that each materialization of the constraints for a *Wall Drawing* is a *distinct* work (LeWitt 1971/2000: 376). Again, there are what seem to be contrary claims as to the bearing of the finished wall drawings on the being and being appreciated of LeWitt's pieces. On the one hand, in his *Paragraphs on Conceptual Art*, he says the following: 'I will refer to the kind of art in which I am involved as conceptual art. In conceptual art, the idea or concept is the most important aspect of the work. When an artist uses a conceptual form of art, it means that all of the planning and decisions are made beforehand and the execution is a perfunctory affair. This kind of art . . . is usually free from dependence on the skill of the artist as a craftsman.' (LeWitt 1967: 79. The 'piece' from which this is excerpted is reproduced in Lippard 1973.) On the other hand, in 'Doing Wall Drawings', he avers that 'the explicit plan should accompany the finished wall drawing. They are of equal importance', and that 'ideas of wall drawings alone are contradictions of the idea of wall drawings' (LeWitt 1971/2000: 376).

What, then, is the artistic vehicle in the case of LeWitt's *Wall Drawing No. 623*, and what bearing do our aesthetic responses to the manifest properties of the painted surface in the National Gallery of Canada have upon the appreciation of this piece? At least three possible answers to that question are suggested by LeWitt's various observations:

1. The vehicle is the *idea* of carrying out a performance as characterized in the specifications. If enactment of the idea furthers our appreciation, it does so only by 'enlivening' the idea, by supplementing the intensionality

of the piece as verbally specified. Or, more radically, the experiencing of the object together with the realization of the contingent nature of our aesthetic responses given LeWitt's 'plan', serves merely to bring home to us the purely conceptual nature of the piece. This fits well with the account of Conceptual Art in the *Paragraphs*, but fits much less well with LeWitt's insistence on the importance of there being executions of his 'plans'.

2. This suggests a second answer to our questions, which supplements the first answer by developing LeWitt's 'music' analogy. The vehicle, on this view, is an abstractly specified design structure, or perhaps an 'indicated' design structure in Levinson's sense (1980), which has executions as 'performances' through which various aesthetic possibilities permitted by that design structure can be realized. On this reading, an encounter with a particular execution of a LeWitt 'plan' is essential if we are to properly appreciate the work, just as it might be said that properties bearing essentially on the appreciation of musical works are only given through performances of those works. Where the executed wall drawing complies with the 'plan', we can refer appreciable properties of the mural to the piece itself in determining the artistic statement thereby articulated. Pillow rejects the music analogy, however, as a confusion on LeWitt's part, and as incompatible with what Pillow views as the most philosophically interesting feature of the *Wall Drawings*, namely, LeWitt's 'remarkable stipulation that each execution of a particular plan makes for a distinct work rather than an instance of one work' (Pillow 2003: 378).

3. Pillow's own reading focuses on the latter claim. A LeWitt wall drawing, or a LeWitt as he terms it, is a two-stage art form 'consisting of instructions and their execution on some wall' (2003: 370). The artistic vehicle, then, is the particular materialization that one confronts in the gallery, taken together with the 'plan' with which it complies. The 'plan' might be thought to function rather like the title for a standard work of visual art, providing a weighting for the manifest properties whereby the piece articulates its artistic statement.[6]

[6] Interestingly, the curatorial notes for the piece at the National Gallery balance uncomfortably between the second and third of these readings. On the one hand, there is celebratory talk of 'the acquisition of this major new work by LeWitt', and of its exciting manifest properties, suggesting

I have dwelt on this example for three related reasons. First, it has a poignant topicality in that one might raise exactly the same sorts of questions in connection with Damien Hirst's 'spot paintings', at least one of which was proclaimed to have been destroyed in the 2004 East London warehouse fire. Hirst's paintings, like LeWitt's *Wall Drawings*, seem to involve both a planning stage—Hirst sitting in Devon coming up with an abstract set of specifications for a painting—and an execution stage—'draftsmen' in London executing the instructions resulting in individual painted canvases that comply with the specifications. If, following our first reading of LeWitt's *Wall Drawings*, we take Hirst's spot paintings to be purely conceptual, then we did not lose a piece in the warehouse fire, but only an object that facilitated our access to and appreciation of a piece. If we apply to Hirst's pieces the second reading of LeWitt, we lost what was perhaps a valuable 'performance' of a piece, but one whose role in the appreciation of the piece is replicable through other executions of the same set of specifications. Only if we subscribe to something like Pillow's reading did we actually lose a piece.

Second, the *Wall Drawings* provide a concrete example of something deeply symptomatic of late modern art, namely, genuine puzzlement as to the nature of a work's artistic vehicle, and, consequently, puzzlement as to what the work is *about*—what artistic statement is articulated through the vehicle. This underlies the bemused expression often seen on the faces of those attempting to appreciate late modern art, the sense of 'what am I supposed to do with *that*'? Is 'that'—the material object in the gallery—an artistic vehicle, or is it merely a means of access to an artistic vehicle? This in turn raises, in a concrete way, the question I want to address in the remainder of this paper: what kind of disagreement is exemplified in the different readings of LeWitt's piece, and what resources should be brought to bear in resolving such disagreements?

Third, to start to answer these questions, one way of defending a reading of the *Wall Drawings* against its competitors is to show that it makes sense of *all* the things LeWitt says about his pieces. Such a defence seems open to proponents of the second 'musical' reading. For we might see the materializations as individual works distinct from LeWitt's piece, to be credited to the persons who exercised their creativity in a particular way in realizing them, just as

that they subscribe to Pillow's reading, while, on the other hand, there is an acknowledgment that 'because it is the concept that is original, the drawing may be redone in other, similar locations by different hands without any loss of its inherent qualities. Every good copy is authentic.' This suggests a certain lack of clarity on the concept of Conceptual Art.

we might view the individual performance events that are performances of musical works as themselves works of performance art. Paradoxically, but perhaps rightly, it would follow that LeWitts, in Pillow's sense, are not pieces by LeWitt.

8.6

We can perhaps throw further light on deciding between competing readings of the *Wall Drawings* if we consider a related issue—the relationship between the artistic vehicles in certain late modern works and the 'documentation' that plays a role in making those works accessible to receivers. The works in question are broadly classifiable as 'conceptual' or 'performance' works, and often involve actions performed by an artist (e.g. Joseph Beuys's *Coyote*), events staged by an artist (e.g. *The Way Things Go* by Fischli and Weiss), temporary installations, essentially ephemeral materialities (e.g. Helen Chadwick's *Carcass*), or some combination of the above. The so-called 'documentation' may be textual, photographic, cinematic, or (usually) incorporate more than one of these elements.

To get a sense of the complexities involved in the appreciation of such works, consider two 'performance' pieces by Vito Acconci to which our access is mediated in some way by such documentation:

1. *Following Piece* (1969): 'Activity, 23 days, varying durations. New York City. Choosing a person at random, in the street, any location, each day. Following him wherever he goes, however long or far he travels. (The activity ends when he enters a private place—his home, office, etc.)' The 'execution' of this piece by Acconci in 1969 is documented by photographs that accompany the description of the piece.[7]

2. *Conversions I, II, and III* (1971), described in a recent exhibition catalogue as follows: 'Acconci attempts to alter his sexual boundaries and, by implication, his sexual identity by turning himself into the image of a woman' (Duke Street Gallery 2001), where one of these attempts involves using a candle to burn the hair off his chest. This was recorded without sound on Super-8 film.

[7] See Lippard 1973: 117, for a description of the piece and reproductions of some of the 'documentation'. For a fuller account, see Acconci 2004: 196–9.

Each of these works incorporates in some way performance events, enacted by the artist, that realize a specifiable set of performative constraints. Furthermore, in each case there is a single performance event that roughly satisfies those constraints. But the relationship between the artistic vehicle, the performance event, and the apparent 'documentation' differs in the two pieces.

Take, first, *Following Piece*. Here the performance event in question arguably enters, as vehicle, into the identity of the work only by instantiating the *type* of performance characterized in the performative constraints set out by Acconci. The photographic record serves only to imaginatively enliven the performance for the receiver, to help her to imagine what the performance was like in virtue of satisfying those constraints. The use of photography in such a minimal documentary role is understood by the receiver as indicating that visible features of the actual performance not preserved on film are not important for the appreciation of the work. The photographs serve to isolate those features of the performance event, as vehicle, which bear upon the articulation of an artistic statement. This analysis of *Following Piece* usefully extends to such works as Duchamp's *Fountain* (see Illustration 3), if, as some have suggested, we take the performance of exhibiting the urinal, rather than the urinal itself, to be the vehicle whereby an artistic statement is articulated. For, while Duchamp ensured that there was photographic and other documentary evidence of his performance, our appreciation of the work is not impaired by our inability to view that performance either directly or indirectly.

In the case of *Conversions*, a Super-8 recording of the performance events was made, and this might lead us to think that appreciation of the work does require taking full account of the perceptible features of the performance as 'preserved' in the documentation, as we might think is the case with standard instances of 'performance art', or with improvised musical or theatrical presentations. *Conversions*, however, is significantly different, for the fact that the camera is recording the very 'private' activities carried out by Acconci is itself an integral part of the performance that serves as vehicle in the piece, and crucial to the artistic statement articulated through that vehicle. For, as Kate Linker stresses in her monograph on Acconci (Linker 1994), one of the central themes in his work of this period is the breaking down of the barriers that traditionally separate artist from receiver, and the attempt to integrate the receiver into the work itself—something most notoriously celebrated in his *Seedbed* (1972; see Acconci 2004: 220–1). In *Conversions*, the observing camera for whom the regendering of the self is staged represents the receiver herself.

Indeed, if, as further claimed in the Acconci catalogue quoted above, Acconci himself filmed part of the segment with the candle, holding the camera in one hand while moving the camera over his body with the other, then he can be seen as simultaneously realizing both the performer's and the receiver's roles.[8]

This inclusion of the photographic presence within the performance that serves as artistic vehicle also figures in the articulation of another important theme in Acconci's work of this period—the mediation between personal and private spheres. Linker writes that 'in its capacity as a record, the photograph has the capacity to re-present and make public an activity that would otherwise go unremarked: it provides a means of transforming private acts into public information, accessible to multiple channels of distribution' (1994: 18). Thus, again, rather than being a documentation of the performance which serves as artistic vehicle for the work, the filming of Acconci's self-manipulations is itself a crucial *part* of that performance. The specifications for the performance itself include the intrusive and collusive eye of the camera.

8.7

In arguing for a particular construal of the artistic vehicle in these examples, I have appealed to a sense of what the point of the piece is, or, in the terms introduced earlier in this paper, what artistic statement is being articulated in the piece. The suggestion, then, is that working out what is going on in works of late modern art requires a reciprocal exploration of possible 'meanings' of a piece, given the artist's other pieces and the art-historical context in which she is working, and possible vehicles through which a meaning could be articulated. Such reciprocal explorations take the form of a narrative which serves not merely to contextualize an artistic vehicle, but to identify *what the artistic vehicle is*, given what is presented to the receiver in the gallery. It is, I think, distinctive of late modern art that such an *identifying narrative* is required in order to make an individual piece available for appreciation, whereas in the case of traditional works, no such narrative is necessary for individual works since the identity

[8] I say, '*if* Acconci filmed part of the segment' because the claim in the Duke Street Gallery catalogue seems to conflict with the description of the piece in other catalogues of Acconci's work. See, for example, Acconci 2004: 230–1, where only his frequent collaborator and fellow performance-artist, Kathy Dillon, is credited with filming Acconci's performance.

of the artistic vehicle is given by an understanding of the artistic medium to which the work belongs. What Lippard terms the 'dematerialization of the art object' is the breaking down of the traditional identity between the material presence representing the work in a gallery and the artistic vehicle, so that access to the latter is derivable from the former only given an identifying narrative that must be in question for each individual work. Returning, then, to the competing readings of the artistic vehicle in LeWitt's *Wall Drawings*, to argue for a particular reading of these pieces would require that one not only take account of LeWitt's pronouncements on his works, but also furnish some sense of what artistic statement is being articulated, and explain how the medium employed by LeWitt enables such a statement to be articulated through the artistic vehicle construed in the way proposed.

We can also reassess the three late modern pieces with which we began. Chadwick's *Viral Landscapes* seems to be the most 'conventional' of the three, in that the artistic vehicle is apparently the object displayed on the gallery wall in the fullness of its manifest properties. Sladen's commentary is indeed necessary if we are to comprehend the materials and methods employed in generating the vehicle, and thereby have access to the artistic statement articulated. But the commentary seems to function as a contextualizing narrative, no different in principle from talk about the pigments used in early Renaissance painting provided in internalist treatments of such paintings, which bears crucially in some cases upon the interpretation of the artistic statement articulated in the works. But even here there is a complication. For the fact that Chadwick used cells from her own body in generating the vehicle is of considerable significance when the piece is located more precisely in the context of her own earlier work. She produced the *Viral Landscapes* following considerable criticism from feminists of her previous works—in particular, the assemblage of blue photocopies of her naked body that were used in the provocatively allusive piece *The Oval Court* (1986), and a companion piece, *Vanity* (1986), in which she posed naked in front of a mirror reflecting *The Oval Court*. By using cells from the interior of her body in the *Viral Landscapes*, Chadwick was able both to acknowledge obliquely this criticism while continuing to incorporate herself in works which explored, among other things, the mutability of the self, a theme introduced in her earlier *Ego Geometrica Sum* (1983). When *Viral Landscapes* is contextualized in this way, the use of cellular material from her own body becomes a crucial element in the artistic vehicle. Thus Sladen's commentary also functions in part as an identifying narrative.

In the case of Ryman's work, the commentary clearly serves as an identifying narrative, informing the receiver that the artistic vehicle is not merely the manifest qualities of the painted surface, but also includes features of the material object in the gallery not normally so implicated. It is, rather, the physical arrangement of objects that presents the painted surface—canvas, frame, and supports—that serves as artistic vehicle, articulating a content that comments on the process of generating and presenting pieces in the visual arts. In this way, the piece differs quite radically from those 'white paintings' with which Ryman's piece might be confused. Indeed, once we identify the vehicle, it is perhaps better to think of the piece as a work of sculpture that comments on painting, rather than as a painting—its most obvious analogues being such pieces as *Untitled* (1962–3) by the Arte Povera artist Giulio Paolini, which consists of a blank canvas inside three frames.

The most puzzling case is that of Tuymans. The thematic content articulated in his pieces, if we are to believe the commentary in the catalogue, concerns the inadequacies of painting as a medium for representing or commenting on our past, the everydayness of evil, and the manner in which meaning can only ever be hinted at through images. What role, then, do the presented images play in giving a particular articulation of this thematic content? Here, perhaps, we find something that genuinely matches Wolfe's account of late modern visual art. For it seems the images not only resemble illustrations but also function as illustrations, or examples, of the 'theory' discursively articulated in the commentary, and artistically articulated in the piece through Tuymans's actions in drawing upon such resources in such a fashion. When, to cite another example, Tuymans responded to the invitation to present a work with political or social content in the wake of the attack on the World Trade Centre in September 2001 by exhibiting an enormous *Still Life* (2002) completely lacking in political or social representational content, the vehicle whereby Tuymans articulated, in this piece, the more general themes in his oeuvre noted above seems again to be his action: the material object on the gallery wall stands merely as an example of a large canvas belonging to a genre that is standardly taken to be lacking in any social or political content.[9] The specific

[9] Tuymans's own commentary on this piece is cited in the Tate Modern guide to the exhibition (8): 'In *Still Life* the idea of banality becomes larger than life, it is taken to an impossible extreme. Its actually just an icon, an almost purely cerebral painting, more like a light projection . . . The attacks of 9/11 were also an assault on aesthetics. That gave me the idea of reacting with a sort of anti-picture, with an idyll, albeit an inherently twisted one.'

details of the visual manifold presented by the canvas, on the other hand, play no role whatsoever in the articulation of the artistic content of the work. If, as seems plausible, we take it to be a necessary condition for an artwork to be a work of *visual* art that its artistic content is articulated by its vehicle through the latter's presented perceptual manifold, then Tuymans's works are not visual artworks, or at least, they are not visual artworks having as vehicles the objects exhibited in the Tate Modern exhibition. So perhaps we do have an example of the kind of late modernism decried by Wolfe, albeit one that differs from other late modern works such as those of Chadwick in precisely this respect.

8.8

I have argued in this paper that the real discontinuities between late modern and traditional visual art are properly seen as inflections of an underlying continuity. The artistic vehicles often flaunt their independence of the objects displayed in galleries, and the artistic statements they articulate are often not grounded in the manifest qualities of whatever materialities serve as entry to the work. But this does not constitute a radical discontinuity in the *art*, for such materialities have always been mere vehicles from which the appreciable content of the artwork stands removed by the two modes of transcendence identified earlier. The most salient discontinuity here resides in the different roles accorded to narratives in the process whereby works can speak, as the works they are, to receivers. While no work can speak without a contextualizing narrative, many late modern works remain mute, or misspeak, unless furnished with an appropriate identifying narrative whereby the artistic vehicle can emerge from the array of texts, images, and aesthetic surfaces through which the work is made accessible for reception and appreciation.

References

ACCONCI, V. (2004), *Vito Hannibal Acconci Studio* (Barcelona: Museu d'Art Contemporani Barcelona).

CORK, RICHARD (2003), 'The Essay', in Alison Roberts (ed.), *Saatchi: The Definitive Guide to the New Thamesside Gallery* (London: The Observer), 4–6.

CURRIE, G. (1989), *An Ontology of Art* (New York: St Martin's Press).

DANTO, A. (1981), *The Transfiguration of the Commonplace* (Cambridge, MA: Harvard University Press).

DAVIES, D. (2004), *Art as Performance* (Oxford: Blackwell).

DAVIES, S. (1995), 'Relativism in Interpretation', *Journal of Aesthetics and Art Criticism*, 53: 8–13.

Duke Street Gallery (2001), Catalogue for the Vito Acconci Exhibition, 29 May to 14 July 2001, 11 Duke Street Gallery, London.

FEAGIN, S. (1982), 'Incompatible Interpretations of Art', *Philosophy and Literature*, 6: 133–46.

GOLDMAN, A. (1990), 'Interpreting Art and Literature', *Journal of Aesthetics and Art Criticism*, 48: 205–14.

LAUDAN, L. (1977), *Progress and its Problems* (Berkeley, CA: University of California Press).

LEVINSON, J. (1980), 'What a Musical Work Is', *Journal of Philosophy*, 77: 5–28.

LEWITT, SOL (1967), 'Paragraphs on Conceptual Art', *Artforum*, 5/10: 79–81.

—— (1971/2000), 'Doing Wall Drawings', reprinted in G. Garrels (ed.), *Sol LeWitt: A Retrospective* (New Haven: Yale University Press, 2000), 376.

—— (1984), *Sol LeWitt: Wall Drawings. 1968–84* (Amsterdam: Stedelijk Museum).

LINKER, K. (1994), *Vito Acconci* (New York: Rizzoli).

LIPPARD, L. (1973), *Six Years: The Dematerialisation of the Art Object 1966–72* (New York: Praeger).

LUCIE-SMITH, E. (1976), *Late Modern* (New York: Praeger).

MARGOLIS, J. (1980), *Art and Philosophy* (Atlantic Heights, NJ: Humanities Press).

PILLOW, K. (2003), 'Did Goodman's Distinction Survive LeWitt?', *Journal of Aesthetics and Art Criticism*, 63: 365–81.

SLADEN, M. (2004), 'A Red Mirror', in M. Sladen, (ed.), *Helen Chadwick* (London: Barbican Art Gallery and Hatje Cantz Publishers), 20–2.

Tate Modern (2004), Guide to the Luc Tuymans Exhibition, Tate Modern, 23 June–26 September 2004.

WOLFE, T. (1976), *The Painted Word* (New York: Bantam).

WOLLHEIM, R. (1980), 'Criticism as Retrieval', in id., *Art and its Objects*, 2nd edn. (Cambridge: Cambridge University Press), 185–204.

9

Conceptual Art and Knowledge

Peter Goldie

9.1 Introduction

Art need not, and often does not, set out to have aesthetic value.[1] This seems true, most of all, of conceptual art; some conceptual artists even produce artworks that, as David Davies has said, 'seem designed to repel rather than seduce one who approaches them with . . . an aesthetic intent'.[2] But if art does not have aesthetic value, then what other kind of artistic value might it aspire to? One possibility is cognitive value, and many conceptual artists (often precisely those who eschew aesthetic value) do claim to produce works with significant cognitive value; roughly speaking, they hold that we can gain substantial knowledge from their artworks.

However, as we will see, there is a view that conceptual art lacks any significant cognitive value. So, if conceptual art does lack aesthetic value, as so much of it unashamedly does, and if it lacks cognitive value, then perhaps it lacks artistic value altogether.[3] In that case, we might conclude that the loss of so much conceptual art at the Momart warehouse fire in London on 24 May 2004 ought to be no source of *artistic* regret—although it might of course be regrettable in other ways, such as for the significant loss of money for the

[1] See Binkley 1977: 'Art need not be aesthetic' (272); '. . . there is no *a priori* reason why art must confine itself to the creation of aesthetic objects' (273).

[2] Davis 2004: 190.

[3] I leave to one side financial value as part of artistic value and, more contentiously perhaps, art-historical value.

owners of the works, and any possible insurance liabilities for Momart.[4] I think that this conclusion would be an unfortunate consequence of a mistaken view about the cognitive value of conceptual art.

What I want to do in this chapter is to outline an intriguing and forceful argument, put forward by James Young in his *Art and Knowledge* (2001), for the view that conceptual art has no non-trivial cognitive value.[5] Whilst my discussion will focus on Young's argument, the idea itself has wide currency: many people express dissatisfaction with conceptual art, not just because it lacks aesthetic value, but also, supposedly, because you can learn nothing from it. Having put forward the argument, I will then show why I think it fails: we can gain significant knowledge from at least some works of conceptual art. This knowledge is not of the kind that traditional art can provide, but it is significant nonetheless. Reflecting on what this knowledge is can reveal some important truths about our appreciation of conceptual art and its value.

Before I begin, let me briefly say what I mean by conceptual art, although more will emerge as I get into the meat of Young's argument. Like other contributors to this volume, I do not intend that the term 'conceptual art' should refer only to that period of 1966 to 1972 celebrated by Lucy Lippard (1973) and others, even though we might well think of that period as the height of conceptualism. I want it rather to extend back to Marcel Duchamp and his readymades (see, for example, Illustration 3), and forward to much of contemporary art today. As Roberta Smith said in her piece 'Conceptual art: over and yet everywhere', 'By now it seems virtually radioactive in its staying power and ubiquity; it is the shifting terra firma on which nearly all contemporary art is built . . . it's hard to think of a supposedly past art movement that feels more present' (Smith 1999).

At the heart of this broadly drawn category of conceptual art, I suggest, is the rejection of the aesthetic and of traditional media, especially painting and sculpture, to be replaced by what we might call the 'idea idea'. As Joseph Kosuth famously claimed, the actual works of art are the ideas. And Sol LeWitt

[4] Indeed, much of the popular press at the time expressed exactly that view, albeit in more vitriolic tones than we might expect in academic circles. For example, Tony Parsons in the Daily Mirror remarked 'Can a fire ever be funny? Only if all the overpriced, over-discussed trash that we have had rammed down our throats in recent years by these ageing enfant terribles is consumed by the fire. Then the fire is not merely funny . . . it is bloody hilarious' (*The Guardian*, 23 September 2004).

[5] Young speaks more widely of '*avant-garde* art', but he clearly intends this 'style' to include the 'sub-style' of conceptual art (2001: 136–7).

wrote in a similar vein: 'In conceptual art the idea or the concept is the most important aspect of the work. When an artist uses a conceptual form in art, it means that all of the planning and decisions are made beforehand, and the execution is a perfunctory affair' (LeWitt 1969). It is precisely this rejection of the aesthetic, and the focus on the ideas 'behind' the work, that places a particular burden on conceptual art to demonstrate that it has some other kind of value, namely cognitive value. Can we learn anything from conceptual art, and if so, what kind of knowledge do we gain, and from what kinds of works?

9.2 The Argument that Conceptual Art Lacks Cognitive Value

In order to appreciate Young's argument that conceptual art lacks significant cognitive value, we need first to appreciate a contrast that he draws between two types of representation: *semantic representation* and *illustrative representation*. It is through illustrative representation, Young says, that traditional artworks have been a source of practical and moral knowledge. The fundamental problem with conceptual art, in contrast, is that 'it has been characterized by an erosion of illustrative representation and its replacement by semantic representation' (Young 2001: 135). The idea, at least in outline, is really very intuitive, and connects directly with what is at the heart of conceptual art. As part of what comes with the rejection of traditional media such as painting and sculpture, we get the rejection of illustrative representation; and as part of what comes with the replacement of traditional media by the 'idea idea', we get semantic representation. So we need to see why, according to Young, illustrative representation, associated with traditional art and its traditional media, can be a source of significant knowledge, and why semantic representation, associated with conceptual art, fails to be a source of significant knowledge. But first we need to understand what illustrative representations or semantic representations are.

Let us start with illustrative representation. Illustrative representation can provide *illustrative demonstration*; this is a kind of 'non-rational' showing, which can 'open perspectives on objects so that audiences may achieve a fuller understanding of them' (*ibid.*: 80). Of course not all perspectives yield knowledge, but a perspective will yield knowledge if it is 'right': 'A perspective

is right when it aids people who adopt it in the acquisition of knowledge'
(*ibid.*: 69). In other words, traditional artworks can yield knowledge, not
by constituting *arguments* to a conclusion, but by *showing* things in the right
perspective. This is what Young says:

> [Traditional a]rtworks cannot provide rational demonstrations of perspectives, but
> they can provide illustrative demonstrations of the rightness of a perspective. That is,
> artworks can put audiences in a position to recognize the rightness of a perspective.
> In *Pride and Prejudice*, Jane Austen does not argue for a perspective on first impressions
> (that they are a poor guide to character) or on inflexible pride (that it is a failing).
> Neither does Picasso's *Guernica* constitute an argument for a perspective on the aerial
> bombardment of civilian populations (that it is indefensibly horrible). Nevertheless,
> both of these artworks present demonstrations just a surely as the theory of evolution
> does. They show or provide illustrative demonstrations. They represent objects
> (human relations or modern war) in such a way that audiences are put in a position
> where they recognize the rightness of a perspective on some matter. (*Ibid.*: 69)

There is one other kind of illustrative representation which we need to
consider here, and which Young calls *exemplification*. An exemplar 'stands for
some property by possessing the property' (*ibid.*: 72): a paint chip exemplifies
the colour of the paint in the can (*ibid.*: 28); a cocktail shaker exemplifies the
property of being a cocktail shaker; Malevich's picture *Red Square* exemplifies
the property of being red. The only kind of exemplification that Young accepts
is what he calls 'literal exemplification'. This is part of a disagreement with
those who advocate metaphorical exemplification: the idea that, for example,
a frenzied painting, whilst not literally frenzied, 'might be metaphorically
frenzied and able to exemplify frenzy metaphorically' (*ibid*: 74). This notion,
Young says, is 'deeply confused' (*ibid.*: 74). The details of this disagreement are
not relevant here, for I will be focusing exclusively on literal exemplification.

Illustrative representation contrasts with *semantic representation*. True declar-
ative sentences of a language are the most familiar examples. A semantic
representation, even if it is true, has no cognitive value unless it is supported
by argument; it can provide knowledge only through *rational demonstration*,
'demonstration by means of an argument, . . . a series of statements designed
to support a conclusion' (*ibid.*: 68). For example, the bare statement of the
theory of evolution does not constitute a rational demonstration, and thus
the statement of the theory on its own cannot provide knowledge; it can
only do so when supported by evidence. The fundamental contrast, then,
between the two sources of knowledge is between, on the one hand, illustrative

representations which show, without the need for supporting argument, the 'rightness' of a perspective; and, on the other hand, semantic representations which require supporting argument to be a source of knowledge.

Now, Young says, and I agree, that most conceptual artworks are either illustrative representations that are exemplifications, or they are semantic representations. In either case, he claims, whether exemplification or semantic representation, conceptual artworks fail to have significant cognitive value. Roughly, the first problem, with conceptual artworks that are exemplifications, is that they provide at best 'knowledge of only rather trivial matters' (*ibid.*: 140). And, roughly, the second problem, with conceptual artworks that are semantic representations, is that they provide no rational demonstration by means of an argument, or, where there is a rational demonstration, the cognitive value is to be found not in the artwork but in the supporting documentation. Young accepts that conceptual artists often intend their artworks to have significant cognitive value, but they fail to achieve what they intend. I will consider these two problems in turn, first setting out Young's arguments in more detail, and then giving reasons why we should not accept his arguments.

9.3 The First Problem: Conceptual Art and Exemplification

Bridget Riley's *Cataract III* is a work which exemplifies the property of causing after-images, which 'lead to the experience of colours that are not present in the painting' (Young 2001: 144).[6] This is known as 'optical bleed'. Young accepts that someone who looks at this picture can gain knowledge of what it is like to experience optical bleed. However, he says, this knowledge is trivial. I agree with Young's judgement about *Cataract III*. But this example by no means shows that all exemplificatory artworks yield only trivial knowledge. Indeed, there are a number of interesting works of conceptual art that yield significant what-it-is-like knowledge that is non-trivial through exemplifying certain properties. Let me now consider just one example.

In September 2002 invitations were sent out to members of the art scene to attend the opening of the £500,000 extension of the Lisson Gallery in Bell Street

[6] This is not a work of conceptual art, although it is an *avant-garde* work; cf. *n.*5.

in London. When the guests turned up, expecting champagne and canapés, what they found instead was that the whole of the front of the gallery was boarded up by a large expanse of corrugated iron, with no means of entrance. The guests were at first puzzled, and then many of them became angry and frustrated at being shut out. Finally, the artist, Santiago Sierra, turned up and told them that this *was* the exhibit, called *Space Closed by Corrugated Metal* (see Illustration 10). Sierra is quoted in *The Guardian* as saying: 'It was part of a broader work which is a commentary on frustration at not being able to get in somewhere for economic or political reasons.' *The Guardian* continues: 'It was prompted by events in Argentina, where, following the collapse of the peso, banks pulled corrugated sheets across their buildings to stop people from withdrawing their savings.'[7]

The relevant property that Sierra's *Space Closed* exemplifies can provisionally be described as the property of causing anger and frustration at being locked out and excluded from a place where one considers one has a right to be. Now, unlike coming to know what it is like to experience optical bleed, coming to know what it is like to experience anger and frustration in this particular way is, I will argue, non-trivial knowledge. But in what sense is this knowledge, and is it only to be gained by those who had direct experience of the work—by those who were actually present at what they thought was the opening of the Gallery?

Let us distinguish. First, there is someone who is gaining for the first time this kind of what-it-is-like knowledge, who for some reason has never previously experienced anger and frustration in these kinds of circumstances—circumstances of being locked out and excluded from a place where one considers one has a right to be. In this case, direct experience of the work would seem to be necessary; analogously, Mary, the scientist in Frank Jackson's famous thought experiment who has lived in a black-and-white world (Jackson 1982, 1986), had to have direct experience of the ripe tomato (which exemplified the property of redness) in order to come to know for the first time what it is like to see something red. Then, second, there are those (most of us I suppose) who have previously experienced anger and frustration in these kinds of circumstances. Here, I do not think direct experience of the work is necessary. Once you know what it is like, perceptual imagining through putting yourself in the shoes of those who were

[7] *The Guardian*, 11 October 2002.

actually present may well be sufficient for having the what-it-is-like experience, perhaps aided by 'documentation', photographs and other supporting information.

This now leads us to the other part of our question. In what sense does someone (like most of us) who has had this kind of experience before gain knowledge from perceptually imagining the experience, or from having been one of those who was actually present at the Gallery, and in what sense is this knowledge non-trivial? Is this not as if Mary were to see Malevich's *Red Square* just after she had seen the ripe tomato, where all the knowledge of what it is like to see red is gained from the first experience and none from the second? I think not for two reasons, both of which are connected with the sheer complexity and richness of the causal property exemplified by *Space Closed*, as compared with the property of being red and the property of causing optical bleed.

First, our provisional description of *Space Closed* as having the property of 'causing anger and frustration at being locked out and excluded from a place where one considers one has a right to be' is incomplete. Part of the work—part of the performance—was the clearing-up of the deception so that those present came to see that their anger and frustration was misplaced, and, in a sense, to see themselves in a new light, seeing their reaction, perhaps, as rather pompous and self-regarding, and thereby coming to know something about their own character that might not have previously been available to them. Moreover, this experience is also available (although admittedly not in such a stark way) to those who weren't present, but who perceptually imagine the experience.

Second, knowledge from an encounter or imagined encounter with *Space Closed* can be gained by those of us who already know what it is like to experience anger and frustration in these kinds of circumstances because the artwork puts us in a special position to *reflect* on the experience. We can reflect on what it must be like to be unable to 'get in somewhere for economic or political reasons'; we can reflect on how many people around the world find themselves in such a dire position; and we can reflect on our own position of relative security to so many others, and on how our own reaction to the events reveals something to us about our own self-regard. The property thus exemplified by this work, and the emotional experience that it engenders, is sufficiently complex and rich for us to be able to return to the work in

imagination on several occasions in order further to enrich our knowledge, including self-knowledge, through this kind of reflection.

Sierra's *Space Closed* is just one of many works of conceptual art which set out to provide significant what-it-is-like knowledge by giving rise to emotional responses that are not amongst those that are traditionally thought of as aesthetic. With *Space Closed* these emotions were anger and frustration; other conceptual artworks aim to engender disgust, horror, and other emotions that are typically considered to be 'negative'. Whether or not the what-it-is-like knowledge that a particular work of conceptual art provides is significant (bearing in mind that significance is a notion that admits of degree) will depend on the properties of that particular work. In the case of *Space Closed* I argued that this knowledge is significant: it is about significant worldly concerns, and it can reveal significant self-knowledge. In the case of *Cataract III*, I agreed with Young that the knowledge was not significant. But an answer has to be sought in respect of each individual work: a blanket dismissal of all will not do. In this respect conceptual art is no different from traditional art.

Now, our being able fully to appreciate the complex and rich causal property exemplified by conceptual artworks such as *Space Closed* draws on—indeed, it *depends* on—our being able to appreciate and understand the intentions of the artist. These intentions are often inaccessible through inspection of the work itself, as they were in *Space Closed*. Young takes this dependency to be an impediment to the work's having cognitive value. I will deal with this concern in the next section. But so far at least, consideration of *Space Closed* shows that not all exemplification is 'at best, a source of knowledge of only rather trivial matters'.[8]

Let me now turn to what Young has to say about conceptual art and semantic representation. The problem here, you will recall, is roughly that those artworks which are semantic representations lack cognitive value because they provide no rational demonstration by means of an argument, or, where there is a rational demonstration, the cognitive value is to be found not in the artwork but in the supporting documentation.

[8] There is an interesting question here concerning the boundaries of the aesthetic and the cognitive, and whether the kind of experience I am suggesting *Space Closed* can give rise to is, in the end, aesthetic as well as cognitive (and we might even ask the same question about Mary's experience). For discussion, see Schellekens 2005.

9.4 The Second Problem: Conceptual Art and Semantic Representation

Many works of conceptual art are what Young calls semantic representations. Some works, which are 'pure' conceptual art, are those in which 'statements of natural languages become works of art' (2001: 150). Young's example is Jenny Holzer's *Truisms*, one such being 'The world works according to discoverable laws' (see Illustration 1). Many other conceptual artworks, Young accepts, aren't *just* semantic representations, but they become 'semantically enfranchised' by a discourse—they are what he calls *discourse-dependent*: they 'cannot be understood and do not represent, except in conjunction with what is said about them' (2001: 146). One such work, as we have just seen, is *Space Closed*, but let us consider one of the examples given by Young of a discourse-dependent artwork, namely Warhol's *200 Campbell's Soup Cans*. Young does not deny that this picture is an illustrative representation of soup cans. But:

[n]o one suggests that it is an artwork *qua* illustration of soup cans. . . . The important feature of a Warhol picture of soup cans is that it is intended to represent something besides soup cans. In particular, it is intended as a representation of facts about images and quotidian life in the modern world. . . . The painting is, however, unable to represent these facts by itself. It can do so only in conjunction with a body of discourse (that is, semantic representations). (2001: 139)

These artworks are about non-trivial matters (Holzer's about the discoverability of laws of nature, Warhol's about consumerism and the modern world), but, being either pure semantic representations or discourse-dependent representations, they will have cognitive value only if justification for the statements, in terms of reasons, is provided (*ibid.*: 149). So Holzer's *Truism*, 'The world works according to discoverable laws', lacks cognitive value because there is no justification provided for it. Warhol's *200 Campbell's Soup Cans*, being discourse-dependent, might provide justification from the associated discourse, and thus might have cognitive value, but then all the cognitive value is in the associated discourse on which the artwork depends, and the artwork itself is redundant. Discussing Duchamp's *Fountain*, for example, Young accepts that it concerns non-trivial truths about what constitutes art, but '[n]othing is gained by contemplating the sculpture [*Fountain*] as well as becoming acquainted with the discourse' (*ibid.*: 150). And I presume he would say the same about *Space Closed*.

How is one to reply to Young's argument? Essentially, what I want to suggest is that it is a mistake to think that discourse-dependent artworks only have cognitive value if they provide rational demonstration by means of an argument. The cognitive value of artworks is not exhausted by their capacity to provide knowledge in the sense of justified true belief. This thought has already been foreshadowed by our consideration of *Space Closed*, which, I argued, had cognitive value through providing a rich and complex what-it-is-like kind of knowledge. The conceptual artworks that I now want to consider possess another kind of cognitive value. Let me begin with an example, and then attempt an argument. The example is *An Oak Tree*, by Michael Craig-Martin (1973). This work (see Illustration 2) consists of a glass of water on a perfectly ordinary bathroom shelf, situated almost three metres high on the wall. But this is not all. When exhibited, a label nearby said that the work was called *An Oak Tree*, and '[t]here was only one other thing in the gallery: a sheet of paper with a series of anonymous questions and answers on it':

Q: To begin with could you describe this work?
A: Yes, of course. What I've done is change a glass of water into a full-grown oak tree without altering the accidents of the glass of water.
Q: The accidents?
A: Yes. The colour, feel, weight, size.
Q: Haven't you simply called this glass of water an oak tree?
A: Absolutely not. It is not a glass of water anymore. I have changed its actual substance. It would no longer be accurate to call it a glass of water. One could call it anything one wished but that would not alter the fact that it is an oak tree . . .
Q: Do you consider that changing the glass of water into an oak tree constitutes an artwork?
A: Yes. (Godfrey 1998: 248)

This is clearly a discourse-dependent artwork in the sense intended by Young: not only does successful interpretation have to draw on the title, but it also has to draw on the provided set of questions and answers. What are we to make of the work? Clearly, we can understand it as being concerned with transubstantiation—a fact which would have remained unknown to us without access to the discourse. Transubstantiation is a philosophically difficult notion, as any Catholic will know. But there is no *argument* about transubstantiation, no rational demonstration of its possibility (or impossibility), and so, according to Young's account, the work lacks cognitive value.

My reply is this. There is a kind of cognitive value that many good conceptual artworks possess (and *An Oak Tree* is one such), which has been ignored by

Young. These works can help us to *think about* certain difficult philosophical ideas (and transubstantiation is one such). They achieve this *in an artistic way*, and not a discursive or philosophical way. This is their cognitive value. So an artwork's being of cognitive value isn't restricted to its yielding knowledge in the form of propositional knowledge, of justified true beliefs. It can also be cognitively valuable in that it *facilitates* knowledge, and enhances our intellectual dispositions. This broader conception of cognitive value, possessed by many good conceptual artworks, helps to explain an important fact: we can return to these artworks time after time and *continue* to find cognitive value in them, and this could not be explained if all they yielded were propositional knowledge.[9]

There are (at least) two possible objections to this claim, both of which raise difficult issues that would take a lot more argument to deal with fully. But I hope that consideration of these objections will help to bring out in more detail what I mean by this kind of cognitive value.

First, one might accept that cognitive value can be extended in this way, but still insist, with Young, that all the cognitive value is in the discourse on which the artwork depends, and that the artwork itself is redundant. At this point we might reply that this objection is grounded in too narrow a conception of what works like *An Oak Tree* consist of. (The following remarks apply mutatis mutandis to *Space Closed*—another discourse-dependent work as we have accepted.) If we were, with David Davies (2004), to think of the work as a performance, to be individuated in a way that includes not only the shelf and the glass of water, which Davies calls 'the focus of appreciation', but also the discourse and much else besides, then a lot of the sting would be removed from this objection: for we can then say that it is the work *qua* performance that has this kind of cognitive value. But then the objection can turn into this: is the focus of appreciation now redundant? After all, this does seem to be behind the remarks of Sol LeWitt cited above.

I think the best response to this objection is to say that it fails to do justice to what is involved in contemplating a work such as *An Oak Tree*, and what is involved in returning to it time after time in the way I have been discussing. It is precisely the focus of appreciation that we return to, either through direct perception of it, or through perceptually imagining it; although we do this with the backgrounding discourse in mind, and perhaps guided by documentation and photographs, it is not the discourse as such, or the documentation

[9] See Lopes 2005, which has helped me considerably here.

and photographs, that helps us time and time again to think about (and to 'problematize') the philosophically difficult notion of transubstantiation.

The second objection to my claim that discourse-dependent conceptual artworks can have cognitive value, takes a different tack. Consider Joseph Kosuth's *One and Three Chairs* (1965) (see Illustration 5). This work raises many interesting philosophical questions about representation, about tokens and types, and about what is real. Now, say I was to set up the 'three chairs', one real, one a photograph of a chair, and one a definition of a chair, as part of a philosophy lecture, perhaps to help my students to think about Plato's discussion of forms in his *Republic*. Would this be raising philosophical questions in an artistic way? Surely not. So what is it that makes 'products' such as *One and Three Chairs* and *An Oak Tree* artworks *as such*, and in virtue of what are we justified in saying that they raise philosophical questions in an *artistic* way?

My response is very straightforward. No doubt we do need an independent account of what makes the doings of conceptual artists a kind of art-making as such, and not, for example, a way of doing philosophy. But there are plenty of good accounts of what art is that do just this.[10]

But now I might be faced with a third objection (I said there were at least two). If it is accepted that there are philosophical ways of thinking about the notion of transubstantiation, particularly through philosophical discourse, and that there are distinctively artistic ways, what is so cognitively special about the artistic ways? Why isn't the cognitive value in the latter otiose or at least plainly inferior to what is to be found in the former?

I could simply accept the force of this objection and then rest my case there: at least I would have shown that these kinds of conceptual artworks have cognitive value, even though it is otiose, or at least inferior to philosophical discourse. But I would like to try at least partially to deflect its force. My claim, that conceptual art can facilitate knowledge through helping us to think about philosophical ideas, is not intended to suggest any kind of a threat to philosophical discourse on behalf of conceptual art—as if conceptual artists could realistically aspire to supplant what philosophers do when they are doing good philosophy.[11] Nor is it intended to suggest that any philosopher, however deeply immersed he or she has been in the difficulties of transubstantiation, will always be able to

[10] See, for example, Levinson 1979, 1989, and Davies 2004.

[11] It may well be that some conceptual artists do have such aspirations (see the Editors' Introduction to this volume); but it is no part of my brief to defend *them*.

think better about transubstantiation, or will always find his or her intellectual dispositions enhanced by contemplating *An Oak Tree*. The claim is just that it *can* help us—some of us—to think, and the deeply immersed philosopher should not forget what a struggle it was to get to where she now is intellectually. She should look with understanding on her excellent graduate student who has a reproduction of *An Oak Tree* pinned to the wall above his desk to help him to think about the difficult philosophical notion of transubstantiation, and to help him to get his intellectual dispositions to a level approaching those of his mentor whom he so much admires. Moreover, she should think of all those people who do not aspire to be philosophers as such, and who find philosophical discourse and argument utterly unintelligible, but who are nevertheless profoundly intrigued by philosophical ideas; these people too might be helped to gain a grasp of the idea of transubstantiation through contemplating *An Oak Tree*. Such contemplation might be otiose for her, or at least inferior to what she can get from philosophical discourse, but not everyone is like her in this respect.

9.5 Conclusion

I have tried to show that conceptual art can have cognitive value: some works, like *Space Closed*, can yield significant what-it-is-like knowledge through exemplification of complex and rich properties; other works, like *An Oak Tree*, can have cognitive value by helping us to think about difficult philosophical ideas and by enhancing our intellectual dispositions. It is surely right, as Young argues, that conceptual art does not provide cognitive value in the way that traditional art has successfully done over the ages—through illustrative representation. Conceptual art does not try to do this and fail. It tries to do something else. And good conceptual art can succeed in what it tries to do. However, the philosopher deeply immersed in the difficulties of transubstantiation need not be missing anything if she finds that *An Oak Tree* does not help her in her intellectual task. In this respect (as perhaps in others too), conceptual art is not for everyone.[12]

[12] Earlier versions of this chapter were presented at an interdisciplinary research seminar in Oxford, *Philosophy and Theory of the Visual Art*, in May 2004, at a conference on David Davies's *Art as Performance* in Maribor in July 2004, and at the Pacific Division of the *American Philosophical Association* in Asilomar in April 2005. I am grateful for the many helpful comments that I received on these occasions, and especially for detailed comments and suggestions from Rob Hopkins and Elisabeth Schellekens.

References

BINKLEY, T. (1977), 'Piece: Contra Aesthetics', *Journal of Aesthetics and Art Criticism*, 35: 265–77.

DAVIES, D. (2004), *Art as Performance* (Oxford: Blackwell).

GODFREY, T. (1998), *Conceptual Art* (London: Phaidon Press).

JACKSON, F. (1982), 'Epiphenomenal Qualia', *Philosophical Quarterly*, 32: 127–36.

—— (1986), *'What Mary Didn't Know'. The Journal of Philosophy*, 38: 291–5.

LEVINSON, J. (1979), 'Defining art historically', *British Journal of Aesthetics*, 19: 232–50.

—— (1989), 'Refining art historically', *Journal of Aesthetics and Art Criticism*, 47: 21–33.

LEWITT, S. (1969), 'Paragraphs on Conceptual Art', *Artforum*, 5/10: 203

LIPPARD, L. (1973), *Six Years: The Dematerialisation of the Art Object from 1966 to 1972* (Berkeley: University of California Press).

LOPES, D. McIVER (2005), *Sight and Sensibility: Evaluating Pictures* (Oxford: Clarendon Press).

SCHELLEKENS, E. (2005), ' "Seeing is Believing" and "Believing is Seeing" ', *Acta Analytica*, 20/4 (October): 10–23.

SMITH, R. (1999), 'Conceptual Art: Over, and Yet Everywhere', Arts & Leisure', *The New York Times*, Section 2, 25 April.

YOUNG, J. (2001), *Art and Knowledge* (London: Routledge).

10

Sartre, Wittgenstein, and Learning from Imagination

Kathleen Stock

10.1 Introduction

A well-documented aim of conceptual art is the undermining of the traditional idea of an artwork as a single physically present object. A common method of achieving this is to present to the viewer a prompt designed to make her think of some absent thing. This may take the form of a written description, a title, a map or set of instructions; the absent entity may be a situation, an event, a process, or an object. To take some examples: Laurence Weiner's *Statements*, consisting of descriptions of objects or processes, such as 'One quart exterior green enamel thrown on a brick wall';[1] Douglas Huebler's *New York—Boston Shape Exchange*, which uses 'maps and instructions to propose the creation of identical hexagons (one in each city) 3,000 feet on a side, whose points would be marked by white stickers 1 inch in diameter';[2] Walter De Maria's *Vertical Earth Kilometer* (see Illustration 11), consisting of a one-kilometre long brass rod sunk into the ground with only the top end visible, a small brass disc 2 inches across; John Baldessari's text-only 'narrative paintings', such as 'Semi-close-up of girl

[1] Documented in Lucy Lippard, *Six Years: The Dematerialization of the Art Object from 1966 to 1972*, 2nd edn. (Berkeley, CA: University of California Press, 2001), 37.

[2] Roberta Smith, 'Conceptual Art' in Nikos Stangos (ed.), *Concepts of Modern Art*, 3rd edn. (London: Thames and Hudson, 1994), 261.

by geranium (soft view) finishes watering it—examines plant to see if it has any signs of growth—finds slight evidence—smiles—one part is sagging—she runs fingers along it—raises hand over plant to encourage it to grow';[3] Iain and Elaine Baxter's 'imaginary visual experiences';[4] Vito Acconci's *Following Piece*, which in addition to photographic illustrations displays the instruction 'Choosing a person at random, in the street, any location, each day. Following him wherever he goes, however long or far he travels. (The activity ends when he enters a private place—his home, office, etc.)'; and so on.

Prima facie it seems plausible to claim that the imagination of the viewer is importantly involved in appreciation of such works, as part of what understanding them requires. Such a claim is apparently endorsed by Mel Bochner when he writes that '[i]magination is a word that has been generally banned from the vocabulary of recent art...There is, however, within the unspecified usage of the word a function which infuses the process of making and seeing art. . . . Imagination is a projection, the exteriorizing of ideas about the nature of things seen. It reproduces that which is initially without product'.[5] For many conceptual works, then, it is natural to assume that viewers are supposed to attend, not only to whatever object is given in perceptual experience, but also, in imaginative thought, to some absent object, action, event, or idea.

Let's assume that there are two principal kinds of imagining: 'bare' propositional imagining (imagining that p, where p stands for some proposition, with no associated imagery);[6] and visualizing (imagining which involves a visual image, or 'image' associated with some other sense modality). Often, as with many of the examples cited above, the viewer is supposed to imagine what the relevant absent entity would look like if it existed physically, i.e. to visualize it,[7] although more rarely it may be that what she is supposed to imagine has no correlate in sense experience, in which case propositional imaging may be what is required. Where visualizing is required by a work, it is also natural to assume that the

[3] Documented in Lippard, *ibid.*, 58.　　[4] Documented in *ibid.*, 67.

[5] Mel Bochner, 'Excerpts from Speculation; *Artforum*, 8/9 (May 1970), 79–83 quoted in Alexander Alberro and Blake Stimson (eds.), *Conceptual Art: A Critical Anthology* (Cambridge, MA and London: MIT Press, 2000), 194–5.

[6] Though rough, this is accurate enough for my purposes.

[7] More rarely, one might be required to imagine an experience in another sense modality, e.g. Bruce Naumann's instruction 'Drill a hole in the heart of a large tree and insert a microphone. Mount the amplifier and speaker in an empty room and adjust the volume to make audible any sound that might come from the tree'. Documented in Lippard, *ibid.*, 162–3.

viewer's images play a genuinely informative role, in so far as by having them she learns, at least, what the relevant absent entity would look like,[8] were it to exist physically. Reflection upon such information plausibly may lead or contribute to other thoughts of intrinsic value connected to the work's meaning.

One might be wary of the claim that imagining, and visualizing in particular, is involved in understanding conceptual works, on the grounds that it apparently commits us to treating works and the thoughts to which they give rise as quasi-aesthetic objects, something that many conceptual artists wish to avoid. Such wariness would be misplaced, however. That such imagining is required does not entail that the viewer should focus on the aesthetic aspects of the imagined object or experience, but only the perceptible ones, assuming these are different. Furthermore, even where she does the former, it may only be instrumentally important that she do so, for the more abstract thoughts and concepts onto which she is then led. In any case, even if it does entail this, to rule out the thought of aesthetic properties a priori as irrelevant to the comprehension of a piece of conceptual art seems to me to be unnecessarily restrictive.

I suppose it might be objected instead that in grasping conceptual artworks such as the ones described, what needs to be understood is simply the thought that the relevant artwork is not a visible material object, and not some further image or thought of what is absent. The former thought, it might be argued, conveys all that the artist wishes to, which is that a material object in the traditional sense is not essential to the experience of art. Yet this response also seems wrong, in so far as it reduces the meaning of all such conceptual works to a single point, which might be made equally well by any one of them, thus rendering the others redundant. In addition it seems wrong, both with regard to the particular works described and in general, to rule out in advance any of the meanings which might be derived from a full imaginative exploration of a conceptual work in its specifics.

Hence as yet we have encountered no good reason to deny that imagination can be important to the comprehension of conceptual works. There looms a threat to this view from other quarters, however: this time, more worryingly, from eminent philosophical ones. Jean-Paul Sartre denies that learning about objects from visualizing is possible, arguing that the image teaches nothing, never produces an impression of novelty, and never reveals any aspect of

[8] Learning what things would look like, I take it, may include learning about their aesthetic aspects, but is not confined to it.

the object.[9] Ludwig Wittgenstein agrees: '. . . imaging . . . does not instruct us about the external world'.[10]

Their respective grounds, which shall be discussed in more depth shortly, can be summarised as follows:[11]

1. One does not observe mental images.
2. One does not interpret mental images, as one would signs or pictures.
3. Mental images are constituted by the thinker, not received from the world.
4. Mental images are subject to the will.
5. Mental images are superfluous to any conclusion reached.
6. One cannot be misled about the object of one's mental image.

If these claims and the conclusions drawn from them by their authors are right, then there are apparent consequences for the claim that visual imagining is important to the grasping of the point of many conceptual works. If one can learn nothing new about the world from visualizing—if our images are somehow unreliably connected to what is the case, and cannot genuinely inform us about entities in the world—then the idea that through visualizing in response to a conceptual work, we can come to some new knowledge of the appearance of an absent object or situation, and through that, of further ideas or concepts, looks pressurized.[12]

[9] Jean-Paul Sartre, *The Psychology of Imagination* (London: Methuen, (1972), 9 (henceforth *POI*).

[10] Ludwig Wittgenstein, *Remarks on the Philosophy of Psychology*, II, ed. G. H. von Wright and H. Nyman (Oxford: Blackwell, 1980), §80 (henceforth *RPPII*).

[11] Sartre and Wittgenstein each tend to take certain of these conclusions as supported by others on the list. For instance, Wittgenstein connects (4) to (1) (e.g. *Remarks on the Philosophy of Psychology*, I, ed. G. H. von Wright and H. Nyman (Oxford: Blackwell, 1980), §131 (henceforth *RPPI*); *RPPII*, §885); and to (3) (e.g. Wittgenstein, *Zettel*, ed. G. E. M. Anscombe and G. H. von Wright (Oxford: Blackwell, 1981), §632). Meanwhile, Sartre defends (1) by citing (6) (*POI*, 7) and (3) (*ibid.*). For this reason, it is somewhat artificial to take each of these conclusions separately. Nonetheless I shall do so, since I think that they can be separated, and since my primary goal is to see whether any of them function as reasons to deny that one can learn from visualizing.

[12] One may seek to block this implication by arguing that typically a conceptual work requires that the viewer have a thought with a certain content, corresponding to the content of the work. Meanwhile, it may be objected, Sartre's and Wittgenstein's arguments do not threaten this requirement, in so far as they do not undermine the view that in having a mental image one can learn something about thought content, but only the view that one can thereby learn about objects in the world. However, even if this is a better characterization of the requirements upon a viewer of conceptual art, typically the content of a conceptual work which viewers are supposed to grasp is thought content which is potentially new to the viewer (including, usually, thought

In the rest of this paper, I shall concentrate on the conclusions about images drawn by Sartre and Wittgenstein. I shall identify certain reasons they present for denying that visualizing can teach us about objects, and suggest that they are not sufficient to establish this. Later on, I shall suggest that, had such reasons succeeded, it would have followed that nothing could be learnt from propositional imagining either, thereby ruling out propositional imagining as a route to the illumination of the meanings of conceptual artworks, as well as visualizing. Hence, as well as being of broader philosophical interest, my argument will allow us to retain imagining of both kinds as a potentially central activity in interaction with conceptual works.

A few preliminaries: first, my goal is to scrutinize certain claims of Sartre and Wittgenstein in relative isolation, rather than to attempt to integrate them into a reconstruction of the respective wider views. Second, though there is much of interest to say about memory images, I shall focus only on claims about visualizing in an imaginative sense. Third, the claim that one cannot learn about objects from visualizing is consistent with the possibility that one can learn thereby about other things: for instance, about one's emotions, desires, neuroses, and so on. Here, however, I shall concentrate on learning about objects.

(1) One does not observe mental images.

This is the well-known point that one does not *observe* mental images to see what they represent, as one might look at a picture or observe some object in the world and reach a conclusion as to its nature.

Our attitude towards the object of the image could be called 'quasi-observation'.[13]
A principal mark that distinguishes image from sense-impression and from hallucination is that the one who has the image does not behave as an observer in relation to the image . . .[14]

Comment can be made relatively swiftly. It is true that one does not observe mental images to see what they are 'of', not least for reasons offered by

content of the artist). At face value, some of Sartre's and Wittgenstein's points (specifically, claims (3) and (4), and perhaps (5) and (6) as well) threaten even this revised claim. Though in what follows I shall focus on the possibility of learning about objects from mental images, it should be borne in mind that several of the arguments advanced by my opponents threaten not only this possibility, but also the possibility of learning via images about the thought contents of others. As such, my rejection of these arguments shall deflect at least two possible sources of doubt about the role of imagining in understanding conceptual works.

[13] Sartre, *POI*, 9. [14] Wittgenstein, *RPPI*, §885.

Wittgenstein: in the grammar of mental images, there is no logical role for 'turning my attention onto my own consciousness';[15] no such thing as 'inner pointing',[16] as there would need to be to make sense of the claim that observation occurs here. However, it does not follow from this, considered on its own, that one cannot learn about objects from visualizing.

What does follow, of course, is that one cannot gain *observational* knowledge from visualizing (that is, knowledge acquired, relatively directly, via observation). However, this is not the only kind of knowledge there is, obviously. Sartre has been charged with implying that all knowledge is observational: that

I cannot *gain* knowledge about something through a *purely* mental activity—i.e., without taking in something 'from outside' or, more specifically, without perceiving something about it.[17]

If this is indeed his view,[18] then the existence of conceptual knowledge, derived through 'pure' reflection, clearly refutes it, as does the existence of empirical knowledge derived via reflection on existing non-perceptual beliefs.[19] It remains to be seen whether, analogously, non-observational knowledge of some kind is available from visualizing.

(2) One does not interpret mental images, as one would signs or pictures.

Sartre's defence of this claim, like the last, comes in an attack on what he calls 'the illusion of immanence': the view of mental images as objects 'in' the head, to be interpreted. On the rejected view, in having an image of an entity E, one has an element representing E somehow 'in' one's consciousness, which bears only an 'extrinsic' relation to the objects it represents, standing towards it in the relation of a sign or picture, which has to be interpreted in order to render its meaning.

Sartre seems right to reject this. Broadly construed, signs are understood either by learning a set of associations, or conventions. Neither of these is the appropriate model upon which to construe one's relation to a mental image. As Sartre notes,[20] mental images are not items one has to *learn* to interpret, as signs are. Furthermore, that mental images require interpretation

[15] Ludwig Wittgenstein, *Philosophical Investigations* (Oxford: Blackwell, 1953), §412 (henceforth *PI*).

[16] Wittgenstein, *PI*, §669–71.

[17] Paul Taylor, 'Imagination and Information', *Philosophy and Phenomenological Research*, 42/2 (1981), 208.

[18] This view reappears in Alan White, *The Language of Imagination* (Oxford: Blackwell 1990), 111.

[19] Taylor, *ibid.*, 209. [20] Sartre, *POI*, 68.

would entail there being, potentially, two acts of consciousness rather than one: an initial, perhaps confused, cognition of the image, followed by an interpretative conclusion. This does not ring true phenomenologically (as Sartre puts it, 'the material of the mental object' is 'already constituted as an object for consciousness');[21] additionally, there is the fact, suggested by remarks of Wittgenstein,[22] that we have no criterion for establishing whether in this case one would be mentally engaging with one image on two occasions, or two.

Nor does an image of E stand for E in virtue of resemblance relations, as pictures may do.[23] First, as acknowledged, one does not observe mental images, as the claim would require. Secondly, a picture, taken on its own, might represent any one of several states of affairs. As Wittgenstein notes, for instance, a picture of 'an old man walking up a steep path leaning on a stick' might have looked 'just the same if he had been sliding downhill in that position'.[24] If one were to treat images as pictures, whose objects were determined by what they (most) resembled, their content would be potentially ambiguous, even to the thinker. Yet the content of mental images, like most mental content, is transparently accessible to the thinker (of which more later).

However, that understanding a mental image is not equivalent to interpreting a sign or picture does not entail that one cannot learn about objects from visualizing. That in consideration of mental images, there is no act of interpretation, but only one experienced stage—becoming immediately and directly conscious of what an image is 'of'—does not *in itself* preclude thereby acquiring new knowledge. It might still be possible to say, for instance, that without having had a particular mental image, one would not have known what one now knows.

Consider an analogy: it is widely denied that perception is interpretative, i.e. that one first perceives basic shapes, and only then interprets what such shapes mean. Yet, of course, this should not threaten the conclusion that one can learn about objects from perceptual experience. Nor is the conclusion that we can learn from visualizing jeopardized by an absence of interpretation alone.

(3) Mental images are constituted by the thinker, not received from the world.

[21] *Ibid.*, 61. [22] Wittgenstein, *PI*, §382.
[23] Those that reject this view of pictures presumably see them as conventional.
[24] Wittgenstein, *PI*, *n.* to p. 4e.

The assumption here, endorsed by Sartre, is that, while perceiving is largely a matter of passively receiving information from objects via retinal input, visualizing is, perhaps wholly, a matter of actively creating.

No matter how long I may look at an image, I shall never find anything in it but what I put there.[25]

Wittgenstein expresses a similar thought:

The concept of imagining is rather like one of doing than receiving. Imagining might be called a creative act.[26]

Often this is equated with the claim that mental images are subject to the will (see the next section). However, they are not equivalent,[27] so I shall treat them separately.

One can see why this claim might lead one to conclude that one cannot learn from visualizing: after all, if images are purely a product of the imaginer, then they need bear no reliable relation, potentially, to the objects they represent. However, the antecedent here is false.

One need not endorse a view of images of a perniciously Humean sort[28] to admit that the content of an image of an entity E must coincide, to some extent, with the content of beliefs one has about E. E could not be presented in an image in a way which in no way coincided with any beliefs one had about the nature of E (broadly construed); for in that case, one would not have an image of E at all.[29]

This claim needs to be distinguished from others with which it might be confused. It is not the claim that the content of an image of E must coincide *only* with the content of beliefs one has about E, since otherwise one could not have images of objects with aspects of their habitual appearance altered,

[25] Sartre, *POI*, 7 *et passim*.

[26] Wittgenstein, *RPPII*, §111. See also, Wittgenstein, *Zettel*, §632.

[27] That an image is subject to the will, in the sense explored in the next section, does not entail that it is wholly constituted by the thinker.

[28] Hume largely saw images as copies of sense impressions. The problems with this view are spelled out by Anthony Manser, *Sartre: An Introduction* (New York: Oxford University Press, 1966), ch. 2.

[29] More precisely, the content of an image of an entity E must coincide, to some extent, with the content of *true* beliefs one has about E. If I have only false beliefs about E, then even if such beliefs inform what I take to be an image of E, it is not clear that I actually have an image of E. This qualification is not important for what follows.

as one can. (Indeed, if this were so, arguably, one would not be imagining so much as considering, or remembering, or something like it.) Nor is it the claim that for any image of E, there are certain beliefs *in particular* about E which one's image must reflect: perhaps any given belief one has about an entity may fail to inform one's image of it. What is claimed is that not all of them may, simultaneously. Finally, nor is it the claim that one's image of E must reflect some of one's beliefs *about the visual appearance* of E. In that case, it would not be possible to have a mental image of, say, the Eiffel Tower, totally wrapped in parachute silk, so that its shape is obscured; yet this seems to be possible. The claim is rather that an image of an entity must reflect at least some of one's (perhaps non-perceptually derived) beliefs about it.[30] Of course, typically, one's mental image of an entity E is partly informed by beliefs about the characteristic appearance of E; but perhaps this need not always be the case.

Given this background, it is wrong to suggest that the content of a mental image is wholly contributed by the thinker: *for those beliefs which partly inform a mental image are contributed by the world, not the thinker.* Take the case where I am considering whether a particular green dress of mine would suit a friend and form a mental image of her in it, partly informed by beliefs I already have about the appearances of, respectively, the friend and the dress (though an image need not reflect beliefs about visual appearances, typically, it will). In which case, I got such beliefs from the world. I did not make them up. I originally acquired them through perceptions, either directly or indirectly. Of course, any such image is not *caused* by my friend actually wearing the dress, as a visual image would be, but it is partly caused by aspects of the world nonetheless. Wherever an image is partly informed by beliefs, as all images must be, the world has made a contribution to that image, in so far as the beliefs in question are gained from the world.

So the fact that mental images are partly structured by prior beliefs undermines the claim that such images are wholly constituted by the thinker. This clears a space for a description of how one can learn from visualizing, in virtue of this world-derived content. Later, I shall try to provide such a description.

Meanwhile I need to dismiss a further potential source of the view that mental images are wholly created, not received. This arises in Sartre's comparison of

[30] Admittedly, how a mental image 'reflects' non-perceptual beliefs is a difficult question. Perhaps one way in which it does so is that it constrains the direction events represented in the image may take.

visualizing with perceiving, where he writes that perceived objects exhibit the characteristic of 'brimming over'.[31] Sartre characterizes an entity's 'brimming over' in terms of two factors, potentially: firstly, its standing in an in(de)finite[32] number of (presumably perceptual or conceptual) 'relationships' to other objects, or secondly, its being composed of 'elements' which too stand in in(de)finite numbers of relationships to one another, and to the elements of surrounding objects.[33] Objects in visual perception can do both of these things, we are told; objects in mental images can do neither. Most of the relationships in which an object, or elements of it, stand to other objects are not apparent to one on first seeing it, and one could never be aware of all of them from a single perception. In this sense, the nature of an object, understood in a rich sense, always exceeds one's current visual perception of it.[34] In contrast, a mental image displays an 'essential poverty'.[35] The quasi-visual elements of an image do not stand to other things in any relationships other than those in which I already imagine them to do so.[36] This is because the objects of visualizing 'exist only in so far as they are thought of'.[37] While 'the object of the perception overflows consciousness constantly',

... the object of the image is never more than the consciousness one has of it; it is limited by that consciousness; nothing can be learned from an image that is not already known.[38]

Sartre conflates two distinct points here: first, that an image cannot outstrip one's awareness of it, in the sense that it has no features which one is not currently aware of; and second, that *the object of* an image (the thing picked out by the image) cannot outstrip one's awareness of it, in the sense that it has no features which one is not currently aware of. If the latter claim were true, and the features of an object in one's image were entirely determined by whether one was thinking of them or not, and what one was thinking, then clearly, this would support the claim that the object of an image is wholly constituted by the thinker. However, it is false.

Sartre is right in his first point. We have no reason to assume that in becoming conscious of some aspect of an image, one is becoming conscious

[31] Sartre, *POI*, 8

[32] 'Indefinite' seems an improvement on Sartre's 'infinite'; Gregory McCulloch, *Using Sartre* (London and New York: Routledge, 1994), 74.

[33] Sartre, *POI*, 7 [34] *Ibid.*, 7–8. [35] *Ibid.*, 8.

[36] *Ibid.* [37] *Ibid.* [38] *Ibid.*

of something that was 'already there', waiting to be discovered, as part of a picture might be. However, we can concede this without it following that the *object* of an image cannot outstrip one's awareness of it.

For one thing, this seems to contradict the plausible point, insisted upon elsewhere by Sartre, that an image is not a thing in consciousness, via which one is *indirectly* aware of some object in the world, but rather is a way of being related consciously, *directly*, to such an object. To think otherwise is to get it wrong about what the intentional object of thought is.[39] In an image of Peter, for instance,

> . . . [t]he imaginative consciousness I have of Peter is not a consciousness of the image of Peter: Peter is directly reached; my attention is not directed on an image, but on an object.[40]

So we can think of Sartre as a kind of 'direct realist' about mental images.[41] Yet, if we take this insistence seriously, as I think we should, we must admit that (whatever problems this view generates for images of non-existent objects)[42] to have a mental image of, say, Westminster Abbey, is to be directly related in thought to the real Westminster Abbey.

Now, the real Westminster Abbey does not exist only in so far as it is thought of; at least, not on the standard story. Rather it is mind-independent, and indeed 'brims over', i.e. exists in in(de)finite relationships to other objects around it, etc. Sartre cannot maintain that objects in mental images do not brim over, on the one hand, and on the other, maintain that visualizing

[39] *Ibid.*, 2–5. [40] *Ibid.*, 5.

[41] Admittedly, the story is complicated by Sartre's later use of the concept of an 'analogon' which according to him is an intermediary in imaginative thought between thinker and object, though it is not experienced as such by the thinker, who is conscious only of the object. However, as long as he insists that to have an image of x is to be conscious of an x, not of an intermediary which stands for x (as I think he should) then he should also admit that x may 'brim over' in a mental image.

[42] There is much that is problematic about Sartre's 'direct realism', not least the problems that not all images are of existing things (McCulloch, *Using Sartre*, appendix to ch. 2) nor are they 'of' particulars (*ibid.*, 72). The former problem beset accounts of perception, in so far as hallucinations and illusions are possible. Since it is not sufficient to undermine direct realism about perception, and since promising solutions are emerging to this problem (for instance, disjunctivism), I take it that the problem of images of non-existents is not sufficient to undermine direct realism about images, although obviously some further account needs to be given. Anyone worried about the absence of such an account can take the scope of my claims about images as confined to images of existent particulars.

involves direct awareness of some particular in the world. Given the latter claim, he should conclude that, like a perceived entity, an entity in a mental image brims over in so far as the total amount of information potentially available about its characteristics inevitably exceeds the information available in any single mental image of it. That this is so is unaffected by the fact that mental images cannot outstrip our awareness of them.

Still, there does seem something right, at least in spirit, with the claim that objects in mental images cannot brim over. It seems to be this: continuous or repeated perceptions of an object can provide one with various information about the object unavailable via continuous or repeated mental images of it. Most obviously, while changes in visual perceptions of E tend to reflect changes in the nature of E, changes in one's mental image of E do not tend to reflect changes in the nature of E. That is, visualizing cannot give us reliable 'real-time' information about objects.

However, this does not entail that visualizing cannot give us any sort of reliable information about objects *at all*. Many beliefs cannot track 'real-time' changes in objects either, and yet there is no temptation to deny that one can learn about the world from such beliefs. More generally, though it is true that mental images are restricted in the sorts of reliable information they can provide, it does not follow that learning anything about objects from them is impossible. So again, the point fails to show what it is supposed to.

(4) Mental images are subject to the will.

This thought is apparently the main source of Wittgenstein's claim that visualizing cannot give us new information about the external world.[43] The sense in which Wittgenstein claims that mental images are subject to the will is not that they always occur voluntarily, for he admits that some mental images arrive involuntarily.[44] Rather, a mental image is subject to the will in the sense that

it makes sense to order someone to 'Imagine that', or again: 'Don't imagine that'.[45]

In contrast, it makes no sense to order someone to see something, providing their eyes are open and they are looking with full attention. From this, Wittgenstein concludes that

[43] This is stressed by Malcolm Budd, *Wittgenstein's Philosophy of Psychology* (London and New York: Routledge, 1991), 104, 113, *et passim*.

[44] Wittgenstein, *RPPII*, §83. [45] *Ibid.*, §86.

[i]t is just because imaging is subject to the will that it does not instruct us about the external world.[46]

Now, perhaps the central point that Wittgenstein is making is only that the fact that visualizing is subject to the will distinguishes its occurrence from *observing*.[47] Whatever, it is certainly true that prima facie his remarks support the broader claim.[48] Hence it is worthwhile examining what consequences follow from the subjection of images to the will for the possibility of learning.

That mental images are subject to the will in the sense identified seems right. Even where a mental image has occurred involuntarily, it makes sense to order someone to stop imagining it, or at least, to try to. However, it is not clear why the fact that one can sensibly be ordered to have a thought, or not to have, should entail that one cannot learn from it while one has it. A history student can be ordered to think about the Great Exhibition, rather than daydreaming, without it following that they can learn nothing from any thoughts they then might have. In short, the fact that a mental item is subject to the will in the sense intended, when considered on its own, does not offer any reason to deny that one can learn from that item about objects in the world.

One might object that the sense considered in which a mental image may be subject to the will is unduly restrictive. In fact, there are two different things that might be meant by this. One is that the occurrence of a mental image is subject to the will, in the sense that one sensibly can be ordered to have it, or not. This is the sense just discussed. The second is that the *content* of a mental image is subject to the will.

Presumably this claim cannot mean that images with certain contents never occur involuntarily, for again this is to ignore the fact that certain images, with particular contents, can occur to one unsought. A better interpretation is that, for any mental image, it would make sense to order someone who had that image to change any aspect of the image's content.

Assuming that one can talk legitimately of a change in the content of a single image,[49] this claim seems true. Of course, for many images, changing some

[46] *Ibid.*, §80. [47] *Ibid.*, §131.

[48] The broader claim is reiterated by commentators, e.g. Budd attributes to Wittgenstein the view that 'images tell us nothing, either right or wrong, about the external world' (*Wittgenstein's Philosophy of Psychology*, 101).

[49] This assumes that one could ascertain that what looked like a change in the content of a single image actually counted as such, rather than as the introduction of a different image altogether.

aspects of their content in particular ways could not sensibly be demanded. One could not sensibly be ordered to visualize a square circle, for instance. But this is not being denied, since all that is being claimed is that one could be sensibly ordered to change any aspect of an image *in some way*. Nor does this conflict with what follows from a point made earlier: that, where one has a mental image of E, one cannot sensibly be ordered to change one's image of E so that it reflects *none* of one's beliefs about E.

However, even if it is true that, for any aspect of the content of a given mental image, one can be sensibly ordered to change it, it does not follow that one cannot learn about objects from visualizing. For the underlying principle invoked must be that, wherever one can be sensibly ordered to change any aspect of the content of a given mental item, it follows that one cannot learn about the world from that item. And this seems to be false. I can be ordered to think of a recent party as I believe it to have been (dull), or to imagine it differently, as having been marvellously glamorous. This does not show, in itself, that I cannot learn from the former thought, unaltered. Analogously, nor does the fact that I might be sensibly ordered to have an image of my friend with a different bodily appearance shows that I cannot learn anything about her, even where I have an image of her with her characteristic appearance, in a green dress.

One might object that there is a disanalogy here, in so far as in the first case there is an envisioned switch from belief to imagining, and in the second there is an envisioned switch only from imagining to a different imagining. But this could be a difficulty only were it independently established that one can learn only from beliefs, not imaginings, which is what is being investigated. Furthermore, as already argued, images partly reflect beliefs, so it is still possible that one might learn from images via such beliefs.

I suspect that behind the thought that learning from an image is ruled out by the fact that one might (sensibly be ordered to) change any aspect of its content is the further thought, already rejected, that in having an image of E, one is, at best, only indirectly related in thought to E; and at worst, not related in thought to E at all. If that were right, then, in changing the content of an image, perhaps one would change the nature of the object directly thought of, so that perhaps one then would be thinking of a different object (if I imagine the party to have been exciting, I am no longer thinking about *that* party, but about a different one; if I imagine my friend with a different appearance, I am no longer thinking about *that* friend). In that case,

any potentially reliable connection between thought and object in the world would be severed. However, if we accept that to have an image of E is to be directly related in thought to some genuine E, then it is not clear why the fact that one might have considered E differently entails that nothing can be learnt from the way one currently considers it.

(5) Mental images are superfluous to any conclusion reached.

It may be complained that an important point has not yet been properly addressed. At times, Sartre apparently acknowledges that understanding of an object may arrive simultaneously with, or after, a mental image. However, he suggests that any such understanding does not result *from* the image, but rather has taken the form of an image: it has adopted 'the imaginative structure':

Understanding attains its end *as an image*, but not *by* the image.[50]

As another commentator, Alan White, puts it:

Trying to visualize a room is trying to think what it looks or would look like. Succeeding in visualizing it is not what enables us to think what it looks like: the former is the latter. Visualization supplies me with answers, for instance how many chairs were in the room, in the same way that thinking about something does.[51]

There are several ways of reading Sartre's point. One is that since having an image is itself a kind of thinking, it cannot enable thought. As expressed by White, the point seems to be that while perceiving E 'enables us to think what it looks like', and so can be distinguished from simply thinking what E looks like, imagining an E *is* a kind of thinking what E looks like, and so cannot play the appropriate enabling role. Yet this contrast seems false: perceiving is not an activity which takes place before thought begins, but, on any plausible account, is infused to some degree with conceptual content, notwithstanding that it clearly 'enables' (other) thoughts about objects. In any case, it seems ludicrous to suggest that thinking cannot enable new thought; as previously discussed, this is belied by knowledge of an everyday kind, arrived at via simple reflection without any direct perceptual input.

Another way of reading Sartre's point is that visualizing can reflect only what non-imagistic thinking might otherwise have achieved; in which case, it cannot be truly said that it is the visualizing which is the source of learning. There are

[50] Sartre, *POI*, 116–18; quote from 118. [51] White, *Language of Imagination*, 57.

three things to say here. First, if this means that an image can convey only what non-imagistic *recollection* of knowledge already possessed might otherwise have conveyed,[52] then this presupposes that one cannot learn anything new from an image, which has yet to be convincingly shown. Alternatively, if it means that any *new* knowledge that occurs simultaneously with a mental image might have been acquired via non-imagistic thinking, and so is not really a product of the image, then this looks a wholly implausible claim. We would not, after all, deny that one could learn from visual perceptions about the nature of an object, simply on the grounds that the information thereby acquired might also have been acquired via non-perceptually derived inference.

Third, it is not clear that all of the (new) knowledge provided by a mental image might have been acquired in some other way. Rather, visualizing can provide us with knowledge about how an object *would look* under certain circumstances.[53] This, I shall suggest, is not knowledge which could have been acquired in some other way.

I have argued that, in all cases, a mental image of E is partly informed by some of one's (true) beliefs about E, allowing that these may not be beliefs about the visual appearance of E. However, since, typically, mental images are partly informed by beliefs about visual appearances, I shall focus only on such cases from now on. In fact, I shall focus only on a subset of such cases: namely, those images informed by beliefs about visual appearances which have experiential content, i.e. beliefs which are gained via relatively immediate experience, and which convey the phenomenological 'look' of objects in a way which could not be captured by propositional beliefs alone (beliefs about appearances, in terms of particular colours, shades, shapes, lines, angles, and so on). Typically, mental images are partly informed by beliefs with such content (henceforth, 'visual beliefs' for short).[54]

Now, generally, it is possible to form new beliefs about a certain entity, on the basis of awareness (explicit or implicit) of prior beliefs about that entity: as, familiarly, in inductive and deductive inference. And this being so, where, for instance, one forms an image of certain entities in combination, which is partly informed by prior visual beliefs about the respective entities,

[52] For discussion, see Taylor 'Imagination and Information', 209–10, 215.

[53] This point, and certain of those that follow, resemble points made by Taylor in 'Imagination and Information'.

[54] Taylor's way of putting this point is that an image is 'always, to some extent, a manifestation of remembered experience' (*ibid.*, 217).

I see no reason to deny that it is possible to form new beliefs about the counterfactual appearances of the entities in combination, on the basis of becoming aware of those prior beliefs. As the image forms, I suggest, so too can one form (some) new beliefs about the objects imagined that one did not have before.

For instance, when I form an image of my friend in the green dress, an image which is informed by some of the visual beliefs I already have about, respectively, my friend and the dress, I can simultaneously form some new beliefs about the visual appearance my friend *would have* in the dress, based on awareness of those prior beliefs.[55] Though my newly formed beliefs are logically preceded by my prior beliefs, they need not be chronologically preceded by them: the new beliefs can form simultaneously with awareness of the image (just as new beliefs can form simultaneously with the consideration of old ones).

These new beliefs are not arrived at via deduction, but then, not all beliefs are arrived at deductively.[56] I do not pretend to describe how such new beliefs are justified by the prior beliefs in question; indeed, it is not clear that one *could* adequately describe how certain prior visual beliefs justify further beliefs about the counterfactual appearance of an object.[57] I claim only that, given: (a) that mental images are partly structured by prior beliefs, typically of a visual kind; (b) that generally, we are familiar with the formation of new beliefs on the basis of prior beliefs; (c) that so far we have found no good reason to deny that new beliefs about counterfactual appearances can form as an image forms; and (d) that our pre-reflective intuitions support this possibility; then (e) we can assert with a degree of confidence that new beliefs about counterfactual appearances can be formed as an image forms, most plausibly on the basis of the relevant prior beliefs. As is rightly intimated by Sartre and Wittgenstein, one does not arrive at such new beliefs via a process of observing or interpreting some 'inner' object. But denying this is compatible with asserting that one can arrive at new beliefs via an image: namely, where

[55] I take it that when Taylor refers to mental images giving rise to 'spontaneous acts of synthesis' (*ibid.*, 210, 218), it is something like this that he has in mind.

[56] *Ibid.*, 210 and 215.

[57] Taylor connects this point to the Kantian point that there are no a priori rules for the application of aesthetic concepts (*ibid.*, 215). Though I do not see this debate as concerned only with the aesthetic aspects of objects (see *n.* 8), it seems implausible that there could be a priori rules governing counterfactual appearances.

it is true that, had one not had the image, one would not have arrived at the given beliefs.

The next thing to establish is whether such new beliefs might count as knowledge,[58] and so as 'learning' in any interesting sense. I do not see why not. It may be objected that any new beliefs about the counterfactual appearance of an object, formed on the basis of an image, are not justified, because they are not, in fact, a reliable guide to the way the object would look.[59] Empirically, however, this seems to be to be false. Otherwise it is hard to explain the apparent sense of such familiar claims as 'that's just how I thought it would look!', as well as our frequent *lack* of surprise when actually confronted with previously unexperienced visual aspects of the world. Of course, depending on their content, *some* images may be wholly unreliable guides to the counterfactual appearances of objects (perhaps those which present an object whilst reflecting very few of one's beliefs about it). However, this does not show that other images cannot be reliable, and in fact, experience shows us that some are.

Of course, the prior beliefs upon which I base my new beliefs may, for all I know, be false; but this is true of belief formation generally and is not normally, except to a rabid Cartesian, an obstacle to counting further beliefs formed on the basis of them as knowledge, so long as the initial beliefs are true. It is also true that the new beliefs are not beliefs about aspects or characteristics which the object currently has, but are beliefs about how the object *would look* (or *might look*); but I do not see why such beliefs may not be knowledge, all the same. Information about the actual aspects of an object is not the only information one might get about an object.

This being so, the present discussion has provided a response to the objection raised earlier. Assuming it is possible to have knowledge of how an object would or might look in counterfactual situations, it is not clear where else one would get such knowledge *except* through visualizing. One cannot get it from perception alone, since by themselves visual perceptions can only inform one about how objects actually *do* look. Nor is such knowledge obviously available via 'bare' propositional thought (or imagining) alone. Visualizing can give us a kind of new knowledge—namely, knowledge about counterfactual appearances—which is unavailable through other routes, conceptual or perceptual.

[58] I will take it that knowledge is justified true belief.

[59] For further discussion, see Taylor, 'Imagination and Information', 222.

The positive conclusion reached here is the inverse of one of Sartre's. He writes, attempting to support the view that mental images come from the thinker rather than the world,

it cannot be said that an image clarifies our knowledge in any manner whatsoever for the very reason that it is the knowledge that constitutes the image.[60]

In fact, I have argued, it is the very fact that our images are partly informed by prior beliefs which makes it possible that we can learn from images, rather than ruling it out.

(6) One cannot be misled about the object of one's mental images.

A final line of objection remains. Sartre argues that one cannot be misled as to the object(s) of one's mental image. He takes himself to offer some grounds for endorsing this claim in a comparison he makes between seeing on the one hand, and visualizing on the other.[61] His apparent conclusion is that information presented in visual perception is potentially misleading, while that presented in a mental image is not. Objects are seen from a particular perspective, or point of view, which may, for those unfamiliar with perspective, distort conclusions as to the true shape characteristics of that object.[62] Furthermore, a visual perspective on a three-dimensional object can give access only to part of an object at a time, and so is necessarily incomplete. For instance, it is only possible to see three sides of a cube at once, not six.[63] Again, then, there is the possibility of being misled by the partial visual information one presently has; for instance:

... when I pass, for example, from sides ABC to sides BCD [of a cube], there always remains a possibility that side A has disappeared during my change of position.[64]

(Perhaps more realistically, there is also a chance that one can be wrong about the sort of object one is perceiving: perhaps one is looking, not at a cube, but rather at an object which only looks like a cube from the front.)

In contrast, Sartre claims, in a mental image of E, there is no possibility of one's being misled as to the object of the image, based on the 'appearance' of E in the image.

[60] Sartre, POI, 96.
[61] Ibid., ch. 1, §3. There is also a comparison with non-imagistic thoughts of objects, which is not relevant for our purposes.
[62] Ibid. 6 [63] Ibid. [64] Ibid.

When I say, 'the object I perceive is a cube', I make an hypothesis that I may have to reject at the close of my perceptions. When I say, 'the object of which I have an image at this moment is a cube', my judgment is final: it is absolutely certain that the object of my image is a cube.[65]

Though visualizing, like visual perceptions, present objects perspectivally, it is not possible that, for all one knows, the nature of the object thought of in the image is other than one takes it to be.

Sartre takes these points to support the conclusion that one cannot learn from images, though the precise nature of the supposed connection is unclear to me. Perhaps it goes as follows. One cannot be misled as to the object(s) of one's mental image. Meanwhile, one can only be ignorant of things that one might possibly be misled about; and one can only learn about things one might possibly be ignorant of. Ignorance requires the possibility of error, and learning requires the possibility of ignorance.[66]

Though they look plausible, I dare say that some may reject the claims of the last two sentences. I prefer to focus instead on the first assumption, that one cannot be misled as to the object(s) of one's mental image, for it turns out that in the only sense potentially conducive to the conclusion that one cannot learn about objects from visualizing, this claim is false.

There are two different things one might mean by this claim. It might mean that (a) in having an image, one cannot be misled as to what the image represents, i.e. its content. (This would mean that, for instance, in visualizing a particular horse, one cannot thereby be misled about the nature of that horse.) Alternatively, it might mean that (b) in having a mental image, one cannot be misled about those aspects of the world which either one takes to be, or are, (part of) the causal origin of one's image.[67] (This would mean that, for instance, in visualizing a particular horse, one cannot thereby be misled about the nature of that claim). (a) is a way of being misled about the nature of one's image, and is unconnected to whether the content of one's images reflects the way the world is or not; (b), in contrast, is a way of being misled about objects in the world.

[65] Sartre, POI, 7.

[66] I am indebted to Robert Hopkins for this suggestion.

[67] Christopher Peacocke, 'Imagination, Experience, and Possibility', in J. Foster and H. Robinson (eds.), Essays on Berkeley (Oxford: Clarendon Press, 1985), 27; Robert Hopkins, Picture, Image and Experience (Cambridge: Cambridge University Press 1998), 162, n.

Now, Sartre is licensed to make claim (a), given his assumption that a human being has the capacity for transparent access to the contents of consciousness.[68] This assumption is at the root of his project,[69] which he regards as phenomenology, or 'description'.[70] Wittgenstein, too, endorses the view that one has a peculiar authority with respect to one's visual images, in that what determines what one's image is an image 'of' is what one is prepared to say sincerely about that content;[71] or, perhaps, the picture one is prepared to draw of it.[72] If it is true that a person has transparent access to the contents of consciousness, then it follows that one cannot be misled as to what one's image represents, i.e. its content.

However, the truth of (a) does not entail that one cannot learn about objects from one's images (or that one cannot be misled about them). For claim (a) is not a special fact about mental images, but stems from a more general point about mental contents.[73] Assuming that one has transparent access to the contents of conscious thought, even so, this does not entail that one cannot learn about objects via thought. Consider the case where I (non-imaginatively) draw a conclusion about the nature of E, based on consideration of certain premises which I hold to be true. The manifest fact that there I can be said to have learnt something about E is not undermined by the thought that I cannot be misled as to what I am thinking, in the sense that I cannot be misled as to the content of my thoughts (e.g. it makes no sense to tell me that I am not really thinking of E). Hence, nor does it have this consequence where one's thoughts involve mental images.

Meanwhile, claim (b), which *does* look relevant to the possibility of learning from visualizing, is false. This is because, as I have stressed, a mental image of an object must partly reflect some of one's beliefs about that object. Some of those beliefs may be, unbeknownst to one, false, leading one to further false beliefs about the nature of the object. This being the case, it is possible for one's image to mislead one about certain aspects of the world in the sense of claim (b). Altering a famous example discussed by Wittgenstein, take the case where someone has in the past been shown Westminster Cathedral, and falsely told that it is Westminster Abbey, so that she gains beliefs about the appearance of the Abbey, based on the appearance of the Cathedral. This person then has a

[68] Sartre, *POI*, 1. [69] McCulloch, *Using Sartre*, 2. [70] Sartre, *POI*, 62.
[71] Wittgenstein, *PI*, §367. [72] *Ibid.*, §300.
[73] Peacocke, 'Imagination, Experience and Possibility', 27.

mental image which she takes to be 'of' Westminster Abbey on fire, informed by the false visual beliefs she has about the Abbey. In that case, surely, her mental image misleads her as to what Westminster Abbey would look like, were it on fire. In other words, she is misled about certain aspects of the world (in this case, Westminster Abbey): namely, those which she takes to be part of the causal origin of her image.

Someone might protest that in this case, it is not the *image* that has done the misleading; it is rather one's prior false beliefs about the appearance of Westminster Abbey. However, things seem symmetrical in the case of visual perception: were the same person to *look* at Westminster Cathedral on fire, and thereby arrive at a false belief about how Westminster Abbey looks when it is on fire, she would do so partly on the basis of her prior false belief about the Abbey's appearance, and yet this is no impediment to saying, fairly naturally, that the she would have been misled by what she has seen.

I have argued that the sense in which it is true that one cannot be misled as to the object of one's mental image is irrelevant to the possibility of learning from visualizing; meanwhile, in the only sense relevant to that claim, one can be so misled. Hence, once again, no support is found here for the claim that learning about objects from images of them is impossible.[74]

10.2 Images and Propositional Imaginings

Here I conclude my dismissal of the reasons for which one might have supposed that one cannot learn about objects from visualizing. It is important to note that, had certain of these reasons succeeded, then they also would have succeeded in showing that one cannot learn about objects from 'bare' propositional imaginings, with no experiential component. For many of

[74] Meanwhile, when Sartre claims that, in the case of visual perception, one *can* be misled as to what one has perceived, he seems to mean that, in having a visual perception of an object, one can be misled as to the nature of the object which one takes to cause, or cause, one's visual perception (cf. his example of how one can be misled as to whether one is really looking at a cube). Yet it seems that, just as one cannot be misled as to the content of one's mental images in the sense that one has transparent access to such content; so too is it true that one cannot be misled as to the content of one's visual perceptions (i.e. when I say that the content of my visual image is that of a red pillar box, it makes no sense for another to deny this). In other words, on the issue of the possibility of being misled, Sartre has offered us a false contrast between mental images and visual perceptions, trading on an ambiguity in what exactly one may be misled about.

the points cited to show that one cannot learn from images apply equally to propositional imaginings: one does not observe one's propositional imaginings; nor interpret what they represent; nor do they provide real-time information; and nor is it nonsensical to command someone to stop having a certain propositional imagining, or to change its content. Furthermore, in the only sense in which it is true that one cannot be mistaken about the object of one's mental images (in the sense that the contents of consciousness are transparently accessible), so too is it apparently true that one cannot be mistaken about the object of propositional imagining. Hence any support such reasons gave to the claim that one cannot learn from images would equally have jeopardized the confidence with which we might talk of using propositional imagining to understand conceptual art.[75] To the extent that my discussion has succeeded, so does it potentially deflect any concern about the role of imagining generally in understanding conceptual art.[76]

References

ALBERRO, ALEXANDER and STIMSON, BLAKE (eds.), *Conceptual Art: A Critical Anthology* (Cambridge, MA and London: MIT Press, 2000).

BOCHNER, MEL, 'Excerpts from Speculation', *Artforum*, 8/9 (May 1970): 79–83.

BUDD, MALCOLM, *Wittgenstein's Philosophy of Psychology* (London and New York: Routledge, 1991).

HOPKINS, ROBERT, *Picture, Image and Experience* (Cambridge: Cambridge University Press, 1998).

LIPPARD, LUCY, *Six Years: The Dematerialization of the Art Object from 1966 to 1972*, 2nd edn. (Berkeley, CA: University of California Press, 2001).

MANSER, ANTHONY, *Sartre: An Introduction* (New York: Oxford University Press, 1966).

MCCULLOCH, GREGORY, *Using Sartre* (London and New York: Routledge, 1994).

PEACOCKE, CHRISTOPHER, 'Imagination, Experience, and Possibility', in J. Foster and H. Robinson (eds.), *Essays on Berkeley* (Oxford: Clarendon Press, 1985), 19–35.

SARTRE, JEAN-PAUL, *The Psychology of Imagination* (London: Methuen, 1972).

SMITH, ROBERTA, 'Conceptual Art', in Nikos Stangos (ed.), *Concepts of Modern Art*, 3rd edn. (London: Thames and Hudson), 256–70.

[75] Not to mention the confidence with which philosophers use thought experiments to draw conclusions about the world.

[76] I would like to thank Robert Hopkins for very helpful comments on a draft of this paper.

TAYLOR, PAUL, 'Imagination and Information', *Philosophy and Phenomenological Research*, 42/2 (1981), 205–23.

WHITE, ALAN, *The Language of Imagination* (Oxford: Blackwell, 1990).

WITTGENSTEIN, LUDWIG, *Philosophical Investigations* (Oxford: Blackwell, 1953).

—— *Remarks on the Philosophy of Psychology*, vols. I–II, ed. G. H. von Wright and H. Nyman (Oxford: Blackwell, 1980).

—— *Zettel*, ed. G. E. M. Anscombe and G. H. von Wright (Oxford: Blackwell, 1981).

Part IV

Appreciating
Conceptual Art

11

Artistic Character, Creativity, and the Appraisal of Conceptual Art

Matthew Kieran

11.1 Introduction

How should we appreciate conceptual art? Indeed, can conceptual art really be valuable as art? These are taken to be hard questions within contemporary philosophical aesthetics. If there's no artfully constructed or styled material object to appreciate, if there's no beauty or other aesthetic qualities to savour, if there's no insight to be gained in an experience with a work, how can it be artistically valuable? Indeed the worries about conceptual art articulated by philosophers tend to be shared by many ordinary art lovers. Yet if we look at contemporary artistic practice there hardly seems to be an issue here at all. Artists are happy enough to produce canvases with text only printed onto them, put together slogans lit up in neon, or enter as an exhibit for the Turner Prize an empty room with the light turning on and off. Within many circles of the art world such works are straightforwardly considered as art, admired, talked about, and evaluated as such. How can this be? Is contemporary artistic practice just confused? Or, rather, is there something fundamentally wrong with the way in which contemporary aesthetics, and indeed many ordinary art appreciators, approach conceptual art? I will suggest it is the latter. Indeed reflecting on conceptual art and the practice of art more generally will show (a) that conceptual art is not as anomalous as is commonly assumed and (b)

that something has gone awry in contemporary aesthetics concerning the ways in which we think of artistic practice and value more generally. This concerns the importance of artistic character and creativity.

11.2 Scepticism and Special Pleading

I am taking 'conceptual art' in a broad sense. Marcel Duchamp, often taken to be the father of conceptual art, famously submitted for an exhibition a French urinal turned upside down, signed R. Mutt and entitled *Fountain* (1917), (see Illustration 3) and his *In Advance of a Broken Arm* (1915) consisted of a snow shovel bought over the counter from an ordinary hardware store. In the 1960s and 1970s the Italian Arte Povera movement exhibited objects made from 'worthless' materials such as soil and leaves whilst the Anglo-American Art & Language movement often exhibited straight text. Robert Rauschenberg even went as far as erasing a pencil drawing by another artist, Willem de Kooning, and exhibiting it as *Erased de Kooning Drawing* (1953). Much more recently Cornelia Parker's *The Distance: The Kiss with Added String* (2003) wrapped a mile of string round Rodin's *The Kiss* (1886), which was cut by a protesting gallery goer and then restored by Parker. The New York artist Les Levine, most well known as a pioneer of video and media art, once bought and ran an ordinary restaurant and declared that all the bills would be works of art. The content was determined by the customers and made out by the waiters. From the 1970s until the present day, the profusion of documentation, multimedia explorations, performance works, installation art, and the presentation of ideas can all be traced through this lineage back to the readymades of Duchamp. The characteristics of these movements and phases are not all shared but there remains a cluster of features, some of which are possessed by them all to a greater or lesser extent. What makes the artistic lineage of conceptual art into a coherent story is the concern with readymade or mundane objects, the primacy of ideas, the foregrounding of language, the use of non-conventional artistic media, reflexivity, and the rejection of traditional conceptions of sensory aesthetic experience.

There are three main interrelated reasons that underwrite scepticism about conceptual art so understood. The first derives from the general orientation of contemporary philosophical aesthetics. It is primarily reception based.[1] Over

[1] See Kieran (2006) for a fuller characterization. There are, of course, exceptions. See, for example, Davies (2004) and Kieran (2004: 6–46).

the last twenty years or more, ranging over a whole host of questions from what it is for something to be fictional or the constraints governing interpretation to the nature of artistic value, philosophical aesthetics has focused primarily on the experience afforded the viewer and the criteria taken to govern an audience's reception of art works. This is especially true with respect to questions concerning the values of art. Of course within this general trend there have been and are many disputes. One such central dispute concerns whether artistic value should be seen as an aesthetic matter—focusing on a work's beauty, complex use of imagery, coherence of style and theme—or a cognitive matter—focusing on how a work may deepen our understanding through our experience with it. Such approaches are united by the assumption that what matters is the value of the experience afforded (whether it be aesthetic, emotional, or cognitive, and so on). Hence conceptual art looks problematic because, at least in many cases, the value of the experience afforded looks as if it is beside the point.

This is related to the second reason for scepticism about conceptual pieces. The dematerialization or apparent artlessness of the art object in conceptual art stands in tension with the assumption that the qualities we appreciate in artworks are conveyed to us by or manifest in our experience with the artwork. Not only is it assumed that the values of art are a function of the value of the experience afforded but those qualities we value art for should be manifest in our experience with an art object.[2] Conceptual art doesn't seem to emphasize qualities afforded in our experience of a work but in the recognition of a given idea. No doubt something like this thought lies behind why many people dismiss conceptual art as worthless. It is not enough to claim that conceptual art can change the way people think about things, thus affording a valuable experience of some kind, for the notion of experience here is too broad. In one sense a work of philosophy, science, or mathematics may change how we think about things. But in philosophical, scientific, or mathematical texts elements of style, rhetorical technique, and artistry are downplayed as much as possible. What distinguishes artworks from such texts is the means used to guide and shape how we look at what is represented, the artistic style, pictorial techniques, and genre conventions, which are used to cultivate certain feelings, thoughts, and responses as we engage with it. But in

[2] See, for example, Budd (1995: 1–44) and Graham (2005).

conceptual art it looks as if, where there is an object at all, we are merely called to register the idea it points to. Where, the thought goes, is the artistry in that?

The third reason, closely intertwined with the first, concerns the outright rejection of Romanticism. The Romantics emphasized the creative role of the artist and held art to be the finest imaginative expression of the human mind. It brought in its wake a focus on the personal life of the artist, the ways in which a work expressed the inner life and attitudes of its creator and tightly tied the meaning of works to artistic intention. Taken as a view of what all art must be, or the doctrine that art should only be valued in such terms, Romanticism loses sight of much that we appreciate art for. It was heavily criticized for drawing attention away from the appreciation of the work as such, by conflating historical or biographical interest with an artistic one, failing to appreciate that the realization of artistic intention depends upon publicity criteria, since what is intended and what an artist actually does can come apart, and for excluding the role of the imaginative contribution made by the viewer in engaging with works.[3] Hence from the advent of formalism and new criticism in the early twentieth century up to the present day, the Romantic view that appreciating art should be bound up with understanding the qualities of mind and creative processes of the artist has been derided and left out in the cold. Thus, in approaching conceptual art, contemporary aesthetics tends not to be interested in nor ask about the imaginative and creative processes that went into the production of such work. Instead it focuses on the end product, what it might mean or how the viewer could possibly value experiencing it.

This has lead contemporary aesthetics to pursue two basic strategies in response to the problem of conceptual art.[4] The first strategy is just to reject it outright as art (or at least as good art).[5] More sympathetically, it could involve a special explanation that construes conceptual work as a kind of anti-art. Consider Duchamp's *Fountain*, Rauschenberg's *Erased de Kooning* (1953), Joseph Kosuth's *One and Three Chairs* (1965), (see Illustration 5) consisting of an actual chair, life-size photograph of it, and a definition of the term 'chair', through to the pronouncements by various artists that a particular empty room, intellectual object, found object, or even hidden object is a work of art.

[3] Classic works developing such anti-Romantic arguments range from Bell (1914) and Wimsatt and Beardsley (1946) to Foucault (1979).

[4] What follows in the rest of this section is a simplified abbreviation of arguments more fully developed in Kieran (2004: 72–75, 127–38).

[5] See, for example, Osborne (1980) and Graham (2005).

The purpose of such works is to subvert and jar with our ordinary conceptions of what constitutes art, what confers artistic status upon an object, and our assumptions concerning how we should engage with art objects. The interest of the point diminishes rapidly with repetition, unless it is made with exceptional wit or complexity, which is not usually the case. But notice that even the particularly original and witty pieces, such as *Fountain*, only have a value in contrast to the standard conception of art. In other words this kind of conceptual art is parasitic upon the standard conception of art it seeks to subvert. So, at best on this strategy, conceptual art requires the standard assumptions about artistic value to be in place in order to have any value at all. Some such works may be good. *Fountain* is both a clever and witty questioning of artistic authority and the art world. But essentially, on this view, this is to be thought of not as art proper but a kind of meta-art or a form of artistic criticism.

The second strategy involves attempting to domesticate conceptual art so that it conforms to (i.e. can be seen to be valuable in terms of) the standard picture of artistic value. There are two parts to this strategy. The first part involves examining whether or not the qualities valued in art must depend on properties perceived in our experience of the object. A matter over which there is serious disagreement. The second part involves attempting to show that, whatever the answer to the first part, we value and appreciate conceptual art in terms of the standard art value of experiences afforded through our engagement with it. [6]

For the first part we may think of a piece like Anya Gallacio's *Intensities and Surfaces* (1996). In an old pump station in Wapping, London, huge blocks of ice were stacked above an electric blue light to make a large rectangle. A half ton of rock salt was then placed on top. Naturally the ice began to melt, pools of water formed around the object and the luminescent refractions of colour off and through the surfaces made for an intensely sensuous aesthetic experience. Although the idea of the dematerializing art object is part of what Gallacio's work concerns, it was, as Tony Godfrey (1998: 383) put it, 'essential to see the work: the sensory experience was far more important and interesting than the concept *per se*'. Furthermore, even construed in the strictest of Kantian terms, the form of ideas may themselves be beautiful and aesthetically appealing.[7]

[6] The literature here is voluminous but perhaps the best place to start is Shelley (2003). It gives a clear diagnosis of the claims at issue and thorough referencing with respect to the various proponents involved.

[7] See, for example, Kieran (2004: 72–4) and Costello (this volume) for treatments of this line of thought. Shelley (2003) comes to a similar conclusion via Hutcheson rather than Kant. Whilst

After all, the simplicity of the formula $E = MC^2$ appeals due to the rigour, complexity, and depth of the ideas involved, the economy of expression of their relations and its explanatory value. Still, in much conceptual art, either sensory or aesthetic appreciation seems to be beside the point or irrelevant. To try to engage with Duchamp's *Fountain*, Dan Graham's *Houses for America* (1966) or Joseph Kosuth's *One and Three Chairs* (1965) in terms of their sensory and/or aesthetic rewards is to miss what they're up to.

Consider Bruce Nauman's *Good Boy Bad Boy* (1985). Two videos, side by side, present us with an actor, a young black man, and a middle aged woman respectively, reciting the same hundred phrases on a continuous loop. They are short, simple and initially the recitation starts off at the same pace in flat tones. Gradually the phrases slip out of synch and the tonal variations grow ever greater. The connotations of the phrases starts to vary depending on who they're spoken by, the tone, and what they seem to be a response to. For example, the black man's '*This* is work' seems to imply that he has to suffer in order to survive, the white woman's 'You *have* work' seems to imply that he should be grateful for having a job. The piece forcefully reminds us that what we assume is being communicated is often refracted through assumptions about and variations in identity at a deep level. Alternatively, consider Jenny Holzer's use of slogans in public spaces from LCD displays in Times Square, New York, to stickers on parking metres or telephone booths, to posters and billboards. The slogans themselves can be thought-provoking. 'CHARISMA CAN BE FATAL' may prompt us to consider the ways in which people can become self-parodies. Where the slogans are placed may prompt us to think about how forms of advertising, entertainment, or style are fetishized and politicized. Indeed, when they are presented en masse, as in the exhibition at the Guggenheim and Venice Biennale of selections from *Truisms, Inflammatory Essays, The Living Senses, Under a Rock, Laments and New Writing* (1989/90), the point may be to foreground how the banality of stock clichés and truisms of contemporary culture threaten to collapse under the weight of their own absurdity.

Although these strategies may hope for partial success they fail to recognize why it is that much conceptual art can, at least in principle, be appreciated as art. Think about cases where experience of the object is, if possible, beside the

I am sympathetic to the idea that such an approach is useful in explaining the value of some conceptual works, as will become clear, I think such an approach cannot but be inadequate to the value of all worthwhile conceptual art.

point. This *might* be somewhat strained. The Rauschenberg seems to work by priming the spectator to try and see what is left after the act of vandalism; the Parker by seeing Rodin's romantic couple as bound by romantic passion and illusions; Duchamp's works by prompting us to see ordinary objects in terms of art appreciation. But the important point here is that value isn't wholly reducible to whatever experiences are afforded. Part of what is being drawn attention to is the underlying expressive gesture itself, via the presentation of the object, and it is the gesture itself, whether it's funny, ironic, contemptuous or commenting on society and the art world, that our meditations are drawn towards in considering their value. To draw the point out properly we need to make some reflections about art as a cultural practice more generally.

11.3 Inherited Value

We value artworks in many different ways and some of those are more passive or active than others. It is a notable feature of contemporary aesthetics that the variety of ways in which we care about and value artworks tends to be flattened out into matters of audience reception. Once we recognize the rich topography of artistic valuing that goes on more clearly it is easier to see the different ways in which artworks can be valuable. Amongst the many ways in which we do so are the following: we engage with them perceptually, emotionally, and intellectually; we judge, praise, and admire them; we treat them with respect, preserving and honouring them; we consider the qualities of mind, creativity, and imagination that went into them; we consider a work's artistry, what makes a work unique or its rarity; we care about them, returning to some works time and again or pointing friends and acquaintances we care about towards them. There are many such reasons, the reasons that hold for valuing one artwork need not hold for valuing another and some reasons at least will blamelessly differ across individuals. A Van Gogh may be valued for the rich blazes of colour, calligraphic contortions, and scarified landscape yet a forgery that possesses the same features may not be. Someone may appreciate a Caravaggio in part because it represents a humanized version of Roman Catholicism close to her heart and yet this may not constitute a reason for appreciation to someone for whom Roman Catholicism means nothing. At least some of the ways in which we go about valuing art aren't reducible to the value of the experiences works afford us.

Consider the following four kinds of cases. First consider Leonardo da Vinci's *The Last Supper* (1495–98). A traditional refectory wall painting in the Santa Maria delle Grazie, Milan, it portrays Christ at the last supper the moment after he has announced that one amongst the disciples will betray him. Its originality lies in part in Leonardo's dispensing with the conventional halo, using the landscape behind to give Christ the luminosity required, combined with the shadowy overcast representation of Judas that marks out his treachery. It was also painted with an experimental mixture of tempera and oil enabling him to achieve something like the effect of oils, previously unheard of for a wall painting. Unfortunately, because of the mixture, the painting rapidly deteriorated. Copies were made, including the sixteenth century one in the Da Vinci Museum, Tongerio, which is almost life-size and contains a wealth of detailing and coloration that even the presently restored original now lacks. The copy gives the viewer a richer, more complex and visually striking experience. Yet we tend to value Leonardo's original more highly. Why? The original is constitutive of Leonardo's achievement. It is the genuine expression of a singular imaginative vision of the Last Supper whereas the copy is a mere imitation.

Second, consider cases where though the value of the viewer's experience may not be particularly high nonetheless works are valued highly because of the development of or solution realized to particular artistic problems. For example, one reason why Cézanne's art is so impressive is because his abstractions of nature managed to combine the concerns of the classical tradition, in terms of compositional structure, with that of realism, which consisted in the rejection of the idealization of nature. This set him apart from his contemporaries since realism tended to go hand in hand with a rejection of classicism. Cézanne, by contrast, strove to represent what he took to be the underlying structure of nature rather than its fleeting momentary impressions. The particular solution to the problem he set himself, in terms of the use of geometric planes and rich tonal shading, was highly innovative and, indeed, paved the way for cubism. At least one of the many reasons why Cézanne is rated so highly as an artist concerns the particular artistic problem he set about resolving and the way in which he did so. If we were to compare a Cézanne with a work that was just as valuable in terms of the experience afforded, but which in no way developed or resolved any particularly difficult artistic problems, then we would have more reason to value the Cézanne more highly.

Third, consider Jackson Pollock's action painting or the work of artists like Frank Auerbach. Pollock's drip paintings treated the whole canvas in a uniform

way, abandoning traditional conceptions of structure and composition. Fixing a canvas to the wall or the floor he poured and dripped paint on, manipulating it with sticks, trowels or knives. Underlying the layered accretions of paint he often first scribbled paint marks onto the canvas to establish a sense of movement across the canvas. One of the important ways to see these paintings is in terms of the kind of actions involved in the process of painting them, seeing the marks and drips of paint as improvised responses to one another. The paintings are in one sense the record of the creative process, response, and improvisation in Pollock's actions as he superimposed one colour on top of another, one free gesture of movement counteracting another. In a different way appreciating the work of the contemporary British painter Frank Auerbach involves a grasp of the underlying creative process. Auerbach's work is almost sculptural, with thick layering of paint piled, scratched and scraped layer upon layer. His subject matter revolves around a group of people, some of whom have sat for him for over thirty years, and the cityscapes of London. The mainstay of his working process as it evolved involves the project of abstraction. Starting from more detailed sketches or painterly characterizations of his subject, Auerbach focuses on the underlying rhythms, sense of movement and definition. He proceeds, both in his sketches and paintings, from the most detailed representation to the most abstract ultimately conveyed in a few strokes and lines. Indeed with his painting after each stage of the process he wipes the same canvas down, leaving the last layer of paint encrusted on the canvas, proceeds to paint the next more abstracted version on top and so on until the most abstract version he is content with is arrived at. The accretions of paint on his canvases are often many layers thick and the paintings take months to dry. The essence of Auerbach's artistic process has much in common with many artists interested in the process of abstraction from Turner through to Matisse or Picasso. Grasping the underlying creative processes in such cases adds to and enhances our appreciation of the works ultimately produced. For part of what we may appreciate here involves the creativity itself involved in the process.

Lastly, consider the following. There are two perceptually indiscernible works. One of them was made wholly accidentally, the other wholly purposefully. It is not that one is valuable whilst the other is not, they both are. But we value the one done purposefully in a way that we don't value the one produced accidentally. Why? The intentionally produced work manifests an imaginativeness and creativity that the accidental work does not. In the accidental case there is little to say above and beyond the way in which what we're presented

with structures our experience. In the intentional case we naturally talk about why the artist did what he did, the kind of thought processes involved. We're interested in, and appreciate, the how and why of what the artist did. It could be claimed that though the works are indiscernible nonetheless the experiences afforded suitably informed and educated viewers would differ. Thus value remains a function of the value of the experience afforded. But the inference gets matters the wrong way round. The reason we value the experience in the purposeful case in a way we do not in the accidental case is in virtue of the creativity and imaginativeness that has gone into the creation of the work, not because the value of the experience afforded is greater. This explains certain kinds of changes in evaluation. You may see one work by an artist and it strikes you as realizing a subtle, eloquent understanding. Although the colours are simple and the shapes basic, you take the way in which the flatness of the surface contrasts with the sense of space and dimensionality to betoken an understated realization of the effects that the juxtaposition of particular combinations of blocks of colour have upon our perception. But then you happen to come across much of the rest of the artist's oeuvre and though some of the basic elements remain she never realizes the same kind of effect. In such a case our evaluation of the first work we saw would naturally be undermined. We would rate it less highly. For what we originally took to be a highly sophisticated understanding in the creation of the work is now revealed to be mere luck. Conversely if, like in the case of Matisse, the artist had produced other works, which achieve their effects in a similar manner, then our original evaluation remains. For we have confirmation that the artist knew, creatively speaking, what he was doing. This is part of what we appreciate.

It is also important to emphasize a side of art that is neglected by contemporary aesthetics. Art as a cultural practice is not just about art appreciation but concerns art-making, without which there would be no practice. This is bound up with a whole host of activities and processes on the part of artists. The development of technical skills is important from learning how to draw or paint, blend colours, manipulate brushwork, use foreshortening, flatten out pictorial planes, realize perspectival effects to realizing how to achieve various structural or compositional techniques. This is bound up with experimentation with the nature and limitations of various media such as the texture of certain materials, testing plasticity, colouration, tonal effects, sharpness, and luminosity. Just as important for the development of creativity is the capacity to realize the cognitive-affective encapsulation of ideas through things like

the crystallization of imagery, free association, juxtaposition, deconstruction into elements, the recombination, development, or antithesis of similes and metaphors. Furthermore, an awareness of past and present artistic styles is important, grasping how other artists developed, articulated, or solved particular artistic projects, the kind of approaches underlying distinctive artistic visions or what constitutes a live artistic issue. Just as in other areas, like philosophy say, different people are creative, or come to be genuinely creative, in different ways. Jackson Pollock proceeded for much of his artistic career to ape the styles of previous great artists, so coming to appreciate the kind of thought processes underlying them, before he was in a position to develop an artistic style that was truly his own. Picasso proceeded by remaking the previous subject matter of great artists in radically new ways. All these things, and many more besides, are bound up with the cultivation of an artist's creative character. It is perhaps not as surprising as it might be that aesthetics has tended to neglect this side of things, since most aestheticians tend to be art appreciators rather than artists. Nonetheless, it remains striking that so little attention has been paid to the importance of artistic character.

11.4 Artistic Character and Creativity

Artworks are typically not accidentally produced objects. They are made for a variety of purposes and are the end result of actions on the part of their makers. As such there is an internal link to the psychological states of a work's maker, their artistic character and the creative processes involved: the thoughts, emotions, beliefs, desires, and intentions in action. Hence, as with action in general, part of the nature and value of what has been done partly depends upon the agent's intentional states in relation to what it is they have created.

In the moral case we hold that the nature and value of an action partly depends upon the agent's character, motivation, and other intentional states bound up with it. If I tell a joke at someone else's expense, what is going on and how it should be evaluated in part varies according to what is true about me in my performing that action. It makes a difference if I was motivated by altruism and the belief that telling the joke would distract attention away from another's embarrassment or whether it was motivated by the desire to be superior and the belief that by undermining someone else I would look better. It makes a difference if my action was performed out of sympathy, was merely

tinged with it, or as I happened to feel sympathetic. After all, I could tell a joke to make myself look superior and happen to feel sympathy for the person I am undermining whereas I could not act out of sympathy and intentionally undermine them. The complex intentional states involved in my action are thus a reflection of my character. Furthermore, it is not just that certain intentional states are involved which is important but the way in which they are related in leading up to and manifesting my action. I could start with the intention of telling the joke in order to make myself look better but, as I proceed, come to realize that doing so would mortify the object of my joke. Thus I could come to modify my intention in acting to merely distracting attention from his embarrassment thereby leading to a change in the developing tone and tenor of my joke. Conversely I could start with the intention of telling the joke in order to relieve their embarrassment but as I do so modify my intention in telling it to that of making myself look better. Thus the nature and evaluation of my action in the moral case partly depends upon what the right story is about the complex interrelations between my character and intentional states leading up to and in what it is I do. This is true even where my behaviour and its effects are identical. The same is true, by parity of reasoning, in the artistic case.

Imagine an artist who paints a work that replicates the style of gaudy, prurient covers from 1950s bodice-ripping pulp-fiction novels. The style is well done and represents three girls in 1950s lingerie in various states of undress with the title 'Spoiled Lives'. In one sense what's done, the end product of the artist's actions, is the way it is whatever the underlying psychological states and processes were. This is just as true in the moral case. The behaviour in and effects of telling a joke may be the same whatever the underlying motives, emotions, and character. But, as in the moral case, a full and proper understanding of the nature and value of what the artist has done nonetheless partly depends upon what was true of the artist in painting the picture. It makes a difference if he was motivated by greed and the belief that knocking out replicas of pulp-fiction covers would sell well because Fifties design is back in vogue or whether he was motivated by the desire to foreground the neglected artistry of such covers and the belief that by replicating it on canvas he would make people consider such a style seriously. It makes a difference if the intention in painting the title was ironic (so it doesn't just refer to the girls in the painting as it would in the original but refers to the original artists of such covers and/or the original readers of such novels) or doing so was merely tinged with irony or the artist merely happened to consider the irony. The

artist might not notice the potential irony of the title but nonetheless consider it ironic that he will make money out of mimicking the original artistry of others. The complex intentional states involved leading up to and manifest in the painting are thus a reflection of his artistic character. As with action generally, how the complex of states evolve and interrelate is important. The artist could start by being motivated by greed but as he proceeds come to appreciate the artistry of the original so leading to the modification of his actions in order to produce a work which foregrounds the artistry of the original style. The nature and evaluation of the work partly depends upon the right story about the complex interrelations between the artist's character and his intentional states leading up to and in what it is he does.

It is of course not enough to have the right kinds of motivations, desires, or thoughts that involve an appreciation or love of artistic values. For many of us may have the sensibility but most of us lack the talent, creativity or application. What is also required is the capacity to realize those values, at least to a degree of reasonable success, through the patterns of mental and physical activity involved in the creation of an artwork. The sensuous artist doesn't just love the beauty of colours, textures, lines, and form, but she knows how to bring them together in a way which gratifies the senses; the didactic artist doesn't just know what he wants to communicate but how to do so through the use of immediate and striking imagery; the expressive artist conceives of the creation of art in terms of giving form to emotions, attitudes, and other cognitive-affective states and knows how to do just that; and so on. And the capacity to realize those values depends upon the creativity and imaginativeness in action, in the process of creation, that the artist has.

We can bring this out by an overly simplified consideration of what is involved in creating an artwork. The artist presumably starts off with certain goals that can vary in terms of their thinness or thickness. It can be as thin as aiming to create something or other. Depending upon the character of the artist she will have particular dispositions to favour certain materials, techniques and designs. How the artist starts can vary from making a mark on a canvas to considering a certain image, or contemplating a particular idea. This constitutes the raw material from which the process of creation takes off. The artist then attends to different potential patterning aspects of the raw material, be it a mark, image, or idea as it strikes her. How does the shape, colour, and texture of the mark strike her? What associations or allusions does the image have and what are the ways in which it is striking? How clear,

inchoate, richly suggestive is the idea? In one sense this is backward-looking. What are the potential patterns suggested by what has already been done or thought of? This gives rise to consideration of how what has been done can be clarified, crystallized, or developed. Out of the host of possible ways of continuing on one is selected and this itself gives rise to the same kind of process. Thus a pattern of creative decisions builds up until the artist reaches a point where (if the creative process has been successful at least) she judges that the work is complete: in other words where what has been created through the process resonates such that any further modification would destroy or undermine the effects and interrelations amongst parts that has thus far been realized. This final creation could not have been determined by or predicted from the original raw material but the pattern of creative decisions that leads from the one to the other is what renders the final product intelligible.[8]

For the process of creative thought in action to occur it must do so in some form or medium. Typically in art this involves a symbiotic interaction with things done in a physical medium appreciable by the senses such as physical marks on the canvas, words or notes on the page, the sound of voices or musical instruments, and so on. But it needn't necessarily do so. A composer can play around with and devise harmonies in his head, a writer can construct a story without writing it down or verbally articulating it, and a painter can design an image in his mind's eye before ever putting paint to canvas. Of course these things usually take on a life of their own and so when the artist starts physically to realize or notate the work, given the nature of the creative process, further adjustments tend to take place as the creative pattern of activity occurs in the physical realization of the work. But this needn't be the case since the creative process may have gone on and been completed prior to any physical interaction and all that may be required is its physical realization. The point here though is that despite not requiring physical interaction in the creative process, artistic creation must involve a pattern of activity in some form or another. Even where this occurs only in the head as it were it must be in terms of the development and crystallization of form in consciousness, whether it be in terms of internal verbalization, imagery or sound. Quite how we account for such phenomena is a tricky matter but this we can leave to one side since nothing hangs on it here. All that we need is the recognition that we can and

[8] See Harrison (1978: 119–56) for a rich characterization of designing while making and the patterns of creative activity involved.

do give such internal form in our consciousness to thoughts, feelings, and attitudes. And even where artists don't or haven't yet gone about physically realizing their goals, they may already have gone through a creative process and patterning activity internally in giving form to something in consciousness.

11.5 Consequences for Appreciating Conceptual Art and Contemporary Aesthetics

The recognition that the creative process can occur internally in this way, plus the recognition that part of what we often value in art concerns the underlying creative process and character of the artist, enables us to make sense of how and why conceptual art can be valuable as art. Furthermore it does so in a way that makes sense of the initial reception, puzzlement, and evaluation of both conceptual work and much contemporary art more generally. The initial reception and puzzlement about conceptual pieces stemmed from the fact that we take the end product as evidence of the creative process. This is, historically speaking, where we were used to looking for the craft and artistry taken to manifest creativity. But if we look at Duchamp's *Fountain* and ask ourselves what has the artist done, it looks as if, if we're looking at the end product, the answer is nothing. Where is the artistry and craft of the artist if he's not actually done anything skilful to the object displayed before us? Interestingly it's not as if this question arose in the twentieth century only in relation to conceptual art. It arose in relation to photography, since people were inclined to dismiss photography as an art on the grounds that no skill or craft was required to reproduce images with a camera. How could it be art if there was no craft in the production of a photograph? Indeed, once people realize that Warhol himself did nothing to and was not involved in the actual production of many of his canvases, and that this is true of many other apparently straightforward artists ranging from Bridget Riley to Damien Hirst, some are tempted to ask the same question in relation to what initially appeared like more straightforward cases. The point is that once we recognize that the end product is not the place to look for the artist's creativity, we are diverted to other areas. Yet we do know where to look and why. We start asking ourselves questions not about the craft of the end product but about the creative processes of thought that have gone into whatever is presented before us and why. The focus of appraisal of

creativity thus lies elsewhere. We evaluate such works as good or bad in terms of, amongst other things, the patterning of thought that has gone into them, their originality, subtlety, insight, wit, or daring. Where we take the creative process underlying what we are presented with to possess those properties then we tend to rate it highly. If there appears to be no great craft or imaginativeness in the underlying creative process, if it seems to lack guile, if it is cheap and easy, if it lacks serious thought, then we will rate it poorly. What we should worry about in relation to conceptual art is not that the pieces are conceptual, nor that what is produced lacks apparent craft or artistry, but whether or not the underlying processes in thought are or were genuinely creative.

How does my general claim apply more concretely to conceptual pieces? Imagine the following. An artist wants to find a fitting way of commemorating the Jewish victims of a Nazi pogrom in WWII. She wants to convey the scale of the tragedy. Yet she also wants to convey the sense that the loss of each and every individual life was its own tragedy. Initially she starts from the idea of marking out the names of the victims on individual bricks in a courtyard that was one of the sites of the tragedy. Although that strikes her as conveying both the scale and individual nature of the tragedy it still doesn't seem quite right to her. To her mind the effect she is after is diminished since many of us are by now so familiar with seeing memorials which list the names of the deceased. It fails to convey the sense of loss or absence of lives powerfully enough. Then she hits on the idea of taking up each individual cobblestone in the courtyard, inscribing the underneath of each one with a name and then replacing them. The courtyard will look exactly as it did before her work and this is what appeals to her. The thought of each individual victim being marked on each stone strikes her as apt for it leaves an unobservable causal trace for every one and yet allows the cobblestones themselves to stand as markers for the scale and individuality of the tragedy. The victims may have left no mark upon the world, perhaps no one notices their absence, and yet the annihilation of each and every one was a tragedy to be commemorated. There is a relationship of fit between what she is trying to express and creating the piece in this way.[9] Now notice that, firstly, it is the idea that is creative here and, secondly, realizing the idea makes no difference to any perceptually discernible properties of the courtyard. Furthermore what would have to be done in realizing the idea wouldn't take any particular artistic skill or craft. It wouldn't matter, for example, if she

[9] See Kieran (2004: 135–8).

merely commissioned some builders to do it. What matters is the creative way in which she has given form in consciousness to what she was trying to express. It is something we can grasp—just reading this should give you enough of a sense of it—and evaluate as such. I am not claiming here that it makes no difference whether she carries out her idea or not. Rather the point is that even assuming she does so a large part if not all of what would be valuable about such a work concerns the creativity that has gone into giving form to the idea—rather than the skill, craft, or lack thereof involved in realizing it. It is difficult to see how this could be anything other than a good work of conceptual art.

I should add an important coda. In no way does my position amount to a denial that an artist can just have a great idea without having gone through a creative process. Composers can wake up with a great tune in their heads, painters may find that a striking image just comes to them, or writers that a story just appears to them as if from nowhere. Furthermore, there can be artistic one-hit wonders which are produced by someone who is neither a creative person nor has gone through a creative process. But this hardly counts against the importance of creativity. The claim is not that all that is valuable about art concerns the underlying creative process and character of the artist nor that they are essentially involved. The claim is just that in many cases this is what we do and properly should value along with many other things that are valued in art. Furthermore it is no accident that just having a great artistic idea come out of nowhere rarely happens to someone who isn't a creative character, since to have such an idea usually requires that someone be steeped in the artistic methods, skills, concerns, and patterns of thinking embedded within whichever art form they are working within. Of course Beethoven could have just woken up with an amazing melody in his head or Picasso could have suddenly had a revolutionary thought about reworking traditional subject matter without necessarily having gone through a creative process. But that is because they had mastered the creative processes and patterns of thought at an earlier stage. Indeed think of how and why we train people into intellectual disciplines in the way we do. For someone to even have a chance of being genuinely creative within philosophy say, they must have gone through and mastered to some degree the processes and patterns of thought involved in thinking philosophically that make for good philosophical work.

Contemporary aesthetics has neglected the role of creativity and artistic character in artistic evaluation. This is because the dominant conception of

artistic value, and the attendant questions thought important, are audience- or reception-focused. Perhaps this can be explained in terms of a too hasty, wholesale rejection of the Romantic conception of art. There was at least a partial truth buried within Romanticism that we seem to have forgotten about. Contemporary aesthetics would benefit from considering more fully the nature and role of artistic virtues and their relation to artistic values. There are some important reasons that often figure in our appreciation of artworks that are inherited values, in particular inherited from the genuinely creative processes and character of the artist. Put this together with the recognition that creative processes can occur internally and we can make sense of how and why conceptual art can be appreciated as art—and in some cases good art at that. Whether or not most work presented to us as conceptual art is or is not genu- inely valuable for this reason is, however, another matter. What I have shown is that, contrary to the standard ways of approaching artistic value, genuinely conceptual pieces can be valuable as art for reasons arising from the creative processes and character of the artist. This shows us both something important about the possibilities for conceptual art and the nature of artistic value.

References

BELL, C. (1914), *Art* (London: Chatto and Windus).

BUDD, M. (1995), *Values of Art* (London: Allen Lane, Penguin Press).

DAVIES, D. (2004), *Art as Performance* (Oxford: Blackwell).

FOUCAULT, M. (1979), 'What Is an Author?', in id, *Textual Strategies: Perspectives in Post-Structuralist Criticism*, trans. J. V. Harari (Ithaca, NY: Cornell University Press), 141–60.

GODFREY, T. (1998), *Conceptual Art* (London: Phaidon).

GRAHAM, G. (2005), 'Aesthetic Empiricism and the Challenge of Fakes and Ready- Mades', in Kieran (ed.), (2006: 11–21).

HARRISON, A. (1978). *Making and Thinking: A Study of Intelligent Activities*. Hassocks: Harvester Press.

KIERAN, M. (2004). *Revealing Art*. London: Routledge.

—— (2005). 'A Conceptual Map of Issues in Aesthetics and the Philosophy of Art', in Kieran (ed.) (2005: 6–8).

KIERAN, M. (ed.) (2006), *Contemporary Debates in Aesthetics and the Philosophy of Art* (Oxford: Blackwell) 5–6.

OSBORNE, H. (1980), 'Aesthetic Implications of Conceptual Art, Happenings, Etc.', *British Journal of Aesthetics*, 20: 6–22.

SHELLEY, J. (2003). 'The Problem of Non-Perceptual Art', *British Journal of Aesthetics*, 43/4: 363–78.

WIMSATT, W. K., and BEARDSLEY, M. (1946), 'The Intentional Fallacy', *Swanee Review*, 54: 78–90, and included in W. K. Wimsatt (1954), *The Verbal Icon* (Lexington: University of Kentucky Press), 3–18.

12

Creativity and Conceptual Art[1]

Margaret A. Boden

12.1 Introduction

If one has a view about the nature of creativity in general, it should apply to all forms of art (and to science too, though that is not our concern here). In particular, if one believes that there are several different types of creativity, one must say how these map onto various examples of art—whether these are general movements, specific art forms, or individual artworks. With respect to conceptual art, do all examples of this genre spring from the same type of creativity? And if so, what is it?

My own approach to creativity does distinguish different types, as I explain in sections 12.2 and 12.3. In section 12.4, I argue that the one which prima facie seems most appropriate is not apposite, in fact. Section 12.5 spells out the categorization I favour. Finally, in section 12.6, I relate this viewpoint to the evaluation of conceptual art.

12.2 What is Creativity?

A creative idea is one that is new, surprising, and valuable (Boden 2004). The term 'idea' is a shorthand, here. In art, the new idea sometimes is an 'idea' in the

[1] This paper forms part of the research supported by AHRC Grant no. B/RG/AN8285/APN19307: 'Computational Intelligence, Creativity, and Cognition: A Multidisciplinary Investigation'.

normal sense: a concept, if you prefer. But it need not be. It may be a method for producing artefacts (a new type of paintbrush, a revolutionary camera or developing technique, or a novel way of casting bronze). Or it may be a general style of painting or sculpting. Or it may be a musical composition or passing harmony, or a new dance-step or choreography, and so on. In sections 12.4 and 12.5, I'll mention a wide range of creative 'ideas' drawn from conceptual art.

Besides the ambiguity of 'idea', each of the three criteria of creativity is ambiguous. That's largely why disagreements about creativity are often carried on at cross-purposes.

There are two importantly different senses of 'novel'. On the one hand, an idea may be new to the person who had it: it's a first-time occurrence within their particular mental biography. Let's call this P-creativity, where the 'P' stands both for 'person' and for 'psychological'. On the other hand, an idea may be—so far as is known—new with respect to the whole of human history: that is, it's H-creative.

From the psychological point of view, which seeks to understand how creativity happens and how it's even possible, P-creativity is the more important concept. For every instance of H-creativity is a special case of P-creativity. (If it's the first occurrence in human history, then it must also be the first occurrence in the mind of its originator.) From the historical point of view, H-creativity is the focus of special interest. But since every H-creative idea is P-creative too, we can always ask what type of P-creativity was involved. This applies to the twentieth-century emergence of conceptual art, just as it does to any other artistic movement.

The second criterion, surprise, has three meanings. One may be surprised because something is statistically unusual, so contrary to commonsense expectations—like an outsider winning the Derby. Or one may be surprised because one hadn't realized that the new idea had been a possibility all along—like discovering a beautiful village tucked away in a hollow between two spurs of the motorway. (Its location had always been marked on the map, but one hadn't examined the whole map closely.) Third, one may be surprised by something that one had previously thought impossible, and which one still sees as utterly counter-intuitive. Here, think of the events categorized by the religious as miracles, or imagine the impact on non-physicists of the introduction of wireless or television.

The third criterion, being 'valuable', has many different meanings. For various reasons, these can't be wholly pinned down. What's valuable in music

is not necessarily valuable in, or even applicable to, architecture. What's valuable in a baroque fugue may not be valuable in the blues. And what's thought valuable in the 1960s may be scorned in the 1970s. As that remark suggests, values can change (sometimes, virtually overnight) as a result of shifts in fashion—some deliberately engineered for commercial purposes, some arising from unpredictable events (such as what an admired 'celebrity' chooses to wear to a party). There may be some universal or near-universal values: symmetry and shininess, perhaps? (Boden 2006: 8.iv.c). But even these can be deliberately transgressed, and their opposites admired in their stead (think of the highly asymmetrical architecture of Daniel Liebeskind).

One class of values merits special mention here, namely, what ecological psychologists call 'affordances' (Gibson 1966, 1979). These are naturally evolved tendencies to behave towards a perceived feature in a particular way. Some are positive: affordances suggesting opportunities for locomotion, for feeding, for stroking, for courting, and so on. Others are negative, such as affordances eliciting fear or disgust. (The latter have presumably evolved to prevent us, and other animals, from eating rotting and/or contaminated food.) The 'crafts' in general depend on the elicitation of positive affordances, which is why they are universal, relatively unvarying, and—unlike 'art'—capable of speaking for themselves (Boden 2000). In other words, craftworks can be appreciated without specific cultural knowledge, whereas artworks cannot. Even if an artwork does exploit inborn affordances (as many do), it's primarily interpreted as a moment situated within a particular cultural context.

The defining characteristic of a new artistic movement is that certain aspects of a wide range of artworks are now valued within a certain culture (or subculture) which weren't valued before. Usually, many—even most—of the previous values are retained. Occasionally, however, almost none is retained. As we'll see, the latter applies to the twentieth-century movement known as conceptual art.

12.3 The Three Types of Creativity

The three types of surprise listed above correspond to three types of creativity: combinational, exploratory, and transformational (Boden 2004: chs. 3–6). They're distinguished by the types of psychological process that are involved in generating the new idea.

The exercise and appreciation of each of these forms of creativity depends upon specific cultural knowledge. Someone from a different culture may not even be able to recognize the novelty involved, and a fortiori they may not be able to understand/appreciate it. In the context of conceptual art, it's worth pointing out that 'someone from a different culture' needn't be a foreigner: they may be your next-door neighbour. If so, they'll have to undergo a learning process if they're ever to understand the novelty and to judge the aesthetic value.

Combinational creativity involves the generation of unfamiliar (and interesting) combinations of familiar ideas. In general, it gives rise to the first type of surprise mentioned above. Just as one does not expect the outsider to win the Derby, because that does not normally happen, so one does not expect ideas X and Y to be combined, because they seem to be mutually irrelevant. Everyday examples of combinational creativity include visual collage (in advertisements and MTV videos, for instance), much poetic imagery, all types of analogy (verbal, visual, or musical), and the unexpected juxtapositions of ideas found in political cartoons in newspapers.

Exploratory and transformational creativity are different. They're both grounded in some previously existing, and culturally accepted, structured style of thinking—what I call a 'conceptual space'. Of course, combinational creativity too depends on a shared conceptual base—but this is, potentially, the entire range of concepts and world knowledge in someone's mind. A conceptual space is both more limited and more tightly structured. It may be a board game, for example (chess or Go, perhaps), or a particular type of music or sculpture.

In exploratory creativity, the existing stylistic rules or conventions are used to generate novel structures (ideas), whose possibility may or may not have been realized before the exploration took place. (You may or may not have had some reasons to expect to find a village nestling between the motorways.) It can also involve the search for, and testing of, the specific stylistic limits concerned. Just which types of structure can be generated within this space, and which cannot?

Transformational creativity is what leads to 'impossibilist' surprise. The reason is that some defining dimension of the style, or conceptual space, is altered—so that structures can now be generated which could not be generated before. Imagine altering the rule of chess which says that pawns can't jump over other pieces: they're now allowed to do this, as knights always were. The result would be that some games of chess could now be played which were literally impossible before. The greater the alteration, and the

more fundamental the stylistic dimension concerned, the greater the shock of impossibilist surprise.

However, not every dimension will have been changed. (Otherwise, why call it a new form of chess?) So there will be both structural continuities and structural discontinuities between the untransformed space and its seemingly impossible successor. If some feature of the game which you enjoyed before the change is retained, you'll find something to enjoy in the transformed version. You may, however, be so averse to jumping pawns—perhaps they make you feel giddy?—that you decide to revert to old-style chess nevertheless. In art, where aesthetic judgements presuppose recognition of the relevant cultural style, there will be aesthetic continuities and discontinuities too. And the discontinuities may or may not be regarded as valuable.

After the transformation has happened, the artist may add new rules, defining and exploring the new style more fully. One clear example concerns the composer Arnold Schoenberg (Rosen 1976). He transformed the space of Western tonal music by dropping the fundamental home-key constraint: it was no longer the case that every composition must favour one of a finite number of sets of seven notes (the major and minor scales). Atonality was born. But besides dropping this constraint, Schoenberg experimented by adding new ones. At one point, for instance, he said that each composition should contain every note of the chromatic scale. Musical exploration could then ensue on this basis. But the radical transformation was the decision to drop the constraint of a home key.

The three types of creativity are analytically distinct, in that they involve different types of psychological process for generating P-novel ideas. But as we'll see when we discuss examples, a given artwork can involve more than one type. That's partly why it's generally more sensible to ask whether this or that aspect of an artwork is creative, and in what way. However, people often ask about the creativity responsible for the artwork as such, because they assume that a particular aspect is in question even if this has not been explicitly stated.

In general, transformational creativity is valued most highly. (That's less true of literature than of the other arts, because language offers scope for especially rich creative combinations, and the theme of human motivation offers huge exploratory potential.) However, novel transformations are relatively rare. All artists spend most of their working time engaged in combinational and/or exploratory creativity. That's abundantly clear when one visits a painter's retrospective exhibition, especially if the canvases are displayed chronologically: one sees a certain style being adopted, and then explored, clarified, and tested.

It may be superficially tweaked (a different palette adopted, for example). But it's only rarely that one sees a transformation taking place. The artists whose names are recorded in the history books are usually remembered above all for changing the accepted style. (Again, that's somewhat less true of writers.)

Typically, the stylistic change meets initial resistance. And it often takes some time to be accepted. That's no wonder. For transformational creativity by definition involves the breaking/ignoring of culturally sanctioned rules.

12.4 Is Conceptual Art Transformational?

It may seem, given what I've just said, that conceptual art is a paradigm case of transformational creativity. After all, it's certainly shocking. One common reaction to it is 'That's ridiculous! What on earth made anyone think of that?'—and that's the polite version. Another is 'That's not art!' This reaction goes with outraged bewilderment at the fact that the work in question is exhibited in a gallery and/or taken seriously by what Arthur Danto (1964) called 'the art world'.

Prima facie, then, it seems as though we're dealing with a case of 'impossibilist' surprise. If these artworks really do arouse impossibilist surprise in the viewers, it would follow that conceptual art is transformational. For the type of surprise and the type of generative creativity go hand in hand. But is this culture shock genuinely impossibilist?

Impossibilist surprise and transformational creativity were both defined in terms of some accepted cultural style, or conceptual space. Each style covers, or makes possible, indefinitely many individual structures—some of which are actually produced by artists. By the same token, however, that style is incapable of generating other structures. For that to happen, some change ('transformation') of the space must be made. The newly created space can then allow the generation of previously impossible structures.

Does that apply to conceptual art? What cultural style, or conceptual space, was transformed by Marcel Duchamp's *Fountain* (see Illustration 3), for instance? Sculpture, perhaps? It was certainly shocking, considered as sculpture, since it was a mass-manufactured object bought from a warehouse, not something lovingly forged by Duchamp's individual skills. It may seem that this is an example of impossibilist surprise. But it is not, really, for sculpture as such is not an artistic style. Rather, it's a form of human activity conceived in highly

general terms. Michelangelo or Barbara Hepworth were equally sculptors, but worked within very different styles. The problem (the shock) with *Fountain* was not the style of its physical form—the nature of the curves, or even the lustre of the ceramic—but its manufactured provenance.

There was another source of shock too, namely its unsavoury associations. Duchamp was not the first artist to exploit affordances of disgust. Jonathan Swift, for instance, had a nice(?) line in scatology, which he used to challenge our safe complacencies (just read the usually expurgated passages of *Gulliver's Travels*). As for the visual arts, Francisco Goya aroused people's disgust (and fascination) by his painting of the cannibalistic Saturn, bloodily devouring his own child. But Goya, having chosen to depict that mythical/political theme, couldn't avoid disgusting us. The same applies to satirical cartoonists such as George Rowlandson and William Hogarth: a biting visual commentary on some social habits (as in *The Rake's Progress*, for example) could hardly fail to evoke disgust.

Duchamp, by contrast, seemed to employ unsavouriness for its own sake—or, more accurately, in order to shock the viewers (as opposed to communicating something shocking to them). Whether or not he was the first artist to do that, he certainly was not the last. This strategy became fairly common within late twentieth-century conceptual art.

Using elephant dung to make a portrait of an African Virgin Mary, as Christopher Ofili did, was one example. This is not an entirely clear case, because although elephant dung may disgust Western gallery-visitors, it's routinely handled for many purposes—including painting—in some African (and other) cultures. But exhibiting piles of one's own faeces, as has sometimes been done, certainly is. So too is designing a turd-making machine, complete with peristaltic pump, as in Wim Delvoye's room-sized installation, *Cloaca*. This twentieth-century successor of Jacques de Vaucanson's famous 'digesting' duck really does break down and ferment food, but it's intended more as cultural commentary than as simulated biology.[2] (The final irony is that viewers/collectors are willing to pay $1,000 per turd.) Even the aesthetic force of Tracey Emin's unmade bed depends largely on involuntary responses of disgust on the viewer's part—a point which she herself has made in interviews. The same applies to bisected cows floating in formaldehyde: part of the power is

[2] Boden 2006: 2.iv.a.

due to the object's disgust value. (Only part of the power: Damien Hirst's oeuvre is a meditation on death, corporality, and our failure to look these in the face.)

One might argue that Duchamp was not challenging the notion of sculpture, so much as the notion of art. Certainly, part of what he was doing was undermining the art world's claim to confer the status of 'art' on items exhibited in its galleries. That's why his readymades are sometimes categorized as art criticism, not art objects (Beardsley 1983: 25).

But others have been explicit about challenging the accepted notion of sculpture. Consider, for instance, Claes Oldenburg's work exhibited in New York's Central Park in 1967. This piece, officially called *Placid Civic Monument*, raised orthodox eyebrows in four ways.

First, the sculpture—though handmade—was not a result of the artist's own handiwork, but of a group of men temporarily employed by him. Second, it was ephemeral. Having taken two hours to create, it was deliberately destroyed only three hours later. Henceforth, it could be 'exhibited' only through a brief film, some still photos, and various texts recording its creation and its brief existence. Like the mass manufacture of *Fountain*, these unorthodox aspects challenged the idea of sculpture in general, not any particular sculptural style.

Oldenburg's third challenge to orthodoxy concerned the stuff of which the artwork was made. Instead of moulding a physical object to be placed on a plinth, or on the ground, he (or rather, a few professional gravediggers) dug a hole in the earth of Central Park. The hole itself, he said, was the sculpture. (In his notebooks, he ignored its official title and simply called it *The Hole*.) Its stuff was the absence of stuff. It had 3D form, of course, before it was destroyed (not by moles, earthworms, and rainfall but by the diggers themselves, who filled it in and smoothed it over after taking their lunchbreak). But its form was defined by what it was not, namely, the surrounding soil.

The particular form chosen was not (if you'll forgive the pun) immaterial. As a six-foot-long, six-foot-deep, rectangular trench it could be seen by the cognoscenti as an inversion of Donald Judd's minimalist rectangular blocks, which were attracting New Yorkers' attention at the time. It was also strongly reminiscent of a grave. Indeed, the art historian Suzaan Boettger points out that it was dug at a time of vociferous protest about the Vietnam war, when graves sprang more readily to mind than usual (2003: 19 ff.). Only three weeks after Oldenburg's quasi-grave was dug, 100,000 people joined in an anti-war march on Washington—and in his diary he explicitly connected the hole with his concerns about the war. In addition, Oldenburg's diary, and his hand-shot

film, repeatedly juxtaposed/contrasted the invaginated form of the trench with the phallic *Cleopatra's Needle* monument, nearby in the Park. What's more, both he and (so his diary memoire recalls) the gravediggers repeatedly referred to the earth as 'virgin' ground, and remarked on its dampness and redness (Boettger 2003: 17). In short, the shape of this hole was neither random nor meaningless—a point we'll return to in section 12.5.

Oldenburg's fourth challenge was invisibility: in his diary, he called the hole 'a nonvisible monument'. For it was debatable whether one can actually see a hole—as opposed to seeing its walls, or boundaries. Some previous sculptors, such as Henry Moore, had used holes very effectively. But theirs were 'stylistic' holes as opposed to 'constitutive' ones. A Moore piece was made of stone or bronze as usual, but its style was defined not only in terms of the types of physical curves and surfaces involved but also in terms of there being some curves and surfaces which were formed by gaps in the physical stuff. The artwork had one or more holes in it, and this was a feature (initially, a transformation) enabling stylistic exploration in the sense defined in section 12.3. In Oldenburg's piece, by contrast, the artwork was the hole. The challenge was to the very notion of sculpture, not to any particular sculptural style.

Some others took the invisibility challenge even further. For example, in 1968 Sol LeWitt made (or rather, he persuaded a metalworker to make) a stainless-steel ten-inch cubical box and buried it in the ground (Boettger 2003: 88 ff.). The box contained a small work of art he'd given to the owners of the ground where it was buried, but neither that nor the box was ever seen again. Both parts of this sculpture were straightforwardly visible in principle, to be sure—but in practice, they weren't.

Similarly, consider Walter de Maria's *Vertical Earth Kilometer*, made in 1977 (see Illustration 11). This was a perfect cylinder, made of highly polished solid brass, exactly five centimetres in diameter and 1,000 metres long (actually, 167 twenty-foot rods screwed together). So far, so orthodox. Unusual, yes. (Have you ever seen a sculpture 1,000 metres long, or weighing nearly nineteen tons?) But not shocking. The shock came when de Maria buried it vertically in the earth (in Kassel, Germany), so that it was invisible. The only indication of its existence was its circular top, level with the ground and kept free of grass by its 'keepers'. (Two years later de Maria fashioned *The Broken Kilometer*, a mathematically precise layout of 500 brass cylinders with the same diameter, and the same overall length and weight. Still on display in Manhattan, this easily visible sculpture can't be properly understood except by reference to the earlier, invisible, one.)

Last, consider Michael Heizer's variously invisible sculptures (Boettger 2003: 107–15, 191–7). These included a large steel cone, buried up to its lip; an (empty) two-part plywood box some four feet square, sunk into the ground up to the level of its top edge; and his hugely influential *Double Negative* of 1969 (discussed below). The first of those three examples involved invisibility by burial, the last, invisibility by absence; and the second combined both.

The aesthetic point, in most of these cases, was to reinforce the Conceptual Art emphasis on ideas rather than sensory perception—what Lucy Lippard (1973) called the dematerialization of the art object. If the idea behind the artwork was more important than its nature as a physical thing, it needed to be thought rather than perceived. There might actually be a material object. And this might have been constructed with considerable skill (not 'perfunctory' attention, as suggested by LeWitt—who famously defined Conceptual Art as being 'free from the dependence on the skill of the artist as a craftsman' (LeWitt 1967: 822)). But it needn't be seen, so much as thought about. And since it needn't be seen, it might as well be made invisible.

There are various ways in which this could have been done. LeWitt's little steel box, Heizer's plywood container, or de Maria's 500 cylinders, could have been wrapped in blankets, for example. But burying and blanketing have different associations: in the terminology of section 12.3, they give rise to different combinations of ideas. A buried artefact brings to mind notions of hoarded treasure, lost valuables, unsuspected potential, long-gone civilizations, hubris and futility, plus death and graves, again—not to mention funerary gifts to comfort the deceased on their dark journey. None of those concepts would be triggered by blanketing, which would rather suggest warmth, caring, vulnerability, and perhaps the sweet promise of infancy. So the artist had to choose the causal source of the invisibility. Having done that, his verbal descriptions, with the accompanying documents if any, could encourage, or validate, some associations (combinations) rather than others. In short, the true artwork, here, was more in the burying than the making. And the shock value lay in sculpting the box, cylinder, or cone meticulously—only to conceal it, for ever, from view.

The shock value of Heizer's *Double Negative* was rather different. It consisted of empty space, as Oldenburg's Central Park project did too. But it was/is permanent, not ephemeral. And it was not made by a few men wielding spades, but required dynamite and bulldozers to dislodge and remove almost a quarter of a million tons of rock. For this sculpture is made up of two horizontal rectangular notches, placed opposite each other in towering cliffs separated by a

chasm in the Nevadan mesa. These notches, and the space between them, could hold a skyscraper lying on its side: they're fifty feet high, thirty feet wide, and over a quarter of a mile long. (They can be reached only in a heavy four-wheel-drive vehicle, and aren't easy to find: visitors are advised to inform the local airport so that a search party can be sent out if they don't check in again soon.)

Heizer himself saw it as utterly new: 'My work is fully independent of anyone else's, and it comes directly out of myself. . . . Whatever I was doing, I was doing it first' (quoted in Boettger 2003: 109). However, doing something first does not necessarily mean doing it wholly independently. For one thing, Heizer was explicitly reacting against Manhattan minimalism, and scorning the New York art scene of the 1960s. For another, he and de Maria had experimented with land art together in the late 1960s—de Maria having proposed a bulldozer-dug artwork ten years earlier than that (Boettger 2003: 115 f.). And for another, he was recalling massive monuments in pre-Colombian America (which he knew a lot about, since his father was an archaeologist specializing in these things). As for the dynamite and the bulldozers, both his grandfathers had been prominent in the mining industry of the West.

These psychological sources of Heizer's creativity were also involved in the aesthetic appreciation of them. Viewers could hardly miss the contrast between the vast desert mesas and the decadent sophistications of the narrow streets of SoHo, nor escape thoughts of ancient temples and pyramids. And besides envisaging centuries-old rock-dragging slaves, they'd wonder at the enormous power of the modern machinery used to build *Double Negative*.

Shock value was prominent, too, in John Cage's composition *4'33"*, which consisted of just over four-and-a-half minutes of silence (Tomkins 1965: 69–144; Solomon 1998/2002). Instead of invisibility, there was inaudibility. The performance of the composition consisted in the pianist's closing the lid of the keyboard at the beginning of the piece (and at the beginning of the three carefully timed 'movements'); lifting it at the end (of the composition and of its component movements); using a stopwatch to determine just when to open or close the lid; and turning the pages of the score—which showed staves with no notes written on them. These hierarchical boundary-indicating actions were the temporal equivalent of the earthen walls of Oldenburg's invisible monument.

Someone might want to say that Cage had accepted an orthodox musical style, and then transformed it. To be sure, he had a pianist sit at a piano, and he defined three separate movements. But he'd written an instruction on the (empty) score saying that the piece was for performance by any instruments.

And he'd chosen the timings of the movements at random, constrained only by the overall period of four minutes thirty-three seconds. Everything else, including sound, was dropped. So whether there really were any instruments, or any movements, was highly problematic. Given these considerations, it's not at all clear that he 'accepted' the familiar style, nor that he 'transformed' it. Rather, he gestured towards it.

Perhaps he was providing a new conceptual space, a new style for others to explore? That description, too, suggests the existence of more structural constraints than were in fact involved. Rather, Cage was alerting other musicians to the nature and power of 'silence', and reminding them of the possibility of using chance to make certain compositional choices. Those ideas could, in principle, be applied to many different styles, perhaps transforming them in the process. But providing an idea which others can follow is not necessarily the same thing as creating a newly structured space. Not all influence is exploration. (Similarly, Heizer's and de Maria's revolutionary sculptures led to an explosion in what's now called land art or earthworks (Boettger 2003). But this is less an artistic style than an entire art form, which can be instantiated by following many different styles.)

Cage's main aim in composing 4′33″ was to challenge the orthodox view of music as such. He'd already done that for many years, by making (percussive) music out of what would normally be termed 'noises'. (In the 1930s, he'd also predicted the rise of electronic music.) Now, in 1952, he wanted to show that music (as he understood the term) is in fact continuous, that what's discontinuous is our voluntary attention to it. In other words, music is made by the listeners as much as by the performers or composer.

The trench in Central Park may not have been absolutely empty: there were probably insects flying around in it, and a few leaves may have been blown into it. But Oldenburg was not interested in that fact. Cage, by contrast, was very interested in the fact that there was not absolute silence during the performance of 4′33″. The movements of the piano lid and the page-turnings were audible. So were the rain on the roof and the birds in the rustling trees. Indeed, the first performance, in Woodstock, was held in a room—aptly named 'The Maverick Concert Hall'—that was open to a forest at the back. Also clearly audible were the moment-by-moment reactions of the audience. These reactions altered over the years. The Woodstock listeners, despite being a group devoted to *avant-garde* music, were outraged: their initial bemusement gave way to steadily mounting fury, and there was uproar when the pianist

got up at the end. Twenty years later, people had got the point: at least one audience exulted in the piece while it was being performed, and gave a standing ovation when it was over.

A superficially similar idea, though one originated with a very different aim, had been expressed over half a century earlier by the French composer Alphonse Allais (Solomon 1998/2002). His 'Funeral March' for the last rites of a deaf man (*Marche Funebre, composée pour les Funerailles d'un Grand Homme Sourd*) consisted of twenty-four measures of silence. It was defined by a score consisting of twenty-four blank staves of equal length, with a note saying that the performance must consist entirely of measurements, not of sounds—plus the teasing instruction that it be played *lento rigolando*.

The similarities to Cage are intriguing. But they don't negate Cage's claim to H-creativity. For the blank score and the measurements were being proffered in a very different spirit in the two cases. Allais had been intending to be funny (he was, in fact, a regular cabaret performer); and he thought of his Funeral March as being genuinely silent ('for a deaf man'). Cage, on the other hand, was denying the possibility of utter silence. And, even more important, he was being absolutely serious. In later life he often referred to 4′33″ as his most important work, and confessed to an interviewer 'I always think of it before I write the next piece' (Solomon 1998/2002: 3). Indeed, he'd already wanted to write this piece as early as 1947, but he'd feared that it wouldn't be taken seriously. It was the blank white canvases of his friend Robert Rauschenberg, seen in 1951, which finally gave him the courage to proceed (Revill 1992: 164). In short, whereas Allais had hoped to make people laugh, Cage had feared becoming a laughing stock.

Rauschenberg's H-creativity, too, had apparently been compromised by the same Parisian joker. For in the mid-1880s, an exhibition of *Les Arts Incoherents* had included a completely white painting by Allais, wittily named *Anaemic Young Girls Going to Their First Communion Through a Blizzard*. What's more, a black canvas of the same period depicted, or so he said, *Negroes Fighting in a Cave at Night*. But again, Allais was merely trying to be funny, whereas Rauschenberg wasn't.

As for predecessors casting doubt on the notion of silence, Cage mentioned in a talk given in 1948 (when he was still weighing the risks of composing 4′33″) that he'd been greatly impressed by a book on *The Art of Noises*, published by an Italian futurist in 1916. Although Cage didn't mention this at the time, the book contained a whole chapter pointing out that the so-called 'silence' of the countryside was no such thing—and that the country noises were

probably a key contribution to our perception of nature's 'beauty'. But even that *avant-garde* author hadn't gone so far as to define music in terms of silence. There, Cage was being genuinely original.

Music, of course, is conventionally regarded as 'a performance art'. But following someone glimpsed on a bus is not. Vito Acconci's journeys in his *Following Piece* of 1969 were not only ephemeral (as all performances are, in the absence of recording technology), but unwatched: invisibility again. Also, and unlike the carefully planned hole and cylinder, they were largely outside the artist's control. The targeted subject was chosen by Acconci at random, and then diligently followed by him until he/she entered a private place, such as a home or office. This might take only five minutes, or it might take all day. Any possible biographical interest was compromised by the fact that there was no guarantee that the 'home' or 'office' in question was that of the person concerned: they could have been visiting a friend or following up a business contact.

Scrappily recorded on the hoof, by snatched photographs and by jottings in notebooks, these followings were 'exhibited' post hoc by these evidentiary documents being shown in galleries. Sometimes, Acconci's photographs and video clips seemed to be selected by orthodox aesthetic criteria; but that was not always so (Davies 2004: 208). In brief, his activities fitted our usual notions of 'art' even less well than performances such as juggling or fire-eating do. A fortiori, there was no accepted style being structurally transformed.

One challenging 'performance artist' even dispensed with the performance itself. In a 1969 exhibition called *Art in the Mind*, Bruce Naumann took this title literally. His exhibit was a verbal snippet giving instructions for a possible performance: 'Drill a hole into the heart of a large tree and insert a microphone. Mount the amplifier and speaker in an empty room and adjust the volume to make audible any sound that might come from the tree' (quoted in Davies 2004: 209). But there was, and had been, no tree, no drill, no microphone . . . in a word, no performance. Even if, following Cage, one prefers to regard Naumann's piece as a description of possible or intended music, in fact there was no music (i.e. no sound). Normally, one would regard imagining an artwork and experiencing it as very different phenomena. Here, they were—shockingly—one and the same.

As a final example, consider Robert Barry's canvas called *All the things I know but of which I am not at the moment thinking—1.36 P.M., 15 June 1969, New York*. There were various aspects of culture shock involved here (see Binkley 1976). These included the irrelevance of the perceptible aspects of the piece; the logical

paradox concerning things 'of which I am not at the moment thinking'; and the fact that 1.36 p.m. on that June day was not an iconic moment in any sense—such as the time when John Kennedy was assassinated, or when the artist's mother died. The moment was not special, and the things listed were so unimportant that they weren't being thought about . . . yet this piece was mounted for serious inspection on a gallery wall.

In all the cases I've mentioned, the artist's aim was to challenge orthodox notions of art (sculpture, music, painting, collage, performance) by playing down what's perceptible and trying instead, as LeWitt put it (1967: 822), 'to make his work mentally interesting to the spectator'. And in most cases, though not all, the emphasis was on apparently unimportant, even randomly chosen, ideas as opposed to significant aspects of life.

Cage was a partial exception, for 4'33" was supposed to make one concentrate very hard on what's perceptible; however, this was not what was usually perceptible in a musical performance, and it certainly was not what's usually regarded as important. Oldenburg was a partial exception too, for graves—and, in that context, ephemerality—are among the most significant things of all.

In sum, the only sense in which conceptual art can be called transformative is in the challenge it poses to the accepted concept of 'art' itself. Various changes are evident, to be sure. We pass from handmade to readymade; from skill to artlessness; from physical object to temporal happening; from musical instruments to rustlings and mutterings; from tonality and atonality to continuous noise; from stuff to the absence of stuff; from visible material to the mere idea thereof, and so on. But none of these changes counts as a stylistic transformation in the sense defined above. Accordingly, conceptual art does not qualify as transformational creativity on my analysis.

12.5 Combinations and Conceptual Art

If conceptual art is not transformational creativity, what sort of creativity is it? Well, it's not grounded in exploratory creativity, either, for that's defined as the exploration of an accepted artistic space. Conceptual artists reject previously accepted styles. Indeed, that's what lies behind the common feeling that this endeavour simply is not art: in other words, that something fundamentally different is going on from what went on before (what Davies (2004: 2) calls

the 'radical discontinuity' thesis). (Before what, exactly? Perhaps *Fountain*, or perhaps mid-century New York: see the editors' Introduction.)

In saying that conceptual art is not grounded in exploratory creativity, I don't mean to say that it does not ever involve exploratory creativity. For it does sometimes produce a new conceptual space that's explored by the originating artist and/or by others.

Think of LeWitt again, here. He exhibited various series of canvases exploring a similar compositional idea. This might be (for example) a square grid, or an arrangement of coloured pyramid-like triangles painted on neighbouring gallery walls. Also, he constructed a three-dimensional enamel-on-aluminium sculpture of open cubes and closed bars of increasing/decreasing size, arranged on a rectilinear grid. Sometimes, he even specified the conceptual space, providing a list of abstract instructions about how such pieces might or should be executed. In those cases, he might leave the execution to others—as Oldenburg allowed his hole to be dug by cemetery workers.

Moreover, in defining conceptual art as such, LeWitt (1967) said that the crucial idea in each case 'becomes a machine that makes the art'. In other words, 'all of the planning and decisions are made beforehand and the execution is a perfunctory affair'. In addition, he said, to use the chosen idea was 'to work with a plan that is pre-set', and to avoid 'the necessity of designing each work in turn' (1967: 824). This art, he said, was not 'subjective': on the contrary, 'The artist's will is secondary to the process he initiates from idea to completion.' And, perhaps most telling of all, 'For each work of art that becomes physical there are many variations that do not' (1969: items 7 and 12). In short, in his practical work he defined and explored various conceptual spaces; and in his writing he claimed that this, at base, is what art is all about.

Much the same applies to some of the other artists I've mentioned. Heizer, for instance, built many massive and 'part-invisible' structures in wild landscapes. Similarly, Acconci undertook other 'followings', embarked on other journeys, and exhibited evidence of them later. Indeed, David Davies (2004: 233–4) has argued that Acconci's work should be seen as similar in spirit to Naumann's. Although Acconci actually did something, whereas Naumann merely gave a list of instructions, his photographs (according to Davies) illustrate a general type of performance rather than being records of some specific performance event.

LeWitt also said that 'The conventions of art are altered by works of art' (1969: item 19). Out of context, one might interpret that as a reference to transformational creativity. But we saw in section 12.4 that this is not what

conceptual art is concerned with. In other words, his phrase 'the conventions of art' does not refer to artistic styles, but rather to our ideas about what art, as such, is. Similarly, we've seen that Oldenburg, de Maria, Heizer, Cage, and Barry challenged our ideas about what sculpture, music, or collage on canvas is.

In each case, the challenge consisted in juxtaposing the familiar notion of art, sculpture, music, etc., with other familiar notions that are normally regarded as irrelevant, or even antithetical to it. The artworks mentioned in section 12.4 exemplified many conceptual alterations in 'the conventions of art'. Here are some of them:

- Instead of personal making, execution by the hands of others.
- Instead of chisels, bulldozers.
- Instead of unique handicraft, mass production.
- Instead of skill, perfunctoriness.
- Instead of the artist's subjective choice, a machine's inexorable following of a pre-set plan.
- Instead of perceptible beauty, conceptual interestingness.
- Instead of emotional expression, intellectual engagement.
- Instead of physicality, absence.
- Instead of visibility, burial.
- Instead of sophistication, nature in the (almost) raw.
- Instead of sound, silence.
- Instead of musical intentions, the noises of the natural and built environments.
- Instead of painting, scraps of text.
- Instead of artefact, performance.
- Instead of contemporary witness, documentary records.
- Instead of performance, an idea for a (non-actualized) performance.
- Instead of experiencing an artwork, imagining it.
- Instead of coherence, paradox.
- And instead of mental focus, mental absence (what I'm not bothering to think about).

In short, what we have here are cases of combinational creativity. We're invited to consider the mutual relevance of ideas normally held to be irrelevant, contrasting, or oppositional. We're even invited to go further, strengthening juxtaposition into definition. These unfamiliar combinations of familiar ideas are elevated from cabaret jokes into intriguing insights, and from insights into

a new understanding of 'art' and its various forms. (Forms, not styles: e.g. sculpture and music as such.)

Once a new combination of ideas—that is, 'art' plus X—has been accepted by conceptual artists as interesting, the concept of X may be experimented with (in a sense, 'explored') by several different people. For example, Cage and his followers used silence and randomness as key musical concepts for many years after 4′33″ was first performed. Similarly, consider the examples of art-burial described in section 12.4. These artworks, and the many inspired by them, were exploring the implications of a particular idea—namely, invisibility caused by burial. But that idea was 'interesting' only in the (combinational) context of the idea of art. Invisibility as such, burial as such, weren't the point. (By contrast, when Schoenberg introduced his rule that every chromatic note should be used, he was specifically opposing styles based on the major and minor scales.)

Other unfamiliar combinations, or reversals, may be introduced not as defining criteria of 'art', but as ideas intended to shock us out of our former complacencies about what art is. Duchamp's *Fountain* is a prime case in point: instead of something satisfying the good taste and sophistication of the aesthete, we're faced with the unsavoury quotidian earthiness of the urinal. Several other, even more unsavoury, examples were mentioned early in section 12.4.

One unfamiliar combination can be conjoined with others. So Oldenburg, at the very same time as he's upsetting our ideas about sculptural physicality, turns our minds to thoughts of graves, death, war, and the archetypal female. We saw in section 12.3 that it's characteristic of combinational creativity that many ideas may be co-relevant. The surprise is in the realization of relevance, and in the further associations that this realization brings to mind.

12.6 Values and Conceptual Art

Those remarks about the realization of relevance are germane to the final aspect of my definition of creativity, namely that the surprising novelty be valuable. Whether a particular artwork (or artistic genre) is produced by combinational, exploratory, or transformational processes is a psychological question. Whether it's an example of combinational, exploratory, or transformational creativity is a partly aesthetic question, because of the implicit reference to value.

Someone who regards conceptual art as entirely lacking in aesthetic (as opposed to historical or sociological) interest might agree that it's due to combinational thinking. But they'd deny that it exemplifies combinational creativity, because—for them—it wouldn't count as 'creativity' at all. Novelty, yes, but novelty alone isn't enough.

In saying that the artworks I've mentioned are examples of combinational creativity, I've implicitly suggested that they're aesthetically valuable. But I haven't explicitly said why. Nor have I made any evaluative comparisons, such as saying (what in fact I believe) that de Maria's invisible sculpture, or Heizer's massive earthworks, or Cage's silent music, or even Barry's paradoxically titled collages, are more aesthetically valuable than Acconci's random stalking. What are the criteria by which such judgements can be made?

In general, the richer the associations, and the deeper the relevance, the greater the aesthetic value of the novel combinations. Combinational creativity in general depends on intellectual interest and emotional resonance, as opposed to the appreciation of structured artistic styles. And intellectual interest, above all, is what conceptual art is aiming for.

To be sure, different types of creativity can exist within the same artwork. So we've seen (with respect to LeWitt and Acconci, for example) that exploratory and combinational creativity can go hand-in-hand in conceptual art. But it's clear from LeWitt's explicit comments on his work (as from Cage's too), that the challenging conceptual combination was considered more important than the stylistic exploration.

To evaluate conceptual combinations, the observers (or art critics) need to be able to do a number of things. They must recognize which ideas are being combined. This is relatively straightforward when several ideas are presented together (in a Barry collage, for instance), but less so when some of the relevant ideas are left unstated (as the concepts of 'art' or 'sculpture' are in Duchamp's *Fountain*). Sometimes, specialist knowledge is needed to see the relevance (as in de Maria's New York exhibit, which gestures towards his earlier work in Germany). At other times, general knowledge and human empathy are the prime motors of the viewer's aesthetic response (remember the comparison of burial with blankets, in relation to invisibility). And always, the individual resources of the viewer's mind can add depth to their appreciation.

People's judgements of the interest—and the attractiveness—of the ideas evoked matter too. Urine, elephant-dung, and turds may sometimes be relevant, even in a sense interesting: nevertheless, they won't be judged by

everyone to be valuable. (Do all shocks carry 'shock value'?) An artist who doesn't merely want to shock the viewer, but hopes to attract their interest and appreciation too, must somehow persuade them—or hope that a sympathetic art critic will persuade them—that the piece is genuinely worthy of their attention: at least for a moment, and perhaps for much longer than that.

All these aesthetic questions arise in appreciating combinational creativity in general. (Think of poetic imagery, for example.) Conceptual art is just a special case. Partly because there's no accepted style involved (at least in 'pure' cases of combinational creativity), and partly because the mental associations aroused differ so much between individuals, it's inevitable that agreement on the aesthetics will be difficult.

You may not share my own preference for de Maria over Acconci, for instance. You might never come to do so, even if we were to sit down and talk about it. You might not be persuaded (one can hardly say 'convinced') by my pointing out that the randomness in selecting Acconci's unknowing prey will only rarely lead to an engaging, still less a gripping, human story. And you might never resonate with my appreciation of the delectable absurdity in crafting a flawless metal cylinder only to hide it from view. Such difficulties aren't unfamiliar. For as remarked in section 12.2, aesthetic values in general are varied, changing, and often elusive.

Certainly, people who value the sensuous qualities of traditional painting, sculpture, or textiles will feel bereft at their absence from conceptual art. Likewise, admirers of skilled craftsmanship will be cast adrift when no art object has been crafted, or when it has been carelessly thrown together or lifted off a warehouse shelf. And those who take joy in stylistic exploration will feel short-changed by 'one-offs' that may be ephemeral, and which in any case don't lead to a series of artworks developing the same style. The shock of a new thought, or the amusement caused by a daring conceptual juxtaposition, may be scant recompense.

However, these are matters more of individual preference than of aesthetic principle. That's why combinational creativity is usually more difficult to justify than its exploratory cousin. Transformational creativity is a halfway house, since stylistic rules are (by definition) broken. Here, justification of the transgressive art object will involve both showing its affinity to the previous style and indicating its potential for the development of a new one.

In sum, and despite its startling difference from previous artistic practice, conceptual art isn't the result of transformational creativity. The huge shock

that it carries results, rather, from highly unexpected combinations of familiar ideas—including, in particular, our culturally cherished notions about art and artistry as such.

The richer the associations, and the deeper the relevance, the greater the intellectual interest. Combinational creativity *par excellence* is about intellectual interest for its own sake, as opposed to the appreciation of structured styles. And intellectual interest, after all, is what conceptual art is aiming for.

As for the coexistence of different types of creativity within the same artwork, we've seen (with respect to LeWitt and Acconci, for example) that exploratory and combinational creativity can go hand-in-hand in conceptual art. But it's clear from LeWitt's explicit comments on his work (as from Cage's, too), that the challenging conceptual combination was considered more important than the stylistic exploration.

In sum, and despite its startling difference from previous artistic practice, conceptual art is not the result of transformational creativity. The huge shock that it carries results, rather, from highly unexpected combinations of familiar ideas—including, in particular, our culturally cherished notions about art and artistry as such.

References

BEARDSLEY, M. C. (1983), 'An Aesthetic Definition of Art', in H. Curtler (ed.), *What is Art?* (New York: Haven), 15–29.

BINKLEY, T. (1976), 'Deciding About Art', in L. Aagaard-Mogensen (ed.), *Culture and Art: An Anthology* (Atlantic Highlands, NJ: Humanities Press), 90–109.

BODEN, M. A. (2000), 'Crafts, Perception, and the Possibilities of the Body', *British Journal of Aesthetics*, 40: 289–301.

——(2004), *The Creative Mind: Myths and Mechanisms*, 2nd edn. expanded/revised (London: Routledge).

——(2006), *Mind as Machine: A History of Cognitive Science* (Oxford: Clarendon Press).

BOETTGER, S. (2003), *Earthworks: Art and the Landscape of the Sixties* (Berkeley, CA: University of California Press).

DANTO, A. (1964), 'The Artworld', *Journal of Philosophy*, 61: 571–84.

DAVIES, D. (2004), *Art as Performance* (Oxford: Blackwell).

GIBSON, J. J. (1966), *The Senses Considered as Perceptual Systems* (Boston: Houghton Mifflin).

——(1979), *The Ecological Approach to Visual Perception* (Boston: Houghton Mifflin).

LeWitt, S. (1967), 'Paragraphs on Conceptual Art', *Artforum*, 10 (June): 79–83. Reprinted in K. Stiles and P. Selz (eds.), *Theories and Documents of Contemporary Art: A Sourcebook of Artists' Writings* (London: University of California Press), 822–6.

—— (1969), 'Sentences on Conceptual Art', *Art-Language*, 1: 11–13. Reprinted in K. Stiles and P. Selz (eds.), *Theories and Documents of Contemporary Art: A Sourcebook of Artists' Writings* (London: University of California Press), 826–7.

Lippard, L. (1973), *Six Years: The Dematerialization of the Art Object 1966–1972* (New York: Praeger).

Revill, D. (1992), *The Roaring Silence: John Cage: A Life* (New York: Arcade).

Rosen, C. (1976), *Schoenberg* (Glasgow: Collins).

Solomon, L. J. (1998/2002), 'The Sounds of Silence, John Cage and 4′33″', available only on the Web, at <*http://music.research.home.att.net/4min33se.htm*>.

Tomkins, C. (1965), *The Bride and the Bachelors: Five Masters of the Avant-Garde* (New York: Viking).

13

Conceptual Art Is Not What It Seems

Dominic McIver Lopes

Hypotheses in aesthetics should explain appreciative failure as well as appreciative success. They should state the general conditions under which people fail to understand and value works as works of art. This stricture is all the more important when the typical response to avant-garde art is incomprehension, resistance, and rejection. Perhaps this typical response is justified and the art in question deserves to be repudiated. Assume this not always to be the case. Then if some art deserves a response that it typically does not get, we should try to explain the appreciative failure. Explaining appreciative failure might require interesting changes to theories about art.

13.1 Rift and Resistance

Conceptual art is the poster child of appreciative failure. Much of it leaves its audience, even those who are well educated in art, feeling frustrated, confused, and dismissive. In an entry on conceptual art in the *Oxford Companion to Twentieth Century Art*, Harold Osborne is openly contemptuous, writing that 'most artists in the field of conceptual art deliberately render their productions uninteresting, commonplace, or trivial from a visual point of view' (Osborne 1981: 122–3). Tom Wolfe, in *The Painted Word,* wallows in sarcasm, likening the

audience of conceptual art to Plato's cave dwellers, who are blind to the true nature of what they struggle to see (Wolfe 1975: 121). We should seek to explain this appreciative failure.

Wolfe pins the blame on a rift in art of the late modern period (the second half of the twentieth century). Whereas art through abstract expressionism and minimalism is to be appreciated by sensory immersion, later art, including conceptual art, can be appreciated only by theorizing.

Of course the appreciative failure of conceptual art issues from a rift between it and more successful art. The trouble is that the truth of this suggestion is inversely proportional to its explanatory power. Everything is different from everything else in many respects, so a rift by itself explains nothing. To give the suggestion explanatory bite, we must pinpoint the rift that causes the appreciative failures to which conceptual art is especially and specifically prone.

Wolfe thinks that the rift is caused by the rise of theory in visual art, but it is not obvious what this means. Here are three ways conceptual art may be so theory-laden as to cause a rift that explains appreciative failure. It may require a new definition of art. It may require a new ontology of art. It may require a new understanding of the art form of conceptual art. Call these the 'new art hypothesis', the 'ontological hypothesis', and the 'art-form hypothesis'.

Selecting the best hypothesis requires some empirical background. Since the best hypothesis best explains the appreciative failures to which conceptual art is especially prone, we need an accurate catalogue of those failures. That is, we need some idea of which works are prone to failure for which audiences in which circumstances. If appreciative failure takes the form of false judgement, then the contents of those judgements could be revealing. If it takes the form of absent affect, then it would be helpful to know exactly how people feel when confronted with conceptual art. Unfortunately, the evidence is anecdotal and unsystematic, so we must guess.

In addition, a scheme is needed that reliably categorizes works as conceptual art. Given the enormous disagreement about the boundaries of conceptual art, a working strategy focuses on acknowledged, canonical works of the classic era of Conceptual Art: works made by such artists as the Art & Language collective (see Illustration 6), Vito Acconci, Robert Barry (see Illustration 7), Hanne Darboven, On Kawara, Joseph Kosuth (see Illustration 5), Sol LeWitt (see Illustration 8), and Robert Smithson between the mid-1960s and mid-1970s. (These are works of Conceptual Art rather than conceptual art, in the convention of this volume.) More famous works of conceptual art

like Duchamp's *Fountain* (see Illustration 3) and Rauschenberg's *Erased De Kooning Drawing*, should be treated as prototypes rather than paradigms of Conceptual Art. A satisfactory definition of Conceptual Art may emerge from an explanation of its susceptibility to appreciative failure.

13.2 The New Art Hypothesis

Conceptual Art is often thought to require a new, expanded definition of art—that is, a new conception of the principles that sort art from non-art. This explains the appreciative failure of its audience, if the audience is committed to a traditional definition of art.

The hypothesis echoes in the writings of Conceptual Artists. Artists' manifestos must be treated gingerly, since they are not on the whole reliable sources of information about what is going on in art. However, the manifestos of Conceptual Artists should be taken seriously, if any should. When a whole art movement suffers appreciative failure, we must consult its founders' statements for an idea of what they hoped to achieve. Moreover, the writings of Conceptual Artists are frequently eloquent and carefully reasoned pieces of theorizing—and Conceptual Art is meant to be theoretical.

To take one example, in 'Art after Philosophy' Joseph Kosuth defines Conceptual Art as an 'inquiry into the foundations of the concept of "art" ' (Kosuth 1999: 171). The inquiry proceeds by making art that does not fit traditional definitions of art, especially aesthetic definitions and definitions that privilege the personal expression of the artist.

The critical literature endorses Conceptual Artists' take on their work. According to a standard taxonomy, Conceptual Art comprises readymades, interventions, documentation of ephemeral events, and words (Godfrey 1998: 7), and critics view works in each of these categories as counter-examples to traditional definitions of art.

The project of redefinition can be understood in different ways. The historian Paul Wood writes that 'the world is not divided into natural kinds . . . rather, our language, and by extension the conceptual structures we employ, help formulate what we see as something' (Wood 2002: 53). Conceptual Art redefines art and thereby changes the reality of art. However, the new art hypothesis requires no such radical metaphysics. Conceptual Art may simply compel us to revise a definition that fails to reflect an independent reality of art.

The new art hypothesis also captures the typical use to which philosophers have put conceptual art. Readymades, in particular, motivate non-aesthetic theories of art (e.g. Binkley 1977; cf. Shelley 2003). They also motivate contextualist theories of art. Here is a urinal and it is not art. Here is another urinal and it is art, though it is otherwise much like the first urinal. The second urinal cannot be art just because of its intrinsic, perceptible properties, which it shares with its artless counterpart. What makes it art is its relation to an art context comprising creative or interpretive practices or a body of pre-existing art (or something along these lines). None of these rule out in advance what can be art. Pouring asphalt down a hill, shaking hands with trash collectors, painting today's date—these can be art, given the right context. George Dickie acknowledges 'the strange and startling innovations of Duchamp and his latter-day followers such as Rauschenberg, Warhol, and Oldenberg' as the inspiration for his contextualist theory of art (Dickie 1973: 27).

In this way Conceptual Art anticipates and resembles philosophy of art. Kosuth writes that 'a work of art is a kind of proposition presented within the context of art as a comment on art' (Kosuth 1999: 165). The manifestos of Conceptual Artists and the writings of its critics are frequently anxious to differentiate Conceptual Art from philosophy.

Grant that the new art hypothesis is true: Conceptual Art requires a new definition of art to replace the traditional ones that it refutes. Also grant, more contentiously, that the existence of Conceptual Art is a reason to accept a contextualist definition of art—an institutional theory, perhaps. The question remains whether the hypothesis explains the appreciative failure of Conceptual Art.

There is reason to think not. The new art hypothesis seeks to explain the appreciative failures of Conceptual Art by tracing them to the inability of its consumers to see beyond traditional definitions of art. That is, Conceptual Art can be appreciated only if it is seen as occupying hitherto unknown regions of the extension of 'art'. That requires giving up on traditional definitions of art to which we are committed. Our commitment to these definitions explains why we fail to appreciate Conceptual Art. The trouble is that there is plenty of evidence that we are not committed to traditional definitions of art.

First, conceptions of art expanded in many directions in the twentieth century while causing little trouble for anyone. Early in the century, African masks migrated from the Museum of Man to the National Gallery. The same happened in the 1970s and 1980s with quilts, schizophrenics' doodles, and other

'outsider art'. At the same time, pop music, movies, TV shows, household appliances, and strip malls were embraced as art. Even abstract painting and minimalist sculpture gained a relatively wide audience. Works that challenge traditional definitions of art do not as a rule induce appreciative failure.

Second, it is a good bet that most of those who come across Conceptual Art *do* recognize that it is art. After all, context gives it away—there it is, in the museum surrounded by many other works of art. Arthur Danto's Testadura is a fiction—nobody ever mistakes Rauschenberg's *Bed* for a mere bed (Danto 1964). Moreover, it is just as plain to those who come across Conceptual Art that it stretches the traditional boundaries of art and therefore challenges traditional definitions of art. The lesson is that recognizing what is art is not sufficient for appreciation. It is at best a necessary condition for appreciation. Since the condition is met even by those who fail to appreciate Conceptual Art, it is wrong to pin their failure on their commitment to some traditional theory of art that blinds them to the fact that Conceptual Art is art.

Suppose there were a Testadura. His puzzlement would not dissipate upon being told that Rauschenberg's *Bed* is art. On the contrary, that is exactly when his puzzlement would begin. You are no Testadura. You recognize that a Duchamp, a Smithson, or a Kosuth are art. Still, you are puzzled. Why a urinal and not a standpipe? Why asphalt down a hill in Italy and not marmalade down the ramp of the Guggenheim? Why three chairs? Why not three cats on three mats? You are tempted to admire the 'arctic sublimity' of the gleaming porcelain, the sticky temporality of the asphalt, the chairs' riff on Book 10 of Plato's *Republic*. But you are warned: *that* is not the point. You are left knowing that the failure is not deserved but you do not know why.

13.3 The Ontological Hypothesis

Distinguish definitions of art from ontologies of art. A good definition of art sorts works that are art from those that are not. An ontology of art states what kinds of entities works of art are, taking for granted that they are works of art. According to folk ontologies of art, some works of art are physical objects (e.g. paintings) and others are multiply instanced works whose instances are performances. According to the ontological hypothesis, works of Conceptual Art have no place in our folk ontology. Our commitment to this ontology explains why we fail to appreciate them.

One problem with the new art hypothesis is that recognizing that a work is art does not suffice for appreciating it. The ontological hypothesis is an improvement because ontology is a guide to appreciation. Appreciating a work means understanding it and thereby absorbing its value, and these activities involve subsidiary activities. Looking may be required for a Degas pastel, listening and dancing for a big band number, and imagining for a P. D. James murder mystery. Which activities are involved in appreciating a work depends on its ontological category. Objects are available for looking at, sonic events for listening to, and stories for imagining. Unless we know what ontological category a work belongs to, we are unlikely to know what to do with it, and so we are likely to misappreciate it.

David Davies suggests that 'much of the discomfort that receivers experience in their attempts to appreciate the art of the "late modern" period, and much of the hostility directed at that art, stems from uncertainty as to what one is supposed to *do* in order to appreciate [it]' (Davies 2004: 189). If what we are able to do with a work depends on its ontological status, then 'we might try to accommodate late modern works of fine art by reconceiving the ontological status of the work' (Davies 2004: 191).

The key step in making a case for the ontological hypothesis is to show that late modern artworks, including Conceptual Art, cannot be fitted into the folk ontology of art to which we are committed. Here there is a moderate version and a radical version of the ontological hypothesis.

According to the moderate version, folk ontology of art serves well enough for traditional art but at least some works of Conceptual Art have no place in its list of categories. *Mona Lisa* belongs in the category of objects, for example, and some works of Conceptual Art are also objects. Thus On Kawara's date paintings are paintings, and the impact of Manzoni's *Merda d'artista* lies in its being the stuff that it is (thankfully sealed in a can). Other works of Conceptual Art are not objects, however. Mierle Ukeles scrubbed the floors of art museums. Robert Barry released two cubic feet of compressed helium into the Mojave Desert (for a similar work in the same series see illustration 7).

Perhaps these are works for performance, like songs and plays? The answer is not obvious. There are elements of theatre in Ukeles's floor scrubbing: it is an action that she does and that an audience perceives. In other works, essential elements of performance are missing. No audience watched Ukeles shake hands with eight-and-a-half thousand sanitation workers over a period of eleven months in *Touch Sanitation*. No audience attended Robert Barry's release

of helium into the atmosphere—and there was arguably nothing he did that an audience could have seen as a performance. Mel Bochner's *Working Drawings and Other Visible Things on Paper Not Necessarily Meant to Be Viewed as Art* was shown as one hundred pages of notes and working drawings. The notes and sketches are not the work itself, nor is the work identical to the artistic performance that the plans document—the plans are not plans of *Working Drawings.* The plans realize a work that is constituted by neither the plans nor the planning process.

Works such as these seem to call for an *expansion* of the folk ontology of art. The folk ontology allows for objects and performances. Some works of Conceptual Art are neither.

Davies defends a more radical version of the ontological hypothesis: the ontological categories provided by the folk ontology of art do not fit any works of art. Despite appearances to the contrary, *no* works of art are objects or performances. Arguments are needed for a revisionist view, and Davies supplies some; suppose that they are strong. Nevertheless, strong arguments are not enough. The view's plausibility also depends on the plausibility of an alternative to the folk ontology. Davies's alternative is, in brief, that an artwork is an action on the part of an artist—one that specifies a focus of appreciation. The focus of appreciation comprises a content, a vehicle for expressing the content, and a medium or set of understandings by means of which the vehicle expresses the content (Davies 2004: 146). The vehicle may be an object or a performance or something else, but the work itself is the artist's act of specifying the focus of appreciation—it is not the focus that gets specified. This applies to all art, not just Conceptual Art.

Supposing that Davies's new ontology of art is correct, the appreciative failure of Conceptual Art still needs explaining. Recall that the ontological hypothesis must explain the appreciative failure to which Conceptual Art is especially and specifically prone. The trouble is that the radical version of the ontological hypothesis implies that we are stuck on an inadequate folk ontology when we encounter Conceptual Art and equally when we encounter traditional art. For Davies, *Mona Lisa* is not a physical object, as we think it is, but rather an action specifying a focus of appreciation, so what goes for *L.H.O.O.Q. Shaved* goes for *Mona Lisa.* The radical version of the ontological hypothesis predicts no rift between Conceptual Art and traditional art. It predicts puzzlement about art across the board rather than puzzlement specific to Conceptual Art.

It would be wrong to infer that Davies entirely lacks the resources to explain the appreciative failure of Conceptual Art. He might pin that failure on a violation of expectations about elements of the focus of appreciation, especially the vehicle for expressing a content. Perhaps we think that vehicle can be an object or a performance and we are frustrated by works of Conceptual Art whose vehicle is neither object nor performance. The proposal returns us to the moderate version of the ontological hypothesis.

In its moderate version, the ontological hypothesis does promise to explain our specific failure to appreciate Conceptual Art. By claiming that traditional works find a place in the folk ontology and works of Conceptual Art do not, it predicts a rift between traditional art and Conceptual Art.

The trouble with the moderate version of the ontological hypothesis is that it underestimates the resources of the folk ontology. The folk ontology accommodates works that are neither objects nor works for performance. Literary works are a good case. First, intuitions do not count them either with *Mona Lisa* or with 'My Favourite Things'. Philosophers who contend that literary works are in fact works for performance must overcome contrary intuitions by vigorous argumentation (e.g. Kivy 2006). Second, to the extent that works of Conceptual Art trade in ideas and propositions, they are the kinds of things that belong with literary works. One should expect works of Conceptual Art and works of literature to be placed in the same ontological category.

What is that category? Propositions, concepts, signs, texts, imaginary states of affairs, abstract patterns? The folk ontology, as embodied in the intuitions and practices of readers, is silent on *this* question. No matter. The ontological hypothesis is in trouble if it is intuitively natural to place works of Conceptual Art in the same category as literary works. Our folk ontology need not include a theory of those entities. After all, the folk ontology of art is silent on the nature of objects and performances too.

The folk ontology of art might not, in the end, accommodate works of Conceptual Art. However, that is not enough to show that the ontological hypothesis explains the appreciative failure to which Conceptual Art is especially prone. We must also show that, as a matter of fact, we now believe that works of Conceptual Art cannot be placed in the folk ontology. The trouble with the ontological hypothesis is that we take the folk ontology of art to be a more flexible system than the hypothesis allows.

13.4 The Art-Form Hypothesis

According to the art-form hypothesis, Conceptual Art seems to belong to the same art form as paintings and sculptures—to what used to be called 'plastic art'. In fact, it does not belong to this art form. It is not what it seems. This is why it is prone to appreciative failure. We attempt to appreciate works of Conceptual Art as if they were works of plastic art, but they are not. No wonder we fail.

The case for the art-form hypothesis depends on accomplishing several tasks. One is to give an independent account of art forms and their appreciative relevance. A second is to show that Conceptual Art is taken to be plastic art. A third is to say what plastic art is and hence what Conceptual Art is not. Finally, it would be helpful, if not essential, to explain why we get wrong the art form of Conceptual Art.

13.5 Art Forms and Media

The art-form hypothesis presupposes some notion of what art forms are and how they are relevant to appreciation.

First distinguish art forms from media. Matisse's *Red Studio* belongs to the plastic art form. *Middlemarch* belongs to the art form of literature, as does John Ashbery's 'Self Portrait in a Convex Mirror'. 'Brick House' belongs to the musical art form. Focusing on the plastic arts, it is tempting to identify media with materials—pastel, oil, and silver gelatin, but this identification is too narrow (Binkley 1977). A better idea is that a medium is a technology, so all art media are technologies used by artists in making art. Heroic tetrameter is an art medium, as is the convention that a narrator's second-person speech addresses the reader. Of course, not all technologies used in making art count as art media. A painter may use a coffee machine to keep up her production the night before the big show, yet the Melita drip is not in this case her medium (it might be in other cases). Art media are technologies that figure in a special way in making art. They might be art-making technologies, facts about which are relevant to appreciation, for example. Nothing hinges on how we spell out the special role of art media in making art. Intuitions about which technologies are art media are enough.

Art forms and art media are systematically related. Art media are unequally distributed across artistic practices. Schubert's compositional activity did not include bronze casting. Boccaccio's storytelling contains no diminished seventh chords. Homer never used raw umber in singing his tales of Achilles and Odysseus. Olmstead had no use for the heroic tetrameter in his practice as a landscape architect.

This is not to say that art media are distributed discretely across artistic practices. Art media cross boundaries. John Cage's 4″ 33′ plays upon elements of staging normally associated with theatre, and Claude Cormier's Blue Stick Garden borrows liberally from resources otherwise drawn upon in minimalist painting and op art. The point is that art media are not distributed close to evenly across artistic practices. They are clumped and the clumpings are informative. Even when media do cross boundaries, the result is not homogeneous: multimedia painting is something quite different from multimedia music. (Carroll 1999: 53–5 describes the distribution of different kinds of representation across art forms.)

With this in mind, define art forms as the kinds whose properties explain the distribution of art media across artistic practices. That is, define an art form with reference to the art media employed in making works in the art form: it is the kind whose properties explain why some art media are and others are not employed in making those works. Composers use counterpoint and pitch rather than casting and patina as their artistic media because they are making music rather than sculptures. Olmstead uses paving and planting rather than heroic tetrameter as his artistic media because he was engaged in landscape architecture rather than poetry.

This 'distribution principle' delivers only a modest conception of art forms, for it merely ties art forms to art media. It does not state the facts about art forms that explain why art media are distributed as they are, nor does it state the facts about any particular art form that explain why works in that art form employ the art media that they do. An ancient but still plausible idea is that works in each art form share a characteristic function. That common function explains why the art form is associated with certain art media if those media are good means of carrying out the function. The distribution principle does not, however, imply this idea.

The distribution principle nevertheless explains our access to art forms. It implies that the art form of a work is indicated, more or less exactly, by the

art media used in its making. Knowledge of a work's art media is not hard to acquire and it points to its art form. On the one hand, art forms explain why works are made using certain art media; and, on the other hand, it is through their art media that we recognize works' art forms.

Contrast the relationship between art forms and art media with that between art forms and genres. While the notion of a genre has many uses in art criticism and theory, one especially prominent use sorts artworks into tragedies, melodramas, thrillers, farces, satires, and the like. Genres such as these are relatively evenly distributed across multiple art practices, so that knowing that a work is a tragedy leaves quite open what art form it belongs to. Whereas X's being cast in bronze makes it likely that X is a sculpture, X's being a comedy does not indicate whether X is a poem, a movie, or something else. (This is consistent with facts about a work's medium explaining facts about the work having to do with its genre—as, for instance, choice of key can contribute to comic effect.)

Kendall Walton showed that categories of art are relevant to appreciation, for the aesthetic properties a work seems to have depend on the non-aesthetic properties it seems to have relative to perceptually distinguishable categories. In the now famous example, *Guernica* looks 'violent, dynamic, vital disturbing' when viewed as a painting, but it would look 'cold, stark lifeless, or serene and restful, or perhaps bland, dull, boring' when viewed as a guernica—a category of works that implement the 2D pattern of *Guernica* in degrees of bas-relief (Walton 1970: 347). Pictures and guernicas are both plastic arts but the lesson extends to the higher-level category of art forms. The aesthetic properties a work seems to have depend on whether we view it as a musical score or a drawing, for example.

Following a suggestion of Walton's, some hold that an appreciation of a work is adequate only if the work is viewed as belonging to the very category to which it actually does belong (cf. Lopes 2007). The relevance of art form to appreciation does not require a view as strong as this. All we need is the claim that we fail to appreciate a work if we view it in some art form to which it does not belong. Perhaps we can appreciate a landscape if we view it as theatre but not if we view it literally as music.

Art forms are relevant to appreciation, and we access the art forms of works via awareness of their art media. It follows that awareness of the art media of works is also relevant to appreciation, in so far as the media afford access to their art forms. Appreciation can involve connecting media up to art forms. When the connection is lost, appreciation may fail.

13.6 Painting with Language?

Grant that artworks belong to art forms which explain the distribution of art media and which are relevant to appreciation. According to the art-form hypothesis, Conceptual Art is wrongly taken to belong to the plastic art form.

One reason to think that Conceptual Art is taken to be plastic art is that it is exhibited and described as such. It is placed in art museums and art galleries and it is written up in critical reviews and art-history books alongside Giotto, Pollock, and Warhol. This is prima facie evidence that expert curators, critics, and historians understand it to be plastic art. It is also good evidence that its wider audience views Conceptual Art as plastic art, for that audience is guided in its opinions of such matters by the experts.

Conceptual Art is also taken to belong to the plastic arts because it is taken to mount a radical challenge to their fundamental assumptions. According to the opening words of the first issue of *Art−Language*, Conceptual Art questions 'the condition that seems to rigidly govern the form of visual art—that visual art remains visual' (Art & Language 1999: 99). In his 'Sentences on Conceptual Art', Sol LeWitt writes that 'when words such as painting and sculpture are used, they connote a whole tradition and imply a consequent acceptance of this tradition, thus placing limitations on the artist who would be reluctant to make art that goes beyond the limitations' (LeWitt 1999b: 106). He intends, of course, to break through the limitations. For Kosuth, 'art's viability is not connected to the presentation of visual (or other) kinds of experience' (Kosuth 1999: 168). Wood agrees that Conceptual Art is 'premised on undercutting the two principal characteristics of art as it has come down to us in Western culture, namely the production of objects to look at, and the act of contemplative looking itself' (Wood 2002: 6).

'Art' in these passages can only shorten 'visual art'. The propositions that art need not be visual and that it exceeds the bounds of painting and sculpture are uninformative if 'art' includes music and literature. What Conceptual Art therefore challenges is one kind of art, the art form of plastic art, which the editors of *Art−Language* imply is wrongly called 'visual art'.

As it is viewed by its makers, Conceptual Art is revisionary, not revolutionary. Their writings insist on its continuity with plastic art of the past, which, they propose, has been misunderstood. Thus Kosuth says, following his statement about the non-visuality of art, 'that this may have been one of art's extraneous functions in the preceding centuries' (Kosuth 1999: 168). He also

approves as a guiding principle for Conceptual Art Donald Judd's claim that 'everything sculpture has, my work doesn't' (Kosuth 1999: 160). About the same time, Ian Burn wrote that 'for painting to be "real", its problems must be problems of art. But neither painting nor sculpture is synonymous with art, though they may be *used* as art' (Burn 1999: 189). In these statements, too, 'art' is a short form. The point they make is that plastic art is not visual art. Such matters as depiction, modelling volume, and the marking of a surface are not essential to plastic art. Conceptual Art shows that only language and ideas are essential to plastic art. Even the plastic art of the past is misunderstood unless this is kept in mind.

13.7 Conceptual Art Is Not Plastic Art

The art-form hypothesis states that Conceptual Art is taken to be plastic art and it is not plastic art. We fail to appreciate Conceptual Art because we attempt to appreciate works of Conceptual Art as belonging to an art form to which they do not belong. What, then, is plastic art? And what explains our mistaking Conceptual Art for plastic art?

Plastic art comprises two art forms: pictures and sculpture (and their boundary is not perfectly sharp). For the sake of simplicity, set sculpture aside and identify plastic art with pictorial art. Works in the art form make use of picturing technologies—technologies for making two-dimensional, static, marked surfaces. Some of these technologies are representational and are used for making works that depict scenes or objects. Some are non-representational—such as the Pollock drip technique. Understanding how these art media are used in making pictures grounds appreciation of works in the art form.

That definition of plastic art is, if anything, too straightforward. One wonders how it could come to be misapplied to a whole art movement. Why do we so badly mistake Conceptual Art for plastic art? Why, indeed, when appreciative failure should signal the mistake?

Part of the answer is that we do not have a clear idea of what art forms are in the first place. The culprit is the idea that each art form makes *essential and exclusive* use of its proper art media. Enshrined as a central dogma of mid-century modernist art by such writers as Clement Greenberg (Greenberg 1961), this idea had an enormous impact on subsequent thinking about art (Carroll 1985). Conceptual

Art was in part a reaction to the Greenbergian dogma; one of its aims was to expose the dogma as a narrow understanding of art forms and art media.

One might think that this last point fuels an objection to the art-form hypothesis. The hypothesis is that Conceptual Art is not plastic art. The objection is that the hypothesis requires a conception of the plastic art form narrow enough to exclude Conceptual Art. But one aim of Conceptual Art is to challenge the narrow, Greenbergian conception of the art form! Conceptual Art is not plastic art only if the narrow, Greenbergian conception is true, and Conceptual Art shows it not to be true. Reject the narrow, Greenbergian conception and then Conceptual Art is plastic art. Put another way, appreciating Conceptual Art requires us to view it as continuous with plastic art, for only so viewed does it mount an internal critique of narrow conceptions of plastic art. Yet the the art-form hypothesis proposes that we fail to appreciate Conceptual Art because we try to appreciate it as plastic art and can only fail.

The objection goes astray because it equivocates on 'narrow'. It is true that the art form hypothesis requires a conception of plastic art that is narrow enough to exclude Conceptual Art. It is also true that Conceptual Art challenges a narrow, Greenbergian conception of the art form. The latter is narrower than the former. Thus to challenge the latter is not necessarily to challenge the former.

Here are the main components of the received Greenbergian view (set aside the question of whether the view is actually Greenberg's). Each art form is specified by an art medium that is unique to the art form. Works in that art form may be appreciated only for their medium-specific features. Since an art medium is a material with perceptible properties, medium-specific features are material perceptibles. In the case of pictures, the medium is visible pigment on a surface. Pictures are necessarily made to be looked at and hence to be appreciated only for their visible features. The epitome of picturing, on this view, is abstract expressionism and maybe minimalism.

Plastic art, as defined above, is not identical to Greenbergian visual art. Plastic art is not uniquely specified by an art medium; art media are not merely materials (they are technologies); and appreciating works of plastic art may involve more than mere looking. A Poussin is as paradigmatic of plastic art as a Pollock. Even a Pollock is more than a pure visual display.

Judging from its literature, the true target of Conceptual Art is the Greenbergian conception of the art form. The artists of Art & Language oppose the doctrines that 'the making of a traditional art object (i.e. one to be judged within the visual evaluative framework) is a necessary condition for the

making of art' and that 'the recognition of art in the object is through some aspect(s) of the visual qualities of the object as they are directly perceived' (Art & Language 1999: 101). Likewise, LeWitt writes that the goal of Conceptual Art is to 'ameliorate . . . [the] emphasis on materiality as much as possible or use it in a paradoxical way' (LeWitt 1999a: 15).

The irony is that Conceptual Art's break with the Greenbergian conception of visual art masks a deeper break with plastic art. According to the art-form hypothesis, Conceptual Art is not plastic art. The hypothesis does not, however, imply a narrow, Greenbergian image of plastic art as visual art. Thus is does not imply what Conceptual Art makes a point of denying. On the contrary, it is consistent with rejecting the Greenbergian image of plastic art. At the same time, it goes further. It says that Conceptual Art is not plastic art in the broader, non-Greenbergian sense. We fail to see this precisely because we accept Conceptual Art's critique of the Greenbergian image of plastic art as warranted.

13.8 A New Art Form

Conceptual Art is taken to be plastic art but it is not in fact plastic art. One objection to this hypothesis fails. That not only deprives us of a reason to doubt the hypothesis, it also shows us how Conceptual Art could be a new art form.

It is hard to see how Conceptual Art could be a new art form as long as we think that certain media, material qualities, and modes of perception belong essentially and exclusively to works of plastic art. Disposing of that Greenbergian dogma means allowing for the possibility that works in different art forms can share some of the same media. Some works of Conceptual Art, such as the Kassel Index, Barry's Inert Gas Series, and Ukeles's *Touch Sanitation*, do not draw upon media used in plastic art. Other works of Conceptual Art do demand attention to material and visual qualities not unlike that required of works of plastic art. The sticky temporality of the material in Smithson's asphalt rundown matters to its appreciation (marmalade would not substitute). The hard-edge monotony of On Kawara's date paintings is also appreciatively relevant, as is the fact that *L.H.O.O.Q. Shaved* looks like the *Mona Lisa*. However, the material and visual qualities of these works may not play exactly the same role as they do in works of plastic art. The fact that the works are Conceptual Art makes a difference.

What, then, are the distinguishing features of the Conceptual Art form? What is required to appreciate Conceptual Art? The questions cannot be given philosophical answers. There is no a priori reasoning from art media to art forms by way of the thesis that each art form has essential and unique art media. The properties of an art form are just those that explain the distribution of art media. We must therefore learn how media are used in Conceptual Art, so as to work out what properties of the art form explain that distribution of media. It is up to critics and historians to say what media are characteristically used in Conceptual Art and how. The art-form hypothesis predicts only that, in the choice of media and the point of that choice, Conceptual Art makes a break from plastic art.

13.9 Explaining Appreciative Failure

The argument for the art-form hypothesis is that it explains better than the competition why Conceptual Art is prone to appreciative failure. The hypothesis predicts the specific failures of appreciation to which Conceptual Art is susceptible. Ukeles shakes the hands of thousands of New York sanitation men. We attempt to appreciate this against our background knowledge of the goals of plastic art as realized via the picture-making media, and we are stumped. On Kawara paints the day's date in large sans serif type. It is quite pretty and bold, as painting goes, but it looks like his paintings of many other dates; so we are driven to look for the significance of the date-recording machine and to allow that the painting is not the whole point. The rules have changed but we are not told the new rules; on the contrary we are told to play by the old ones. However, the art-form hypothesis also explains what's true in the new art and ontological hypotheses.

Conceptual Art does stretch traditional definitions of art. It does this by introducing a new art form. Traditional definitions have also been stretched by the recognition of primitive art, pop art, and outsider art. None of these are new art forms: African masks are still carvings and pop songs are still music. The appreciative failure of Conceptual Art is caused not merely by stretching definitions, but by stretching them in a specific way: by introducing new art forms.

Moreover, we should expect the properties of an art form roughly to determine the ontological category of works in the art form. The properties of picturing, realized by picture-making media, explain why pictorial works

are objects. The properties of music, realized by sonic technologies, explain why musical works are sonic events. Ontology consequently tracks art forms: a difference in ontological category is a good indication of a difference in art form. Thus if we treat Conceptual Art as plastic art, then we will expect works of Conceptual Art to be objects. It turns out that many works of Conceptual Art are not objects. Our ontological expectations are frustrated and we may wonder whether our folk ontology has let us down.

It does not follow works of Conceptual Art mandate a wholly new ontology. They may be placed in the same category as works of literature, for instance. Nor does it follow that works of Conceptual Art prove plastic art to have a different ontology—that they dematerialize the art object, as Lucy Lippard puts it (Lippard 1973). Perhaps, instead, they belong to a different art form altogether.

Examining the appreciative failure of Conceptual Art teaches some general lessons. Definitions and ontologies of art figure in our explanations of artistic phenomena, but they cannot do all the work they are sometimes asked to do. They must be supplemented or nuanced by a general theory of art forms and art media and by special theories of the individual art forms. Theories of art media and art forms might make many problems in philosophy of art more tractable. After all, artists make—and think of themselves as making—not art, but rather art of this form or that. You and I appreciate—and think of ourselves as appreciating—not art, but rather art of this form or that.

Breaking the link between Conceptual Art and plastic art may also help in the tricky task of deciding which works belong to the art form. Having misclassified Conceptual Art as plastic art, we might well have missed some works as Conceptual Art. For instance, there are strong similarities between much canonical Conceptual Art and concrete and visual poetry of the late Sixties and early Seventies. Perhaps this poetry is not literature but Conceptual Art instead. Ian Hamilton Finlay is usually described as a sculptor, concrete poet, philosopher, and landscape architect. Perhaps he is really none of these; perhaps he is a Conceptual Artist. History, when it is a history of error, cannot decide. A better way to decide is to canvass the explanatory benefits—historical, critical, aesthetic, philosophical—of a reconception of the field of Conceptual Art.

Likewise, there is some debate about whether certain works of the Eighties and Nineties are Conceptual Art. This debate can be decided in many ways. The works in question could be included or excluded. They could also be seen as hybrids of Conceptual Art and plastic art. At the very least, the debate can be pursued from a new angle.

If the art-form hypothesis is correct, then the good news is that it is merely contingent that Conceptual Art is an appreciative failure. The hypothesis shows us how to convert failure into success, namely by viewing Conceptual Art as an art form in its own right. This undertaking does not undermine the radical aspirations of Conceptual Art. On the contrary, it is nothing terribly difficult to expand the boundaries of art; it is an achievement to expand the boundaries of art by creating a wholly new art form. It is something new.

Acknowledgements: I thank audiences at the 2004 Conference on Philosophy and Conceptual Art and the 2005 American Society for Aesthetics Pacific Division (and especially Diarmuid Costello and Aaron Meskin) for comments and suggestions.

References

ALBERRO, ALEXANDER and STIMSON, BLAKE (eds.) (1999), *Conceptual Art: A Critical Anthology* (Cambridge: MIT Press).

ART & LANGUAGE (1999), 'Introduction to Art–Language, Volume 1', in Alberro and Stimson (1999: 98–104).

BINKLEY, TIMOTHY (1977), 'Piece: Contra Aesthetics', *Journal of Aesthetics and Art Criticism*, 35: 265–77.

BURN, IAN (1999), 'Conceptual Art as Art', in Alberro and Stimson (1999: 110–11).

CARROLL, NOËL (1985), 'The Specificity of Media in the Arts', *Journal of Aesthetic Education*, 19: 5–20.

_____ (1999), *Philosophy of Art* (London: Routledge).

DANTO, ARTHUR (1964), 'The Artworld', *Journal of Philosophy*, 61: 571–84.

DAVIES, DAVID (2004), *Art as Performance* (Oxford: Blackwell).

DICKIE, GEORGE (1973), 'The Institutional Conception of Art', in Benjamin Tilghman (ed.), *Language and Aesthetics*, (Lawrence: University Press of Kansas), 21–30.

GODFREY, TONY (1998), *Conceptual Art* (Oxford: Phaidon).

GREENBERG, CLEMENT (1961), *Art and Culture* (Boston: Beacon).

KIVY, PETER (2006), *The Performance of Literature* (Oxford: Blackwell).

KOSUTH, JOSEPH (1999), 'Art After Philosophy', in Alberro and Stimson (1999: 165).

LEWITT, SOL (1999a), 'Paragraphs on Conceptual Art', in Alberro and Stimson (1999: 12–16).

_____ (1999b), 'Sentences on Conceptual Art', in Alberro and Stimson (1999: 106–8).

LIPPARD, LUCY R. (1973), *Six Years: The Dematerialization of the Art Object from 1966 to 1972* (New York: Praeger).

LOPES, DOMINIC MCIVER (2007), 'True Appreciation', 7 in Scott Walden (ed.), *Photography and Philosophy* (Oxford: Blackwell).

MORGAN, ROBERT C. (1996), *Art into Ideas: Essays on Conceptual Art* (Cambridge: Cambridge University Press).

OSBORNE, HAROLD (ed.) (1981), *Oxford Companion to Twentieth Century Art* (Oxford: Oxford University Press).

SHELLEY, JAMES (2003), 'The Problem of Non-Perceptual Art', *British Journal of Aesthetics*, 43: 363–78.

WALTON, KENDALL (1970), 'Categories of Art', *Philosophical Review*, 79: 334–67.

WOLFE, TOM (1975), *The Painted Word* (New York: Farrar, Straus, and Giroux).

WOOD, PAUL (2002), *Conceptual Art* (London: Tate Gallery).

14

Emergency Conditionals
Art & Language

We were surprised to be invited to speak at the conference on Philosophy and Conceptual Art. In fact the invitation was made to Charles Harrison. He is sometimes an academic. But he felt (a) that it would be inappropriate to respond as such, and (b) that together we would probably represent our relations with philosophy (whatever that is) to greater practical purpose; that's to say that we might be able to represent our practice—as something that absorbs or spits out 'philosophy'—in such a way as to reflect the thirty-odd years of our conversation. The brief for the conference seemed historically naïve—unaware of the vicissitudes and variations in the use of the term conceptual art. So we began to trace a sort of narrative. To do this it was necessary to distinguish our sense of conceptual art from at least two possible others. To this extent, we were adding philosophical and practical flesh to what seemed at the outset some very meagre bones—or not even bones, just vague and ambiguous usage. . . . Not that that's always so bad. What was disturbing was the sense of aestheticians' dreariness: a sort of killing abstraction that failed to recognize the practical and philosophical connectedness of the territory. Edwardian uncles get round to it after thirty-five years and get it wrong. (Imagine philosophy discovering cubism in 1947.)

Anyway, what we offered was not a performance. It was a sort of expository paper converted to the representation of an artistic practice. This practice is discursive and reflexive—talkative. How do we represent ourselves among philosophers? Not as philosophers. Was what we said philosophy? Is it affected

by the faint whiff of scandal or insecurity that is expressed by what we call the emergency conditional?

The 'voices' that are connected to particular speeches have no urgent or unique connection to what they say. They do not record an actual speech event. The text was divided up into speakable chunks. Each chunk was assigned a number from 1 to 3—on a more or less arbitrary basis. 1 was spoken by Michael Baldwin, 2 by Mel Ramsden, 3 by Charles Harrison. There is no necessity in this, either psychological or factual. We have collaborated on several occasions with the members of the Jackson Pollock Bar of Freiburg. We write theoretical texts and they install them. Professional actors perform the lines and actions variously assigned to Michael Baldwin, Charles Harrison, and Mel Ramsden. In the case of the following text the speakers could have been rearranged. As to whether there would have been some loss as a consequence of a rearrangement we do not know, nor will we ever know what loss there may have been as a consequence of the arrangement we followed. To this extent it was a performance as in live theatre—or as in instruments playing from a score.

At the same time, the text is readable, translatable and so forth—a mere text. Was our reading of it art or philosophy or drama? It is possible that it belongs to a genre that could include *The Blue and Brown Books: the Musical*, or *Painting as an Art on Ice*. It is more likely, though, that it bears a passing family resemblance to what the Jackson Pollock Bar calls Theory Installation. How would it then be distinguished from what might normally be presented at an academic conference?

Michael Baldwin. By way of an opening we need to ask just what the term conceptual art is supposed to pick out. It has lately come to mean more or less any kind of art that does not explicitly seek to attach itself to a technical tradition and is not medium-specific. Art is no longer conceived on the basic principle of a painting/sculpture axis, but rather as a current and continuing generic product capable of installation and distribution within some institution of an art world.

Mel Ramsden. As an alternative, we could think of Conceptual Art as a specific critical development in the historical ambience of high modernism during the mid-to-late 1960s and early 1970s. In talking of high modernism we mean not just a selection of transatlantic art made in accordance with a purified Greenbergian theory—not just the paintings of Morris Louis,

Kenneth Noland, and Jules Olitski, and the sculpture of Anthony Caro—but also the work that both overlapped and competed with theirs: Frank Stella's, Don Judd's, Dan Flavin's, Robert Morris's, Sol LeWitt's. A Conceptual Art movement conceived along these lines is associated with a specific historical period—though we can still argue both about how that period is defined and about what work does or does not come up for the count. Thus, by analogy, while cubism was a movement with fuzzy boundaries, and while the epithet 'cubist' was used by non-professionals as late as the mid-twentieth century to refer to odd-looking avant-garde art, it could be said that a cubist painting made in the 1950s would have been unlikely to deserve much serious critical attention.

Charles Harrison. It might seem that these two different modes of usage of the category of conceptual art are easily enough reconciled. We can simply consider a continuing generic conceptual art as the long-term outcome of the historically specific Conceptual Art movement—or of what has been called 'modernism's nervous breakdown'. But we have to be careful. It was not as though practical dissent from hegemonic modernism had one single possible outcome. It might have seemed for a while that everyone was busy disinterring Marcel Duchamp and playing the same game of appropriative and nominative gestures. (I think of this as the 'When Attitudes become Form' moment—lasting until around the summer of 1969.) But it very soon became apparent—at least to Art & Language—that this could develop in several quite different ways, from which we pick out a contrasting pair.

MR. It could go towards a kind of *institutional theatre*: from Joseph Beuys and Daniel Buren, to the more recently celebrated works of Ilya Kabakov, or to more or less anything liable to be installed in the Turbine Hall of Tate Modern.

MB. Alternatively it could lead to a kind of *essayistic practice* that reflected upon its own conditions and considered the language and vocabulary and historicity of the appropriative gesture itself.

CH. But these were not possibilities with equal pragmatic legs. The first may have been the complaisant client of demotic institutional theory, but by the early 1970s informal versions of that theory were spreading apace both through the avant-garde sectors of the art world and through the graduate departments of American universities. The art of institutional theatre both rode and was ridden by various types of fashionable postmodernist theory, and particularly by those that were vehicles for virtuous anxieties about the

consequences and inequities of class, race, gender, and expansion of the media. Its various practical modes were unified under the sign of the curator, and were supported from the world of cultural studies and corporate radicalism.

MR. In the climate of taste this alliance has served to encourage, pathetic modernists like Cy Twombly and anti-modernists like Francis Bacon and Lucien Freud could be recuperated alongside such exciting newcomers as Damien Hirst and Tracey Emin. 'You've got to choose between Mondrian and Duchamp', Ad Reinhardt said in 1967. Now choice means the right to consume everything indifferently.

MB. Not long ago we participated in a symposium addressed to the question, 'What work does the artwork do?' On that occasion we suggested that for the sake of argument a distinction might be made along the following lines: on the one hand there are works of art—and theories about works of art—based on the proposition that work is what spectators do in variously animating the work of art through interpretation and exegesis. It should be clear enough that the art of institutional theatre tends on the whole to conform to this mode, and that it delivers itself up with some facility to journalism, whether of the popular or of the academic variety.

MR. Media-led critical bullshit sticks easier to the slight and the trivial than it does to the articulate and the complex.

MB. On the other hand there are works of art—or theories about works of art—based on the proposition that whatever work is done is intimately connected to the intentional character of the artwork, and that it is what that artwork does in animating its suitably attuned and attentive spectator.

CH. We should make it clear, perhaps, that we do not here mean to invoke that Wollheimian gentleman who is the artist's boon companion. We simply mean to suggest that there exists the possibility of interpretative failure, and that to a significant degree the work will be the arbiter of that. When we refer to the intentional character of the work, we do not want to suggest that this is the intentionality of a single individual, but that there is some critical dialogue that the work and the viewer enter into regarding what is relevant and resonant in a given interpretation, and that one of the participants in this dialogue will be the work itself conceived as intentional.

MB. The second, essayistic type of conceptual art tended to look to the second of these modes. It separated itself out from the permissive melange of 'When

Attitudes become Form' at a point when it no longer seemed defensible to treat modernism's nervous breakdown as an occasion of opportunity. It developed out of a kind of anxiety regarding the relaxed, ostensive practice of dematerialization-as-liberation. One couldn't just live in a relaxed world of wilful artistic ostension. How, we asked, might one make work with detail in a circumstance where the possibility of detail is not given among the resources of a specific medium? By detail, what we had in mind was some aspect or set of connected properties that both required and arbitrated a complex description—one that was not just an account of how the work interacted with the art world.

MR. The problem was not that one objected to art getting away with things under the artistically demotic forms of an institutional theory—'If someone calls it art, it's art' and so on. For the most part the emptiness of Conceptual Art amenable to such theory just seemed critically harmless.

CH. Nor was the problem how to have something of aesthetic interest in a Wollheimian sense that nevertheless didn't have the physical properties by which that interest was supposed to be provoked. At a certain level the issue of aesthetic interest was simply beside the point. Art is theory-laden and concept-laden whatever anyone claims to be seeing and feeling in front of it—and not just any old concepts or any old theories. Peter Lamarque has made a similar point with respect to the work of Rembrandt. It could be said that essayistic conceptual art simply made an issue of this.

MB. The difficulty was that neither of these senses of the problematic took adequate account of the consequences of the collapse of the Greenbergian mainstream; nor did they properly acknowledge the insecurities attendant on the institutional theory—the concern that it might simply be wrong in its accounting for the relations between perceiving and describing, or that, in accepting it, artists might find themselves in an invidious position vis-à-vis actual institutions—or in a dead end so far as art was concerned.

MR. In fact it could be said that one consequence of the institutional theory has actually been to licence an obsession with the idea of art as generic, when much of what is produced in the name of generic art could quite well be accounted for as continuous with the critical concerns of late modernism. After all, there are actually very few Snow-Shovel-like things, but many paintings with words and tasteful arrangements of stuff—which do no more

real damage to modernist ideas about medium-specificity than did Frank Stella's black paintings.

CH. As we have already suggested, the alternative modes we have labelled institutional theatre and essayistic practice were not actually equivalent and parallel developments. The consequences of the development of generic conceptual art were such as to suppress the discourses of autonomy and internality, and to obliterate the sense of a parallel development that retained some investment in their continuity. It grew fat on the very theoretical resources it claimed to have transcended. In the new hegemony, even the supposedly outmoded modernistic discourse on autonomy was somehow incorporated and represented.

MR. But we do clearly identify the practice of Art & Language with the essayistic alternative. We are therefore unwilling to accede to the idea that generic conceptual art is the unchallengeable outcome of the original Conceptual Art movement. This does not mean that what we have been and are trying to do is to flog Greenbergian modernism back into life, or to reinstate its concepts of autonomy and internality. It may be that our form of conceptual art had in common with painting the fact that it did not actually *require* a specifically institutional kind of theory to tell it what it is. But given the way things were going, autonomy was always going to be a contested and insecure project. It was not as though the question of what work the artwork does was ever really going to be settled one way or the other. Indeed, if it were, art would almost certainly be a thoroughly uninteresting business.

CH. We should try to review some of the conditions of problems. One is that the critical negativity—bankruptcy?—of modernism was part of the reason that the conceptual art movement could emerge.

MR. A second is that institutionality is or has become a sort of enslavement to management.

MB. A third is that only by means of some form of internality combined with some capacity for detail could death by curatorship be effectively resisted.

MR. A fourth is that the denizens of the happy world of wilful ostension failed to grasp the complexities and difficulties of the very language by which that ostension was being effected. Instead they relied both on the artist being accorded a kind of 'Romantic' authenticity and on a complaisant acceptance of the transparency of his words.

MB. A fifth problem is that this authority and mystification could only be resisted by description, and by a theory that was in some way internal to the work itself. What was required was a social world in which and into which the work could be uttered.

CH. In fact it is not entirely clear which came first: the imperative to beat the curator by creating a descriptive circumstance, or the need for some sort of internal complexity in the work.

MB. The best way to resolve that issue is to say that a sort of context of conversational concentration was 'naturally' established once one recognized that art is vacuous unless it is describing as well as described.

MR. And once you have got a conversational process going it tends quite naturally to take on a project-like character: in being conversational it tends also to take account of the world of which it is with difficulty a part, and in which it is uttered. It is thus availed as a matter of course of the grounds on which to contest claims for the internality of its own outcomes. This is to say that a conversational practice will be disposed to sustain a degree of tension between, on the one hand, its contextual and institutional circumstances, and on the other the kinds of claim it might make to internality (to having an oeuvre, and to there being some degree of formal integrity in its products, and so on).

CH. In fact the conversational practice tends to militate against any purified sense of what the work is, so that its capacity to constitute an oeuvre is severely impeded. There is a popular representation of Art & Language according to which we are held to have made an avant-garde claim to the effect that our conversations and proceedings are art. This vexatiously misses the point. It takes us as it were back to the original point of bifurcation and associates us with the institutional theatre of such figures as Ian Wilson—who did indeed claim around 1970 that his conversations were art.

MB. We can recall having had conversations with Ian Wilson. We can recall nothing of their content. The presupposition was presumably that as artworks they need have none. 'Conversation' was a quasi-Duchampian readymade—in this case an appropriated category, or . . . what? In fact were one able to remember the content of a conversation with Ian Wilson one would be the less likely to recover conversation itself as a readymade.

MR. For us, the conversational process was not a Duchampian gesture. Though it may have had heir-lines to it, it also had heir-lines to the 'internal' critique of high modernism and its penumbra. But first and foremost it was a means of exchange and production. The point was that we were in no position confidently to impose a sense of artistic hierarchy on the distinctions between verbal discussions, informal on-paper exchanges, essays, and pieces of paper stuck to the gallery wall. Of course certain hierarchies did get established for purposes of publication and display, but they were matters of practical contingency.

MB. It would be wrong, though, to suggest that there were no normal aesthetic considerations in play. Whether we cared to admit it or not, certain matters of taste were relevant, and these were of a more-or-less Wollheimian kind—to do with the physical properties of things.

MR. That which was produced for distribution and display was not without its vestigial aesthetic aspects. There was no pink conceptual art, and absolutely no green. What tended to predominate was the black, white, and grey of the office and of the otherwise socially unspectacular. There was a kind of truth to materials in this. In those days there were no colour photocopies. In the case of a great deal of conceptual art—some of our own included—there may in the end be little remainder once considerations of graphic taste are accounted for. It is an open question just how far Wittgenstein-on-the-wall escapes significantly from the kind of aesthetic admonitions that were associated with the work of Don Judd, without in the process simply being reduced to an inefficient form of Wittgenstein-on-the-page.

MB. We did have some anxieties about this at the time. What followed were texts printed in green and red and so on. The point was to evade the myth that neutral taste was co-extensive with critically significant dematerialization—and that there was a progressive political aspect to both.

CH. We were well enough aware of the silly hypostatizations. Some of the talk about dematerialization certainly muddied the waters. In fact it was in muddy water that we saw our work as in constant transition between the conversation, or the theorizing that it recorded, and the gallery wall it had syndicalized or taken over. In so far as it achieved some independence from graphic considerations, that work put itself in the way of aesthetic virtues that were literary—either theoretical or descriptive.

MR. It did not follow, however, that in so far as it achieved virtue of a kind it must therefore be embedded in the theoretical discourses of literature or philosophy. To say that it was theory was false, since the work it did as art absolved it of the standard assumptions that it was truth-telling, coherent or extensible in ways that theory and philosophy are supposed to be. Nor was it literary in a normal sense. It did not and could not demand of the viewer that she be a literary reader.

MB. This sense of permanent transition and instability brought us to what we called an emergency conditional. The work was theory (or something) just in case it was art, and it was art just in case it was theory. Could we say then, that in its strangeness it resonated with both?

CH. And, further, permanent transition and instability called forth other emergency conditionals. We were artists just in case we were critics, and critics—or teachers or art historians—just in case we were artists. This 'homelessness' gave the work a brief independence; paradoxically, a place of production that was not wholly subservient to institutions and disciplines.

MR. But what if someone objects that the work actually *was* 'theory'; that it could be read and (occasionally) used as theory. Is it then displaced or disqualified as art? We are not sure that it is. It may end up, like Flaubert's *Madame Bovary*, as a kind of book about nothing. But if it *is* theory, then on the whole it will try to be about something—some object or relation or process; and this will then map it back to the circumstances of the original bifurcation consequent upon modernism's nervous breakdown.

CH. What is perhaps more to the point—if more problematic—is the thought that by around 1968 to 1969 the original ontologically iffy art-works—air-conditioned rooms, columns of air, and what have you—had been swamped or themselves partly displaced by the theory that was intended to be 'about' them. The 'Air-Conditioning Show' of 1967 furnishes an example. This consisted of a text proposing the air in an air-conditioned room as an art object and expanding on the problems that that proposition entailed. The question raised was, 'Is it necessary actually to install air-conditioning as described in the text, or will the text do just as well?' Was the text to be identified as the art—the meaning—we make, and was any concrete 'realization' of that which it described merely a conservatively contemplative distraction?

MB. We might think of this question as marking the distinction we have already proposed between conceptual art thought of on the one hand as a kind

of Duchampian extension of minimalism occasionally outside the realm of middle-sized dry goods, and on the other as a fundamentally textual cultural practice.

CH. Imagine that someone asserts that 'Everything in the unconscious perceived by the senses but not noted by the conscious mind during trips to Baltimore in the summer of 1969' is his work of art, and someone else says, 'What do you mean?' The 'What do you mean?' is supposed by the artist and his admirers not actually to impinge on the assertion. To treat that assertion as a speech act—or its textual equivalent—is to commit a kind of foul. It seems nevertheless necessary to treat it as the speech act it actually is. But to do this is to impede it. What we had in mind was a kind of text in which the interrogative is included along with the appropriative claim—and one which would therefore be an object of a quite different order. The consequence was considerably to increase the detail of the appropriative gesture—the theoretical content that it wore on its face.

MB. The difference entailed is more than merely quantitative. The viewer is made a reader of sorts—a conversationalist of sorts. This seems a not undesirable outcome. It is one with which we have tried to render our subsequent practice consistent. Conceptual art may entail a way of making art. If it is one in which painting as traditionally understood can only be sentimentally pursued, it is not necessarily one in which the possibility of internality is ruled out. What may be ruled out is the idea of an oeuvre as unified by some biologically authenticated style. A conversational practice will tend to rule against certain kinds of consistency and purification.

MR. If conceptual art as we understood it had a future it was not as conceptual art—not, at least, if what that means is simply the Duchampian model emptied of its transgressive potential and rendered congenial to the managers of interdisciplinarity.

INDEX